Blood
Art, Power, Politics and Pathology

Blood

Art, Power, Politics and Pathology

Edited by James M. Bradburne

With contributions by James Clifton, Valentina Conticelli, Stanislaw Dumin, Claudia Eberhard-Metzger, Mino Gabriele, Henry A. Giroux, Christian Holtorf, Georg Kugler, Jonathan Miller, Giuseppe Orefici, Kim Pelis, Joachim Pietzsch, Miri Rubin, Annette Weber, and Peter Weiermair

Prestel
Munich London New York

This book appeared on the occasion of the exhibition entitled "Blood: perspectives on art, power, politics and pathology," held at the Museum für Angewandte Kunst and the Schirn Kunsthalle, Frankfurt am Main, from November 11, 2001–January 27, 2002

Cover illustration: Hermann Nitsch, *Station of the Cross*, 1962
Frontispiece: Andres Serrano, *Semen and Blood II*, 1990

Library of Congress information is available

Prestel books are available worldwide. Visit our website at www.prestel.com or contact one of the following Prestel offices for further information.

Prestel Verlag
Mandlstrasse 26, 80802 Munich
Tel. +49 (0) 89 38 17 09-0, Fax +49 (0) 89 38 17 09-35
e-mail: sales@prestel.de

4 Bloomsbury Place, London WC1A 2QA
Tel. +44 (0) 20 7323-5004, Fax +44 (0) 20 7636-8004
e-mail: sales@prestel-uk.co.uk

175 Fifth Avenue, New York, NY 10010
Tel. +1 (212) 995-2720, Fax +1 (212) 995-2733
e-mail: sales@prestel-usa.com

Editors: James M. Bradburne, Annette Weber, Maria de Peverelli
Editorial assistance: Caroline Gerner

Translation from the German: Paul Aston, Ishbel Flett
Translation from the Italian: Jane Carroll, Beryl Stockman
Translation from the Russian: Frank Goodwin

English copyediting and text coordination: Michele Schons
Additional copyediting: Danko Szabo
Design and Layout: WIGEL, Munich
Lithography: ReproLine, Munich
Printing: Passavia Druckservice, Passau
Binding: Conzella, Pfarrkirchen

The final selection of images for this book was the responsibility of the publisher and not the authors.

ISBN 3-7913-22600-7 (English edition)
ISBN 3-7913-2599-X (German edition)

Printed in Germany on acid-free paper

Schirn Kunsthalle Frankfurt
Römerberg
60311 Frankfurt am Main
www.schirn.de
Director, Max Hollein

Museum für Angewandte Kunst
Schaumainkai 17
60594 Frankfurt am Main
www.mak.frankfurt.de
Director, James M. Bradburne

From the moment we are born, every human is engaged in the process of making meaning. This activity defines our humanity, shapes our lives, and determines the way in which we create the world around us. We are born into a world of experience, but this experience is interpreted for us and to us in our interaction with it and with others. Our culture is defined by the complex ebb and flow of our attempts to decipher the world, and the way in which the meanings we ourselves create shape that world.

Blood is an extremely powerful symbol. From the first time a child cuts its finger, blood, with its shocking redness, salty taste, and musty smell, assumes a symbolic dimension. Blood accompanies new life, the transition of women to adulthood, and often accompanies violent death. This book, and the interdisciplinary exhibition it accompanies, explores the compelling emotional, social, cultural, and scientific power of blood. It invites us to think about the ways in which the entire culture—from the fine arts to technology and scientific research—has been shaped by the changing understanding of what blood is and what it does.

Preface

The exhibition "Blood: Perspectives on art, power, politics and pathology" is the latest in a series of attempts to create thought-provoking exhibitions that bring together material from the fine arts, applied art, science, and technology. "L'Âme au corps," for instance, presented in Paris in 1993 at the Grand Palais, assembled material from across a wide spectrum of art, science, and technology to explore the idea of the human soul. "The Merchants of Light" (part of a major cultural event celebrating Rudolph II that took place in Prague in 1997) brought together astrolabes, Arcimboldo paintings, alchemical treatises, and astronomical and allegorical paintings in an attempt to present the complexity of late Renaissance culture. A more recent example, the multidisciplinary exhibition "Light," which presented paintings alongside stock coupons and Fresnel lenses at Amsterdam's Van Gogh Museum in 2000, won widespread international acclaim.

It has long been our conviction that—contrary to the belief of some museum professionals—visitors are not only intelligent, but that they derive real pleasure from confronting material that makes them think about the world in which they live. Thus there need be no contradiction between a "popular" exhibition and a thought-provoking, "difficult" exhibition. The term "edutainment" has always seemed a pernicious nonsense, a puritan prejudice that associates pain with gain, and pleasure with frivolity. The overwhelming evidence is that most people are quite prepared to read challenging murder mysteries, play games, and watch difficult films. Sustained intellectual engagement is a real, sometimes almost sensual pleasure. The fact that many museums are under-attended is witness not to the inability of the visitors to appreciate the material but evidence of the museum professionals' inability to make it interesting.

The subject was inspired initially by Miri Rubin's book *Corpus Christi*, in which she describes the late medieval Christian practices that coalesced into the canonical celebration of the Mass. The thinking on the ways in which our changing understanding brings about very real changes in the world was further fueled by Jonathan Miller. Jonathan Miller's work—as a scientist, a writer, exhibition-maker, and stage director—all revolves around the constructive power of the metaphor.

The exhibition is unusual insofar as it is a single exhibition displayed in two different venues. The collaboration was initially developed with the former Director of the Schirn Kunsthalle, Hellmut Seemann, who enthusiastically agreed to work on making the challenging exhibition a reality. To Hellmut go our thanks for his support throughout the initial stages of the project. Any work of this scope and ambition of necessity owes many debts of gratitude, and it would be impossible to list all the many people from all walks of life who have helped shape the exhibition and the accompanying book. We would nevertheless like to acknowledge the help of the following collaborators, apologizing in advance to any whom we have inadvertently omitted.

First of all, we would like to thank the project's sponsors, Aventis and the Kulturstiftung of the Deutsche Bank. Our thanks also go to the German Red Cross, also enthusiastic supporters of the exhibition from the outset. The Hessische Kulturstiftung, the Georg and Franziska Speyer'sche Hochschulstiftung and Dr. Hans Schleussner also contributed to important aspects of the exhibition's programs, including the exhibition website, www.bloodexhibition.de.

Second, we wish to thank the City of Frankfurt, in particular its Lord Mayor, Petra Roth, its Deputy Mayor for Cultural Affairs, Hans-Bernhard Nordhoff, and the members of the Cultural Committee of the City parliament, chaired by Alexandra, Prinzessin von Hannover. Their support of the exhibition as a model of cooperation between institutions shows the strength of Frankfurt's commitment to becoming a vital European cultural capital.

We would like to thank the curators and authors of the catalogue, James Clifton, Valentina Conticelli, Stanislaw Dumin, Claudia Eberhard-Metzger, Mino Gabriele, Henry A. Giroux, Christian Holtorf, Georg Kugler, Jonathan Miller, Giuseppe Orefici, Kim Pelis, Joachim Pietzsch, Miri Rubin, Annette Weber, and Peter Weiermair. To Jonathan Miller go special thanks for generously taking the time for the exhibition from its first beginnings in 1997 and throughout its subsequent development.

We wish to thank Prestel Verlag for having enthusiastically accepted the challenge of publishing the book to accompany the "Blood" exhibition. Our thanks are also due to the translators, Paul Aston, Hubert Beck, Jane Carroll, Ishbel Flett, Frank Goodwin, Bram Opstelten, Nikolaus Schneider, and Beryl Stockman, and specially to the copyeditor, Michele Schons, and Prestel's editorial team. Annette Weber, exhibition curator and author, also deserves special thanks for the time and enormous effort she devoted to editing the German edition of the book, as does Maria de Peverelli for her editorial insight at every stage of the evolution of the book. Caroline Gerner was an enormous help in the final weeks of preparation.

We would like to thank the staff of both museums. At mak.frankfurt, Margrit Bauer has been indispensable in ensuring that the exhibition loans were secured and registered, and Margit Emrich and Martina Schmidt have managed the vast amount of paperwork with unflagging good humor. Jürgen

James M. Bradburne and Max Hollein

8

Dietrich and his team have made sure that the exhibition could be installed under difficult conditions. Eva Linhart and her colleagues have also played an important role in ensuring that the exhibition gets the public attention it deserves. The curators Volker Fischer, Stephan von der Schulenburg, Stefan Soltek and the conservators Andrea Schwarz and Alexandra Bersch also assisted the implementation of the exhibition at several junctures.

At the Schirn Kunsthalle, we would especially like to thank Karin Grüning for her efforts above and beyond the call of duty to ensure that the exhibition loans, in particular those for the twentieth-century section, were coordinated and installed. Ingrid Ehrhardt was involved in the curatorial side from the beginning of the project until her maternity leave, and helped the project with her usual dedication and thoughtfulness. We are more than grateful to Ronald Kammer and his team for their consummate professionalism and ability to work to very tight deadlines. Stefanie Gundermann, in charge of conservation, as well as Irmtraud Rauber and Andreas Gundermann are also to be thanked for the important roles they played during the implementation and installation of the exhibition. Several new faces have appeared at the Schirn Kunsthalle in recent months, including Ingrid Pfeiffer, Dorothea Apovnik, and Inka Drögemüller, and they deserve thanks for having made the realization of the exhibition possible in its final stages.

For the outstanding exhibition design, we would like to thank Peter de Kimpe, whose affability and good humor is so pronounced that sometimes it masks the fact that he is a brilliant exhibition designer at an international level. His insights into the challenges of how to translate complex and difficult ideas into a physical setting helped the project evolve at several key junctures.

We would like to thank our colleagues at other museums, both in Frankfurt and abroad. In particular we would like to thank Tamara Igumnova of the State Historical Museum in Moscow, for the difficult loan of the Repin portrait of Tsar Nicholas II, Lindsay Sharp, Tim Boon, and their colleagues at the Science Museum in London, Lawrence Smaje, Denna Brown and David Pearson of the Wellcome Institute. In Frankfurt, our thanks go to Herbert Beck at the Städel, Jean-Christophe Ammann and his team at the MMK, and Walter Schobert, Hans-Peter Reichmann, and their colleagues at the Deutsches Filmmuseum.

We would like to thank Britta Fischer and Sue Bond and their respective staff for coordinating the public relations for the exhibition, as well as the public relations staff of all the sponsors, who contributed to publicizing the exhibition. Our thanks go as well to Andreas Redlich and his team at Publicis, who generously offered their time and effort developing the promotional campaign for the exhibition, as part of their ongoing partnership with mak.frankfurt

Finally, a very large debt of thanks goes to Maria de Peverelli, without whose efforts neither book nor exhibition would have taken place. It has been a rare treat to work with such a consummate museum professional, able to take anything in stride, and able to transform the most heterogeneous mass of information into a coherent, organized whole.

James M. Bradburne Max Hollein
Director Director
Museum für Angewandte Kunst Schirn Kunsthalle
Frankfurt am Main Frankfurt am Main

"The metaphor is probably the most fertile power possessed by men."

Ortega Y Gasset

"Since finding out what something is is largely a matter of discovering what it is like, the most impressive contribution to the growth of intelligibility has been made by the application of suggestive metaphors."

Dr. Jonathan Miller in The Body in Question

Perspectives on Art, Power, Politics and Pathology
James M. Bradburne

Andres Serrano, *Semen and Blood II* (detail),
cibachrome, 1990, New York, Paula Cooper Gallery

Blood is one of the most powerful and ubiquitous of human symbols. It signifies both life and death, health and disease, power and powerlessness. This book looks at the ways in which changing metaphors of blood have determined the construction of social relations, and the creation of material culture. This is not idle, abstract speculation. If you believe that blood sacrifice is necessary to ensure the sun rises and the crops flourish, culture forms around the necessities of ritual bloodletting. If you believe that being of a certain descent—your "bloodline"—legitimizes political power and social prestige, it is important to "preserve the blood" by marrying a close relative. It also pays to have one's bloodlines publicly displayed in the form of portraits, medals, engravings, and regalia. If you believe that blood can transmit dangerous diseases, you think twice before you risk an exchange of fluids. The way we understand this "special juice" shapes the way in which we conduct our lives, choose our partners, structure our institutions, and express our culture. The changing understanding of what blood is, the role it plays, and the properties it confers, can bring either prosperity or devastation to countless millions.

Several major themes run through the book, its "red threads," so to speak. These themes include blood sacrifice (both self-sacrifice and the sacrifice of human and animal victims), power (both human and divine), and disease. Our material culture—from objects to altarpieces, from paintings to posters—is examined according to different perspectives on the subject of blood and its qualities. The cultural output of very different times and historical contexts is seen as an expression of our beliefs about the world—as a lens that helps us look at beliefs that are often simultaneously rational and irrational, harboring atavistic superstitions and contemporary understanding. Thus the book explores the tension between blood as a magical substance, and blood as a subject of rational scientific investigation—and the tension between those who invoke the metaphor of blood as an instrument of liberating power, and those who see it as a means of repression and control. These themes are illustrated and explored in individual essays, each treating a part of the rich story of our understanding of blood, and the traces this understanding has left on our culture.

Each of the essays found in this volume sheds light on the subject of blood from a different point of view, opening up new perspectives on the constructive power of metaphor. They follow in roughly historical sequence, although many of the issues touched upon recall past practices or prefigure future ones. Each essay attempts to put specific elements of cultural production—objects, buildings, manuscripts, paintings, engravings, caricatures, posters, photographs—in the context of a broader discourse on blood. The changing nature of this discourse can be seen to have had a dramatic influence on material culture in its broadest sense, and the traces this discourse has left are themselves evidence of the power of our understanding of blood to shape the world in which we live. Most of the essays have been written specifically for this book, but three essays were considered so compelling that we asked their authors to revise them to be included in this volume.

By virtue of its subject, this book risks being simultaneously arcane and commonplace. It tries, however, to avoid both overspecialization—a pitfall of many scholarly books and exhibition catalogues—and the obvious. Some of the essays deal with little known chapters in the history of theology, while others treat issues surrounding AIDS, the Genome Project, and violence in advertising. It remains, however, a collection of specific perspectives—*essays* in the literal sense of the word. The subject of blood is vast, and no book could do justice to all its many facets. With the exception of the chapter on the Maya, the essays look primarily at the Western tradition, as to attempt to examine all the cultures in which blood has played a role would be too unwieldy and heterogeneous to fit comfortably between the covers of a single book. Thus the rich cultures of Africa, Asia, and the Islamic world have been referred to only in passing, despite the sacrificial traditions of Africa, the importance of the Arab world to the development of anatomy and medicine, and the Japanese practice of ritual self-sacrifice—*hara kiri*. A full treatment of the role of blood in these cultures must, regrettably, be left until a future writer takes up the challenge of doing justice to them.

Since earliest civilization, blood and sacrifice have been linked to good fortune, propitious harvests, and the renewal of life. Perhaps extrapolated from the menstrual cycle, the symbolic role of blood in renewal and regeneration was undisputed, and blood played a role in making a building's foundations firm, a firstborn's fate provident, a nation's prosperity secure. Blood was used to temper swords and smooth complexions. Blood was a magical substance needed to appease the gods in the heavens and ensure the smooth functioning of the social order on earth. Blood has always been believed to have magical properties, and blood is often cited as a key ingredient in magical preparations.

The book is introduced by an essay by theologian Christian Holtorf, who surveys the wide spectrum of beliefs and symbolism surrounding blood. In particular, he looks at the various ways in which Christ's sacrificial offer—"my blood for thee"—is woven through Western culture, and sketches many of the issues that are treated in detail in subsequent chapters.

In his essay, Mino Gabriele looks at the legacy of antique notions of blood —many of them highly magical—and explores the complex symbolism Western Europe inherited from pre-Christian cultures. Mino Gabriele, a specialist in the legacy of the antique in Renaissance thought, and recently responsible for the complete annotated edition of the Renaissance masterpiece *The Dream of Polyphilus*, is ideally suited to telling the little known story of the transmission of Classical beliefs—a story that saw certain intellectual traditions reduced to a single manuscript or disappear altogether from the third to the ninth century. On the basis of rare manuscripts, incunabula, and later books Gabriele looks at the understanding of blood and its relationship to divination. In the Classical world blood was assumed to play a part in conjuring the dead in order to establish contact with the Underworld, or gain access to knowledge of the future.

The theme of sacrifice has always played an important role in the Western tradition. The Old Testament tells us that Abraham was commanded by God to sacrifice his son, Isaac—only to be allowed to substitute a ram at the last moment. Nevertheless, however important the theme of sacrifice in the Western tradition, one of the purest examples of a culture shaped by blood sacrifice was that of the Maya, whose civilization flourished in Central America from the sixth

to the sixteenth century, described by Maya specialist Giuseppe Orefici. Blood saturated the Maya experience, and like no European culture past or present, blood and its symbolism shaped Maya society. According to the Maya, man was made of maize, and infused with the sacrificial blood of the Gods. Ritual bloodletting characterized every aspect of Maya life. Blood was shed by Maya kings to sanctify their accession. Captives were sacrificed alive, their beating hearts excised, to signify the power of the Maya rulers. Blood was part of the complex renewal and control of a chaotic and often malevolent universe, and sacrifice was an integral part of the natural order. Maya art reflects the culture's obsession with blood. Finely wrought "eccentric flints," obsidian knives, pottery vessels depicting human sacrifices, and ornate gold plates are among the elaborate and beautiful expressions of a civilization renewed by shedding human blood.

Blood was not always seen solely as a magical substance, but also as a vital one—one of the keys to health and well-being. In her essay, Valentina Conticelli, a specialist in the history of early medical thought, picks up where Mino Gabriele leaves off, and taking the Classical legacy as a starting point, looks at the doctrine of the microcosm and macrocosm (the belief that human physiology is a mirror of the organization of the natural world) and its influence on the theory of the four humors further developed by Galen and his followers in the early centuries after the birth of Christ. According to the neo-Platonists of the Renaissance, the angelic powers of the super-celestial spheres of the macrocosm could be drawn down to the microcosm of man, affecting his humors, his character, and, ultimately, his destiny. Conticelli follows Galen's elaboration of the four humors as it ripples through the Middle Ages, shaping the early history of anatomy, dissection, and medical practice. Foremost of the four humors, blood was let in order to treat dangerous ailments until well into the nineteenth century. Leeches are still used today in specific cases to promote blood flow following difficult limb reattachments.

In the Christian faith, the sacrifice of one man, the "lamb of God," replaced with a single Divine act, once and for all, the multiple and repeated animal sacrifices of the pagans. Christ's blood washed away the sins of the world, and cleansed fallen humankind. The miracle of Christ's sacrifice was celebrated as the sacrament of Holy Communion, wherein the bread was transformed by the priest to flesh, and the wine, to blood, to save the penitent believer. Western art has been dramatically shaped by Christian iconography and its celebration of the redemptive blood of Christ.

James Clifton, art historian and specialist in Christian iconography, examines in detail the imagery of blood as it is used in Christian worship. He looks at works ranging from little-known manuscript illuminations to well-known masterpieces from the late Middle Ages to the late Baroque, which explicitly depict the life-giving redemptive power of Christ's blood in striking images —fountains filled with blood, chalices filled directly from Christ's wounds, the wounded and bleeding Host. In addition to being aids to private devotion, these images—the result of the artist's need to render written doctrine visible— were also powerful tools in the Church's attempts to promote "correct belief" and to prevent heresy among a far flung and often unlettered flock, both clergy and laity. As the Church consolidated its power, the need to insist on a cohesive body of beliefs increased, and the tolerance of competing or divergent inter-

pretations of Holy Scripture diminished. In particular, in response to those who claimed that Christ's divinity lessened the nature of His sacrifice on the Cross, the Church went to great lengths to communicate the doctrine that Christ was both all God, and all Man, making His death on the Cross a true sacrifice of one man for all. For centuries, one's beliefs about blood—at least Christ's blood—could mean the difference between a life within the loving embrace of Catholic orthodoxy, or a heretic's death at the stake.

In the late Middle Ages, following the confirmation of the doctrine of transubstantiation by the Fourth Lateran Council, in 1215, in which Christ was claimed to be physically present in the wine and bread of the Mass, Jews were increasingly accused of stealing the Host, either to "test" Christian truths, or to desecrate the Christian God. This accusation was later expanded to include stealing children in order to use their blood in preparing the Passover meal, or removing vestigial horns from the foreheads of Jewish children that bore witness to the Jews' role as the killers of Christ. These accusations fanned the flames of anti-Semitism, and led to widespread pogroms throughout Europe. Historian Miri Rubin, a leading scholar of the development of the Mass in the late Middle Ages, looks at the images used to communicate the doctrine of transubstantiation, and discusses disturbing examples of how the tale of Host desecration was used to justify the persecution of European Jewry.

In the early 1600s, the natural philosopher William Harvey established for the first time the circulatory nature of the blood system, and soon afterward experiments in blood transfusion were conducted at the Royal Society in London. Published during the Thirty Years' War (1618–48), his work challenged the prevailing Galenic view of blood, and came at a time when both the late Renaissance magical view of the world and the doctrines of the Roman Catholic Church had been called repeatedly and violently into question. Writer and director Jonathan Miller—widely known for his documentaries and exhibitions on human physiology and perception—discusses the ways in which new metaphors and new technologies—the pump, the microscope, anatomical dissection, the cell—profoundly changed the manner in which we looked at blood and its function. In three short essays, he examines the nature of blood itself, and how, under the influence of new scientific understanding, the notions of blood and heredity were eventually untangled.

Contemporary political power is conferred either by force or by suffrage. However, for millennia, political legitimacy was largely a matter of blood. Blood was the symbolic means to perpetuate, legitimate, and corroborate earthly power. Marriages were intended to conserve blood—or bond blood—irrespective of the wishes of the individual partners. Nearly all aristocratic families used their children's marriages to create political alliances and acquire new possessions, but some families went further. In order to ensure loyalty and consolidate political power, certain families made "marrying in" (marriage to close relatives—first cousins or closer) more than desirable—they made it family policy.

Georg Kugler, historian and a former Director of the Kunsthistorisches Museum in Vienna, looks at one of the dynastic families who married their close relatives as a means of conserving precious blood—and power—the Habsburgs. The family consciously used the symbolism of blood to create, legitimize, and sustain their power and reputation. The Habsburgs went to great lengths to trace their ancestry to the Roman Emperors, and explicitly used the imagery

of blood—and all its religious overtones—to reaffirm their God-given right to rule. Habsburg portraits graphically show the physiological consequences of a political strategy based on reducing genetic variety to ensure political dominion. Only in the eighteenth century do we see a change—in profile, not in politics —when the Habsburg Maria Theresa married Francis Stephen of the House of Lorraine, and subsequently blessed Austria with thirteen children who survived to puberty. Not unsurprisingly, this injection of fresh blood into the Habsburg line was not shouted from the rooftops—the sanctity of Habsburg blood had become so inextricably linked to power that a change in blood risked under-mining the Empire.

Stanislaw Dumin, historian at the State Russian Museum in Moscow, looks at another imperial family that made keeping blood in the family an ex-plicit part of their dynastic aspirations—the Romanovs. The Romanovs, who continued to marry "in" despite the evidence of a debilitating genetic disease —hemophilia—were sacrificial victims in the power struggle between the old order and the new. The Romanov sacrifice was indeed twofold. In addition to suffering the consequences of keeping blood in the family (not to mention the murder of Ivan the Terrible's son by his father, the murder of Ivan IV, and the murder of Paul III), the Romanovs were martyred by the assassination of Alexander II in 1881, and by the murder of Nicholas II and his entire family in 1918 by the Bolsheviks. The Romanovs are often portrayed as martyrs for their people—after his murder Nicholas II was canonized by the Orthodox Church, and features on popular icons.

Experiments in transfusing blood to humans were carried out even before Harvey's discovery of the circulation of blood, although with limited success. From Harvey onward, as the Galenic tradition was grafted to a growing scientific understanding of blood, bloodletting and blood transfusion were repeatedly tried as both prevention and cure. The efficacy of bloodletting and transfusion were hindered by a lack of a sound understanding of blood, as witnessed by the at-tempts to transfuse humans with animal blood, the blood of children, and the blood of close friends in attempts to treat disease or save lives. Instead of the desired effect, here the consequences of an inappropriate model for blood's function could be fatal. In the case of bloodletting to reduce an excess of the "sanguine" humor, the practice could lead to shock and collapse. Historian of science Kim Pelis looks at one aspect of the history of transfusion, as it was employed in the nineteenth-century world of Dr. Frankenstein, Count Dracula, and Mesmerism, and the Romantic belief that advances in scientific under-standing could bring the dead—or at least nearly dead women suffering from postnatal hemorrhage—back to life.

Blood has always been linked to power—both temporal and spiritual— and was early linked to heredity. From the belief in the sanctity of "limpieza de sangre" in Philip II's Spain to the "blue blood" of the aristocracy, blood—its purity and its continuity—shaped cultural discourse. By the eighteenth century, a theory of the ways in which traits were transmitted began to emerge, although an understanding of genes and chromosomes would appear only in the nineteenth century. Darwin's theory of natural selection, published in the mid-nineteenth century, was quickly seized upon by social scientists and political opportunists as a means to promote policies aimed at improving the gene pool. Annette Weber, a leading historian of the Rothschild family, writes about the rise of the notion of

race—in art, in science, in political thought—and the way in which Orientalism gave rise to racial types, such as the "Jewish beauty" and the swarthy Arab. It was not long before the idea of eugenics, from seemingly benign beginnings in the early twentieth century, mutated monstrously into the Holocaust as Hitler tried to create a pure Aryan race in the century's most horrifying social experiment. Never before had metaphors of blood been used so extensively to justify mass murder. At the same time, scientific knowledge of the importance of inherited diseases increased throughout the twentieth century, moving genetics from the periphery to the forefront of experimental science.

Since the early twentieth century, blood has been implicated in some of humankind's most pernicious and ravaging diseases—syphilis, hepatitis, malaria, sleeping sickness, and most recently, AIDS. The realization that certain diseases were transmitted by blood is relatively new, although the diseases themselves have been with us for centuries. From the Great Plague of 1348, to syphilis, to malaria, research into blood-transmitted diseases has fueled scientific investigation. Although AIDS has nearly disappeared from the headlines, it remains a deadly disease, especially in Africa—and the issues of AIDS prevention and treatment are as pressing now as they were in the mid-1980s. As science journalist Claudia Eberhard-Metzger describes, the discovery of the role blood plays in transmitting disease was anything but easy. During the Crimean War, the British Army wrapped "volunteers" in garments soaked in the "black vomit" of fevered malaria patients in order to confirm their belief that malaria was not an infectious disease. Fortunately the soldier guinea pigs did not contract the disease, while those exposed to mosquitoes did. The discovery of blood groups, which finally made the safe transfusion of human blood a reality just when it had become a true necessity, was also largely a consequence of World War I, in which an unprecedented amount of human blood flowed unchecked and unshared into the fields of France and Flanders.

The understanding that blood is, in Jonathan Miller's words, a "tissue in motion," whose only worth lies in its ability to circulate, made the metaphor of the financial market an easy one to adopt. With the discovery of blood groups, which made blood transfusion safe, blood itself was to circulate in the marketplace, calling into question the whole range of social practices around gift giving and sale. As pointed out by Richard M. Titmuss in his masterly study of the British and American transfusion services, blood transfusion is among the most fundamental of gift relationships, and risks becoming profoundly corrupted when it becomes commodified. The scandal surrounding the transfusion of untested blood in France until 1985, despite the knowledge of the nature of HIV and the means to test for its presence, shows all too clearly the consequences of the discourse that continues to surround the issue of giving or selling blood.

The role of blood in transmitting disease is a relatively recent discovery, but as a consequence of this new understanding, blood took on another dimension—life-threatening in addition to life-giving. Blood is not just nectar—it is also poison. This shift was reflected in art, and throughout the twentieth century contemporary artists and photographers used blood as a theme, as a medium, and as a symbol. Some of them depict the effects of diseases of the blood, some use blood as a symbol of life or death; others use blood itself as a medium. Peter Weiermair, currently the Director of the Institute for Modern Art in Bologna,

looks at the work of Joseph Beuys, the Vienna "Actionists" Hermann Nitsch and Günter Brus, Gina Pane, and the installations of Marina Abramovic. In Abramovic's *The Lips of Thomas* the artist offers herself as a sacrificial victim, putting her own life in the hands of the watching public. During the course of her 1975 performance the artist mutilated herself, carved a star into her belly, and ultimately needed to be rescued by the audience as she lost consciousness due to loss of blood. Here the artist's sacrifice is seen to mirror Christ's sacrifice of one on behalf of many. Weiermair also looks at photographs of Andres Serrano, who manages to achieve a subtle aestheticizing effect in the presentation of blood and semen, as well as the works of the British artists Gilbert & George—striking images that address the difficult subject of AIDS and sexuality.

Traditionally the "high" culture of painting and sculpture was controlled by those with money and power—and a strong interest in keeping them. High art was one of the means by which orthodox values and beliefs—the dominant discourse—was communicated. On the other hand, the "low" culture of engravings, postcards, advertising, and cheap newspapers was created and controlled by very different economic interests. In the twentieth century, the roles of "high" or "official" and "low" or "popular/critical" culture were largely "inverted," and photographs, television, posters, and advertising—far from being marginalized— have become the dominant form of public communication, even propaganda. Blood is all around us—on the covers of magazines, in the cinemas, on posters, on television—and what we know about blood and, more importantly, the public discourse about blood derives largely from the popular media. The fact that institutions of high culture, such as art museums, now host "critical" art, while the instruments of popular culture have become the main vehicles of "official" opinion is an important sociological phenomenon of the late twentieth century. Henry A. Giroux, a specialist in "public pedagogy," writes compellingly about the ways in which images of suffering—of blood, of AIDS victims—have been exploited by commercial interests, their ambiguity raising troubling issues about the linking of private interests with public causes. For instance, Benetton has been heavily criticized for its advertising campaigns, which show shocking or provocative images. In his essay, Giroux analyzes some of photographer Oliviero Toscani's most famous images, including the dying AIDS patient David Kirby surrounded by his family, and the bloodstained clothes of a Croatian student —shown displayed alongside the Benetton logo. Benetton argues that these images serve a constructive social purpose, and highlight the tragedy of war and bloodshed, an egregious interpretation called into question by Giroux.

Finally, science journalist Joachim Pietzsch looks at the enormous importance of genetics in the last century, and in the decades ahead. By the early twentieth century, the paths of blood and genetics had been partially unraveled. Blood was shown to have particular properties—it could carry diseases such as malaria or syphilis, and it could be transfused. Genetic information, on the other hand, was properly seen to reside in chromosomes and—with the discovery of James Watson and Francis Crick—in DNA. The paths of blood, at least as far as medical science was concerned, had sundered. For rational science, blood was no longer a legitimate metaphor for genetic inheritance, while at the same time, research into blood and blood-transmitted diseases had never been so urgent. However, at the same time, in the mystical world of magic and the irrational—and

in the equally irrational world of Realpolitik—the strands of blood and race were laced even more tightly together. Racism flourished in the early twentieth century, and blossomed as an anti-Semitism more virulent and murderous than ever before in the years following Hitler's rise to power, culminating in the industrialized mass murder euphemistically referred to as the "Final Solution" to the Jewish Question. Despite the advances of science and a new and deepened understanding, the discourse around blood seemed no closer to being tamed than it had been in the fourteenth century.

The situation we face at the beginning of the twenty-first century is complex and troubling. The irrational power of blood has not been diminished by the discoveries of science. Blood is everywhere—in the galleries, on the stage, in the news, on the ground. Blood remains a dangerous, disturbing, and uncontrollable substance. Images of blood, discourse around blood, practices of giving blood and spilling blood—blood itself—cannot be entirely contained. Images of blood are refracted, reflected, transformed, and distorted in the media. We turn on the television. We are told that medical science holds out the promise that by decoding the human genome we will discover the secret of eternal life, a promise of rebirth, renewal, plenty. On the same program, a heavily armored policeman clubs an antiglobalization protester. We are confronted with scenes of women and children massacred in the name of "ethnic cleansing," and the World Trade Center collapsing along with thousands of innocent victims in the name of fundamentalist terror—shocking images of sacrifice, power, and politics. An art gallery documents the work of a young artist who attaches a leech to her tongue, letting the blood run down her chest. A fashion magazine shows top models strapped to the gurney, giving blood. Artificial blood may now be a reality, but donated blood is now in short supply. Blood splatters across the screen and trickles down advertising posters. Our ideas have consequences. The voice of reason argues persuasively for calm, but the voice of blood has not lost its power to enchant and ensnare.

Now, more than ever, we must examine the power of our ideas to shape the world in which we live. Democratic society depends and will continue to depend on discussion, debate, and tolerance. Only by opening our eyes to the power of our symbols and the terrible uses to which they can be put, can we hope to fight ignorance, intolerance, and violence. The essays collected in this volume suggest that our understanding of blood—in both its rational and its irrational dimensions—still has the power to influence the way we behave, the society we build, the culture we create. The story of blood is not closed, neither will it be closed by new scientific discoveries. After all, the genome, too, is but a way of talking about the world in terms of what we think it is like. The symbols we use will shape the worlds we continue to make as long as our hearts and our minds remain open to the creative power of metaphor.

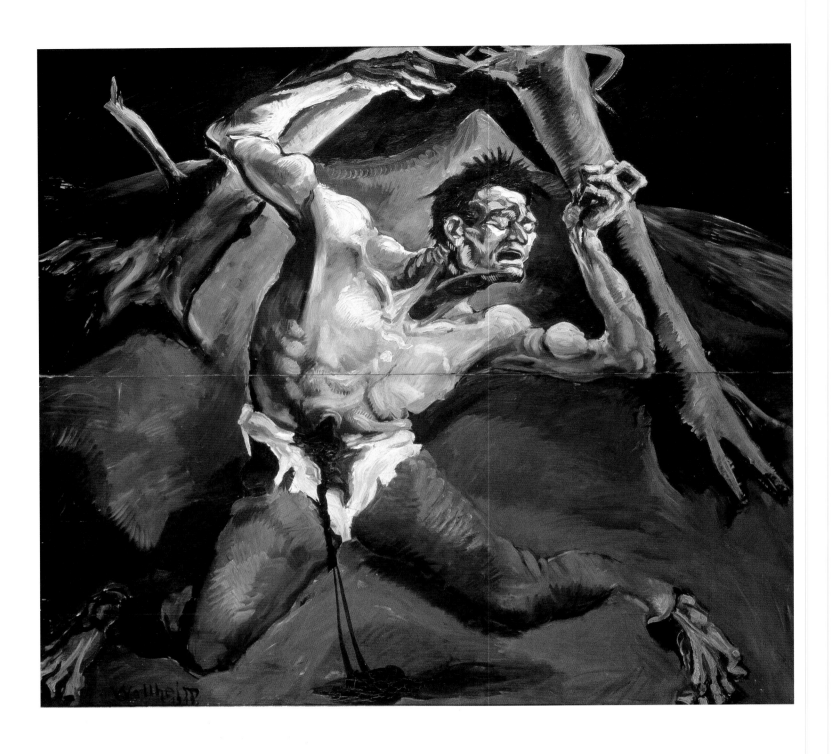

When men get involved with blood they tend to make something liquid into something solid. Statues of the Madonna weep blood and tears, but American Indian boys have tribal symbols scratched on their skin. *Liquid* blood circulates, transforms itself, and withdraws; it carries life through the organism, and when it is a mother's blood it helps to create new life. Blood that has become *solid* is shed blood. It is sticky. It is the blood of ritual and conquest, war and vengeance, violence and sacrifice. Solid, congealed blood secures order.

 A recent survey shows that men's and women's ideas of blood reflect this *liquid-solid* distinction.[1] Men are closer to the symbolic, life-related aspect of blood, its symbolic role as the "sap of life" and the "elixir of life," whereas women are more inclined to think of actual bloodshed and loss of life, of blood flowing and then ceasing to flow. A male respondent explained: "I think that something always has to pass away if something new is to come. Under certain circumstances even as a sacrifice, so that others can survive."[2] But a female respondent said: "I do not need any sacrifices. Women do not need sacrifice."[3]

"My blood for thee"
Christian Holtorf

Women say they are more interested in passing on life than in expiation, sacrifice, and redemption through "male killing blood" (an expression used by Jutta Voss).[4] They claim that only "female transforming blood" makes life possible, and resists dying and death; it is a counter-symbol to the violent blood of Jesus. Our history is shaped by the ambivalent nature of blood: by male sacrifices and female cycles, by blood brothers and bloodbaths on the one hand and the heart's blood and life-blood on the other. *Woman and man, body and spirit*, and *life and death* are directly juxtaposed in blood. "Of everything written," pronounced Friedrich Nietzsche's Zarathustra, "I love only that which someone writes in his blood. Write in blood: and you will know that blood is spirit."[5]

The anthropology of blood is a drama

The setting

Summer 1999: the German Red Cross is advertising for blood donors on large posters all over Germany. The campaign consists of eight motifs in landscape and in portrait format: four women and four men. The *left-hand* half of the image consists of a close-up of a human face seen from the front. It is cropped at the top, at the bottom, and on the left-hand side. The mouth is closed, the expression serious, the eyes are looking directly at the observer. The background and the *right-hand* side of the poster are white. There are four words printed in red on the black-and-white poster: halfway up the half with the face it says "my blood," and on the other half, on the bottom edge of the image, in larger type, "for you." My blood for you. Top right is the campaign logo with a red cross and the slogan "Give blood to the Red Cross" (Fig. 2).

 The concept behind this campaign requires giving blood to be seen as a service to one's fellow men and women, performed on grounds of personal conviction. Individual commitment to the cause is the key to it. The portraits

1. Gert H. Wollheim (1894–1974),
Der Verwundete (The Wounded Man), **1919,**
oil on panel, private collection

SPENDE
BLUT ✚
BEIM ROTEN KREUZ

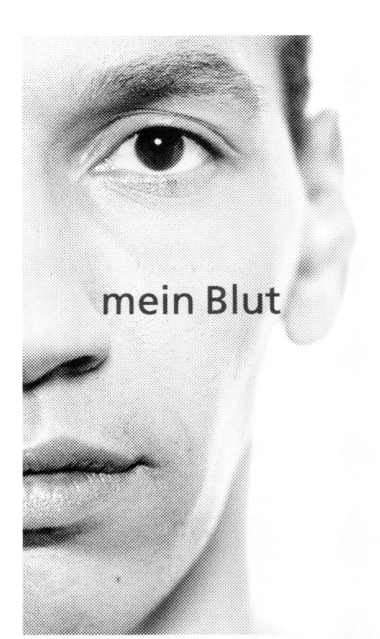

mein Blut

für dich

Informationen und Termine bei Ihrem Roten Kreuz unter **0800 / 11 949 11**

2. Poster campaign, German Red Cross, Summer 1999

are intended to make eye contact with the viewers, address them directly, and incite them to act. It is as though all the blood has already drained out of the black-and-white faces, as though they have no blood in them at all, because they have given their blood for us. Earlier campaigns had different aims: in the 1980s they appealed to a sense of concern and used models like Götz George and Franz Beckenbauer; in the early 1990s the Red Cross relied on "thought processes" and put up posters reminding us of the "morally valuable … everyday hero." The Red Cross motto has changed as well: the earlier challenge "Join in! Give blood!" was shortened to the succinct "Give blood to the Red Cross." The typeface is larger and more striking because of the black-and-white layout. The black frame has been abandoned as well, "as we are open to all," as the Red Cross emphasizes to non-heroes as well.

The advertising hoardings were made available to the Red Cross free of charge. In 1999 there were 40,000 of them, intended to reach 50 percent

of the population. Television and radio campaigns were launched at the same time. The blood donor services are compelled to rely on advertising. Almost 2 million people do give blood each year, but there are still bottlenecks that have to be dealt with at the peak holiday periods. The blood is needed mainly for cancer patients, heart operations, and the treatment of stomach and intestinal diseases. Sport and road traffic accidents are only in fourth place.

In stark contrast to the Red Cross campaign, Benetton billboards also grabbed the attention of drivers hurtling down the motorway during the summer of 1999. Here, too, blood was the message—only in this case the bloodstained clothes of a young Croatian student (see Fig. 6, p. 224) was meant to sell clothing. Benetton, too, claimed to have a higher purpose for its shocking advertising—to sensitize a sleepwalking world to the horrors of war and disease. And if a few more sweaters were sold at the tills of luxury stores, well that was just a coincidence. Two campaigns, blood twice over, two sacrifices, two settings—and also two worlds? Blood that saves lives and the blood of experience. Sacrifice for others in need and emotional exploitation. An advertisement for community spirit and a show of unwanted intimacy. We find the law, sacrifice, and the blood that redeems life in both images. Both motifs refer to human sacrifices as elementary cultural traditions.

The historical material

The sacred order

The formulation "my blood for thee" comes from the sacrament of Holy Communion. The Catholic Church sees the sacrifice of the Mass as an image of Christ's one sacrifice, as a "true expiatory sacrifice," as a living mystery. Christ is there himself in the Communion, the substance of his body and blood, which are made present. "But," as C.G. Jung stated, "his presence is not a reappearance ..., but rather an eternally existing fact becoming visible."[6]

The Reformed Churches set the sacrament's element of promise and proclamation against this. For them Communion is not expiation, but faith and receiving, a common hope made certain. Christ's death, they accept, is not to be made a new presence each time; it is already present in the fact that the Church is the body of Christ—and here it is the Church (not the Mass) in which the real presence of Christ is made visible, outlasting all ages. But the process remains an assimilation into Christ, he remains a human sacrifice,[7] though it is a sacrifice made by God and not by man.

When a priest offers the chalice and the wafers, he speaks the so-called formula of donation: "The body of Christ, which was given for thee. The blood of Christ, which was shed for thee." It is striking how tenaciously the otherwise rich vocabulary of the liturgy clings to this one point. The distribution of bread and wine has to speak for itself: Christ's body, given for you. Christ's blood, shed for you. The formula is always the same, and it is not weakened by repetition: it is about sacrificial blood. We drink the blood of Christ. The centuries-long theological conflict about whether priestly consecration actually turns bread and wine into the body and blood of Christ or whether they just symbolize it shows how serious it is that Christ is consumed by the faithful. "The blood of God is the wine of metaphysics," as the action artist Hermann Nitsch put it.[8]

Christ's sacrificial blood has binding significance, it links man with God again. The chalice with the wine is the new covenant given in Christ's sacrificial blood. It re-enacts the Last Supper that Jesus shared with his disciples. The New Testament records this in several places; in Matthew it reads: "Now as they were eating, Jesus took bread, and blessed, and broke it, and gave it to the disciples, and said, 'Take, eat; this is my body.' And he took a cup, and when he had given thanks he gave it to them, saying, 'Drink of it, all of you; for this is my blood of the covenant, which is poured out for many ...'"[9]

"My blood for thee." Christianity starts with Jesus' sacrifice. The individual is introduced into the congregation in the Communion, incorporated into it, assimilated. As an initiation ritual it decides who shall be taken into the community and who not. Blood sacrifices show where a person stands and to whom he is faithful. In Genesis (chapter 22), God tests Abraham by asking him to sacrifice his only son, Isaac (Fig. 3). Abraham's faith does not falter, and so he builds an altar in the chosen place, puts wood on it, and ties Isaac to it. As he draws back his knife to complete the sacrifice the angel of the Lord suddenly calls him back and orders him to sacrifice a ram instead of his son. He says that God now knows that Abraham honors and fears him, and that therefore God will bless and multiply his whole race. This story records the value of the bond of blood. Abraham's blood flows in Isaac, and for this reason he is to sacrifice him as his most precious possession. But as soon as God sees Abraham's faith confirmed, he includes all Abraham's descendants in the reward: all the blood relatives are chosen.

Bonds of blood and the law of blood go beyond this world and conjure up a sacred order. Our word sacrifice is derived from the Latin *sacrificium*, which means "producing something sacred" or "making something sacred." The ethnologist René Girard points out that sacrifice resolves human conflict, it is a ritual act of violence, but the last one. The act of sacrifice reinforces the unity of the community, it redeems it from antagonism, and establishes a symbolic order. Jesus allows himself to be crucified in order to break the vicious circle of violence. At the same time he founds the community of those who follow him. Here blood had to flow to escape from earthly power. Blood sacrifices are the greatest acts of devotion that a human being is capable of performing. They go to the outermost point, because they touch the innermost point. "Therefore, brethren," says the Epistle to the Hebrews, "since we have confidence to enter the sanctuary by the blood of Jesus, by the new and living way which he opened for us through the curtain, that is, through his flesh ..." (Hebrews 10:19–20).

Identity and renewal

We are familiar with scenes of blood sacrifices and human sacrifices from many other sources, from our own history and from that of other nations and peoples. For example, think of the Cyclops Polyphemus. He was a demigod, but ate two of Odysseus' companions each day. Or remember the witch in the fairy tale of Hansel and Gretel, who checks to see whether Hansel has put on enough weight to provide a decent roast. These and other stories are myths, and their blood-thirsty nature reflects above all the shock of alienness. Cannibalism, the most notorious of human sacrifices, is probably the most hardened cliché of primitiv-

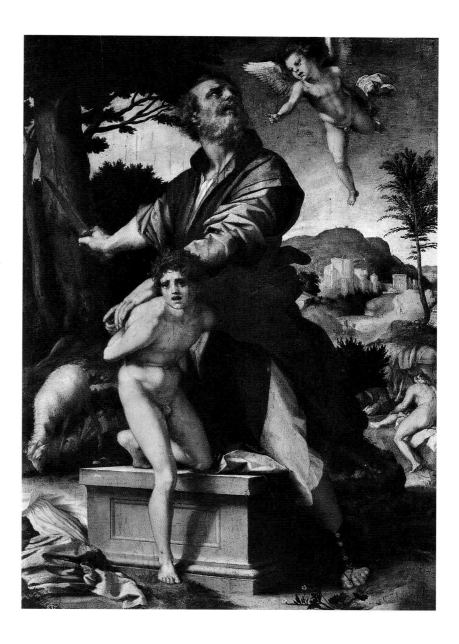

ism, but it is quite possible that it is only a fantastic insinuation that was never ritual reality. The legend of mankind's cannibalistic, primeval condition was debunked as early as the nineteenth century, but cannibalism still tended to come to mind if indigenous populations behaved in ways that were open to misunderstanding. Cannibalism is one of the metaphors for being different, for being uncivilized. A revealing incident occurred at the Lisbon congress on prehistory in 1871. A decision was to be made about whether cannibalism was practiced in the Stone Age, and a vote was taken on the subject: there were two votes in favor, two definitely against, and three abstentions. Sometimes science is all about the right insinuation, and then the majority decides.

Our own flesh and blood are still the most sacred taboos. Every presentation of their being sacrificed invokes elemental life symbols. These also include traditional rites of initiation and passage, in which those who are to be initiated are detached from their earlier social status and introduced into society as full members. During this, young men live away from their families for a long time, sometimes for several years. They feed themselves in the bush using the simplest of resources, and are subjected to certain rituals before they are allowed to return

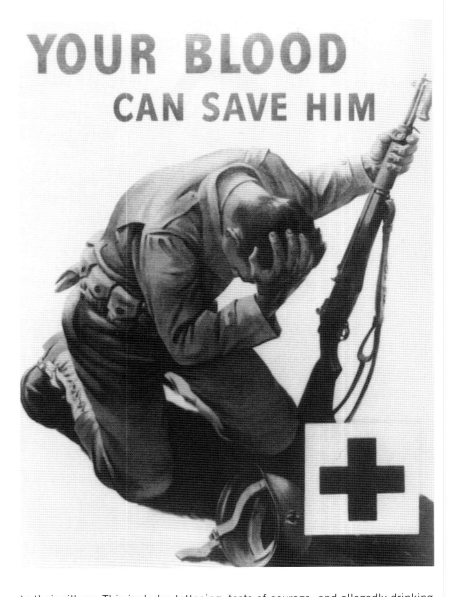

to their village. This includes tattooing, tests of courage, and allegedly drinking their own blood as well. Often the novice is considered dead in the transitional phase, so that he can then be brought back to life. The killing serves to re-create the young man being initiated as a new, whole human being. This path to the development of awareness—like any path to the development of awareness—can be painful. But it is "only the ability to sacrifice oneself that proves self-possession," as C.G. Jung put it.[10] It proves the ability to live. For life, according to the ethnologist Arnold van Gennep, means "ceaselessly separating and coming together again, changing condition and form, dying and being born again. It means acting and pausing, waiting and resting, so that one can then act again, but act differently."[11]

In the world of the Greek gods, the story of Dionysus links up with this tradition. Zeus' new-born son Dionysus, as myth would have it, is carried off by the Titans. When he tries to escape from his tormentors by changing himself into one animal after the other, he is torn to pieces by the Titans. They devour his raw flesh. Zeus then kills the Titans with thunderbolts, and mankind rises from their ash and soot. The head of Dionysus is rescued by his grandmother Rhea, his scattered limbs are collected and put together again. The god is reawakened.

Dionysus is the god of intoxication, of madness, and of wine. His dismemberment and restoration is a cosmic myth of eternal return, of renewal, of the cycle of coming into being and passing away. The Dionysiac rites repeat this story. Their climax is the dismemberment of wild animals and the consumption of raw flesh with the blood still warm, as illustrated in Euripides' play *Bacchae* (*The Bacchants*). This tells the story of Dionysus coming from the mountains to the Greek city of Thebes. There he lures the women, including Agave, the king's mother, into taking part in wild and extravagant feasts outside the city. At first the king himself, her son Pentheus, is indifferent to all this, but then he starts to be curious, slips into the feast secretly, is quickly discovered, and killed by his own mother in her frenzy. A horrifying act: the mother has torn her own son to pieces. The city of Thebes falls back into a state of barbarism. But this is the only state—or so the myth is interpreted—from which a fresh start can be made: a new life cycle can start only at the moment of catastrophe. The repetition of the sacrifice of the son of God and the consumption of his body are the guarantee of abundant harvests, fertility, and renewal. "The symbolic return to chaos," writes Mircea Eliade, "is indispensable for any creation.... Creation can take place only through the sacrifice of a living creature.... A living whole shatters into fragments and is scattered into myriads of living forms. In other words, we find here the familiar cosmological pattern of the primeval whole that shatters into fragments as a result of the act of creation."[12] It is only the blood sacrifice that makes life possible, that redeems life.

The dramatic action

And blood is still flowing today. From being a mythological substance, blood has now become a biological organ that transports nutrients and metabolic products around the body. The heart lost its spiritual significance in the seventeenth century, to become nothing more than a mechanical pump for the circulation of the blood. Even the Romantics did not view the heart as an active supporter of living movement; the warm heart became the stone-cold heart. The discovery of the circulation of the blood in the body then became the model for the flowing, indeed "pulsating" traffic of large cities and of all other modern circulation systems: "In about 1950," writes Ivan Illich, "wealth and money [started] to circulate. Society is now imagined as a system of pipes. 'Liquidity' became a dominant metaphor after the French Revolution: ideas, newspapers, news items, gossip; and after 1880: traffic, air, and energy—everything circulates."[13]

Things are moving on—that was the leitmotif of the industrial age, and of the development of modern modes of transport, such as steamships, cars, railways, and aircraft. But blood did not come back into circulation as part of all this. Modernism simply brought blood down to earth, whereas until then it had conjured up the eternal recurrence of cosmic cycles. Blood came down to earth in a way that could only happen as part of the highly mechanized slaughter of animals. We hear about this in a piece called "Meat as the Customer Wants it":

> The law on the slaughter of animals requires that warm-blooded animals are to be anaesthetized before blood is removed. A manually executed blow (stunning) is acceptable only to a limited extent ...

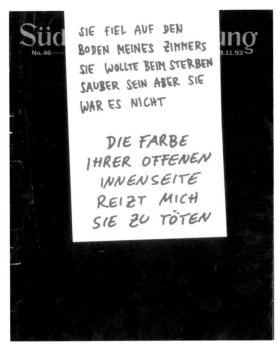

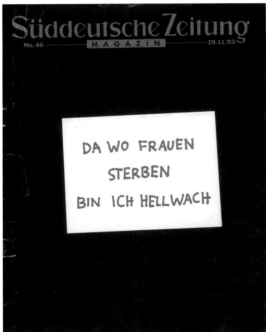

5. Jenny Holzer (b. 1950), "Da wo Frauen sterben bin ich hellwach," November 19, 1993, magazine of the *Süddeutsche Zeitung*

In modern slaughterhouses, bleeding animals by hanging has become standard practice. [The animals are] … bled in a vertical position by puncturing the thorax, i.e. by opening the large blood vessels in the front part of the thorax that flow towards the neck. [This means that] … the amount of blood removed by bleeding when hanging can be improved by 40% in contrast with bleeding from a prone position …

When pigs are stunned electrically the blood pressure falls rapidly while current is passing through the animal's body, and then reaches a high point well above normal levels immediately after the current is switched off. If the bleeding incision is made during this phase, the best bleeding level is achieved. (However, small blood vessels can burst as a result of blood pressure fluctuations) … causing the spots of blood that occur in ham. Research is still needed into the extent to which these spots of blood affect the keeping qualities of the meat, especially in the case of goods with a long storage life.[14]

About 60 million liters of blood and blood plasma are given per year worldwide. Germany alone uses 4.5 million units of blood preserved with an anticoagulant, which is the highest consumption per capita in the world.[15] But this certainly does not mean that scientific and social progress have in any way reduced the amount of sacrificial blood shed. The heavy demand for donor blood, says the Red Cross, is in fact itself the consequence of medical progress, as many operations, organ transplants, and tumor treatments are only possible at all thanks to modern transfusion techniques.

Taking blood gives life, losing blood purifies. Today this process is known as "giving blood." But whether the blood is offered to the gods or donated to medicine, the ritual remains the same: giving blood is also a service to the community in the name of a higher power, a kind of scientific religious service. Donors make themselves available voluntarily, for no reason other than a sense of responsibility—or one could also say because of a fear of God. They do not receive any remuneration for their donation, but they hope—like a profound believer—that theirs will be a symbolic reward. Like priests, Red Cross helpers work for charity or on a purely honorary basis. The taking of the blood itself is subject to strict regulations. These seem like religious rituals and meet certain hygienic and medical requirements. Blood donors are also given a health check, a precautionary measure to establish their suitability as donors. Everyone is responsible for his or her own health in a democratic society, and the gods advise prevention.

"My blood for thee"—that is Christian liturgy, but at the same time it implies the global raw materials market and world trade. Blood has lost a great deal of its mythical and religious significance this century: it was relegated to its organic function, dissected down to the last detail, and finally industrialized. Blood as an organ has become a resource, a global trading product and strategic material. Stocks of blood plasma are traded on the world market, blood banks dominate the market—even blood donor identity cards are issued. The worldwide annual turnover of the trade in donor blood is 18.5 million dollars. Donor blood is part of the organized organ trade.

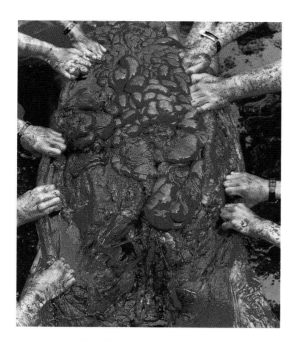

6. Hermann Nitsch (b. 1938), 6-day play from the Orgien Mysterien Theater (Orgies Mysteries Theater), 1998, videos, Prinzendorf, Schloss Prinzendorf. Photo: H. Cibulka

The world wars of this century showed us all too clearly how important a national supply of blood can be. People were now able to accumulate huge stocks of blood, separate the plasma, break it down into its component parts, and freeze-dry it. Blood had to be available in large quantities during air raids, for there would not have been time in war to take blood from volunteers. To cover the enormous amount of blood needed, the German authorities set up blood donor centers from 1940. Donors were given food ration stamps or money in return. Soldiers were not given anything—they were simply sent off to give blood without further ado. Blood can still be a war-winning raw material, for which reason some people advertise for donors ("Your blood can save him"; Fig. 4) and others protest: it is well known that the most important slogan used by opponents of the Gulf War was "No blood for oil."

Blood as a raw material and commodity is subject to the old purity law in a new way. If blood is to be used for medical purposes it requires protection from pollution at the level the gods used to be permitted to expect. In the Judeo–Christian tradition the diminished status of women relates to the alleged impurity of their blood.[16] Some people are still convinced that the blood of Christ is not compatible with female blood and that for this reason women should not administer the holy sacrament, and should not attend Communion while menstruating. Today blood rights determine a person's eligibility for acquiring German citizenship, which is still exclusively based on the nationality of the parents' blood (not on place of birth), even in a unified Europe.

But the modern purity laws are reflected most clearly in the handling of HIV and AIDS. The illness came to public attention on a large scale for the first time in the early 1980s, when HIV-infected donor blood penetrated the global blood market. This led to a new purity movement, as the HIV virus "pollutes" the blood, causes a "bad blood-picture," and requires "antibodies." The language gives a lot away: it reveals how short the path is in cases of impurity from infection to debasement and defamation. Here modern medical categories are continuing the purity law and the mythical ritual of sacrifice and blood. Religious blood myths have remained powerful.

In the Communion rite, as we have seen, the administering of bread and wine is marked by a strange silence. The mystery speaks for itself. For "where blood speaks, the law commands silence, where it goes to the head, the law puts the head right."[17] This law is infringed today, or put in another way: it is the law of blood that is coming into force—sometimes ironically and playfully, sometimes bloodily and seriously. Once more it is a matter of appearance, of the fact that the blood emerges. The interpersonal expectation "open yourself" has acquired a new and individualistic sense in the opening of one's own blood vessels. We remember the issue of the *Süddeutsche Zeitung* magazine (November 19, 1993) that was printed in blood: The artist Jenny Holzer provided a wrapper for the title page with the sentence "Da wo Frauen sterben bin ich hellwach"[18] printed in real women's blood (Fig. 5). And we are familiar with the blood orgies in the work of the Austrian artist Hermann Nitsch, which can include actors being tied to crosses and having blood poured over them. Nitsch compares the Christian ritual of transubstantiation with the "condensation process of good art." And about his own Orgien Mysterien Theater (Orgies Mysteries Theater; Fig. 6) he says:

squashed fruit flesh, slimy egg yolk, raw, wet meat, blood, blood serum. slaughtered sheep were used for action that did not happen in a picture any more but in the room. When it was gutted the gaping, skinned, wet, and bloody sheep's cadaver vomited and bore moist and bloody colored entrails gleaming bright red. excrement-filled, bulging bowels were touched and torn out. the process of action painting became theater, became a dramatic process. the end of the dionysiac release of repressed emotion, set in train analytically, was achieved by the sadomasochistic basic excess experience, achieved by tearing the sheep to pieces. the mythical fact of Dionysus dismembered is cited, of the dismembered animal representing him in the cult action ... the catastrophe of the drama brings our actual sensual intensity to an end. our suppressed intentions break out of us, intoxicated and ecstatic ... the sensual delights of killing and the sensual delights of love fuse. assimilation takes place through metabolism. The presence of death allows living things to swallow each other up and to murder. Victim and murderer are one, death and life are merely a stream of sensual transformation.[19]

"Blood" as a technical and transport metaphor has become an identity metaphor that is struggling to prove it is alive. We notice how stark a contrast there is between this theater and the sausage industry's slaughterhouse regulations. Slaughter is no longer "kosher," the blood is back. AIDS as a topical subject fits into this context as well: it has made us take a new look at the connection between blood and identity, purity, and life in all their violence.

The great ancient blood myths seem to have been washed away by history, but blood itself still speaks of them. The return of blood is like a rediscovery, a reconstruction that has repossessed both life dimensions and spiritual rituals. Blood is appearing again, it is positively bubbling out; its demons are transferred, its composition analyzed; finally it is collected, distributed, and drunk. My blood for you (not for oil)—that is the idea behind the new blood law, which is an old law. It is a formula that has not worn out—blood that has not lost its power. The global blood industry has not been able to modernize its valuable product or silence its myth. Identity and community, the strength to live and the fear of death are condensed in blood. Hermann Nitsch again: "the finale, the fulfillment of the intensive great existence happens evermore, will always happen, NOW and for evermore. happens at the moment experienced when we are WIDE AWAKE, NOW ... the NOW in the midst of our sacredly splendid existence, which occurs through flesh and blood."[20]

Blood stands for the last rescue. We remember: "Something always has to pass away if something new is to come. Under certain circumstances even as a sacrifice, so that others can survive."

This it what is meant when someone—writing in blood—says: my blood for thee.[21]

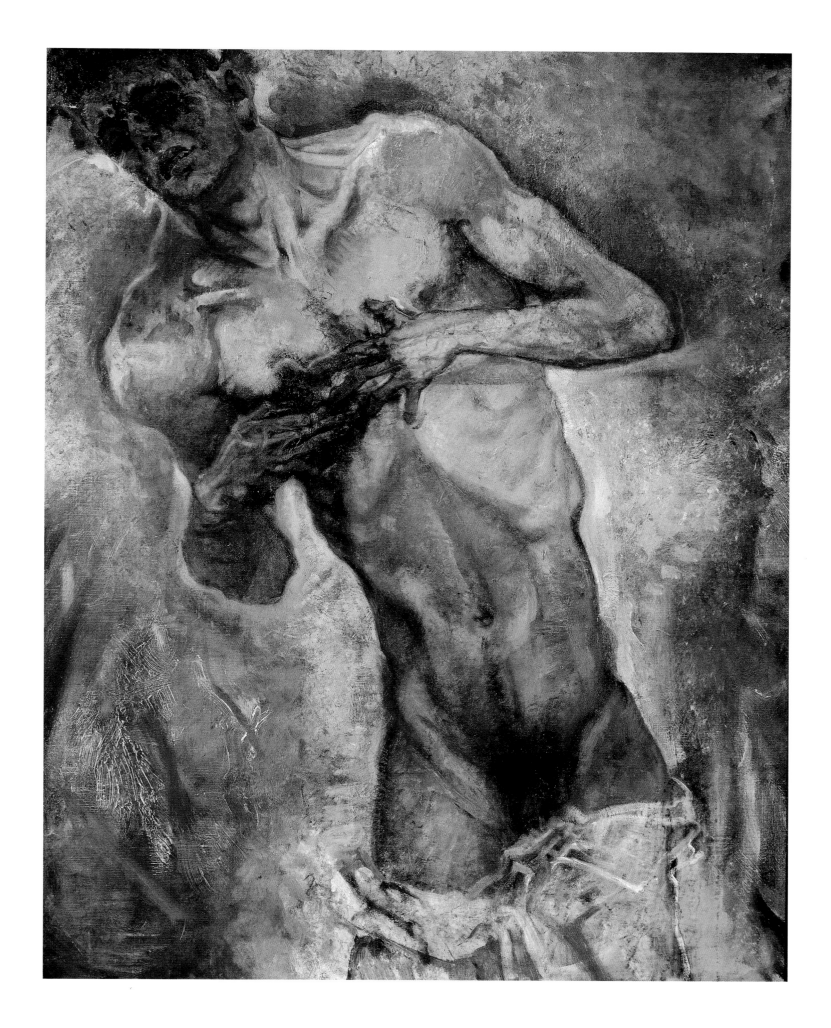

"My blood for thee"

tum sese in aëre ita resupinans, vt vngues quidē
sursum, pennas verò ac posteriores partes deor-
sum versas habeat, cum idem auis quę cum eo
congreditur efficere nequeat, ita facilè eam in-
fugam vertit, ac sibi victoriam parat. Quin &
pro anima ponitur accipiter, iuxta nominis in-
terpretationem. Siquidem Ægyptiis accipiter
baieth dicitur, quod nomē si diuiseris, animam
& cor sonat. Bai enim anima est, eth cor. Cor
autem ex Ægyptiorum sententia, animæ ambi-
tus est. Itaque nominis compositio animam cor-
datam notat. Vnde & accipiter ob eum quem
cum anima habet naturæ consensum, aquam o-
mnino nõ bibit, sed sanguinem, quo & ipsa nu-
tritur anima.

Πῶς ἄρεα, κ̣ ἀφροδίτων.
Ἄρεα δὲ γραφοντες κ̣ ἀφροδίτων, δύο ἱέρα-

Blood either flows through the body, where it is enclosed within the human or animal microcosm, or else it flows out of the body and spills elsewhere. It goes to meet other bodies, objects, and things. Here we have two fundamental ways of looking at blood, which also provide confirmation of its use and significance. On the one hand, blood is a warm liquid that moves and nourishes the body from within, filling it with life. On the other hand, however, if the blood flows out of the body, this heralds death. The spilling of blood evokes rituals and arcane liturgies, and invokes and nourishes the gods. It is almost as if there were two parallel and symmetrical realities, one inside and one outside the body. In the one instance blood can be seen as a flowing red sap, in the other as a liquid that quickly turns dark, thickens, and curdles. In the first case, it is mainly the history of science and medicine that provides us with investigations and descriptions of the many aspects of blood, as well as information on its physiological function. In the latter case we need to look to the history of magic and religion. Certainly, this is an arbitrary division for such a complex subject. However, it is a necessary one if we are to reach a better critical understanding of the subject. Yet, as a division, it does not fail to take into account the way in which these different cultural paths frequently cross, and are sometimes similar to the type of philosophical speculation that has endeavored to explain how one feels, thinks, and recognizes that which is beyond the realm of human experience.

Magia Sanguinis: Blood and magic in Classical antiquity
Mino Gabriele

According to the magical wisdom of the Greco-Roman world, blood plays a fundamental role as mediator between Man and the gods. This understanding has been nourished and handed down by means of the collective actions, secret operations, special formulae, and *imagines* (symbolic images) that constitute man's attempts to interact—positively or negatively—with natural and divine forces. Here we are talking about practices in which spirituality and superstition, and sacred, folkloric, and in some cases protoscientific aspects, frequently blend with one another. The ways in which they do so tend to vary, and are not necessarily the same, a factor that depends on the various cultural and geographical climates in which these practices were formed and diffused. Certain experiences, if viewed in their entirety, prove to have antithetical, contrasting phenomena at their extremes. For example, in the most noble form of theurgy, or "white magic," the rituals aim to form a pious alignment with cosmic symmetries, as opposed to the ambitious transgressions of "black magic," which attempt to subvert the natural order of things. There is a substantial difference between these two approaches. A priest worships divine powers with an attitude of humble submission. An evil magician tries to force them to obey him, using the power conferred upon him by his knowledge of their secret names and of the esoteric arts.

1. Horapollon, *De sacris notis et sepulturis libri duo...,* Paris, apud Jacobum Keruer, 1551, Magl. 19.6.283, Florence, Biblioteca Nazionale Centrale. Photo: Microfoto, Florence

Calling forth the dead: Blood and magic in ancient Greece

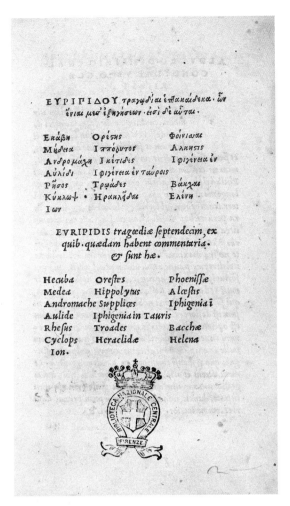

2. Euripides, *Tragoediae*, Venice, apud Aldum, 1503, Nenc. Aldine 1.1.11, Florence, Biblioteca Nazionale Centrale. Photo: Microfoto, Florence

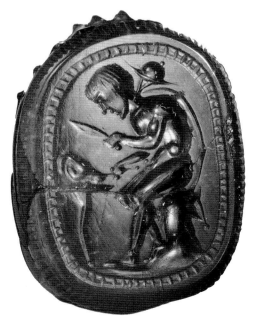

3. Odysseus, antique intaglio, Berlin, Staatliche Museen zu Berlin—Preussischer Kulturbesitz, Antikensammlung

The most ancient description of a magic ritual involving blood is to be found in the verses of Homer,[1] a passage in which Odysseus performs a ceremony to summon the dead according to the advice of the witch Circe. He enters Hades in order to consult the soothsayer Tiresias, and there he pours forth libations of milk, honey, and wine, followed by the blood of a sacrificial ram. It is precisely this bloody sacrifice that calls up the spirits of the dead, who crave a drink of that "black, steaming" blood in order to be able to recall their memories of life on earth and recapture that vital breath for a brief moment. The same thing happens in *Hecuba*[2] by Euripides, in which the black blood of the young Polyxena, sacrificed by Neoptolemos, serves to attract and placate the spirits of the dead, in particular that of his father, Achilles. The son invokes Achilles and invites him "to drink the pure blood of the virgin." Another example of the spilling of blood as part of a ritual to meet with the souls of the dead appears in Virgil's *Catabasis*.[3] As Saint Augustine recalls, "[Varro] says that when blood was employed, the shades of the dead were also summoned, a practice called *nekyomantica* in Greek … in which the dead reveal the future."[4] In addition to songs, prayers, and various natural substances, the basic "tools" in such a divinatory practice are blood, and the trench into which it is poured. The trench must be square, and the sides must measure one cubit:[5] a ritual and poetic archetype that was copied in many later works of literature.[6] It is a magic pit, a symbolic cavity uniting the surface of the earth with the underworld, a liturgical threshold, its concave form suggesting the depths, and bringing them into contact with the living.

The act of spilling blood in magical practices is closely linked to the invocation of divinities, particularly those of the underworld:[7] Medea,[8] the niece or sister of Circe, sorceress *par excellence*, wounded her arm with a sacred knife so as to enable her to pour drops of her blood on the altars of Hecate. Circe[9] practiced a ritual of purification and expiation by sacrificing a piglet to the "helpful" Zeus and immersed her hands in its blood.[10] On another occasion, proof of her witchcraft manifested itself in drops of blood scattered on the pastures like dewdrops. For Dido,[11] when invoking Hecate, it was the blood of Dido's imminent suicide that consecrated the potency and efficacy of her imprecation (Fig. 4). In Ovid,[12] the passage that speaks of Tisiphone, one of the Furies, those dreaded demons from the infernal regions, also contains a description of a *philtrum monstruosum*, which if poured onto the chest of the victim causes him to go mad, as it causes turmoil in the very depths of his heart. The potion in question, composed of saliva, poisons, tears of rage, and other such diabolical substances, is mixed with fresh blood to bind it together.

The central symbolic role of blood in such forms of magic is no accident, and it underlines the extreme importance of blood in making the rituals effective. Thanks to blood the potion is strengthened, it is enriched with those energies that make up the life "force." It is important to note that in the various mixtures blood is usually used warm. It is either boiled and then added to the other ingredients, or else introduced into the lifeless body in order to reproduce by magic the vivacity that the body had when blood flowed through its veins. It is a game of sympathetic magic, which reflects the dichotomy of cold = death, warm = life,

4. Virgil, *Aeneis, The Suicide of Dido*, 1513,
woodcut, Leipzig, 1979

5. Virgil, *Aeneis, Entering the Underworld*, 1513,
woodcut, Leipzig, 1979

and the magician adapts it and offers it in a form that fits his operational micro-cosm. Partly because blood has extremely close real and symbolic links with both body and soul, and partly because, in some mysterious way, it represents primary evidence of the flow of both life and death, and therefore of the order and succession of things, it becomes a hinge, a threshold, between this world and the next, so much so that occasionally it can bring them together.

But magic practiced in a way that is devoid of all religious or sacred piety is—according to classical, medieval, and Renaissance *topoi*—a mere subversion of the cosmic order, it is a trickery that manipulates and disturbs the natural equilibrium of things. An example of such ideas can be found in the verses of Lucan,[13] in the passage which states that "the spells of the witches of Thessaly" were actually capable of making the earth's center of gravity oscillate by disturbing the equilibrium of its axes. From this point of view, blood is essential to magical practices, because it bears within it the force of the natural "order" of things, a force without which not even black magic (let us call it the magic of "disorder" for clarity's sake) can exist, since it would inevitably be deprived of its destructive power in relation to the vital governing principles of the cosmos.

Pouring the blood of wounded victims into a trench is, as stated previously, a divinatory act in which the souls of the dead are given the drink they need in order to return to life for a brief moment. In this case, "order" and "disorder" become two faces of the same coin, in that the necromantic rite lends itself to the inexorable ambiguity between life and death, precisely because it takes place on the threshold of Hades, between here and the other side. In Virgil[14] and Horace, the ceremony follows traditional religious forms,[15] which observe the *pietas*.

6. Odysseus, antique intaglio, Copenhagen, National Museum, Department of Classical and Near Eastern Antiquities. Photo: Jesper Weng

cruor in fossam confusum, ut inde

manis elicerent, animas responsa daturas[16]

(the blood was all poured into a trench, that therefrom they

might draw the sprites, souls that would give them answers).

In Lucan, however, we have the most terrifying and detailed description of black magic that has come down to us by way of ancient literature. In book VI of *The Pharsalia*,[17] Erichtho, a genie of Death and of the Night, a witch so powerful that she could manipulate corpses, is questioned by Sextus Pompeius on the outcome of the battle of Pharsalusia. Being unable to respond directly, she brings a recently expired corpse back to life and gives it a voice in order that it might predict the future. The episode of necromancy unfolds in a scene of seething impiety. Erichtho, dressed as a Fury, and capable of gnawing at rotting corpses, chooses the corpse to whom she wishes to give a voice. She drags him into a cave as black as hell, and there she uses repugnant animal and vegetable parts, utters spells and iniquitous mutterings, then throws the boiling blood of animals[18] into a gash in the dead man's chest. The spirit appears beside the corpse, which is lying on the ground. It is afraid to re-enter the body since this has been so badly torn apart. Such a display of resistance on the part of the shade astonishes Erichtho, who urgently needs to revive the corpse and get it to prophesy. Thus the witch intones a macabre chant, in which she actually threatens the gods and goddesses of the underworld, Hecate, Proserpine, and Pluto, threatening to reveal their "secret" names so as to take possession of their personalities and powers. Then the corpse starts to come back to life, or as Lucan puts it, "instantly the clotted blood grew warm; it warmed the livid wounds, coursing into the veins and the extremity of the limbs."[19] The heart began to beat again, and the young man, being restored to life, if for only a short time, was able to predict the outcome of the battle of Pharsalus.

In this case, leaving aside the monstrous acts committed by Erichtho, we can see fully the total dependence of the spell on the fact of the blood "returning" to the lifeless body as an infusion that changes the dark coagulated state of the blood in death back to the red, flowing form it takes within the live body. In rare cases, such a belief in the properties of blood even culminated in forms of medicinal vampirism, if we believe what Pliny the Elder[20] and others[21] have written about the custom of epileptics drinking the blood of wounded gladiators, treating the latter as if they were "live cups." Pliny recounts how certain patients, in particular epileptics, believed sucking the warm blood of a live man, thus absorbing the vital force from open wounds, to be a highly effective remedy.

At this point, it might seem superfluous to pose the question why the function of blood in Greco-Roman magic is above all to bring the dead back to the ranks of the living, just as it acts *mutatis mutandis*, to revitalize the sick or to give the magician special evocatory powers. Clearly, the answer refers us back to the vital force contained in blood, and to its close connections with the generation and preservation of life. But that is not all. In fact, as the evidence of the Homeric traditions shows,[22] it seems blood also restored memory and consciousness to the dead. Anticleia, the mother of Odysseus, drank "dark steaming blood" and immediately recognized him and started talking to him. The same is true of Agamemnon.[23]

7. Pierio Valeriano, *Hieroglyphica, seu de sacris Aegyptiorum...*, Lyons, apud P. Frellon, 1626, Magl. 1.1.271, Florence, Biblioteca Nazionale Centrale. Photo: Microfoto, Florence

8. Antonio Ricciardi, *Commentaria Symbolica in duos tomos distribuita*, Venice, apud Fr. De Francischis, 1591, Magl. 1.1. 184, vol. II, Florence, Biblioteca Nazionale Centrale. Photo: Microfoto, Florence

The heart of the matter: The life of death

In a later period, one of the first Greek philosophers to elaborate the theory that the blood circulating through the heart was the source of thought, and therefore of awareness, was Empedocles,[24] a doctor, priest, and soothsayer, who lived in Acragas (Agrigentum) in the fifth century BC. Such ideas marked the beginning of the theory of "hemocentrism" (the belief in the central importance of the heart and blood), which became so popular from the classical era onward.[25] It is not our task to discuss the question of the medical and philosophical contents of the theory here. It is merely important to stress how, for centuries, blood and the heart were closely linked to thought, to the mind, and to the cognitive process throughout a period stretching—with the necessary historical and cultural distinctions and differentiations—from ancient times until the Renaissance, when, through one of those fortuitous twists that sometimes occur in history, the cardiac and hemo-psychological symbolism of Ancient Egyptian civilization made a reappearance.

In 1422 the Florentine priest Cristoforo Buondelmonti bought a codex of the *Hieroglyphica* of Horapollon[26] on the Greek island of Andros and took it home to Florence (Fig. 1). It proved to be an extremely popular text throughout the Renaissance (the first edition appeared in 1505) and beyond. It is, in fact, the only systematic treatment of the meanings of Egyptian hieroglyphics to have come down to us from Antiquity. Until Champollion deciphered it during the course of the nineteenth century, to European culture it represented a legendary dictionary for familiarizing oneself with and decoding the secrets of the fascinating wisdom of Ancient Egypt. The seventh hieroglyph of the first book of *Hieroglyphica* is accompanied by the explanation: "[the Egyptians] use [the symbol] of the sparrow hawk to represent the soul on account of the meaning of its name. In fact, the Egyptian for sparrow hawk is *baieth*, a word which, when broken down, means heart and soul, since *bai* is soul and *eth* is heart."[27] According to the Egyptians, the heart is the sheath of the soul. Therefore, because of its affinities with the soul, the sparrow hawk does not drink water at all, only blood, which is also the food of the soul.[28] What is striking here are the statements to the effect that "the heart" is "the sheath of the soul" and that the latter is nourished by blood.[29]

The former statement finds full justification in the supremacy of the heart in Egyptian human physiology.[30] Thoughts and intentions originate in the heart. Through it the god guides and governs the actions of man, whose heart is, in turn, his own god in that it is the seat of his will and intellect. It is precisely the area upon which divine inspiration takes effect. It is also the center of the physical and mental life of the individual, and of affections, states of mind, and feelings.[31] However, precisely because of their exalted psychological connections, blood and the heart assumed a considerable degree of importance in Egyptian religion and magic.[32] The latter, which finds no match in Egyptian culture, appears to be of Hellenic origins and refers back to the hemocentric tradition noted above. Here we have proof that Horapollon's text reflects a syncretic religious symbolism with strong Hellenistic overtones.

The relationship between blood and the psyche is not the only symbolic hub of the magic practices in Antiquity. There is also evidence of a considerable body of beliefs in the reality of dreams and portents, in other words, phenomena

in which the microcosm and the divine powers can meet by means of magical and supernatural sympathies. Examples of this can be seen in the work of the rhetorician Elius Aristides, who lived in the second century BC. In a number of passages from the *Discorsi sacri*, he tells us that all the numerous blood-lettings necessary in order to cure his psychopathological illness were carefully prescribed to him in dreams by Asclepius, the god of medicine. Thus Aristides submitted his health, his physical and mental state, and therefore his hemocardiac state, entirely to oneiric discourse with divine powers. In a number of passages of his work *Onirocriticon libri V*, Artemidorus of Soli, a contemporary of Aristides, writes about the oneiric symbolism of blood, but in a way that deliberately marries divinatory matters with systematic scientific and documentary investigation.[33] In fact, his oneiric critique (which was rediscovered in the fifteenth century and enjoyed great popularity, arousing considerable interest among scholars and men of letters but also among philosophers of the occult sciences),[34] in other words a scientific work on dreams, interpreted blood symbolism thus.[35] To vomit deep-colored, untainted blood meant wealth for the poor, a child for the childless, or the welcome return of a relative from afar. If the blood was pouring into a vase, this meant that both child and parent would live long lives. But if the blood were spilling over the ground they would both die. At this point I should like to draw the reader's attention to a specific and predominant aspect of this interpretation. Blood was seen as a bearer of positive messages: birth, long life, etc., provided it was not vomited or spilled on the ground. In other words, when spilled over the bare ground blood became a metaphor for death. How can we fail to see in this an echo of the necromantic practice with which we are now thoroughly familiar, according to which blood spilled on the ground was a means of invoking the dead? Elsewhere in his work Artemidorus explains that to dream of someone drinking blood alludes to a ferocious and bloody means of staying alive, for example, a gladiator fighting to the last drop of blood. With regard to these quotations it is important to note that, the former talks of vomiting blood and the latter of eating it. In other words, we always come back to the duality of blood leaving or entering the body, to the dichotomy of death/life referred to above.

Artemidorus uses the same interplay in order to decipher dreams containing metaphors of blood. Another story from *Onirocriticon libri V*[36] seems significant from this point of view. It tells of someone who dreamed he was the River Xanthus running through the Troade. He continued to emit blood for ten years, but without dying, for according to the Homeric tradition the River Xanthus is immortal.[37] It is evident here from the relationship between dream and reality that the waters/blood analogy is based on a dual symbolic meaning. On the one hand, the everlasting waters of the divine Xanthus will never run dry, just as the unfortunate individual's blood, even though it is spilled for ten years, will never run out. On the other hand, the paradox of blood that is continuously being spilled and yet does not lead to death impresses on the mind the fact that such is the physiological consequence of losing blood, in accordance with the metaphorical dynamics already examined.

Finally there is the world of miracles. Iulius Obsequens, a Roman author from the fourth century AD, wrote a work entitled, precisely, *Prodigiorum liber*. Only part of this has survived. In it are accounts of portentous, paranormal events of a physical and biological nature occurring between the consulship

of Lucius Scipio and of Gaius Lelius and that of Paulus Fabius and Quintus Elius, i.e., from 190 BC to 11 BC.[38] Such phenomena could be explained only as manifestations of the will of the gods. Among the many miracles are some involving blood:[39] raining blood, streams or rivers containing not water but blood, blood flowing during a *comitium* or from a statue of Jove, or else blood gushing from the ground or staining the swords kept in the Temple of Juno. All these supernatural events have one thing in common: they were bad omens heralding wars, disastrous bloodshed, or imminent death. Therefore, they were *signa* to be warded off with the appropriate sacrifices and other purificatory rites. Such phenomenology shows clearly the negative aspects of blood in the sense of it appearing to "pour" out of the sky or of the ground or manifesting itself in streams or on divine images. Evidently, this too is a repetition of the symbolic *topos* of blood "coming out" of the body, any body (the sky, the ground, etc.) and, meta-phorically, heralding misfortune, precisely as in the natural and physiological event of being wounded or dying a bloody death.

It is impossible not to reflect on the extent to which the power of metaphor influences the magical significance of blood. A comprehensive reading of the subject shows that, in necromancy and other magic practices, as well as in dream images and portentous visions, the presence of blood is tied to the primary sig-nificance it has within the body of a living person. It is precisely the latter that is the archetype, the natural *exemplum par excellence* that forms the basis for all the successive blood-related transformations of every magic potion, be it real or imaginary

Thus blood, for all its raw physicality, its heat, color, and smell, remains first and foremost a powerfully symbolic substance—capable of representing the most primeval forces of life, and of death.

Maya civilization developed over a period lasting more than two thousand years, from the middle of the first millennium BC until the Spanish Conquest in the sixteenth century.[1] The Maya people were spread over a vast area that was geographically very varied, covering present-day southern Mexico, Guatemala, Belize, and part of Honduras and El Salvador.[2] Their fame rests on their great achievements in the fields of art, science, architecture, and writing and on their knowledge of astronomy and methods of calculating calendars. Unlike Western cultures, in which blood sacrifice played an important role, in the Maya culture, it played the central role. More than in any other advanced civilization, blood sacrifice involved either the blood of the nobility shed voluntarily, or the blood of captured prisoners, shed after painful torture and humiliation underpinned the Maya culture and gave it meaning.[3]

Bleeding Hearts, Bleeding Parts: Sacrificial blood in Maya society
Giuseppe Orefici

The fact that we have been able to decipher Maya writing in recent years has opened up enormous possibilities for interpreting archaeological finds, enabling us to gain a new view of the ancient world of the Americas, a universal view that reveals to us not only the religious beliefs and practices of a civilization and of the peoples who observed this form of religion.[4] Systems of calendars and of writing had been developed in earlier epochs of Mesoamerican history and were not the invention of Maya priests or wise men. However, it was the Maya of the Classic Period who perfected these systems. The art of making inscriptions on stelae (stone shafts) and other architectural structures gradually spread over a vast territory, resulting in the widespread dissemination of the main features of Maya culture. One of the earliest known examples of an inscription is on Stele 29 at Tikal, which dates from AD 292.

The countless narrative images left behind by the Maya celebrate the deeds of rulers, blood sacrifices, victories, life and death, communication with deities, ball game triumphs, and royal dynasties from such important centers as Tikal, Palenque, Yaxchilán, Naranjo, Copán, Quiriguá, Chichén Itzá. All these celebrations were closely interwoven with the universe of the gods, and in all scenes relating to the Cosmos, the events were recorded with precise and frequently mentioned dates.[5] Other inscriptions relate to the supernatural world and to rituals and ceremonies practiced by humans. The illustrations on vases in particular were inspired by myths and by the deeds of deities, humans, and animals.[6] The narrative language and the symbolism of all these scenes are extremely rich, having evolved over a very long period.

The tools used by the Maya during the various phases of self-sacrifice or for the sacrifice of prisoners of war, and in the complex bloodletting ceremonies that accompanied each stage in their life, are well documented in images on vases and in the bas-reliefs adorning temples. The scenes depicted on monuments are mainly about the life, death and actions of successive rulers, whose lineage, date of birth, date of accession, battles, and deeds are all recorded. These scenes not only commemorate rulers from the past, but also represent

1. Embossed disk depicting human sacrifice (Disk H), Maya, Late Classic/Early Post-Classic Period (9th century AD), Mexico, Yucatan, Chichén Itzá, gold, Cambridge, Mass., Peabody Museum of Archaeology and Ethnography, Harvard University

them in material form, thereby symbolically restoring them to life. The persons they represent are thus transformed into divine beings, to be admired by the people. By transferring the existence of the gods from a remote cosmic era to an earthly level, they could be more easily understood by human observers. In this way men of high rank and gods were united and brought back to the present, eloquently legitimizing the power enjoyed by nobles in Maya society.

The great variety of styles, which was inevitable in a culture that flourished over several centuries, indicates the influence of other cultural centers existing at the same time, as well as changes that took place in political and social life. Around the ninth century AD very few dynasties survived the prevailing political chaos and the social catastrophe arising from the final disintegration of the Maya monarchy in the southern lowlands.[7] The tradition of narrative portraits accompanied by inscriptions was abandoned, and instead there were crowded series of portraits carved on the pilasters of colonnades or on the interior walls of temples. The scenes of sacrifice represented in the architectural decoration of this later period show figures bearing axes for ritual decapitation and knives for cutting the heart out of victims' chests.

In order to grasp fully the significance of the cultural heritage left behind by the peoples of Mesoamerica, and in particular the Maya, we need to learn something about their religious ideas and the systems of beliefs and customs they followed. The abundant information gleaned from inscriptions on Maya monuments and clay vases and in their manuscripts has enabled us to learn something about the culture and rituals of these people, and to gain an understanding of the complexities of their religious ideas and their view of the cosmos.

Keeping the worlds in balance: Ceremony and blood ritual in Maya cosmology

First of all, we must forget for the time being the way in which we in the Western world separate the physical from the spiritual. For the Maya, the physical world was the material expression of the spirit, just as the spirit was the primary essence of matter. Their religious vision was essentially based on the power of supernatural elements, each of them with a life of its own, with no distinction between animate and inanimate. The cosmic system interacted continuously with human life and actions. For the Maya, the great metaphor of life involved the practice of rituals and complex ceremonies. If the maize crop could not grow without human intervention, likewise the Cosmos required continual blood sacrifices to ensure its life and perpetuation. These rituals might seem to our eyes absurd and unfounded; to the Maya, however, they represented acts of spiritual devotion that were indispensable in order to maintain eternal equilibrium between the Cosmos, the human world, and the Underworld.

Existence manifested itself, and was experienced, thanks to the complementarity between two dimensions: the first was that of the daily life of humans, with its own world, and the second was the dwelling place of divine beings, ancestors, and minor deities, the Underworld. Both dimensions were regarded as sacred spaces, which interacted with each other in a continuous manner, influencing every human action, just as the inhabitants of the underground world, and the spirits of the ancestors awaiting rebirth, depended on the

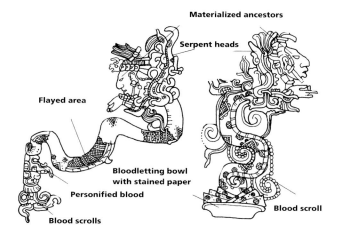

Materialized ancestors

Serpent heads

Flayed area

Bloodletting bowl
with stained paper

Personified blood

Blood scroll

Blood scrolls

2. Serpents of Vision, from Linda Schele and David Freidel's *A Forest of Kings*, New York, 1990

Rope and thorns

Blood scrolls

3. Necklace-like "blood scrolls," from Linda Schele and David Freidel's *A Forest of Kings*, New York, 1990

living for the sustenance they needed. In the complex Maya system of cosmology, the world was conceived as a whole composed of three superimposed layers, which were regarded as living entities endowed with sacred powers. Each of these three worlds, the starry vault of Heaven, the Earth in the middle, dwelling place of humanity, and the dark Underworld, sometimes called Xibalbá, had its own well-defined natural and conceptual characteristics. The human world was linked to the others by means of an imaginary axis called "6 heaven" or "raised heaven" (*Wacah Chan*), symbolized by a tree that reached across the three worlds. The tree's roots sank deep into the Underworld; its trunk crossed the human world and its branches stretched up as far as the uppermost area of Heaven.

The axis that linked the human world and the Underworld ran through the center of existence and could be made to materialize only by means of very specific rituals celebrated by a king, in whose person the axis manifested itself and came into existence, during visions he experienced when he entered a state of trance. This visionary trance was achieved through ritual bloodletting practiced by kings. The symbols of the communication between the two worlds were the sovereign himself and his natural counterpart, the Tree of the World (or of Life), the great *Ceiba*.

According to Maya belief, gods and men were in continuous communication. Humanity owed its existence to the fact that the gods, during a sacrifice carried out back in the mists of time, gave life to humanity with their blood. For this reason, humans had to pay tribute to the gods with the same element that enabled them to exist: in other words, their own blood. The Spanish regarded the Maya custom of taking blood, from any part of the body, as their principal act of worship. Iconographic evidence from the Classic Period up to the Post-Classic period, and even from the period following the Spanish Conquest, shows that the most important ritual involved extracting blood from the penis or the tongue, although it was also possible to use other parts of the body. For the ancient Maya, the ritual had two main objectives: to nourish the gods and to experience visions, which they interpreted as communications from the Hereafter. They believed that the vision ritual, intimately linked to bloodletting, infused life into the gods, giving them material presence in the human world. Every important event of the ruling dynasty, or the calendrical cycle, had to be sanctified with blood, which activated the world's central axis and allowed communication with ancestors and with the gods.

Instruments of the state: Blood sacrifice in Maya society

Bloodletting was one of the practices that dominated Maya religious ceremonies in the Classic Period. To offer one's own blood was an act of devotion that occurred in all the rituals, from childbirth to burial of the dead. It could be a simple act, consisting of the offer of a few drops of blood, or it could be extreme, involving the mutilation of various parts of the body. The most sacred sources of blood were the tongue (for both men and women), and the penis (for men). Depictions of these acts (Figs. 3 and 4) show the participants drawing cords of about a finger's thickness through their wounds in order to direct the flow of blood toward pieces of paper. Men, having cut their genitals, would spin round in a kind of whirling dance, so that the blood ran on to wide strips of paper or cloth

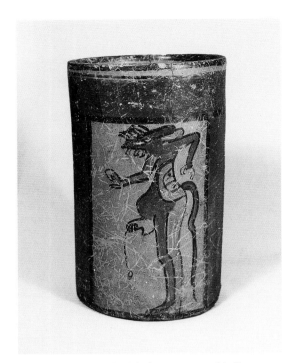

4. Ceremonial vessel with three zoomorphic figures, Late Classic Period, AD 600–800, probably from the lower Maya countries, clay, Guatemala City, Museo Popol-Vuh

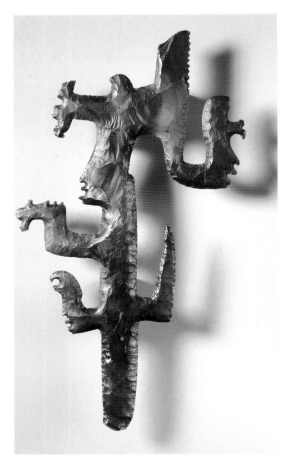

5. Flint, Mexico, AD 600–800, Cleveland, Museum of Art

tied to the wounded penis. The ultimate purpose of this rite was to achieve a vision of the opening of a door into the Underworld through which the gods and ancestors could be invited to communicate with the world of the Earth. The Maya considered this process to be a way of "giving life to the god" or the ancestor, and of enabling them to assume a physical form and thus be on the same level of existence as humans. This effort to enter a visionary state was therefore one of the most important acts in the ascetic ceremonies to which Maya nobles subjected themselves.

The practice of bloodletting was carried out not only in the temples of powerful men, but also on the altars of humble villages, as is clear from the fact that obsidian, one of the principal elements of ritual, is present at many sites of ancient villages. Obsidian is the glassy volcanic rock formed from lava spewed out by the great volcanoes of the plateaux of the Maya territory. Skillful craftsmen used this black material to make long, thin, razor-sharp blades (Fig. 7), which can still be found today at the site of any Maya community on the plains. Obsidian was held to be precious not only for its rarity but also because of its incomparable ability to produce clean-cut wounds very rapidly. Without doubt, the obsidian blades were also used for other purposes than that of causing blood to flow; however, it is certain that for the Maya, when obsidian was used in its primary, ritual function, it assumed a symbolic, almost sacramental value similar to that of the wine and host for Christians. What the great ruler carried out with obsidian for the good of his people, the peasant carried out for the good of his own family. It is even possible that the gift of obsidian from a king to one of his subjects, in exchange for the latter's labor, tributes, and allegiance, was meant as a subtle form of coercion.

In order for flint or obsidian to work more effectively as piercing (rather than slicing) instruments, they were cut in the shape of a prism. Other types of tool for making perforations were the thorns of plants and stingray spines, fixed in a handle carved to look like a long-nosed face. Some examples of this kind of tool have the appearance of a stem with three knots, symbolically representing the necklace-like gushing forth of blood during self-mutilation (Fig. 6). Among the other objects used during ceremonies are knives for removing prisoners' hearts, blades, and puncturing instruments for scarifying the skin, as well as the elaborately carved "eccentric" knives made of flint or obsidian (Fig. 5). These finely crafted articles, found in many different shapes, combine an ordinary blade with divine or sacred anthropomorphic motifs. At sites such as Palenque the eccentric flint represented the object sent by the ancestor to the ruler for use in investiture rites. In other places, such as Tikal, Copán, and Yaxchilán, the various combinations of symbolic elements relate to warfare and the capture of prisoners. In many cases they have been found in special deposits beneath temples and other buildings.

Obsidian, like many other materials, was distributed throughout Mesoamerica by merchants, who constituted a privileged category in Maya society. Linda Schele and David Freidel, in *A Forest of Kings*,[8] write of merchants visiting Cerros, in Belize, and describe them as patriarchs with a profound knowledge of the customs of the various peoples in the lands they crossed, experts in magic and in the tools that they brought with them to trade or to offer as gifts. These men were probably also able warriors, capable of defending themselves anywhere they went. It seems that they too took part in and carried out ritual bloodletting.

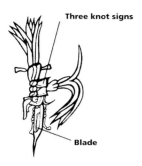

Three knot signs

Blade

6. Personified perforator symbolizing gushing blood, from Linda Schele and David Freidel's *A Forest of Kings*, New York, 1990

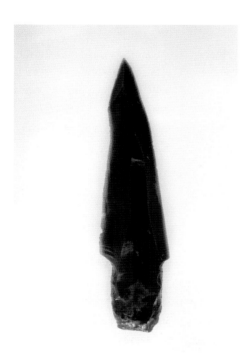

7. Obsidian dagger, Maya (Aurora Phase), 1st–4th century, Guatemala, Kaminaljuyu, Cambridge, Mass., Peabody Museum of Archaeology and Ethnography, Harvard University

Blood scrolls

Shell and bead sign

Kancross

Zero

8. Necklace-like "blood scrolls", from Linda Schele and David Freidel's *A Forest of Kings*, New York, 1990

The leaders of an expedition would climb on to a temple platform and stain bands of paper with their own blood issuing from cuts in their ears and arms. Then, according to tradition, the bloodstained paper would be burned, together with grains of incense, in wide drum-shaped bowls standing on terracotta plinths and decorated with masks representing the ancestral twins referred to in the sacred text of the Popul Vuh.[9] The purpose of this ritual was to thank the deities for a successful journey.

The plates and bowls for containing the cloth or paper impregnated with sacrificed blood are wide and shallow, with a rim angled inwards. The *lac*, as the Maya called this receptacle, could also contain the piercing instruments, the cords that were drawn through the holes made in the tongue, and offerings of all kinds. Frequently, following use, these receptacles were buried with a corpse, together with the funerary offerings; in this case a second dish was placed over the receptacle, as a lid. The decoration adorning these containers frequently includes the symbolic portrayal of the three worlds, with crossed bands representing heaven, the stingray spine recalling sacrificial blood and, therefore, the earthly world, and a shell, emblem of the watery world of Xibalba, the Underworld. On a blood-collecting dish standing on three feet, described by Schele and Miller (Fig. 19),[10] a highly skilled artist has painted a clear representation of the Cosmos as viewed by the Maya people. In this design, the open jaws of a serpent symbolize the open doors of the Underworld. Out of these jaws gush the limpid waters that fertilize the earth, while the dark and fertile waters of the Underworld are seen flowing below. In the upper part of this image appears the symbolic representation of Heaven, the great Cosmic Monster, embracing within itself the Sun and Venus, the ancestral stars. The flow of Heaven's blood, like falling rain, is symbolized by the great scrolls formed by the head and backbone of a crocodile. From the head of the god Chac Xib Chac the Evening Star that emerges from the dark waters of the door separating the two worlds rises the Sacred Tree. One of its branches assumes the shape of the Serpent of Vision, whose open jaws represent the path taken by the gods and ancestors when they emerge to unite themselves with earthly sovereigns and powerfully interact with them in a ritual (Fig. 2).

Blood, the precious element obtained during the course of these rituals, is represented in Maya symbolism by a double-ended scroll, whose outline can be either plain or decorated with pearl-shaped elements, like drops (Fig. 8). In order to differentiate these signs of blood from other types of figure, additional emblems were combined with them, corresponding to sacred and precious elements, such as the colors yellow, red, and blue-green, shells, jade, obsidian, and zero symbols.

Scenes of self-sacrifice and bloodletting: The temples at Yaxchilán

The practice of self-sacrifice with bloodletting is represented in especially abundant detail and with unprecedented narrative skill at Yaxchilán on the River Usumacinta, the seat of one of the most influential Maya dynasties of the seventh century AD.

During the reign of Jaguar Shield, who ascended the throne on October 23, 681, and ruled for at least sixty years, until the age of about ninety-two, there was a great wave of building important monuments and temples, including the beautiful Temple 23. Scenes sculpted on the architraves of this temple depict

**9. Murals in Bonampak, Room 1, Chiapas, Mexico,
ca. AD 790. Photo: Giuseppe Orefici**

the principal rituals relating to the life of the sovereign and his wife, Lady Xoc. The importance given to a woman in these scenes is unusual in Maya art and unprecedented in Yaxchilán. Lady Xoc played a special and important role in the history of Yaxchilán because of her noble ancestors, through whom she was related to the clan of which the mother of Jaguar Shield was a member. Moreover, the fact that she belonged to such a powerful clan was certainly a significant factor in the forging of alliances with other dynastic groups and in the legitimization of the dynasty's continuing royal status. She shared with her husband, with his consent, prerogatives that normally would have been the exclusive preserve of the supreme ruler. Although she does not seem to have governed directly, evidence of her influential role is to be found in the scenes carved on the architraves above the temple's exterior doors.

These show the three rituals marking the most significant moments in her life, in which the queen sheds her own blood, having pierced her tongue. The artists who sculpted these architraves used an ingenious method that enabled the actions to be read in sequence. In one scene, the observer sees the materialization of the Serpent of Vision; in another, Lady Xoc is helping the sovereign to don his battle garments. Probably, it was the king's intention that the scenes should be viewed separately, with the glyphs of the inscriptions and the details of clothing worn by the figures portrayed helping to make clear that the same ritual was being celebrated on different occasions: his accession to the throne; the birth of his son, Jaguar Bird; and, finally, the consecration of the temple.

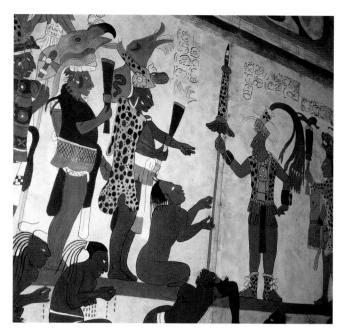

10. Prisoners' bleeding fingers (detail of Fig. 9). Photo: Ferdinand Anton, Munich

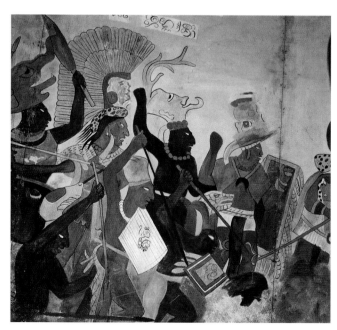

11. Battle scene (detail of Fig. 9). Photo: Ferdinand Anton, Munich

In the first scene, illustrated on Architrave 24, which was originally above the left doorway, Lady Xoc is seen kneeling at the feet of her husband, Jaguar Shield, who is letting his own blood. The king is holding a large torch, which might indicate that the ritual was being conducted in a dark chamber inside the temple, or else at night. The richly clothed woman is carrying out a ritual act of self-sacrifice, pulling a cord with thorns attached through the holes she has made in her tongue. The end of the cord falls into a receptacle that contains the instruments of penance and bloodstained paper. The inscriptions accompanying the scene state, at the top: "He is bleeding, the Lord Shield Jaguar, he who captured Lord Ah Ahahual, he who is Lord of Yaxchilán." Another inscription, referring to Lady Xoc, states: "She is bleeding herself, she who possesses various titles, Lady Xoc, the Lady Batab." The date shown on the architrave corresponds to October 28, AD 709, and, strangely, relates to an event that took place twenty-eight years later: the birth of the king's son, Jaguar Bird, whose mother was Lady Evening Star.

The carving in the middle, Architrave 25, is rich in detail, making it easier to interpret the complex scene. It shows Lady Xoc on her knees, calling upon Yat Balam, founder of the dynasty. In one hand she is carrying the dish containing the instruments of penance and the bloodstained paper from the self-sacrifice just carried out. She is gazing upward, contemplating the Serpent of Vision, poised above her head. The serpent is rising out of another bowl, which is placed on the ground at the queen's feet, ominously dominating the scene. From its jaws emerges the head of Yat Balam, who holds a dart and a shield; his headgear bears the effigy of the Rain God. The presence of this solitary woman in a ritual celebrating Jaguar Shield's accession to the throne suggests that the king regarded his queen's bloodletting as the most significant act of that moment in political history, because it symbolized the materialization of the ancestor who founded the dynasty, thus sanctioning the consecration of his direct descendant as king.

The next scene in the sequence, on Architrave 26, shows Lady Xoc, with blood still flowing from her mouth, assisting Jaguar Shield to dress for battle. He is preparing for the capture of prisoners to be sacrificed in rituals performed during the dedication of the temple, the date of which is not known for certain: it took place either on February 12, 724, or, according to other calculations, June 26, 726.

Other stelae and architraves illustrate events connected with the history of Yaxchilán, including scenes of self-sacrifice; however, these depict figures belonging to later times, including Lady Evening Star, mother of Jaguar Bird, and Lady Great Skull Zero, the latter's wife.

War, victory, and human sacrifice: The murals at Bonampak

The extent of Yaxchilán's influence in the Usumacinta basin is noticeable in numerous centers in the Late Classic period, in particular Bonampak, the ruins of which were discovered by chance in 1946 by two American explorers, thanks to information provided by some local guides of the Lacandón ethnic group (Fig. 13). Among the remains of temples, which have been the subject of numerous archaeological surveys, three rooms were discovered that contained wall paintings of extraordinary beauty (Fig. 9). These paintings represent various

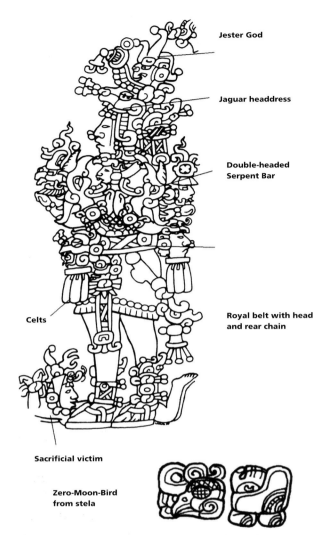

Jester God

Jaguar headdress

Double-headed
Serpent Bar

Royal belt with head
and rear chain

Celts

Sacrificial victim

Zero-Moon-Bird
from stela

**12. The "Leyden Plate," from Linda Schele and David
Freidel's *A Forest of Kings*, New York, 1990**

episodes of a battle, with a detailed depiction of the rituals and feasting that followed the victorious outcome. Here too the Maya tell their story with a wealth of detail and meticulous description. The whole story unfolds on three separate bands and has to be read by looking at the walls and the ceiling together, in order for the complex scenography of the individual scenes to be fully grasped.

The battle scene shows fighting between magnificently dressed warriors and their enemies, to the sound of war trumpets played by musicians, and other, masked figures, symbolizing the water deities. The story continues, with the action transferred to the setting of a stepped platform; here, prisoners captured in battle are seen stripped naked and subjected to torture and humiliation, including, as can be deduced from their bleeding fingers (Fig. 11), having their nails torn out. Another prisoner, apparently of higher rank, lies lifeless on the steps and, a little lower down, a severed head lies on a bed of leaves. On the top of the platform appears a flamboyantly dressed figure bearing the insignia of nobility, receiving the supplications of a man kneeling at his feet (Fig. 10). The sequence culminates in a representation of the final scenes: firstly a group of actors wearing water deity masks, together with musicians, and then the sacrifice, carried out to the sound of long trumpets played by figures adorned with long quetzal feathers. The noblewomen of Bonampak, wearing white robes or tunics, are seated on benches to watch the ceremony, and are engaged in drawing blood from their own tongues.

The eloquent narrative presented by the iconography and glyphs of Maya art lays particular emphasis on the presence of prisoners in association with the figures of rulers. The prestige of a Maya king was considerably increased according to his ability to capture prisoners. It seems that this was not easy to achieve, but entailed direct combat with the person he wished to capture. A king's prestige was even greater if he managed to capture a prisoner of royal blood. Often a ruler added the names of any high-ranking prisoners to his own name, and kept them for the rest of his life. Prisoners were therefore also an obvious symbol of the valor and power of a sovereign and of his ability to subjugate his enemies. This practice dated back to ancient times and, as we know from the numerous documentary sources that have come down to us, played a fundamental role in the institution of monarchy, as did warfare.

The Maya did not wage war with the object of killing their enemies, since it was much more important to capture them alive and keep them in reserve for sacrifices connected with major events. A defeated king or nobleman was stripped of his insignia, bound and led into the victors' city to be tortured and sacrificed during public rituals. Prisoners of prestige were therefore not necessarily sacrificed immediately, but often were kept alive for years. In such cases, they were exhibited during the course of rituals and ceremonies, and normally played a macabre part in them, in that they would be subjected to humiliating and distressing ill treatment. The main motive for these sacrifices is once again to be sought in Maya religious beliefs, according to which the gods had to be nourished not only by ritual bloodletting and self-sacrifice, but also by the blood of prisoners of noble birth. Often, victims' corpses were buried as offerings at the end of rituals connected with the building of temples, or together with the corpse of a powerful king, as in the case of Pacal, king of Palenque.

At Tikal, on Stele 39, the king Great Jaguar Paw is shown holding an axe with an eccentric flint blade symbolizing a jaguar, and menacing a prisoner at

13. Ruins at Bonampak, Chiapas, Mexico. Photo: Ferdinand Anton, Munich

his feet. In this monument, in which the end of the *katun* (a period comprising twenty years) is celebrated at Tikal (October 21, 376), the king bears the regal insignia of his ancestors and ankle bands, but the fact that he is holding a weapon instead of the ceremonial staff accentuates his demeanor, which is warlike, or characteristic of someone performing a sacrifice. Almost always, during important events, it was the king himself who put noble prisoners to death.

The Leyden Plate, or Plaque, shows the king of Tikal, Bird Moon Zero, together with a prisoner prostrate at his feet (Fig. 12). Once again such images confirm the essential role played by war and by the capture of prisoners.

Although these unfortunate victims are represented in Maya art in an individualized manner, there are almost never any descriptive features that would enable them to be identified precisely. In some cases, glyphs are engraved on the body, but virtually all prisoners remain anonymous, and their names are not mentioned in the inscriptions. Only a negligible number of portrayals provide some kind of identification and even fewer refer to the victim's name or the kingdom he came from.

The ball game: A matter for the living and the dead

One of the sacrificial practices was that of decapitation, a custom referred to in the earliest Maya sources. Perhaps its deepest significance is to be sought in the myth of the Hero Twins recounted in Popol Vuh,[11] the ancient book of the Quiché Maya, according to which the Twins cunningly persuaded the Lords of Death of Xibalbá to submit themselves to sacrifice by beheading. The myth tells how the Twins, Hunahpu and Xbalanque, were conceived at the moment when the severed head of their father, hung from a tree by his executioners, spat into the hand of Blood Moon, bringing about a miraculous fertilization in the Underworld. The mother of the Twins fled from Xibalbá and gave birth to the pair of heroes on the surface of the Earth. The Twins, using wily and ingenious ploys, managed to evade the traps set by the Lords of Death, driving them to a state of desperation. Challenged to take part in the ball game, which had proved fatal to their forebears, the Twins won the game and survived all tests to which they were subjected. Eventually, having disguised themselves as two poor vagrants who were skillful conjurers and capable of great feats, pretended to kill one another and then to come back to life. Having thus aroused the curiosity of their enemies, who begged them to perform the same marvelous feat on them, the Twins proceeded to sacrifice them, without bringing them back to life. Then the Twins tried to restore life to their forebears, their father and uncle, who were buried in the "place of sacrifice of the Ball Game," but in vain. From this point on, the Popol Vuh narrative recounts the deeds of the two Heroes after they left Xibalbá, when they transformed themselves into Sun and Moon and initiated the creation of the present world.

The sacred space devoted to divine communication was the *sphaeris-terium*, the enclosure where the so-called ball game took place, where the eternal drama of life and death was represented, in which defeat and victory, rebirth and triumph were the predominant and ever-recurring elements. At its most basic, the game involved putting a hard rubber ball through stone hoops without using the hands. It was extremely physically demanding and, because of the mass of the ball, the players had to wear padding around their waists

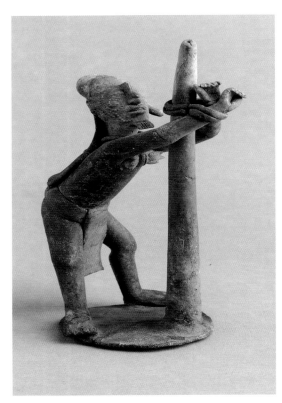

14. Figurine of a Maya prisoner, Late Classic Period, AD 600–800, Island of Jaina, Campeche, Mexico, clay, Cologne, Rautenstrauch-Joest-Museum. Photo: Rheinisches Bildarchiv, Cologne

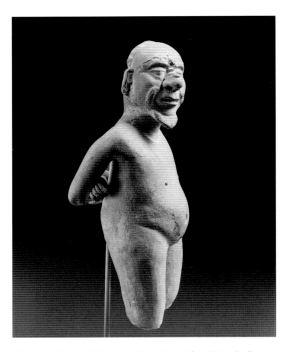

15. Portrait of a Maya captive, Late Classic Period, AD 600–800, clay figurine, Princeton, Princeton University Art Museum

and arms. Owing to the difficulty of the game, it often continued for days without scoring. The ball game was the metaphor for life that is reborn out of death. The symbolic-religious significance of this game is its representation of the eternal struggle between conflicting cosmic elements, whose unceasing opposition is the source of every form of life in the universe. This ritual game was accompanied by solemn processions and sacrificial decapitations. The head, which significantly was symbolized by the rubber ball, represented the sun and, in the case of ceremonies connected with fertility rites, the ear of maize. In the course of the game, the movement of the celestial bodies was also propitiated.

The ball game provided the ideal environment in which kings could promote their own authority by means of acts of sacrifice, reliving the deeds of the mythical Twins who played numerous matches against the Lords of Death and eventually transformed themselves into Sun and Moon. The game took place in an enclosure that was in the form of an elongated "H," bordered on either side by twin structures decorated with panels leaning in toward the pitch. On the walls of these lateral buildings there were stone rings. According to the rules of the game, two teams took part, and their players could touch the ball only with their sides, buttocks, elbows, or knees. If prisoners participated, at the end of the game they could be sacrificed. The type of sacrifice most closely associated with the ball game was decapitation. At Tikal and Uaxactún kings exhibited severed heads as a means of attracting the public's interest and attention. At Naranjo, an event that took place on May 4, 627 was commemorated on the Stairway of Hieroglyphics, where it was referred to as a ball game. The sacrificial execution of high-ranking prisoners was often carried out during a simulated ball game.

At Palenque scenes of battle and human sacrifice decorate the Temple of the Sun. The main scene shows a shield with the Sun Jaguar and crossed spears; this and other images rest on a throne with jaguar heads and bleeding dragons, reiterating the symbolism of sacrifice by decapitation and recalling the mythical defeat of the Lords of Death.

Shifting fortunes: The development of Maya culture at Chichén Itzá

The social and economic catastrophe that altered the face of the Maya cultural panorama after the ninth century AD did not have identical repercussions in all the territories. In the northern regions, the progressive disintegration of the Maya monarchy led to changes in some of the fundamental institutions of the political structure. Transforming a system of government such as one based on the concept of *ahau* (sovereign-lord) was fraught with problems and few kingdoms in the southern lands managed it successfully. The Itzá kings of the north succeeded instead in creating a model that contrasted with the ancient political structure, a model based on a form of joint power, *mul tepal*, which produced a hegemonic and expansionist type of government, with its capital at Chichén Itzá.

Subsequently, the states of the northern lowlands enjoyed a period of well-being up to the tenth century, and expanded considerably into adjacent territories as a result of their innovative political strategies. Sites such as Chichén Itzá flourished to an exceptional degree, thanks to Mesoamerican influences, which archaeological studies suggest came from the Toltec capital of Tula.

16. "Rack of skulls," Chitzén Itzá, Mexico, AD 900–1100/1200. Photo: Giuseppe Orefici

The northern states flourished during the final Classic Period (AD 750–900) and Chichén Itzá's dominance continued for much of the Post-Classic Period (AD 900–1100/1200), and indeed it was never entirely abandoned, even during the centuries that followed.[12] Numerous historical sources document quite precisely the dominant role played by Chichén Itzá in the Yucatán Peninsula. It seems that its expansionism led it to become the most important political center in the territory, thanks to the activities of its *ah tepal,* its rulers. At the same time, other peoples, settled in western and eastern Yucatán, were prospering, and important centers were springing up. These peoples together were known as *itzá,* according to information contained in the books of Chilam Balam.

The most significant changes were those affecting architecture, certain rituals, and the manner of conducting wars of conquest. Although there was still widespread destruction and the practice of capturing prisoners continued, a different attitude developed toward the defeated. A government founded on and organized around principles of confederacy and of assembly had no interest in defeating a rival dynasty and humiliating it. The tendency was above all to incorporate other dynasties in order to strengthen further the expanding cosmopolitan state. However, if it was not possible to negotiate, then war was waged implacably, its object being the enemy's total submission.

The public monuments of Chichén Itzá provide exhaustive documentation concerning military campaigns conducted by its kings against neighboring peoples. The images painted on the walls of the Upper Temple of the Jaguars eloquently illustrate the type of battle waged with great destructive force against enemies. The defeated peoples underwent the usual fate: they were captured and sacrificed on a scale perhaps greater than was the case in the southern kingdoms (Figs. 14 and 15).

The treatment of prisoners was unlike that in the southern kingdoms. Here they are dressed in magnificent garments, like those worn by the most valiant warriors. This suggests that there was a tendency to assimilate rather than destroy or humiliate them. Some prisoners chose to accept subjugation and to join the victors, while others opted instead for death. Sacrifice by cutting out prisoners' hearts happened on a much more massive scale than in earlier times, but the object was still the same: to produce a flow of blood in order to invoke the Serpent of Vision.

17. Sacred Cenote waterhole, Chitzén Itzá, Mexico. Photo: Giuseppe Orefici

18. Embossed disk depicting warriors (Disk F), Maya, Late Classic/Early Post-Classic Period (9th century AD), Mexico, Yucatan, Chichén Itzá, gold, Cambridge, Mass., Peabody Museum of Archaeology and Ethnography, Harvard University

The fate of the vanquished was to be captured and sacrificed. Their hearts were torn out by warriors dressed as birds, with the great plumed serpent floating above them. Other prisoners were killed by shooting with arrows or by decapitation. In this case too, beheading was closely linked to the ball game or to the fire ritual. Such scenes are shown in the images painted on the wall at the base of the Temple of the Warriors and in the reliefs in the *sphaeristerium* (the ball game court) as metaphor for battle and the battlefield. Evidence of the vast number of sacrifices carried out at Chichén Itzá is found on the platform adjacent to the pitch, with its disturbing "rack of skulls" with row upon row of skulls (Fig. 16). Clearly this depiction is based on the practice of conserving enemies' heads as war trophies to be exhibited, or else, in the case of heads of people who died of natural causes, as sacred relics. In other Mesoamerican regions, too, there was the custom of displaying trophies obtained during battles or sacrifices on wooden shelving that was constructed in the major centers. In the Aztec capital, Tenochtitlan, where ritual human sacrifice was also practiced on a massive scale, wooden structures of this type were called *tzopantli*.

Another form of sacrifice that was practiced at Chichén Itzá, and is described by Diego de Landa in *Relación de las cosas de Yucatán*, was that of throwing victims in the waters of *cenotes*. These deep natural waterholes were created by subsidence in limestone soils, so that underlying aquifers came to the surface. The Yucatec Maya believed that these waterholes provided access to the Underworld. Certain buildings were linked to them by paved causeways. One of the largest and best known, the Sacred Cenote (Fig. 17), was situated to the north of the city and it played a special role in rituals celebrated by the inhabitants of Chichén Itzá. Men and women were thrown into it, and it was believed that since they did not reappear, they must still be alive. This ceremony was held especially in times of drought, to invoke rain, and it was accompanied by the offering of objects of all kinds, such as precious handcrafted articles, textiles, shells, and ceramic bones.

Among the most important finds from the Sacred Cenote are two discs of rolled and embossed gold (Figs. 1 and 18). The two scenes on these discs seem to be in sequence, and they illustrate the capture of two Maya prisoners by a warrior dressed in the typical clothing of the "Toltec Maya," who ruled the Yucatec city during its heyday. One disc shows the moment just before the sacrifice, in which the victor, with an assistant, is threatening two defeated Maya. The second disc shows a prisoner's heart being cut out by a warrior wearing a headdress in the shape of an eagle's head, accompanied by two attendants carrying the weapons of the officiating warrior and by four other assistants who are holding the victim in position. The overall style of these two discs and the presence of symbolic elements that belong to the Mexican plateaux as much as they do to the truly Maya regions, clearly demonstrate that there was considerable interaction between different cultures and that this was decisive for the socio-political development of Chichén Itzá. New deities joined the Yucatán pantheon, influencing both the content and form of ceremonies, and giving particular importance to the cult of the Plumed Serpent, Kukulcán.

The world of the Maya stands in sharp contrast to the world of Western Europe. In the Maya world, as we have seen, the idea of the sacred embraced every area of human life, including the practical concerns of politics, war, econ-

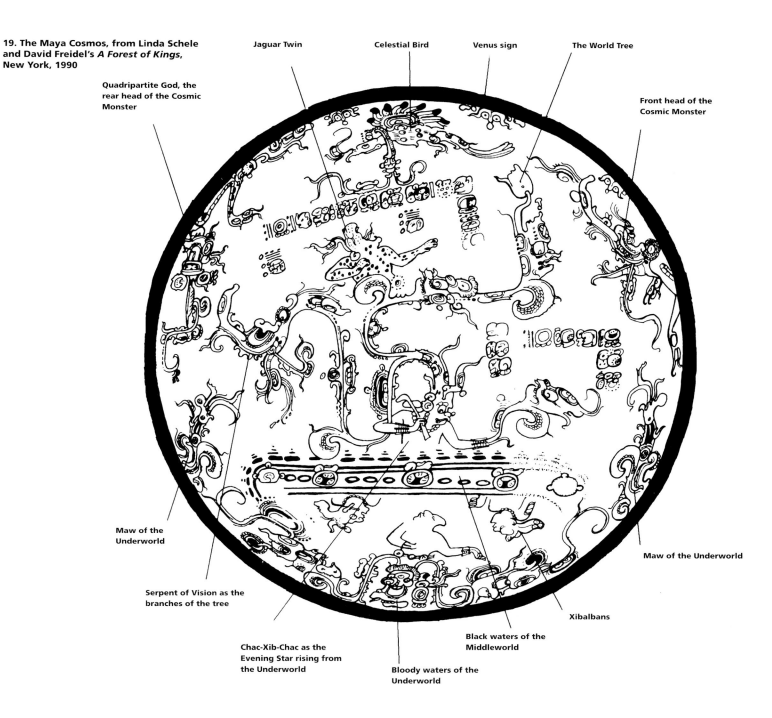

19. The Maya Cosmos, from Linda Schele and David Freidel's *A Forest of Kings*, New York, 1990

Jaguar Twin

Celestial Bird

Venus sign

The World Tree

Quadripartite God, the rear head of the Cosmic Monster

Front head of the Cosmic Monster

Maw of the Underworld

Maw of the Underworld

Serpent of Vision as the branches of the tree

Xibalbans

Chac-Xib-Chac as the Evening Star rising from the Underworld

Black waters of the Middleworld

Bloody waters of the Underworld

omy, and people's everyday activities. The Maya world was built on foundations of blood. Every action and every event was codified through the rituals required to enter into communication with the gods. These rituals and the communication were made possible by blood. Whether it was the blood from the king's own tongue spattered on a strip of paper, or the hot blood from a still-beating heart, it was blood which summoned the Serpent of Vision, and opened the door between worlds. The public and private expression of these beliefs is still to be found today in the art that the Maya people have left us and it is this art that can help us to gain some understanding of the cosmic vision conveyed in their writings and their monuments.

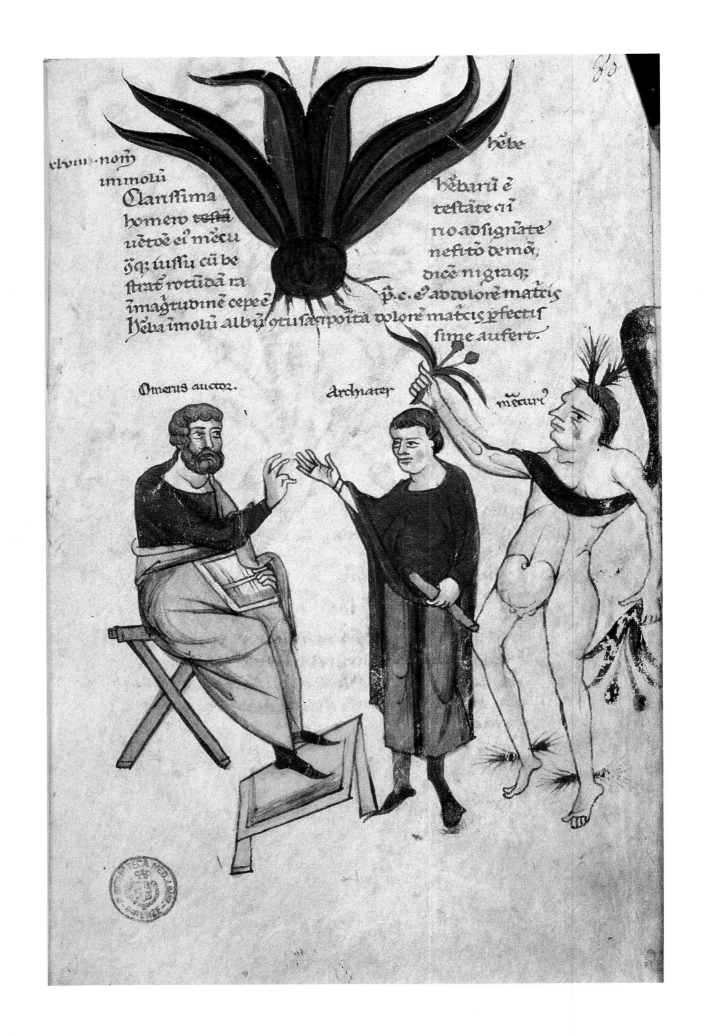

elvIII· notͅ
immolͅ

Clariſſima hͤbaruͦ ē
homͤro teſtͣ teſtͣte cͧ
uͤtoͤ eͧ mͤcu rͦo adſignͣte
q; iuſſu cͧ be neſito demͦ;
ſtͣb rotͧdͣ ta dicͤ nigͣq;
imaͤtudinͤ cepͤ ē p.c. eͧ avͦlorͤ matͨciſ
Hͤba imolͅ albuͤ ͤtuſaͦpoſtͣ vͦlorͤ matͨciſ pͤfectiſ
 ſime aufert

Omerus auctor. Archnater mͤcurͤ

"Blood, *sanguis*, is named in Latin because it is pleasant to the taste, *suavis*; whence also men with whom the humor blood predominates are pleasant and agreeable."[1]

With this sentence Isidore of Seville describes in a nutshell many of the ideas on blood expressed by Classical thinkers. Written in the latter part of Antiquity, the words of this Spanish archbishop still bear clear traces of the most archaic physiological doctrines. There is strong evidence that blood was considered a vital element throughout Antiquity. It is a cultural thread that begins in mythology. The vital and fruitful properties of the substance often emerge in adventures attributed to the Greek gods. In particular we find this in legends regarding the birth and metamorphosis of certain plant species, in which magical and mythological plants, such as the *prometheion* and the *moly*, as well as actual species, such as the hyacinth, the violet, the crocus, and numerous others, are said to have originated by drawing life from the drops of blood that fell from the mortal wounds of the protagonists of mythological events. Whether these figures were divinities, heroes, or ordinary mortals, the result was the same: from a sacrifice, from spilt blood that made the ground fertile, a new plant species was born.[2]

Sanguis Suavis: Blood between microcosm and macrocosm
Valentina Conticelli

The predominance of the sanguine temperament over the other four humors—as recalled in Isidore's statement that a man dominated by the sanguine humor is *dulces et blandus*—an idea that later evolved into a canon of Scholastic philosophy, can be considered a late reflection of the value that had been attributed to blood as a vehicle for life and the seat of the soul ever since the pre-Socratic era.

Archaic Greek examples of biological and physiologicalresearch are generally characterized by a need to identify a general principle within the human organism. The results of such speculations—and it is only possible to give a sketchy outline of them here—led to the formulation of two theories that vied for supremacy over biological research throughout much of the history of Greek medicine, namely, the encephalocentric theory (the notion that the head is the seat of consciousness) and the hemocentric theory (the idea that blood and the heart are the seat of consciousness).[3] The former theory tends to reflect a more scientific and anatomical approach to the analysis of bodily functions, and in particular those mechanisms by means of which man perceives reality through his senses.[4] The founder of the theory was the Pythagorean physician Alcmaeon, who lived in Croton in the second half of the fifth century BC, and who was the first, actually, to dissect a human body. To get an idea of encephalocentric thinking, let us recall an important fragment that has come down to us through Theophrastus, in which Alcmaeon describes the activities of hearing, smelling, and seeing, and ends by stating that "all the sensations are somehow gathered in the brain."[5]

On the other hand, hemocentrism (which enjoyed great popularity later as it was partly accepted by Aristotle),[6] developed from the doctrines of one of the most important pre-Socratic philosophers, namely Empedocles (who also lived in the fifth century BC, in Acragas (Agrigentum). In order to understand the fundamental role of blood in Empedoclean physiology, we must briefly

1. Aulus Cornelius Celsus, *De medicina*, Italy, late 9th–early 10th century, parchment codex, Pl. LXXIII cod. 1, Florence, Biblioteca Medicea Laurenziana

2. Robert Herrlinger, diagram, from E. Schöner's *Das Vierschema in der antiken Humoralpathologie*, Wiesbaden, 1954

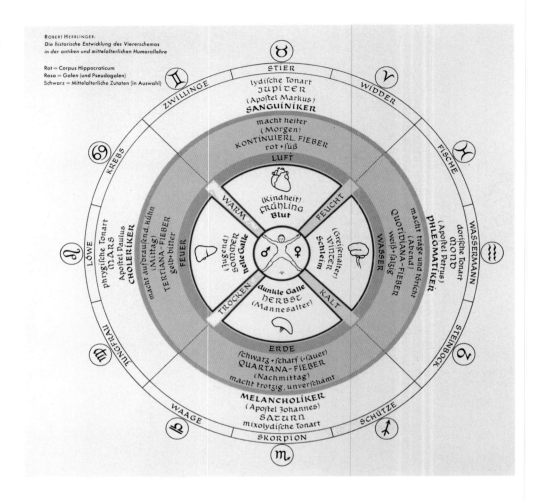

summarize the original principles upon which it is based. Empedocles was one of the first to maintain that the cosmos has a four-part structure. In fact his thinking combined the doctrines of the Pythagoreans (sixth century BC), who considered the number four to be the basic principle governing the structure of the universe and therefore the structure of the human body, with those of the natural philosophers, such as Thales and Anaximander (sixth century BC). According to Empedocles, four elementary principles made up everything that existed within the Cosmos, and these were the four elements: air, water, earth, and fire. These elements corresponded to the four cosmic forces, namely, sky, sea, earth, and sun.[7] Consequently, since man was part of the universe, his body (the microcosm) must function like the universe (the macrocosm), and therefore it must be governed by the same principles as the world. So man's potential for understanding reality must be based on a sympathetic rapport established between the elements that existed within him and those of the outside world. Therefore, similar elements were thought to form a relationship, and by recognizing one another enabled one to have certain sensations: "For with earth do we see earth, with water water, with air bright air, with fire consuming fire; with Love do we see Love, Strife with dread Strife."[8]

Empedocles did not analyze the workings of the sense organs from an anatomical point of view. Instead he concerned himself solely with explaining how the senses might relate to the elements.[9] Within this mechanism of sensations based entirely on analogy, blood plays a major role, because not only the individual's perception of reality but also his temperament and lesser or greater degree of intelligence depend on the mixture of elements inside his body. In

3. The Four Temperaments, the top couple representing the Sanguine temperament, Italy, second half of 13th century, Ms. Ham. 390, Berlin, Preussische Staatsbibliothek

4. The Phlegmatic temperament, from *regimen sanitatis Salerni*, Italy, ca. 1450, manuscript, Ms. germ. fol. 1191, Berlin, Preussische Staatsbibliothek

5. The Melancholic temperament, from *regimen sanitatis Salerni*, Italy, ca. 1450, manuscript, Ms. germ. fol. 1191, Berlin, Preussische Staatsbibliothek

particular, it is blood that represents the principle of thought. If the blood consists of a balanced, harmonious mixture of the four elements,[10] it can nourish the body with the air, water, earth, and fire it needs, and since it contains the four elements it can also think them, therefore, it can think the whole of nature.[11] Every body in existence has many "pores," which place it in direct relationship with the outside world. Furthermore, each body emits "effluences," and these are perceived by the "pores," which select them and direct them toward similar ones existing inside the body, i.e., air, water, earth, or fire. The meeting takes place in the blood, and generates thought for, as Empedocles says, "the blood around men's hearts is their thought."[12] In Empedoclean physiology, the fundamental vital principle is blood, since this is the most perfect tissue in the body. Its warmth means that it is intrinsically linked to life, because it enables the body to carry out the main vital functions: self-nourishment, digestion, respiration, and thought. As J. Bollack says, blood is the main means by which the body adapts to and reflects the conditions of the universe around it through perceptions.[13] So life itself is associated with the warmth of the blood, because death comes about through the cooling of the body, which also leads to suspension of thought and of all the vital functions. Thus, the death of the body corresponds to the death of the mind.[14]

The "king of the humors": Blood as the seat of the soul

In this sense it is easy to see consonance between one particularly significant moment in Homer's *Odyssey* and the theories of Empedocles. When Ulysses meets the souls of the dead during his descent into the underworld, he offers them the blood of several sacrificial beasts, since only by drinking this vital liquid can the dead regain their memory and reacquire a level of consciousness that enables them to recognize the hero.[15] Already in Homer blood is seen as a vehicle for consciousness. As well as conceiving blood as being the essence of thought, Greek philosophy actually identified it with the soul, an idea that, in the archaic period, sprang from the observation of steam rising from blood that

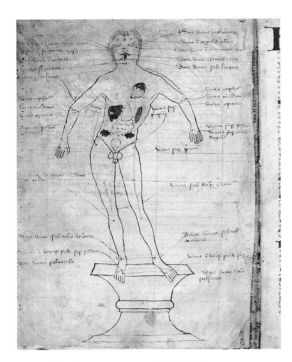

6. Bloodletting man, second half of 15th century, paper, parchment, Ms. W 308, c. 1v, Cologne, Historisches Archiv v. Photo: Christoph Hennes, Cologne

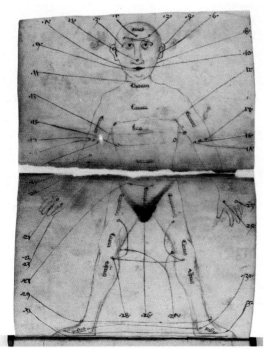

7. Zodiac man, from John of Ketham's *Fasciculus medicinae*, Germany, second half of 15th century, paint on parchment, Cod. Palat. Germ. 644, fol. 61v, Heidelberg, Universitätsbibliothek

had spilled from a mortal wound.[16] The main upholder of such a theory was Critias (fifth century BC). Aristotle makes reference to this in *De anima* when he states: "others, like Critias, have imagined the soul to be blood because they have supposed that sensation is the peculiar characteristic of the soul, and that is due to the nature of blood."[17] In a later period this stance was supported by several Hippocratic doctors and by Diogenes of Apollonia (fifth century BC). However, these figures were more inclined to see blood as the seat of the soul than to associate it with the soul itself.

The central role of blood within Empedoclean physiology derives neither from biological and anatomical observations nor from scientific considerations. Instead it springs from the fundamental value blood must have possessed for the purposes of those purificatory sacrifices practiced within the magical priestly tradition to which Empedocles was an heir.[18] Traces of this tradition also emerge in the value that blood assumes within Homer's *Odyssey*.

From Empedocles onward, and throughout the entire history of ancient and medieval medicine, blood was destined to play a central, if diversified, role in cosmographical schemes based on the number four. These are syncretic systems based on the principle of analogy, of the relationship of like with like, uniting the universe and man (macrocosm and microcosm) in a single structure in which all the parts relate to one another (see Fig. 2).[19] Various components of the ancient doctrines contributed to the creation of this fascinating syncretism, which formed such a fundamental cornerstone of the medical and philosophical traditions of the Middle Ages and the Renaissance. In addition to the ideas of Empedocles and Pythagoras, the doctrine of Hippocrates played an extremely important role in this process.

The *Corpus Hippocraticum*, the collected writings of this great doctor from Cos and his pupils (fourth/third century BC), laid the foundations for new developments in ancient medicine. Its authors were strongly influenced—although in a different way—by the theories of Empedocles and by hemocentric theories.[20] The work shows the unfolding of a process that proved highly significant to the development of physiology, namely the definition of the theory of humoralism, which derived mainly from a fusion of the Empedoclean concept of the elements with the properties put forward by Alcmaeon.[21] The latter had identified the prevalence of certain properties within the body, such as heat, cold, dryness, humidity, sweetness, and bitterness, as being responsible for illness. He maintained that good health meant a harmonious balance between such properties.[22] The Hippocratic doctors combined the theory of elements and properties with the humors that had previously been identified in ancient medicine as causes of illness.[23] The latter were identified with those elements of ingested substances that were not digested, and were not therefore used by the body. Such elements were thought to remain in the body as excess, which unless eliminated could lead to illnesses. The first two humors to be identified in ancient medicine were bile and phlegm. Two types of bile were then distinguished: yellow and black. Subsequently, blood was added to the three "negative" humors. Even though it could not be classified as excess, or bodily waste, it was incorporated into this system, forming the ideal number of four.

The identification of the humors, which vary in number depending on the author involved, is one of the main advances to be found in *Corpus Hippocraticum*. It was in the work of Polybus, who may have been Hippocrates' son-in-law, and

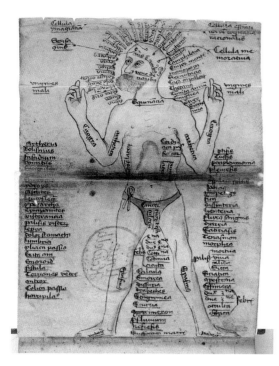

8. **Illness man, from John of Ketham's** *Fasciculus medicinae*, **Germany, second half of 15th century, paint on parchment, Cod. Palat. Germ. 644, fol. 62r, Heidelberg, Universitätsbibliothek**

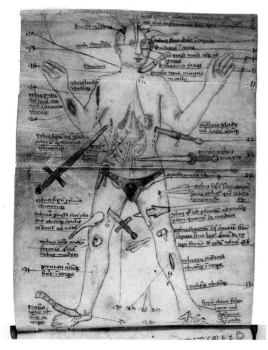

9. **Wounds man, from John of Ketham's** *Fasciculus medicinae*, **Germany, second half of 15th century, paint on parchment, Cod. Palat. Germ. 644, fol. 78v, Heidelberg, Universitätsbibliothek**

author of *De natura hominis*,[24] that humoral pathology became fused with the Empedoclean cosmological doctrine, resulting in the initial formulation of the quadripartite system that eventually became canonical, and remained so throughout the Middle Ages and the Renaissance. Harmony among the humors was considered to be the only source of good health. Therefore, it was necessary to balance these within the body, and the predominance of one over the others was thought to give rise to illness.[25] It was precisely in this treatise by Polybus that the correspondences between the different physical and cosmological groups of four—i.e., the humors, the properties, and the seasons—were summarized according to the following scheme:

Humor	Season	Qualities
Blood	Spring	Heat and humidity
Yellow bile	Summer	Heat and dryness
Black bile	Autumn	Cold and dryness
Phlegm	Winter	Cold and humidity

The principle of analogy had led the doctors of antiquity to relate the passing of time and the transformations that take place in nature to what occurs inside the human body. Consequently, each season was characterized by a corresponding prevalence of one of the four humors and, therefore, of the illnesses associated with it. According to Hippocratic doctrines, the justification for linking blood with Spring lay in the observation that blood increased in the Spring and decreased in the Autumn. Furthermore, Spring expressed the nature of blood perfectly, being warm and humid.[26] From this point of view, once again it was Polybus who affirmed that blood apparently increased in relation to certain weather conditions, in particular on the hottest days and as a result of violent storms.[27] By the same principle, drinking warm beverages, such as wine, was also said to increase the blood. But the mechanics of analogy governing this type of system did not stop here. The next step with regard to identifying the connection between the seasons and the humors came in a number of Hippocratic treatises linking the humors to the age of the person, one of the ideas expressed in them being that in youth there was a greater abundance of blood.

As M. P. Duminil said, what is involved here is an extremely ancient idea, which the pupils of Hippocrates simply codified. It originates in the identification of water with life, as maintained by Thales, a theory according to which dying of old age meant dying of aridity.[28] In Hippocratic texts, according to the analogy between the structure of the microcosm and that of the macrocosm, the venous system is frequently compared with rivers and with water irrigating the land: "[within the ventricles] are the founts of human nature, the rivers that branch off within the body and give life to the human being. And if they dry up the person dies."[29]

The idea that the quantity of blood varied according to the age of the person was subsequently taken up again, by Aristotle. As we shall see, he attributed blood with a great deal of influence over human and animal psychology. In addition to the seasons and to the ages of man, the system also extends to colors and to the organs of the body. Hence, blood is obviously associated with red and with the heart.[30] In the teachings of Hippocrates, some organs are indicated as sources of humors. For example, the heart was supposed to be the source

10. Spring, *Tacuinum sanitatis*, Lombardy, before 1405, codex, Vienna, Österreichische Nationalbibliothek

11. Summer, *Tacuinum sanitatis*, Lombardy, before 1405, codex, Vienna, Österreichische Nationalbibliothek

of blood, the brain the source of phlegm, the liver the source of black bile, and the spleen the source of yellow bile. The Hippocratic teachings provide a series of correspondences among the humors, the parts of the body and variations in the weather affecting man both externally (the seasons) and internally (age). However, as E. Schöner rightly points out, these are not codified in a single text. They can be deduced and schematized by marrying up items of information from the various Hippocratic treatises.[31] As is clear from the summarized table compiled by Robert Herrlinger, according to the analogies between the macrocosm and the microcosm defined in *Corpus Hippocraticum*, blood is linked to humid warmth, the heart, Spring, and childhood (see Fig. 2).

Other important observations contained within the Hippocratic texts concern the link between blood and human behavior and intelligence. Doctors who followed that school of thought maintained that changes in the blood affected intelligence.[32] One direct consequence of these affirmations is of great interest. Several of the Hippocratic treatises maintain that there is a close link between madness and the state of the blood. According to one, an attack of madness is preceded by clotting of the blood within the chest. The proposed remedy is also significant from our point of view in that bloodletting from the chest is recommended.[33]

The theory of a strong connection between blood and behavior in both animals and human beings deriving from Empedocles' psychology of the blood also became extremely important in the work of Aristotle. According to him, man is superior to other animals because his blood is "purer and more abundant."[34] Therefore, the greater dignity of man in comparison with other species, which nevertheless have blood, lies in the fact that man's blood is more plentiful. Moreover, the heat carried by the blood, together with man's upright posture, determines a correspondence between the area man occupies spatially, with its high and low point, and the absolute dimensions of the universe. In this way Aristotle reaches the conclusion that man "is the biped most in accordance to nature."[35] Once again blood is considered to be a criterion, a cornerstone, and point of reference linking man with the world. The type of blood contained in the bodies of the various species of live beings was also thought to determine several important characteristics. In *De partibus animalium* the author states: "there are many points both in regard to the temperament of animals and their power of sensation which are controlled by the character of the blood. This is what we should expect: for the blood is the material of which the whole body consists—material in the case of living creatures being nourishment, and blood is the final form which the nourishment assumes. For this reason a great deal depends upon whether the blood be hot, cold, thin, thick, muddy or clear."[36]

Yet it is precisely the presence of blood in the four-part system codified by Hippocrates and his followers that constitutes one of its fundamental incongruities. Blood can only be a humor *sui generis*, since it is not a harmful substance. Furthermore, it is found in constitutionally abundant amounts in the human body, and its basic function is that of conveying nutrients to all the various parts of the body.[37] It is generally thought that Hippocratic doctors believed that an excess of blood could cause illness.[38] However, this idea might derive from the fact that they frequently prescribed bloodletting as a cure. Yet, the main aim of phlebotomy was not to take blood, but to eliminate excessive, harmful humors that mingled with the blood and caused illness.[39]

12. Autumn, *Tacuinum sanitatis*, Lombardy, before 1405, Cod. Palat. Germ. 644, Vienna, Österreichische Nationalbibliothek

13. Winter, *Tacuinum sanitatis*, Lombardy, before 1405, Cod. Palat. Germ. 644, Vienna, Österreichische Nationalbibliothek

In the doctrine of the temperaments, which was formulated subsequent to the Hippocratic theories, and codified into a proper system only in late Antiquity, blood played an atypical role. As a doctrine it was simply an extension of the system of four-way correspondences between the microcosm and the macrocosm, affirming further relationships between the properties, elements, and possible characteristics of human beings. The texts that contributed to the formation of this new tradition explicitly link not only the humors and temperaments but also the humors and elements. Air, which is warm and wet, within the body corresponds to blood, whereas earth, which is cold and dry, corresponds to black bile, while fire, which is warm and dry, is related to yellow bile, and water, which is cold and wet, is related to phlegm (see Figs. 3–5).

The great synthesis: From Empedocles and Hippocrates to Galen and his successors

The theory put forward by the Hippocratic doctors, introducing the idea of the influence of the various humors on different human types, enjoyed widespread popularity during ancient times, particularly as doctors began to take an interest in physiognomy (the shape of the body and its parts) and characterology (the temperament of the individual). The system was finally codified by Galen (second century AD),[40] who drew attention to the existence of different categories of physical types and behavior, depending on the prevalence of one or other of the humors within the body.[41]

According to Galen, the consequences of the influence of blood on the human constitution are not at all positive,[42] and, in fact, seem to negate the characteristics attributed to this humor by the Hippocratic teachings and by Aristotle. However, such was not to be the case in the tradition that followed, and which marked the true codification of the doctrine of the four temperaments. In fact, in the physiognomic literature produced between the third and sixth centuries, which proved to be the determining factor in the formation and diffusion of the aforementioned theories, the sanguine *krasis* or *complexio* is the best of the four.[43] It portrays the sanguine nature—as distinct from the pseudo-Galenic work *On the Cosmos*, which simply characterizes such types as being milder—in a similar way to the definition given by Isidore (quoted above). In other words, those with a sanguine temperament are benevolent, unaffected, mild, and of good character (Vindician), moderate, mild, and good-looking (Pseudo Soranus), and finally, cheerful, serene, helpful, prone to laughter, and talkative (Bede; see Figs. 3 and 14).[44]

Later, in Scholastic philosophy, the temperament deriving from a prevalence of blood over the other humors was actually identified with the *complexio temperata*, in other words, a state of good health.[45] In fact, according to William of Conches (twelfth century), it was only the arrival of Adam in the earthly Paradise that produced for the first time the proportioned mixture of qualities attributable exclusively to mankind. After the Fall, Man lost these characteristics, and from the corruption of their original nature other temperaments derived. However, when the human properties reach a certain state of equilibrium (albeit not total equilibrium as in Adam), then the sanguine temperament prevails.[46] In the final analysis, these somewhat contradictory indications signify that the sanguine nature is man's own original temperament. In fact, according to William, there

14. The Four Temperaments, manuscript of Gallus Kemli, 15th century, Ms. C. 101, fol. 25v, Zurich, Zentralbibliothek

are no animals that have a sanguine temperament. All animals are melancholy, choleric, or phlegmatic.[47]

During the course of the Middle Ages the system of four of remote Hippocratic descent was frequently expressed in the form of illustrations, probably from lost ancient prototypes. The images are fascinating, and they give us a direct sense of this ancient syncretism. They were normally compiled using circles, in which the circumference was divided into four sections, each one associated with a different correspondence between the elements, properties, temperaments, etc., which might vary from one instance to another.[48] In fact, it was precisely the medieval period that saw a further multiplication of the correspondences, so that these could now include the winds, the cardinal points, the planets, and the signs of the zodiac.[49] Thus, blood was associated with the south, the Spring signs of Aries, Taurus, and Gemini, south winds such as the "Auster" and the planet Jupiter.[50]

With regard to the iconographic characteristics of the sanguine temperament too, medieval miniatures and Renaissance prints testify in various ways to the benign nature of this particular humor. It was usually represented either as corresponding to youth (in the case of individual figures), e.g., a man in good health, or else in terms of its virtues, such as generosity (see Fig. 3). Alternatively, in the case of scenes containing more than one figure, the sanguine temperament was illustrated in the form of a pair of lovers.[51]

Another important feature that medieval and modern culture inherited from the ancient world was bloodletting. The treatment actually goes back to mythological times, as it is said to have been discovered by Podalirius, the son of Aesculapius. Bloodletting was a widespread practice in ancient times. From the Hippocratic doctrines onward it was believed to serve to eliminate harmful humors from the blood, and Galen came to recommend it most strongly.[52] In fact, it was precisely due to the importance Galen attached to phlebotomy that, during the Middle Ages and the Renaissance, it became transformed into a kind of panacea for all illnesses.

The practice of bloodletting was also strongly linked to the relationship between microcosm and macrocosm. The doctors of the ancient world always had to bear in mind that the human body was composed of four elements, and that the temperaments derived from the predominance of one of these. They also had to remember that the "the entire human constitution depends on the celestial spheres, through a relationship of necessity or one of sympathy. In particular, the zodiacal belt governs man's external anatomy, whilst the planets rule the gut and internal organs."[53] Therefore, many of the doctors of Antiquity and of the Middle Ages also needed to be astrologers, or rather iatromathematicians.[54] In other words, they had to be able to combine astronomic prediction with the art of medicine. It was not only in the case of phlebotomy that medicine took into account the relationship between man and the universe, but in all types of treatments and cures.

Doctors needed to know the right moment to practice bloodletting. They also had to know which veins were appropriate for curing certain illnesses. In order to achieve both these things, they had to take into account the influence of the signs and the planets on the different parts of the human body, and astrology was used, above all, to determine suitable times for carrying out phlebotomy operations. Whether to let blood from one part of the body or from another de-

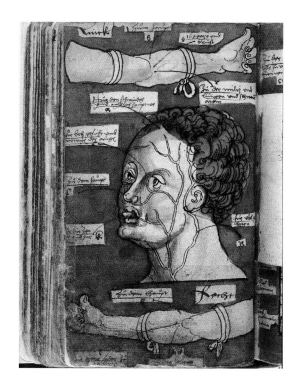

15. *Arzneibuch* **(Book of Medical Remedies), Germany, 1524, WMS 93, London, The Wellcome Institute, Western Manuscripts Collection**

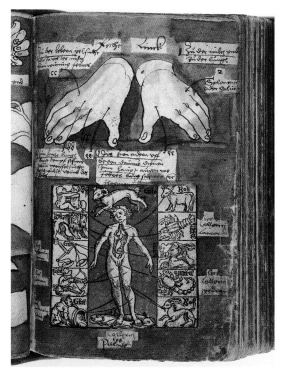

16. *Arzneibuch* **(Book of Medical Remedies), Germany, 1524, WMS 93, London, The Wellcome Institute, Western Manuscripts Collection**

pended on the month, and therefore on the corresponding sign. Thus, in the month of Aries it was the head, in the month of Taurus the neck, and so on, until you came to Pisces, which corresponded to the feet. Another crucial element in bloodletting was the position of the moon, the underlying principle being that the influence of the moon on earth's tides was automatically reflected in the flow of humors within the body. In fact, in many medieval calendars and in the principal fifteenth-century medical texts, so-called lunar almanacs were supplied, and these informed doctors of the propitious moments for carrying out phlebotomy.[55]

Finally, from an iconographic point of view, it is important to note how all this is reflected, in a fascinating way, in certain medieval medical illustrations, which highlight the principal veins normally used for bloodletting (see Figs. 6 and 8). What these amount to are anatomical images, in which lines running through the human body and directed towards the exterior indicate the letting of blood. The lines are marked with the names of the veins, and this information is often accompanied by descriptions of illnesses in which bloodletting at that particular point might prove beneficial. In many cases these bodies are also depicted with the chest and thorax opened up so as to give a view of the internal organs. In turn, the latter, along with all the other parts of the body, are related to the signs of the zodiac that govern them, hence Aries/head, Taurus/neck, Gemini/arms and shoulders, Cancer/chest and stomach, Leo/ribs and heart, Virgo/intestines, Libra/buttocks and hips, Scorpio/genitals, Sagittarius/groins and thighs, Capricorn/knees, Aquarius/shins and Pisces/feet. Thus, the "bloodletting man" relates to the "man of the signs of the zodiac" (Fig. 16). Among other things, the latter fulfilled a function that was extremely important to medieval medicine: not only did the signs have an astrological influence on bloodletting and on medical practices in general, they also served to indicate the right moment to use purgatives and laxatives.[56] According to the eminent medical historian Karl Südhoff, what we have are two different types of anatomical illustration, both deriving from Hellenistic prototypes, of which the "bloodletting man" is probably the most ancient.[57] The illustrations in question became fused into one didactic image for the purposes of medieval manuscripts, which then became widely distributed thanks to the invention of the printing press.

It was precisely on account of their didactic function that images such as the bloodletting man and the man of the signs of the zodiac were often included in printed form in the so-called bloodletting calendars that were popular mainly in Germany in the last three decades of the fifteenth century. The latter were veritable handbooks containing all the necessary instructions for practising phlebotomy throughout the year, which demonstrates how the relationships between the microcosm and the macroscosm which connected the seasons, the lunar phases and the positions of the planets and signs of the zodiac were all part of the everyday heritage of medieval and Renaissance life.

Galen's theories—and particularly his enthusiasm for bloodletting—were to continue to exert an enormous influence throughout the Middle Ages and later. However, it was particularly during the Renaissance that the legacy of Classical Antiquity, transmuted and refracted through the lens of the intervening centuries, would come to mingle with Christian beliefs about the multifaceted significance of blood.

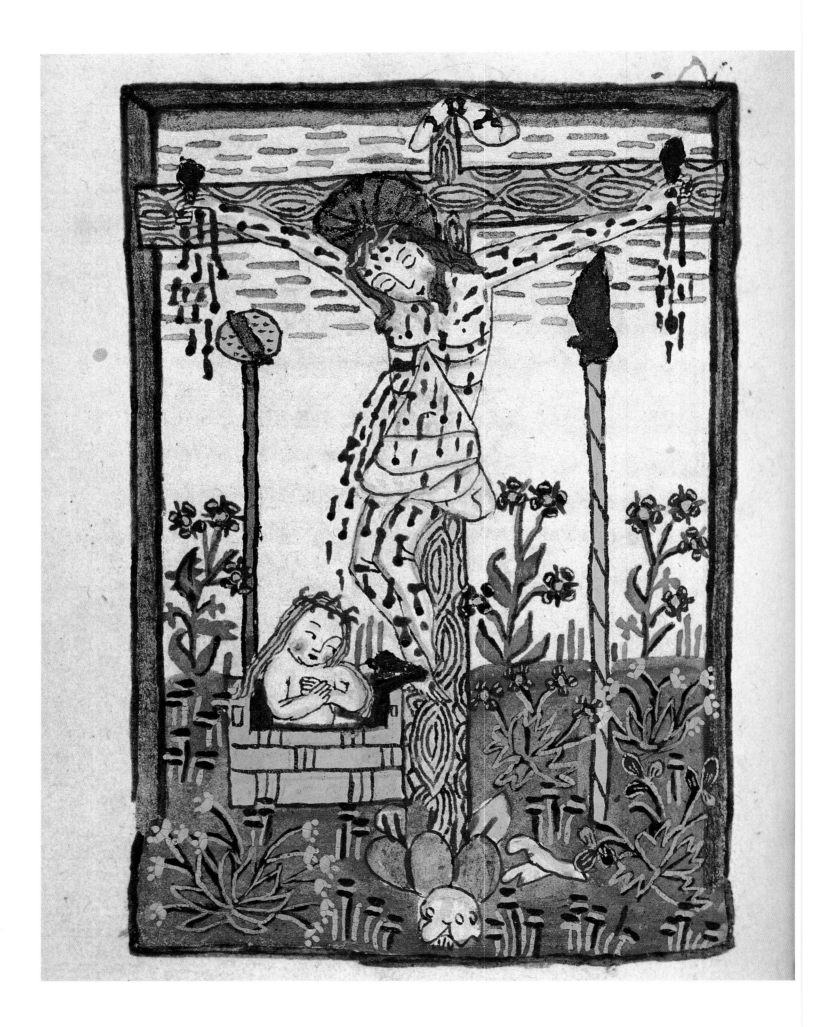

There is a fountain filled with blood
Drawn from Immanuel's veins;
And sinners, plunged beneath that flood,
Lose all their guilty stains.

William Cowper

When sung in a context devoid of visual representation, the words of the eighteenth-century English poet and hymn-writer William Cowper—graphic though they seem—entail a certain abstraction, without implication of physical reality, suggesting a purely metaphorical and symbolic interpretation. Singers, listeners, and readers are, of course, free to visualize themselves (mentally) plunging into Cowper's "fountain filled with blood," which might be unsettling for those not accustomed to this kind of devotional language, but such a visualization can become almost shocking when it is rendered, for example, on the page of an early sixteenth-century prayer book from Strasbourg (Fig. 1).[1] How are we to understand such images? What was their purpose?

At the last session of the Council of Trent, in December 1563, the council confirmed the use of religious images that the Church had advocated and practiced for a millennium:

> [L]et the bishops diligently teach that by means of the stories of the mysteries of our redemption portrayed in paintings and other representations the people are instructed and confirmed in the articles of faith, which ought to be borne in mind and constantly reflected upon; also that great profit is derived from all holy images, not only because the people are thereby reminded of the benefits and gifts bestowed on them by Christ, but also because through the saints the miracles of God and salutary examples are set before the eyes of the faithful, so that they may give God thanks for those things, may fashion their own life and conduct in imitation of the saints and be moved to adore and love God and cultivate piety.[2]

A Fountain Filled with Blood: Representations of Christ's blood from the Middle Ages to the eighteenth century
James Clifton

1. *Crucified Christ with Female Figure Bathing in His Blood*, Strasbourg, early 16th century, illuminated manuscript, Inv. Ms. St. Peter, pap. 4, fol. 30v, Karlsruhe, Badische Landesbibliothek

Images are thus to provide instruction in doctrine, guidance in conduct, and stimulation to piety.

The inscription at the top of the frame of a German panel painting of 1503 (Fig. 2) explicitly exhorts the viewer to engage in the suffering Christ directly, implicating him or her in the meaning and function of the work: "Man, look at me; see what I have done for you." Kneeling around the Trinity of God the Father, the Dove of the Holy Spirit, and the God-man Jesus Christ are Premonstratensian nuns. Banderoles articulate their thoughts: "Lord have mercy on us" and "Lord have mercy on me." As in several of the works illustrated here, secondary figures offer us simultaneously a model for viewing and a model for prayer. The importance of visual imagery in devotions from the late Middle Ages through the eighteenth century is manifest in the plenitude of images which concretize a trend in devotional literature exhorting the devotee to imagine himself or herself as present at the great events of sacred history. Thus, in the context of the Crucifixion, Ludolf of Saxony's *Vita Christi* urges the reader to "look at the

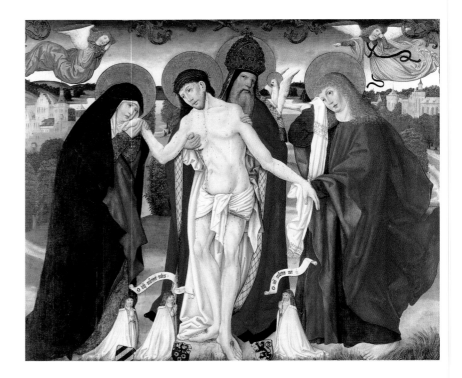

evildoers everywhere striving villainously. Observe what they do to your Lord, what is said, and what happens by and through Him. Vividly imagine yourself present."[3] Similarly, the popular *Meditations on the Life of Christ* by Pseudo-Bonaventure includes numerous injunctions like: "observe everything well," "you must learn all the things said and done as though you were present," and "you go with them."[4] The author calls the reader to witness Christ's terrible beating:

> The Lord is therefore stripped and bound to a column and scourged
> in various ways. He stands naked before them all, in youthful grace
> and shamefacedness, beautiful in form above the sons of men,
> and sustains the harsh and grievous scourges on His innocent,
> tender, pure, and lovely flesh. The Flower of all flesh and of all
> human nature is covered with bruises and cuts. The royal blood
> flows all about, from all parts of His body. Again and again, re-
> peatedly, closer and closer, it is done, bruise upon bruise, and
> cut upon cut, until not only the torturers but also the spectators
> are tired; then He is ordered untied. Here, then, consider Him
> diligently for a long time; and if you do not feel compassion at
> this point, you may count yours a heart of stone.[5]

Devotional writers (and, with them, visual artists) increasingly dwelt on Christ's suffering, interpolating details into the laconic scriptural accounts, relying on non-canonical texts, other devotional writings and visions, prophetic scripture understood to refer to Christ, and even contemporary experience.[6] Critical to the forlorn, abused, even ugly figure of Christ that appealed so directly to the viewer's empathy were passages in the Hebrew Bible, especially Isaiah 1:6: "From the sole of the foot unto the top of the head, there is no soundness therein: wounds and bruises and swelling sores"; and Isaiah 53:2–5:

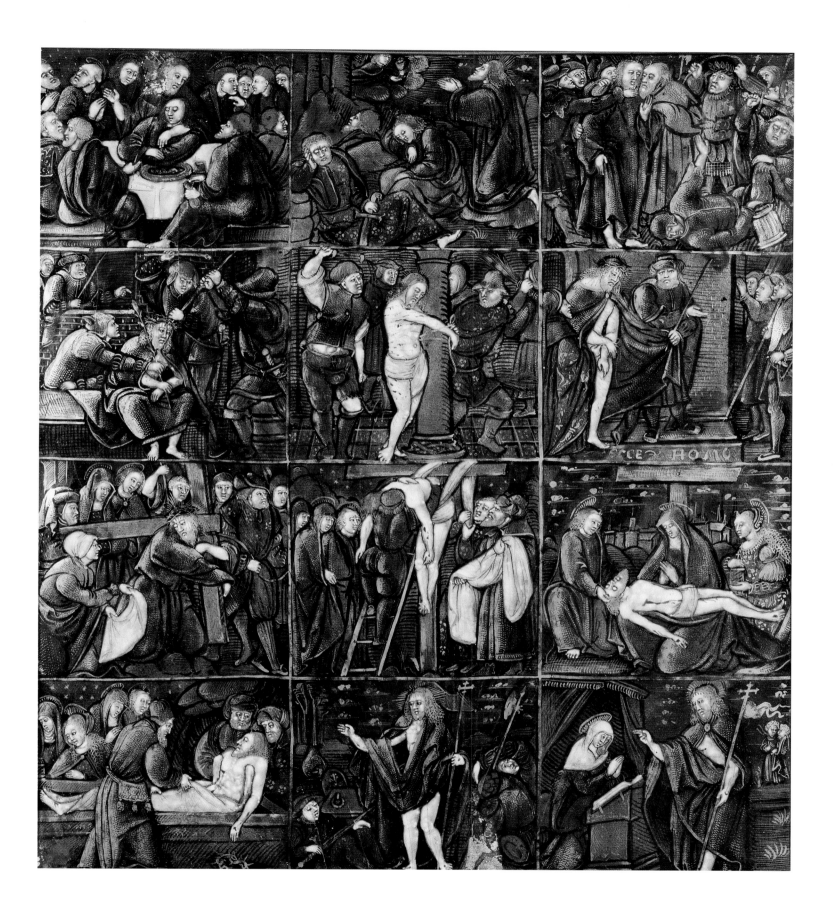

**3. Jean I or Nardon Penicaud, *The Passion of Christ*,
Limoges, ca. 1520–1540, enamel on copper, Frankfurt
am Main, mak.frankfurt**

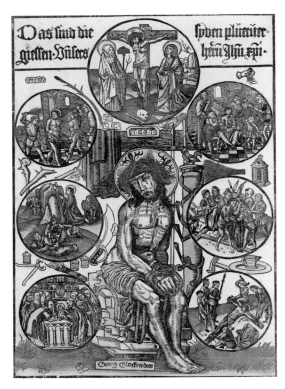

4. Georg Glockendon the Elder (active 1484–1514), *The Seven Bleedings of Christ*, late 15th century, woodcut, Munich, Staatliche Graphische Sammlung

5. *Fides baptismus*, Stavelot, ca. 1150, copper, gilt, gold plated, champlevé, Frankfurt am Main, mak.frankfurt

There is no beauty in him, nor comeliness: and we have seen him, and there was no sightliness, that we should be desirous of him: Despised, and the most abject of men, a man of sorrows, and acquainted with infirmity: and his look was as it were hidden and despised, whereupon we esteemed him not. Surely he hath borne our infirmities and carried our sorrows: and we have thought him as it were a leper, and as one struck by God and afflicted. But he was wounded for our iniquities, he was bruised for our sins: the chastisement of our peace was upon him, and by his bruises we are healed.

It is a type of Christ almost universally met in representations of the shedding of his blood.

The circumstances under which Christ's blood has been represented vary in both specific subject matter and function of image, but they might reasonably be divided into three categories: narrative, symbolic, and devotional, to each of which a section of this essay is devoted (with a fourth section addressing the representation of Christ's blood in the Protestant Reformation). It must be stressed, however, that there are no distinct boundaries between these categories, that they overlap considerably, and that any given image could have quite different significance to different viewers.[7]

Narrative blood: Telling the Passion of Christ

Today [the Feast of the Circumcision] marks the first time he shed his blood for us, as he was to do five times in all. The first was the circumcision, and this was the beginning of our redemption. The second was when he prayed in the garden, and this showed his desire for our redemption. The third, the scourging, merited our redemption, because by his bruises we are healed. The fourth was his crucifixion, and this was the price of our redemption, since he made payment for what he had not taken away. The fifth was when the soldier opened his side with a spear, and this was the sacrament of our redemption, for blood and water issued forth: this prefigured our cleansing by the water of baptism, because that sacrament has its efficacy from the blood of Christ.

Jacobus de Voragine [8]

Jacobus de Voragine, the thirteenth-century Dominican, author of the monumental and enormously influential compendium of saints' lives known as *The Golden Legend*, organized his material into carefully numbered lists, among which were the five sheddings of Christ's blood. With the exception of the Circumcision, the subjects were, of course, drawn from Christ's Passion and Crucifixion, which, with post-Crucifixion subjects up to the Ascension, comprised the great majority of narrative images of Christ. A sixteenth-century enamel from Limoges consists of twelve scenes, from the Last Supper to Christ Appearing to Mary after the Resurrection (Fig. 3), whereas, for example, Albrecht Dürer's very popular series of woodcuts from 1511, known as *The Small Passion*, contains well over thirty.

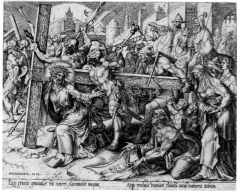

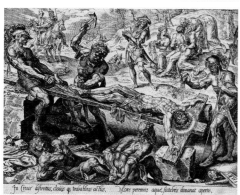

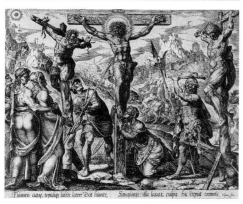

6. Herman Jansz. Muller (1540–1617) (after Maarten van Heemskerck [1498–1574]), from *The Seven Bleedings of Christ: The Circumcision, Christ Bearing the Cross, Christ Nailed to the Cross, Longinus Piercing Christ's Side with a Lance*, 1565, engravings, Leyden, Prentenkabinet, University of Leyden. Photo: University of Leyden

7. Luis de Morales (ca. 1520–1586), *Ecce Homo*, second half of 16th century, oil on panel, private collection. Courtesy of Rob Smeets, Milan

The Golden Legend's list notwithstanding, the number of Christ's bleedings was generally put at seven, but there was some variation in the subjects chosen. A colored woodcut from the first half of the fifteenth century depicts the seven bleedings in roundels surrounding a central figure of Christ bound, whose bloodied body is a distillation of the narrative scenes (Fig. 4). Clockwise from the lower left, they depict: the circumcision, the agony in the garden, the flagellation, the crucifixion (displaced from chronological order to give it due compositional prominence), the crowning with thorns, the disrobing of Christ (which reopened the wounds of the flagellation), and the nailing to the cross.[9] Over half a century after the rather humble devotional woodcut was made, the seven bleedings were the subject of a series of sophisticated engravings by Herman Jansz. Muller after the Dutch humanist artist Maarten van Heemskerck: *The Circumcision*; *The Agony in the Garden*; *The Flagellation*; *The Crowning with Thorns*; *Christ Bearing the Cross*; *Christ Nailed to the Cross*; and *Longinus Piercing Christ's Side with a Lance* (Fig. 6). For Heemskerck, it is Christ falling under the heavy burden of the cross that reopens his wounds, as the inscription below that image explains. But beyond the fact that the works are not colored, Christ's blood is not emphasized in any of them, and in some cases is not evident

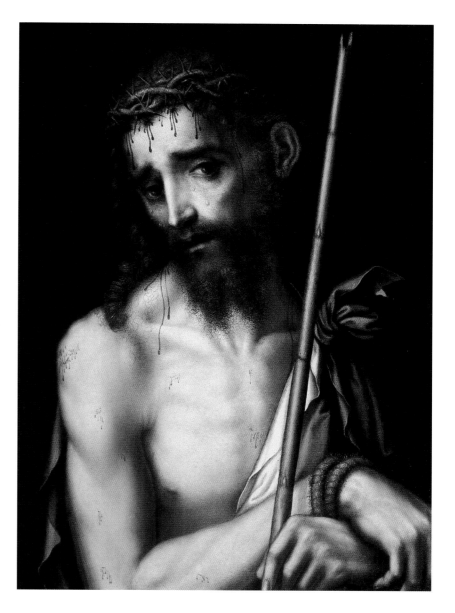

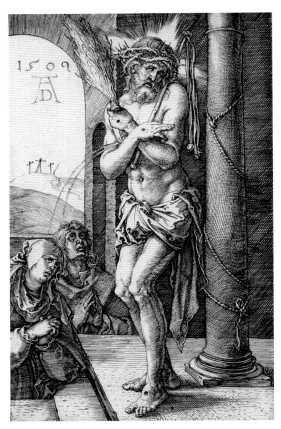

8. Albrecht Dürer (1471–1528), *Man of Sorrows*, 1509, engraving, Karlsruhe, Staatliche Kunsthalle

at all. Rather, the viewer's engagement with the subject of the bleedings is more intellectual than emotional.

Scenes from Christ's Passion were often shown in isolation, for liturgical or devotional purposes, most frequently, but by no means exclusively, the Crucifixion. An *Ecce Homo* by the sixteenth-century Spaniard Luis de Morales exemplifies the way in which a narrative subject—Pilate presenting Christ to the people—might be denuded of its context for devotional contemplation (Fig. 7). The bound hands, the reed "scepter," the mock royal cloak, and the crown of thorns are enough to remind viewers of the narrative context, so that we become the crowd calling for his crucifixion. At the same time, Christ's direct gaze and the closely cropped composition make each viewer feel alone with him, individually responsible for his torment.

Non-narrative or symbolic images of the bleeding Christ are derived from, or assimilated to, conventions of representing the narrative episodes. The most widespread of such figures is the Man of Sorrows, the *vir dolorum* of Isaiah 53.[10] It is an intentionally ahistorical subject: Christ usually wears the crown of thorns and displays the wounds suffered in his Passion, including the post-mortem lance wound; and he is somehow alive but not risen from the dead, lacking the glorious body of the Resurrection. In its origins, the Man of Sorrows type derives from images of Christ dead on the cross but came to conform more to an *Ecce Homo* type, rendered in non-narrative terms, as in Albrecht Dürer's image accompanying—and summarizing—Christ's suffering in his engraved suite of Passion episodes (Fig. 8).

Symbolic blood: Eucharist, sacrifice, redemption

By His Passion He inaugurated the Rites of the Christian Religion by offering "Himself—an oblation and a sacrifice to God" (Ephesians 5:2). Wherefore it is manifest that the sacraments of the Church derive their power especially from Christ's Passion, the virtue of which is in a manner united to

9. Juan Patricio Morlete Ruiz (1713–1772), *Christ Consoled by Angels*, ca. 1760, oil on copper, Mexico, Pinacoteca Virreinal, Instituto Nacional de Bellas Artes

10. Giovanni Bellini (1431/36?–1516), *The Blood of the Redeemer*, 1465, tempera on panel, London, National Gallery. Photo: National Gallery, London

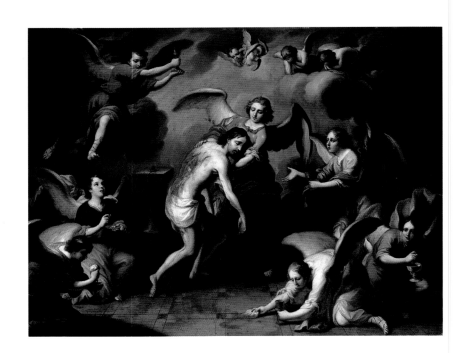

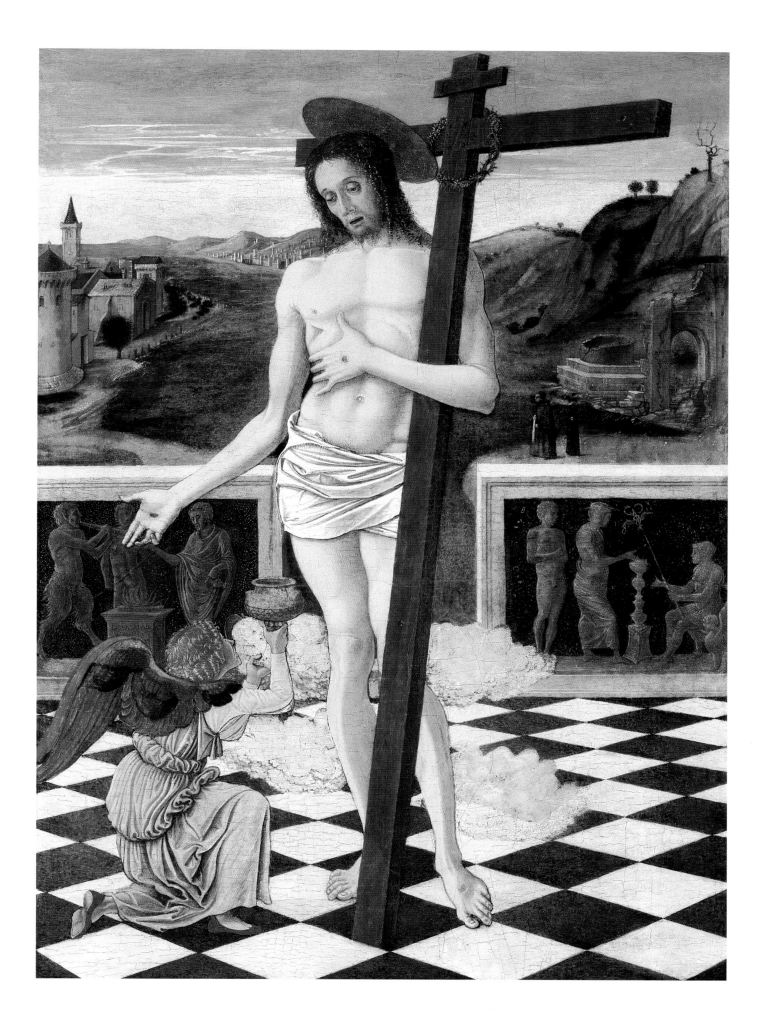

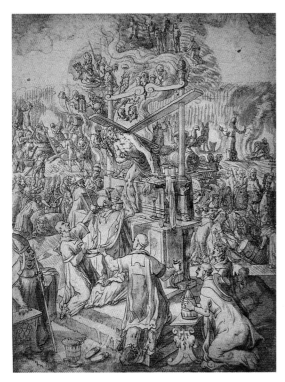

11. Pieter Aertsen (1507/8–1575), *Mass of Saint Gregory,* **drawing, Utrecht, Museum Catharijneconvent. Photo: Museum Catharijneconvent, Utrecht, Ruben de Heer**

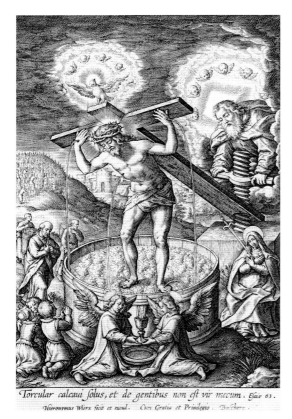

Torcular calcaui solus, et de gentibus non est vir mecum. Esaie 63.
Hieronymus Wierx fecit et excud. Cum Gratia et Priuilegio. Boetherr.

12. Hieronymus Wierix (1553–1619), *Christ in the Winepress,* **second half of 16th century, engraving, Brussels, Bibliothèque Royale de Belgique**

us by our receiving the sacraments. It was in sign of this that from the side of Christ hanging on the Cross there flowed water and blood, the former of which belongs to Baptism, the latter to the Eucharist, which are the principal sacraments.

Saint Thomas Aquinas[11]

Needless to say, descriptions and representations of Christ's Passion readily transcend simple narrative significance. Whenever Christ's blood spurts or streams onto or into anything, even within the context of a narrative, it is departing from narrative to convey symbolic meaning. In scenes of the Crucifixion, angels often catch Christ's blood in chalices, signifying the direct connection between that blood and the wine of the Eucharist. The angels in Claude Mellan's virtuoso engraving *Christ Led Away by the Soldiers,* from 1659, stoop to sop up Christ's blood that has fallen on the ground. In a remarkable painting by the Mexican Juan Patricio Morlete Ruiz, *Christ Consoled by Angels,* of a century later, while some angels preserve the blood in chalices, another picks up pieces of Christ's torn flesh and places them on a paten as his eucharistic body (Fig. 9).

When Christ's side was pierced by the centurion after his death on the cross, according to the Gospel of John 19:34, "immediately there came out blood and water." This dual stream was taken to be the source or signifier of not only the two major sacraments of the Eucharist and Baptism, as suggested by Thomas Aquinas in the passage quoted above, but of all seven sacraments, evident in a woodcut from around 1510 by Wolf Traut. Roundels in the four corners contain Old Testament prefigurations of the Eucharist, and Moses and John the Baptist point toward a central scene of Pope Gregory the Great raising a host in consecration. From the side wound of the Man of Sorrows appearing on the altar six lines reach to little scenes of the other sacraments: baptism, confirmation, penance, ordination, matrimony, and extreme unction.

Confirming a direct connection between Christ's body and the Eucharist, images in which his blood is caught in chalices are common both north and south of the Alps, as in Giovanni Bellini's well-known painting in London (Fig. 10). There is a direct association between the cup held to the bleeding Christ by an angel (or, alternatively, by a figure of Ecclesia, or simply positioned on an altar or the ground) and those that are used in the Mass.[12] Although the original context of Bellini's small panel is unclear,[13] the iconography of a Man of Sorrows as a standing figure, holding a cross by his side, commonly appeared in central Italy (known there as Christ of the Passion) on the bronze doors of tabernacles (where consecrated hosts are kept).[14]

Also eucharistic is one of the most striking subjects in late medieval art: the figure of Christ in the Winepress, based on Isaiah 63:3: "I have trodden the winepress alone, and of the Gentiles there is not a man with me: I have trampled on them in my indignation, and have trodden them down in my wrath, and their blood is sprinkled upon my garments, and I have stained all my apparel." From the late fourteenth century Christ was shown as thorn-crowned and bleeding, squeezed within the press, the beam of which was sometimes represented as a cross. The eucharistic connotations are evident in a woodcut from Nuremberg around 1435–50, as Christ's blood flows through a channel into a chalice.[15] Sometimes it is God the Father who turns the screw of the press, here as in a

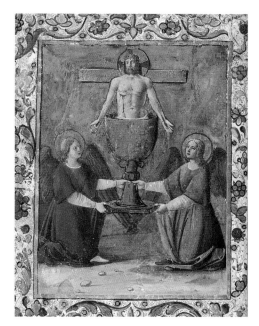

13. *Christ in a Chalice Held by Angels*, Register of the Scuola del Corpo di Cristo, Venice, 15th century, illuminated manuscript, London, British Library

14. Jean Bellegambe (ca. 1470–1535/36), *The Mystic Bath of Souls*, ca. 1525, triptych, oil on panel, Lille, Musée des Beaux-Arts. Photo: RMN, R.G. Ojeda, Paris

painting from Albrecht Dürer's workshop of ca. 1505–10 and a work from the Antwerp engraver Hieronymus Wierix of around a century later (Fig. 12), making explicit the Father's sacrifice of his Son. In the Dürer workshop painting, a papal figure catches in his chalice not blood but hosts, suggesting the doctrine of concomitance, that is, that both the body and the blood are present in each of the species of communion, the bread and the wine.

The unity of body and blood is also made explicit in a small panel painting from the late fifteenth century by a lower Rhenish artist (Fig. 8, p. 93). A thorn-crowned Christ stands above a basin of blood, opening his side wound with his left hand in a conventional *ostentatio vulnerum* gesture. Both blood and hosts spring from his side.[16] The symbolic unity is also implied when Christ, usually as a Man of Sorrows, is represented in a chalice,[17] a subject particularly common in Renaissance Venice, where it was employed for the many confraternities devoted to the Sacrament, as in a fifteenth-century manuscript register of the Scuola del Corpo di Cristo (Fig. 13).[18]

The doctrine of Christ's Real Presence in the Eucharist was also given visual form in a subject of great popularity, especially in Northern Europe, in the late Middle Ages: the Mass of Saint Gregory (Fig. 11; Fig. 6, p. 92; Fig. 9, p. 94), in which a Man of Sorrows appears at the altar, his blood sometimes streaming directly into the chalice, as Pope Gregory the Great (d. 604) consecrates the bread and wine.[19] Literary sources for the legend are obscure, and images of the Mass of Saint Gregory do not seem to depict a clear or specific

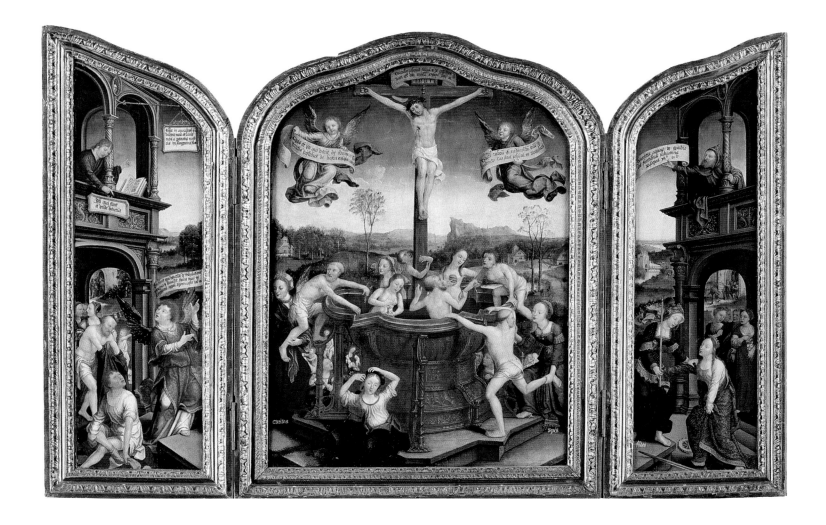

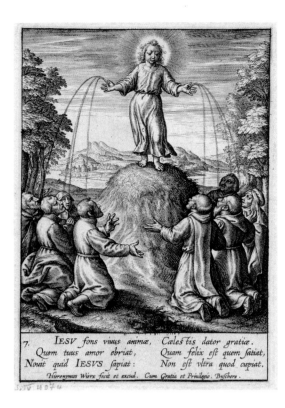

15. Hieronymus Wierix (1553–1619), *The Christ Child Spouting Blood (Fons Pietatis)*, engraving, Brussels, Bibliothèque Royale de Belgique

narrative, serving instead as a general representation of a miraculous epiphany meant to confirm the doctrine of transubstantiation—that Christ is truly present in the bread and wine of the Mass.

Christ's blood often pours into a basin, known as the *Fons Pietatis*, *Fons Vitae*, or *Fons Misericordiae*.[20] The *Fons Pietatis* may have eucharistic associations, but it is concerned primarily with salvation. In one of the painted windows of the Jakobskirche in Rothenburg ob der Tauber,[21] Christ hangs on the cross set in a fountain within an elaborate ecclesiastical setting. Blood from his right hand falls into a chalice held aloft by a priest at an altar, while the stream from his left hand falls to a baptismal font—a slight variation on the iconography of the blood and water from his side as the source of the two major sacraments. Below Christ, naked figures—human souls—with hands folded in prayer, look up to his flowing blood. The inscription on the fountain reads: "Wash us in your blood" ("Lavabi nos in sanguine tuo"). To the blood streaming from Christ's side an angel holds up a blessed soul rather than the eucharistic cup. In a triptych attributed to Jean Bellegambe, which was painted around 1525 for the abbey of Anchin near Douai (Fig. 14),[22] seminude figures —both tonsured males and females—bathe together in the fountain, although "frolic" might be a more apt description. The three inscriptions above the cross come from Isaiah 63 and refer to the mystical winepress, although a straightforward crucifixion is depicted. The power of the blood to bring salvation is alluded to in three of the inscriptions. At the top of the left wing, for example, appears Revelation 1:5: "He loves us and freed us from our sins by his blood."[23]

That Christ's blood can heal both body and soul is represented in an unusual engraving, labeled "Miracula Christi," by Hendrick Goltzius, in which Christ is named the "Medicus" of Matthew 12, a Gospel chapter that tells of his healing of a man with a withered hand, a blind and mute man, and many others who followed him. Vignettes along the sides and top include the raising of Lazarus and the woman healed of the issue of blood. A line accompanying the stream of blood from Christ's side comes from Isaiah 53:5: "by his bruises we are healed." Christ raises—like a urine sample held up to the light for diagnosis— a human heart. It is a heart polluted by sin, represented by beasts, and the sickly soul—the "Anima morbida"—his weak arm supported by Faith, barely manages to lift a cup to catch Christ's healing blood.

As the use of allegorical imagery waned in European painting in the later sixteenth and seventeenth centuries, it continued to proliferate in prints, such as those produced by the Wierixes in Antwerp, which were often used by missionaries worldwide. Perhaps because of the influx of such imagery and the emphasis on doctrine in missionary work, religious allegories, including those concerned with Christ's blood, flourished in all media in Spanish America. In a late seventeenth-century Mexican painting, a vine grows from the wound in the side of Christ's blood-spattered body (Fig. 16). In self-sacrifice Christ squeezes a bunch of grapes—taking a more active role than he does in winepress imagery—onto a platter held by a pope. Surrounding the vat of Christ's blood are sheep representing souls, as in the pastoral imagery of the Divine Shepherd common in New Spain. The blue globe on which Christ balances precariously—deriving from the sphere he often holds in his hand as Salvator Mundi—reappears in a gigantic canvas by Miguel Cabrera. As the Virgin Mary and Saint Joseph intercede with Christ on behalf of pleading souls, his blood

16. Juan Correa (ca. 1646–1716), *Allegory of the Eucharist*, ca. 1690, oil on canvas, Denver, Mayer Collection

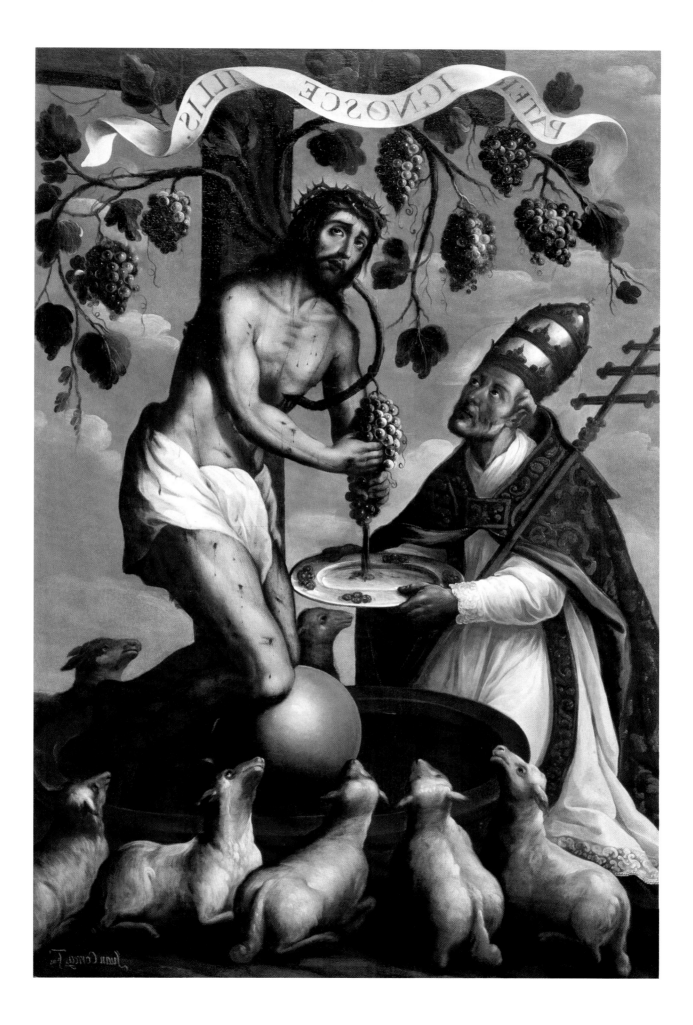

Christ's blood from the Middle Ages to the eighteenth century

17. Matthias Zündt (d. 1572), *The Ship of Christian Faith*, 1570, etching, Williamstown, Mass., Sterling and Francine Clark Art Institute

streams to more awaiting figures below, not in a *Fons Pietatis*, but in the fires of Purgatory. On a banderole held by angels at his feet, a line from Psalm 129 attests to the bounty of his saving grace: "with him plentiful redemption."

Reformed blood: The role of blood in the Protestant Reformation

> Let us seek the sprinkling of the spirit and the inward washing which Peter (I Peter 1:2) calls "sprinkling with Christ's blood," by which all of us who hear and believe the Gospel of Christ are cleansed. The mouth of a man who teaches the Gospel is the hyssop and the sprinkler by which the teaching of the Gospel, colored and sealed with the blood of Christ, is sprinkled upon the church.
>
> *Martin Luther*[24]

The Reformation of the sixteenth century had a substantial effect on the production, function, and iconography of religious images, although this effect varied considerably from one Protestant movement to another. Within those movements that did not reject imagery altogether, there is a persistence of conventional iconography, though sometimes altered slightly to suit a new theology. It is often difficult to identify the confessional affiliation of an image, both because Catholics and Reformers still shared fundamental theological concepts and because artists were eager to appeal to as wide a market as possible. The motif of the *Fons Pietatis*, for example, appeared fairly frequently in Protestant as well as Catholic contexts, especially on epitaphs.[25] A polychrome stone epitaph from 1547, complicated somewhat by the inclusion of Adam, Eve, and the serpent, is identifiable as Protestant only by the fact that it was placed in the Protestant Domkirche at Bremen, rather than by any distinguishing iconographic features.

Although Martin Luther accepted the Real Presence of Christ in the Eucharist, he rejected transubstantiation, and Lutheran images avoid the direct flow of Christ's blood into the cup. In a large etching of *The Apostle Ship* (*The Ship of Christian Faith*) by the Nuremberg artist Matthias Zündt (Fig. 17), blood

18. Lucas Cranach the Elder (1472–1553), *Allegory of Law and Grace*, ca. 1529, pen and ink, Frankfurt am Main, Städelsches Kunstinstitut. Photo: Ursula Edelmann, Frankfurt am Main

19. Lucas Cranach the Elder (1472–1553), *Allegory of Damnation and Salvation*, 1529, oil on panel, Gotha, Staatliches Museum. Photo: Bildarchiv Foto Marburg

from a Man of Sorrows (functioning as the mast of the ship) streams to the two Lutheran sacraments: Baptism at the left and Communion at the right.[26] Christ's blood descends on the head of the minister offering communion of the cup, sanctioning his action, but it does not enter the cup directly, thereby resisting the equation of blood and consecrated wine. Zündt's etching is not stridently anti-Catholic: the enemies of the Church in the water—among them Nero, Pilate, Nestorius, Pelagius, Arius, Mahomet, Attila, the Turk—do not include, as much confessionally polemic imagery would, the Catholic Church.[27] More polemical is a composition from the Lucas Cranach workshop of Luther and John Huss giving communion to members of the princely house of Saxony before a copiously bleeding crucified Christ in a fountain on the altar (Fig. 20). The doctrine of concomitance—which stipulates that both the flesh and the blood are wholly in each of the forms of the Sacrament, the bread and the wine—was established at the Council of Constance in 1415, the same council at which Huss was condemned and burnt at the stake. The Church used the doctrine to withhold the eucharistic cup from the laity, offering only the consecrated bread, a practice decried and rejected by Hussites and sixteenth-century Reformers.

Reformation images of the bleeding Christ were more frequently associated with purification than directly with the Eucharist. The most important of these was a composition from around 1529 by Lucas Cranach the Elder generally

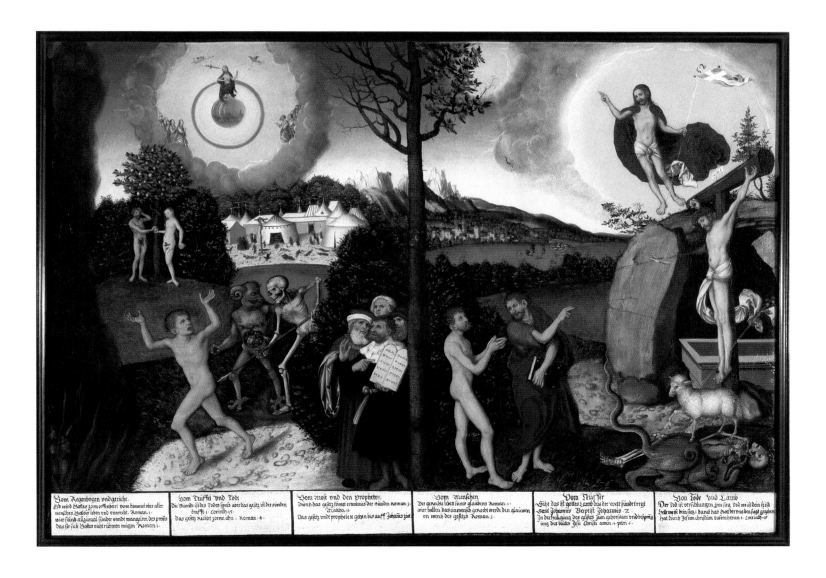

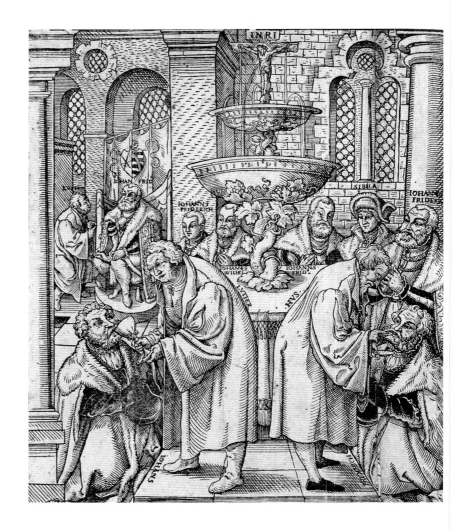

20. School of Cranach, *Luther and John Huss Sharing Communion with the Royal House of Saxony*, 16th century, woodcut, Coburg, Kunstsammlungen der Veste Coburg

known as the *Allegory of Law and Grace*, which was often repeated, in several media and with variations, both in the Cranach workshop and elsewhere (Figs. 18 and 19). It illustrates the Lutheran idea that the Law, addressed in the left half of the images, brings humans to an awareness of their sin and wretchedness, but cannot save them, because humans are incapable of following the Law without Christ; hence the naked figure, who is labeled "Mensch" in one version, is driven into the fires of Hell by Sin and Death. Adam and Eve are pictured in the background, while Christ sits above in judgment. A tree—barren on the left and in leaf on the right—divides the composition symmetrically into two antithetical halves. On the right, Christ—as the Resurrected Lord or as the Lamb of God—is victorious over Sin and Death. John the Baptist points *Mensch* to the crucified Christ, who showers *Mensch* with a stream of saving blood.[28]

The Lutheran meaning of the works has been amply demonstrated— and it is assumed that Luther probably even collaborated with Cranach on the iconography and composition—but it has also been rightly remarked that the individual motifs are traditional and, therefore, not specifically Lutheran in and of themselves. Taken out of context, the motifs are stripped of their Lutheran meaning. Part of that context is provided by the inscriptions accompanying the images. Verbal texts more frequently accompany Protestant artworks than Catholic ones, and those texts are much more frequently drawn directly from the Bible: *sola scriptura* in action, as it were. Luther's own middle-of-the-road approach to images, between idolatry and iconoclasm, called for biblical scenes

accompanied by quotations from Scripture.[29] The biblical inscriptions below the finished versions of the *Allegory of Law and Grace* refer to each of the motifs in the composition. The passage relating to Christ's shower of blood comes from I Peter 1:2, in which the apostle addresses Church leaders in Asia Minor as those "who have been chosen and destined by God the Father and sanctified by the Spirit to be obedient to Jesus Christ and to be sprinkled with his blood." The text had traditionally been understood as a reference to the Trinity, but Cranach includes only the latter part, without mention of God the Father. The text was only infrequently cited prior to Luther, who gives it an idiosyncratic interpretation, suggesting a further Lutheran wrinkle to the meaning of the composition.

In 1529, the year Cranach dated the *Law and Grace* panel in Gotha, Luther established an interpretation for the verse that he would adhere to in sub-sequent writings.[30] In his commentary on Isaiah, he defined the term "sprinkle" as "a Hebraism for 'it will be preached.'" Thus, "Peter speaks of 'sprinkling with His blood' (I Peter 1:2) to denote preaching about the blood of Christ."[31] Luther later referred the passage to preaching in general, rather than preaching specifically about Christ's blood. His commentary on Psalm 51 of 1532, quoted at the beginning of this section, in which he draws a distinction between Old Testament sprinkling and New Testament sprinkling—and thus a distinction between Law and Grace, as in Cranach's works—could almost function as a verbalization of Cranach's motif of the dove of the Holy Spirit riding the stream of Christ's blood to the prayerful *Mensch*. Christ's blood, for Luther, held the power for the remission of sins and eternal life, but its sprinkling—referred to in I Peter 1:2 and in Cranach's composition—is effected "through the ministry of the Word."[32]

The Cranach workshop returned to the motif of Christ's spurting blood, in a very personal way, in the Weimar altarpiece of 1555, now generally attributed to Lucas Cranach the Younger, perhaps completing a design by Cranach the Elder. The central panel consists of a Crucifixion and several other motifs taken from the *Allegory of Law and Grace*, including Christ victorious over Sin and Death, and the Agnus Dei. At the right are posthumous portraits of Martin Luther and Lucas Cranach the Elder. Beside them John the Baptist points to the bleeding Christ, as in the *Allegory of Law and Grace*. Christ's blood spurts in a fine stream —remarkably, here, across his body—splashing onto the head of Cranach, whose hands are folded in prayer like those of *Mensch* in the *Allegory of Law and Grace*. But in this work a different scriptural text is adduced for the blood. At the far right Luther holds a book inscribed with biblical passages open to the viewer. Along with Hebrews 4:16 (on the reception of mercy at the throne of grace) and John 3:14 (comparing Christ's crucifixion to Moses' raising the brazen serpent, which was also an important element in the *Law and Grace* compositions) is I John 1:7: "the blood of Jesus his Son cleanses us from all sin."[33] Given the posthumous portrait of Cranach the Elder, the painting func-tions almost as an epitaph, in which the references to I John 1:7 and Hebrews 4:16, with their reassurances of salvation, would be particularly apt.

The pre-Reformation use of Christ's blood spurting directly on a living human is unusual, and it would seem that the motif, while not invented by Cranach, was made popular in his workshop and established as essentially Protestant.[34] Its use may have long been avoided by Catholic artists because of the passivity of justification that it implied—precisely the point to be made

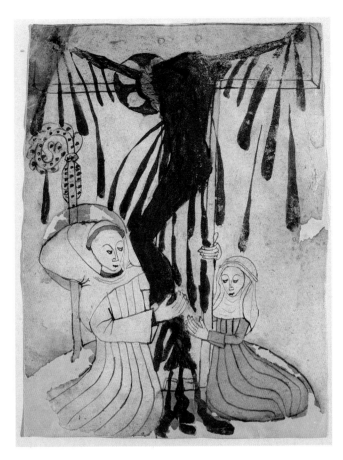

21. *The Vision of Saint Bernard*, 14th century, drawing, Cologne, Schnütgen Museum

by Luther and Cranach—or because the reception of the saving grace is unmediated by the Church.[35] This Lutheran motif (if such we can call it) was, however, ultimately adopted by Catholic artists.

In Hieronymus Wierix's engraving of *Christ on the Cross, Refuge against Miseries*, a soul—or *Mensch*, as it were—embraces serenely the cross at Christ's feet while he is assailed by allegorical figures of the miseries named in Romans 8:35, which are listed in the inscription on the print: "Who then shall separate us from the love of Christ? Shall tribulation? or distress? or famine? or nakedness? or danger? or persecution? or the sword?" The famous answer, of course, is none: "But in all these things we overcome, because of him that hath loved us. For I am sure that neither death, nor life, nor angels, nor principalities, nor powers, nor things present, nor things to come, nor might, nor height, nor depth, nor any other creature, shall be able to separate us from the love of God, which is in Christ Jesus our Lord" (Romans 8:37–39).

This image, like the Cranach compositions, is not eucharistic, but rather soteriological. Christ's love is represented here as the crucified Christ, who himself had suffered all these miseries, and whose side wound pours saving blood on the head of the besieged soul. Although most of the Wierix brothers' religious imagery is identifiably Catholic, often specifically Jesuit, this image itself is not specifically confessional, and thus could be used without alteration a short time later on a Lutheran epitaph.

In an engraving from around 1550 by Dirck Volkertsz. Coornhert after Maarten van Heemskerck—probably of Coornhert's invention—a female figure with a cruciform broom washes hearts in a fountain filled with the blood from Christ's side. The inscription below the image in Latin and French identifies her as Faith, who washes hearts of goodwill. Although Coornhert never broke with the Roman Church, he was most unorthodox as a writer on theology and philosophy, advocating a kind of confessional indifference, and no assumptions can be made about the confessional position of this print. But the instrumental role assumed by Faith in justification suggests a Lutheran meaning—"*sola fides*," the inscription begins. A second version of the print was made in which the potentially offending inscription was removed—allowing now the identification of the woman as Ecclesia—and a passage from I Peter 1:18–19 placed on the rim of the basin: "You know that you were ransomed from the futile ways inherited from your ancestors … with the precious blood of Christ.…" Cited by Ambrose, Augustine, Jerome, and other Church Fathers as often as by the Reformers, the new text would have made the print more palatable to Catholics, and the two versions of the print may well have been produced to satisfy the two separate constituencies.[36] A Catholic variation of the composition in an epitaph from around 1560 incorporates both the *Fons Pietatis* composition (in which the broom has become an anchor labeled with the good works of alms, prayer, and fasting) and Coornhert's companion composition of Faith—perhaps here also recharacterized as Ecclesia—protecting Man from Satan.[37]

I Peter 1:18–19 appears again in another confessionally ambiguous image produced in Coornhert's circle. It is the title inscription on Hendrik Goltzius' *Satisfactio Christi (Christ's Fulfillment)*. The crucified Christ bleeds into a heart-shaped bowl held by Faith, from which the blood pours into a chalice in a scale held by Justice. The balance is tipped heavily in favor of the chalice, although the other end is weighted by the (broken) tablets of the

22. Louis Cousin (ca. 1606–ca. 1667/8), *Saint Catherine of Siena Drinking from the Side Wound of Christ*, ca. 1648, oil on lapis lazuli, private collection. Photo: Courtesy of Christie's

Law. A favoring of Grace over Law, as in the Cranach compositions but realized differently and more succinctly, would seem to suggest a Protestant bias, except that Grace is represented by a chalice filled almost directly with Christ's blood, therefore suggesting the doctrine of transubstantiation. Interestingly, the second state of the engraving, probably produced before 1594 and possibly soon after the first state of 1578, seems to make a concession to Protestant iconoclasm. In this state the face of God the Father has been completely obscured by cross-hatching, a move that would have been neither mandated by nor even desirable in Catholic theology or devotion.

Devotional blood: Meditating on the blood of Christ

> And after this, looking at the body bleeding as severely as it had at the scourging, I saw the following. The fair skin was broken all over the sweet body with very deep cuts into the tender flesh, by sharp blows. The hot blood ran out so abundantly that neither skin nor wound could be seen—as if all the body were blood. But when the blood came to where it should have fallen down from the body, it vanished…. The bleeding was so abundant as I saw it that I thought if it had been actually happening that way in nature and substance at that time, it would have filled the entire bed with blood and spilled over on all sides.
>
> *Juliana of Norwich*[38]

Among the most arcane of allegorical subjects, representing "wounding love," is Christ Crucified by the Virtues, whose most well-known representation is an illumination in a Cistercian Psalter now in Besançon (Fig. 23).[39] As Humilitas

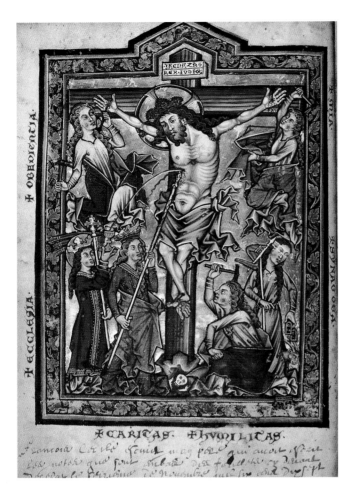

23. *Christ Crucified by the Virtues*, Cistercian Psalter, called "de Bonmont," Upper Rhine (?), second half of 13th century, Ms. 54, fol. 15v, Besançon, Bibliothèque Municipale

and Obedientia drive nails into Christ's hands and feet, Caritas, playing the role of the centurion, pierces his side with a lance, and Ecclesia catches the stream of blood and water in a chalice. What may seem at first glance to be an image operating on the plane of the impersonally intellectual and theological is, in fact, in keeping with Saint Bernard of Clairvaux's affective piety. In Jeffrey Hamburger's words, "The personification of *Caritas* acts out the cry of the bridegroom in Song of Songs 4.9: 'Thou has wounded my heart, my sister, my spouse, with a glance of one of thy eyes.'" And the image also plays a role in what Hamburger has called the "increasingly important role of corporeal imagery in spiritual life" in the later Middle Ages, this in spite of Bernard's famous advocacy of "imageless devotion."[40]

As has been pointed out, even in monastic circles this supposed ideal was not necessarily pursued.[41] The role of corporeal imagery in medieval spiritual life is, in fact, nowhere seen at such an extreme as in a fourteenth-century Rhenish drawing showing a nun—vicariously representing the draftswoman and/or the user of the image—and Saint Bernard embracing a cross on which Christ hangs, covered in blood (Fig. 21).[42] The image represents the desire of the kneeling figures to engage as directly as possible the suffering Christ, and although their attempt may not ultimately be completely successful (they remain curiously unspotted by the excessive flow of blood), it provides both a model and a visual stimulus for devout viewers. Devoid of either historical narrative or allegory, although its scriptural and theological underpinnings would be understood, the image, like innumerable others, manifests the affective piety that bloomed in the late Middle Ages and, in many cultures, continued to flourish in subsequent centuries.

It was through an imitation of the sufferings of Christ and the Virgin Mary, recommended by many devotional texts of the later Middle Ages and following, that one could achieve the most intense spiritual experiences.[43] Thus the immensely popular subject of the Pietà provokes an empathic experience of the immeasurable grief of the mother cradling the body of her dead son.[44] Or an *Agony in the Garden* isolates a copiously bleeding Christ from the sleeping disciples as an "ascetic example" of prayer.[45]

An illumination from a fifteenth-century manuscript of the Life of the Dominican tertiary, Saint Catherine of Siena (1347–1380), by her confessor and biographer, Raymond of Capua, visualizes an extreme of the *imitatio Christi*: flagellating herself, the young Catherine has relived some of Christ's torment, her body rendered as bloodied as his. Catherine was outstanding among medieval religious devoted to the blood of Christ, approaching communion with an extraordinary sense of longing.[46] In her writings, she spoke often of the blood of Christ crucified, of the soul's being inebriated with it, or immersed, bathing, and even drowning in it. Blood was said to flow from her mouth in eucharistic ecstasies. As reward for her selfless tending of a nauseatingly diseased nun, Christ appeared in a vision, offering her his blood. Raymond of Capua described the event:

> And putting his right hand on her virginal neck and drawing her
> towards the wound in His own side, He whispered to her, "Drink,
> daughter, the liquid from my side, and it will fill your soul with
> such sweetness that its wonderful effects will be felt even by the
> body which for my sake you despised." And she, finding herself

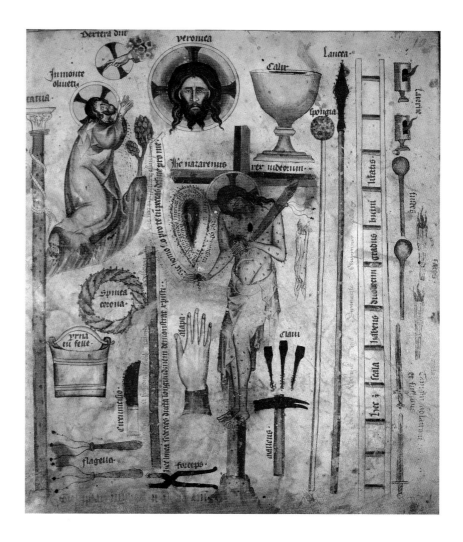

24. *Arma Christi*, Prague, Narodní Galerie.
Photo: © Martin Hruska

thus near to the source of the fountain of life, put the lips of her body, but much more those of the soul, over the most holy wound, and long and eagerly and abundantly drank that indescribable and unfathomable liquid. Finally, at a sign from the Lord, she detached herself from the fountain, sated and yet at the same time still longing for more.[47]

While not every Christian, or even every Dominican tertiary, could expect to be favored as Catherine was, the saint nonetheless could be an important model for devotional aspirations, and representations of her were common. The fifteenth-century manuscript of Raymond's Life of Catherine includes an illustration of the visionary episode, as well as of the self-flagellation. The subject remained popular for centuries; a composition by Francesco Vanni first appeared as an engraving by Pieter de Jode in 1597, was reused for a Life of Saint Catherine published by Philips Galle in Antwerp in 1603, and was the basis for a jewel-like painting on lapis lazuli of around 1648 by Louis Cousin (Fig. 22).[48]

In the late Middle Ages, new devotions that emphasized Christ's torment appeared, and perhaps the most purely devotional figure of Christ of this time is the Man of Sorrows. The terms for the type used most frequently in the late Middle Ages, such as *imago pietatis* and *Pietié de Nostre Seigneur*, suggest both the pity the viewer is to have for the suffering Christ and Christ's pity and sacrifice for the viewer. In conjunction with the Man of Sorrows, artists began to

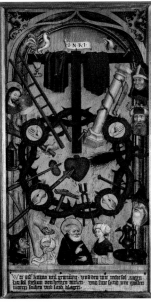

25. *Christ Appearing to Mary and Saint Augustine* (left panel), and the *Arma Christi* (right panel), two panels from the Buxheim Altarpiece, Ulm School, ca. 1510, Ulm, Ulmer Museum. Photo: Stadtarchiv Ulm, W. Adler

represent the so-called weapons—the instruments of the Passion and vignettes of episodes surrounding it, known as the *arma Christi* (Fig. 24)[49]—as well as the five wounds in his hands, feet, and side, all isolated for prayer not only from the narrative of the Crucifixion but even from Christ's own body. On one of the outer panels of the so-called Buxheim Altarpiece from around 1510, the *arma Christi* and the five wounds are tightly composed, some of them interwoven in a giant crown of thorns (Fig. 25). The inscription below the image challenges the viewer to emotional prayer: "He who would win this crown and wear it with right must love Jesus from his heart and bewail his sins with much sighing and sorrow."[50] Some of the instruments of the Passion reappear in another of the outer panels, a complicated image relating to the work of the Dominican mystic Henry Suso.[51] Christ appears as an example of both prayer and suffering in the Garden of Gethsemane in the lower register of the image and again above as a Child in a thorny tree, astride the lance that would pierce his side. The words he speaks—"I will pluck roses and bestow many sorrows on my friends"—connote the suffering of the devotee, to be endured patiently and submissively, as Christ endured his.

The side wound itself was often the focus of devotion. A late example is in a German prayer book from 1608, which claims, with phrasing in use since the late fifteenth century, that the image in it corresponds to the length and breadth of Christ's wound and promises seven years' indulgence for kissing it with remorse, sorrow, and devotion (Fig. 26). The cross within the wound is said to be one-fortieth the length of Christ himself; kissing it will provide protection from sudden death or misfortune.[52] The physical contact with the "actual-size" image of Christ's wound dripping blood recalls Saint Catherine of Siena's vision and is a reminder of the potent intimacy of such devotional art. The wound was both a symbol for the whole of Christ in his humanity and a gateway to his loving heart, itself pierced by the *coup de lance*. The heart could also stand in for the whole Christ or be combined with the sites of his other wounds, the hands and feet, as in two German woodcuts from the second half of the fifteenth century (Fig. 27). Vestiges of the narrative are evident in one of them in the words "Maria" and "Johannes" inscribed on either side of the heart, standing in for the

26. *Christ's Side Wound*, prayer book, Germany, 1608, Frankfurt am Main, mak.frankfurt

figures that would be flanking the cross in a Crucifixion scene. A multiplicity of devotions is available in these images as it is the Christ Child, the object of a cult in its own right, who holds the flail and scourge with which he was beaten as an adult.

The devotion to the Sacred Heart of Jesus arose in the Middle Ages and was extended dramatically in the seventeenth century, stimulated especially by Saint Margaret Mary Alacoque's visions of Christ offering her his heart, locus of both his love and his suffering. The most famous image of the Sacred Heart is undoubtedly the painting by Pompeo Batoni in the Roman Jesuit church of Il Gesù, in which Christ proffers the viewer his flaming heart, crowned with thorns and pierced in the side, and it was the Jesuits who were primarily responsible for spreading the cult globally.[53] In a small Mexican painting on copper of the late eighteenth century, Christ's heart floats alone, again with marks of the Passion, reinforcing the theme of Christ's self-sacrifice as central to this cult of his supreme love (Fig. 28). As in many devotional images, not only is the object of adoration isolated from a narrative context for adoration, but saintly figures are included as models of devotion; here the Jesuits Ignatius of Loyola and Aloysius Gonzaga kneel before the heart, their arms crossed in prayer.

Among the most personal of devotional images, of unprecedented iconography, is a composition by Gian Lorenzo Bernini, known in various versions.[54] A drawing now in Haarlem (Fig. 29), attributed by many to Bernini himself,

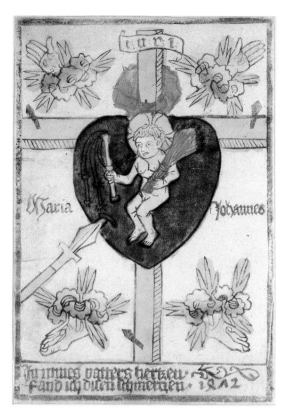

27. *Five Wounds with Child of Suffering in Sacred Heart*, southern Germany, 1472, woodcut, Berlin, Staatliche Museen zu Berlin—Preussischer Kulturbesitz, Kupferstichkabinett. Photo: Jörg P. Anders

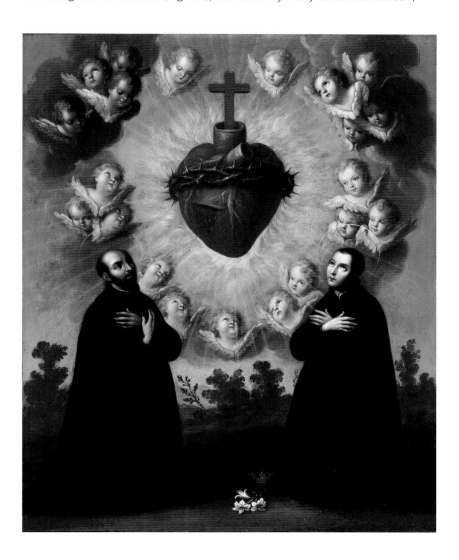

28. José de Páez (ca. 1720–1790), *The Adoration of the Sacred Heart of Jesus with Saints Ignatius Loyola and Aloysius Gonzaga*, late 18th century, oil on copper, Denver, Mayer Collection

29. Gian Lorenzo Bernini (1598–1680) (attributed), *The Blood of Christ*, **ca. 1669, drawing, Haarlem, Teylers Museum**

shows Christ on the cross, blood streaming from his hands and feet. From his side blood arcs into the waiting hands of the Virgin Mary. God the Father and a crowd of angels surround the cross. A painted version, probably executed by François Spierre after Bernini, completes the lower part of the composition, revealing the cross hovering over a sea of blood (Fig. 30). Filippo Baldinucci, Bernini's first biographer, described both the great artist's piety and the generation and function of this remarkable image:

> So spiritual was his way of life that … he might often have been worthy of the admiration of the most perfect monastics. He always kept fixed in his mind an intense awareness of death.… So great and continual was the fervour with which he longed for the happiness of that last step, that for the sole intention of attaining it, he frequented for forty years continuously the devotions conducted toward this end by the fathers of the Society of Jesus in Rome. There, also, he partook of the Holy Eucharist twice a week.… He became absorbed at times in the thoughts and in the expression of the profound reverence and understanding that he always had of the efficacy of the Blood of Christ the Redeemer, in which, he was wont to say, he hoped to drown his sins. He made a drawing of this subject, which he then had engraved and printed. It shows the image of Christ Crucified, with streams of blood gushing from his hands and feet as if to form a sea, and the great Queen of Heaven who offers it to God the Father. He also had this pious concept painted on a great canvas which he wanted to have always facing his bed in life and in death.[55]

Although the work expressed Bernini's own personal piety and played a significant role in his long preparation for a "good death," he had the composition engraved, thus sharing it as a devotional device. The inscription on the engraving, deriving from Hebrews 9:14, encapsulates much of the theological and devotional force of countless images of Christ's blood: "the blood of Christ, who offered himself unspotted unto God, will cleanse our conscience."

30. François Spierre (after Gian Lorenzo Bernini), *The Blood of Christ*, **ca. 1699, oil on canvas, Rome, Museo di Roma. Photo: Studio Fotografico Idini**

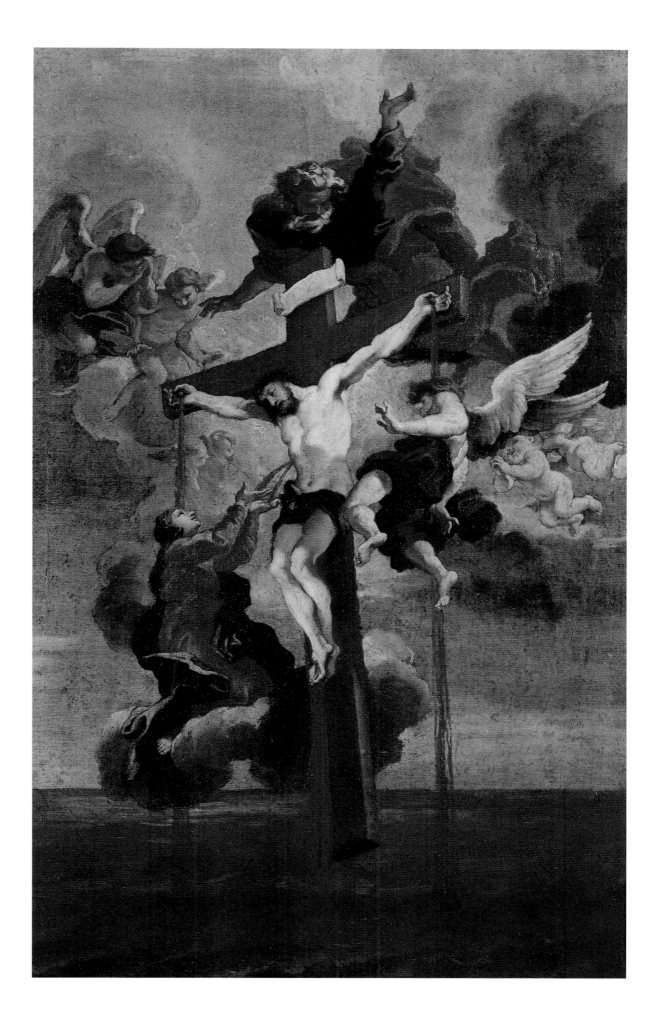

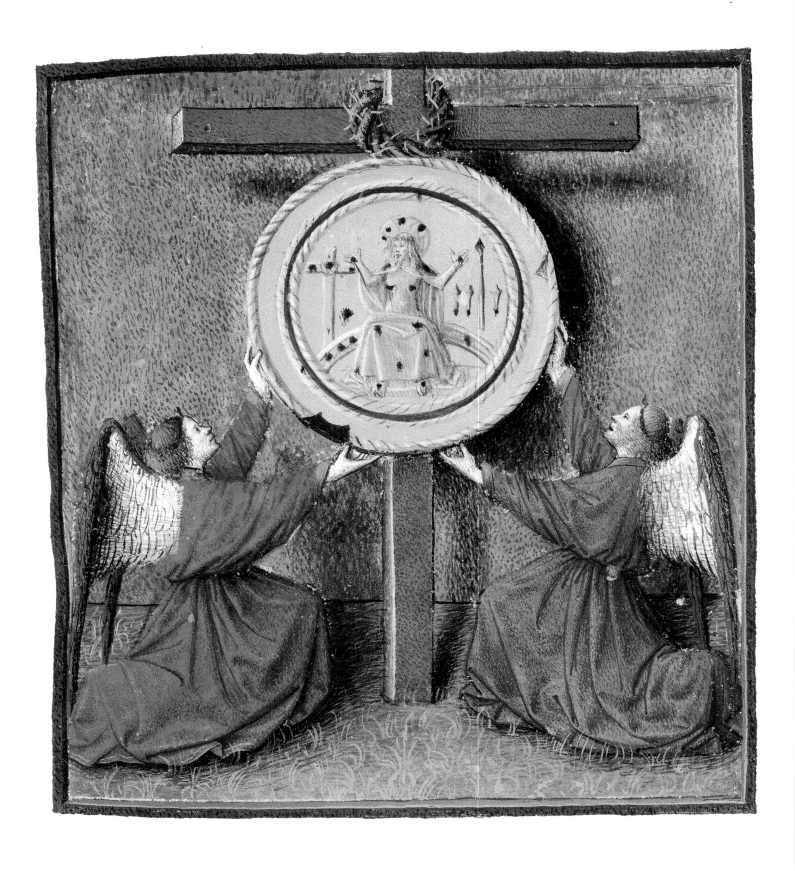

Christian belief and practice, as it evolved in the Middle Ages, came to place growing value and enhanced meaning on the blood of sacrifice, the blood of salvation. In the Christian story, Christ's incarnation, His taking of human form, enabled Him to offer His blood, which was first shed at His circumcision, followed by the Flagellation and the Crucifixion. But that was not the end, for the High Middle Ages—primarily the period from 1100 to 1250—also saw a renewed emphasis placed upon Christ's sacrifice. The Eucharist—the ritual reenactment of the Last Supper, during which the Passion was foretold—came to be seen as the central ritual of Christian belonging, the occasion on which the promise of salvation was reaffirmed. From the late twelfth century an extraordinary claim was made by theologians—one that became a required belief following the Fourth Lateran Council, in 1215—that at mass, during the celebration of the Eucharist and through the words of consecration spoken by a priest at the altar, bread and wine were turned into Christ's body and blood. *Corpus Christi* —Christ's body—was the very same that had suffered on the cross, was buried, and was resurrected after three days, ascending to heaven, where it awaited the Day of Judgment. The process of transforming the substance of the bread and wine into body and blood without changing their external properties and appearance was to be known as transubstantiation.

Blood: Sacrifice and redemption in Christian iconography
Miri Rubin

A great deal of effort was made to convey this mystery, which in many ways defied or at least challenged commonplace understandings of the material world. The instruction of the laypeople, careful formulation, and every aspect of the ritual aimed at enhancing the dignity of the occasion and at treating the Eucharist as venerably as the body of God deserved. Precious vessels (see Fig. 3) were required to hold the wine and bread, as were appropriate vestments for the priest and his helpers, as well as suitable decoration of the altar and its surroundings. The choir and presbytery became increasingly marked off from the lay area to enhance the aura of mystery. Almost all medieval churches acquired a choir screen, which served to separate these areas of the church. Such screens were usually made from stone and quite elaborate in design.

This remarkable effort provided a powerful symbolic as well as a material framework of Eucharistic practice and belief. But it also created an event and a set of ideas that could never be contained within church walls or adequately explained by the logical formulations of theologians. The offering of God during Communion—believers were required to receive the consecrated host in a state of merit at least once a year, at Easter—was an experience that people came to reflect upon, anticipate, and to some extent design for themselves. Moreover, attending Mass was claimed to be a good thing at any time, full of spiritual and physical benefits. The devout were encouraged to turn their thoughts to Christ's sacrifice and to imagine his suffering. A world of empathy was developing around the image of a suffering body, and around the seemingly simple, small, and pristine white wheaten host. Yet the most affective engagement seems to have

1. *Desecrated Host of Dijon*, Book of Hours of René of Anjou, King of Sicily, Burgundy, 15th century, Egerton Ms. 1070, London, British Library

 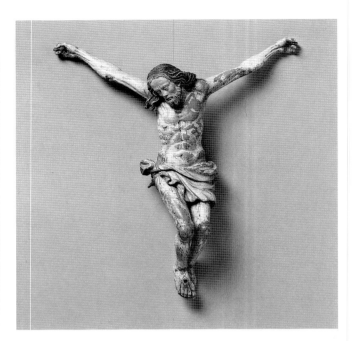

2. Processional Cross, Germany, 15th century, copper, gilt and engraved, Frankfurt am Main, mak.frankfurt

3. Chalice, southern Germany, ca. 1480, silver, gilt, Frankfurt am Main, mak.frankfurt

4. *Crucifixion*, probably southern Germany or Austria, 17th century, ceramic, Inv. 2589, Frankfurt am Main, Liebieghaus—Museum alter Plastik

5. Follower of Robert Campin (ca. 1375/9–1444), *Madonna of the Firescreen*, ca. 1430, oil on panel, London, National Gallery. Photo: National Gallery, London

been brought about by the representation of Christ's red, mediating blood. This precious liquid, which was spilled at the Crucifixion, was cherished and reproduced at every Mass.

Those who meditated on the image of the blood of the suffering Christ were many. They ranged from contemplative monks in their cells, female mystics in their communal houses (such as the Beguines of the Low Countries), and women living solitary lives in Italian towns and cities.[1] The trend was to explore the possibilities of the suffering body, and to enjoy imagining routes to that body, into that body, often through the bleeding, open wounds. The Christ Child sometimes represented the suffering body. In *The Madonna of the Firescreen* of ca. 1430 by a follower of Robert Campin (Fig. 5), the child's body is shown with tiny, outstretched hands and feet, as if waiting for the imprint of the nail.[2]

The confirmation in 1215 of the doctrine of transubstantiation had a profound impact on the subsequent history of Europe. Belief in transubstantiation became the acid test for detecting heresy—be it among Jews or in such dissident Christian communities as those of the Albigensians, the Cathars, or the Lollards. Moreover, differences in belief about the doctrine of transubstantiation were to be at the heart of the Protestant Reformation three centuries later. Luther himself mocked the cult of the Holy Host at Sternberg (the site of a putative fifteenth-century Host desecration), and wrote in a letter to the town's prior in 1524, "I rejoice in the fact that you have cut short the superstitions that have prevailed among you and have put an end to Godless profit."

Christ's sacrifice was explored most often through the powerful image of the crucified Christ, in tumultuous, bustling Calvary scenes, flanked by two thieves, witnessed by His mother and Saint John the Evangelist, and a multitude of others, often characterized as Jews. Another possibility was to separate Christ's body (most frequently the torso) from the narrative frame, and present it as a Man of Sorrows, sometimes accompanied by the instruments of his suffering, the *arma Christi*—the column and whips of the Flagellation, the hammer and nails, the sponge of vinegar, and the lance that pierced his side. The bleeding body was sometimes shown shedding its blood onto a rock (Calvary) under

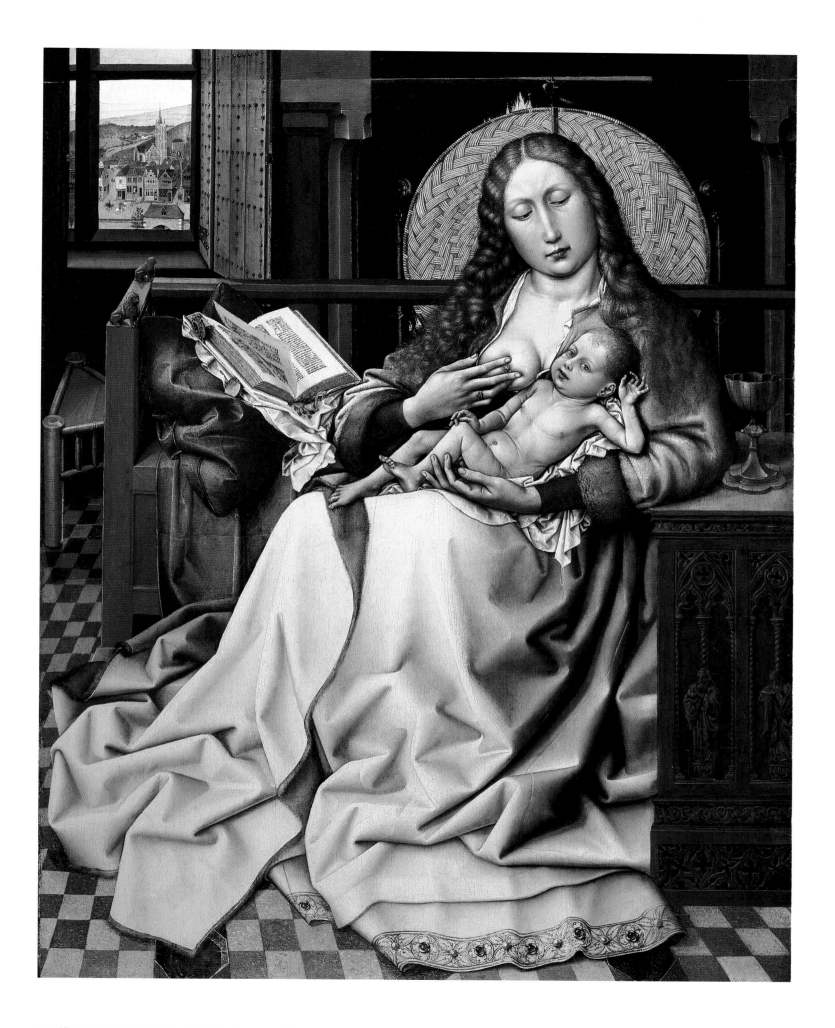

6. *The Mass of Saint Gregory,* **Book of Hours, in the style of Willem Vreelandt (?), Ms. 195 f. 93f, Baltimore, Walters Art Gallery**

7. *Christ in the Winepress,* **Ms. 691, f. 5, New York, Pierpont Morgan Library**

which was buried the skull of Adam, thus linking Original Sin with the need for redemption. Moreover, the blood of the wound in Christ's side was occasionally depicted simultaneously with that of his genitals—the so-called blood hyphen—linking Christ's first bleeding with his last. Christ's loins were almost always discretely covered, but they nonetheless marked the place of the Circumcision to which the blood trickled from above. These images could be portrayed on large altarpieces, or on the pages of Books of Hours. Depictions of the Mass of Saint Gregory are an elaboration on this theme, insofar as the celebrant at the altar (sometimes the saint himself) is shown witnessing the miraculous manifestation of the bodily aspect of the Host, in the form of the Man of Sorrows (Fig. 8), the blood from his side wound sometimes represented gushing into an adjacent chalice (Figs. 6 and 9).

Blood is associated with pain and violence, but in late medieval spirituality it was also identified with nurturing and life. Out of the drama and trauma of the Crucifixion a whole world of associations was created, which emphasized the saving, redemptive, and nurturing promise of Christ's sacrifice. Just as the medical understanding based on Galenic theories had the blood of menstruation turn into the breast milk of the nursing mother during pregnancy, so the blood of Christ's sacrifice was sometimes shown satiating hunger and quenching thirst, often oozing from the side of Christ's torso, just as his mother's milk flowed into his mouth from her breast. Mystics, especially women known in northern Europe as Beguines, who lived, worked, and worshipped in philanthropic communities, imagined themselves as children suckling at Christ's side wound (see Fig. 22, p. 81). Moreover, as the importance of the Sacrament grew, Scholastic theology developed new types of images that enabled mysteries to be represented as vivid metaphors. The body of Christ, for example, was shown as the bread of life that was sacrificed during Communion and nourished the devout in their certainty of salvation. The Virgin's role in the creation of this bread was underscored. In some texts she is described as the oven in which it was baked or as a priest who "serves up" God at the altar.

As the nurturing mother of the redeeming Christ, the Virgin was directly involved in the promise, foretelling, and enactment of redemptive sacrifice. Because she fed the infant Christ, was present during his Circumcision, and witnessed his growth and development, she came to be seen as playing a Eucharistic and redemptive role. It was after all from her own flesh and blood that God took the form of humanity.

Yet, above all, the Virgin witnessed the sacrifice at the Crucifixion, the miraculous events of the Deposition, Burial, Resurrection, and Ascension. As a mother, she suffered from the death of Christ more intensely than any other living being. Owing to her profound sorrow and grief, the Mother of God was thought to be the highest intercessor, the mediatrix of redemption and grace who proffers the blood as the best possible interceder for the devout. Her sorrow was taken up in prayer books and special cults that created a link between the sacrificial death of Christ and his mother's suffering. In the mid-fifteenth century, rosaries were invented, a form of worship in which prayer and contemplation are structured by the number and sequence of Hail Marys and Joyful and Sorrowful Mysteries of Christ. The link is reinforced between the mother who brought forth the body and gave milk and blood, and the Son and Incarnation of God who gave his own blood.

8. *The Man of Sorrows as Fountainhead of Blood and Dispenser of Hosts*, Germany (Lower Rhine), ca. 1480, oil on panel, Cologne, Diözesanmuseum. Photo: Lothar Schnepf, Cologne

This nourishing, redemptive, affirmative, if often painful, representation of the body of Christ transformed the traces of blood into love and grace that the Savior and Son of God bestowed on mankind. Casting off the corporeal shroud was the necessary fulfillment of his prophecy. At the Crucifixion, Christ was therefore not only a sacrificial victim, but also a willing actor and even creator of salvation. The parable of Christ in the winepress (Fig. 7; Fig. 12, p. 72), which dates from the fifteenth century, emphasizes his role as an actor in the Crucifixion, incorporating redemption and the sacrament into a new pictorial metaphor: Christ the Man of Sorrows treading on grapes to press out the Communion wine. In depictions of the Seven Sacraments, the crucified body is linked with the seven sacraments by bloodstreams, which represent the transformation of the sacrifice into an iterative, reliable, and predictable act of mercy.

But blood—being so precious, so redemptive, so necessary—also required protection, as all precious things do. A bulwark of carefully placed containers was created and placed in churches and chapels. Access to the blood and the flesh was controlled, and consecrated blood was no longer offered to the laity after the twelfth century. The precious redemptive blood was offered at the sacrifice of the mass, and the officiating priest drank it with the consecrated Host, but fear of the sublime seeming ridiculous led Church authorities to offer God in the form of bread alone, and to offer a drink of unconsecrated wine to believers for the sake of symbolic wholeness. Why was this so? Because the technicalities of offering the blood were too demeaning, as they provided the occasion for slippage, spillage, loss, and abuse, as "it trickled down the coarse beards of believers." So the laity contented itself with the bread, the flesh of Christ. Yet, since living flesh is full of blood, the precious liquid was also consumed, even if it was not offered separately. In addition they imagined it, saw it in the ubiquitous Crucifixion scenes, and were encouraged to meditate on it in their prayers during Mass, in their contemplation of devotional images, in their devotional sequences as members of religious confraternities. Moreover, as participation at Mass became obligatory for members of the Christian community, exclusion from the Holy Sacrament increasingly turned against society's misfits: nonconformists, heretics, and, above all, Jews, who were believed to revile the object that symbolized their exclusion.

The blood could be imagined as saving and nurturing, but also as a precious thing under attack. By the year 1300 a narrative had developed in Europe that included a sequence wherein a Jew acquired the consecrated host, and abused it.[3] According to it the blood gushed forth from the "abused" Host as the most visible sign of the outrage that the Jews were alleged to have perpetrated. As the Host was pierced, and remained miraculously whole, the Jews were thought to prolong the torture by a variety of means: cutting, cooking in boiling water, burying in pits or wells. The host desecration story was powerful in illustrating the miraculous survival of the Host, thus making a powerful statement about the Host's true nature as Christ's body, indestructible and mighty. Rather than be torn, broken, or damaged, the Host triumphantly bled, or in several cases was reported to have turned into a Christ Child, and in these moments of triumph blood abounded. The Host desecration was turned into a bloody scene not only as a vindication of the claims made about it—that it was real flesh and blood—but also to elicit empathy and compassion in the viewer, and feelings of outrage toward the perpetrator, the Jew (Fig. 10).

The motivation for imagined Jewish abuse was sometimes described as doubt, a desire to test the Eucharist and see if it is indeed anything but bread, but there was the more powerful imputation, that the Jews were hereby recrucifying Christ. It was implied that, although they publicly denied Christ was the Son of God, they secretly recognized him as such and for this very reason had abandoned him to condemnation. However, although this condemnation had been nullified by the Resurrection, the Jews were believed to endeavor to put Christ to death time and again, and for this they needed the Host. Contemporary Jews were thus seen as reenacting the historic, traumatic, and all-important story of the murder of God, a tale that by 1300 was told as one in which Jewish participation was knowing, and Jewish guilt clear. By delivering Christ to his death on the Cross with the words "His blood be upon us, and on our children," Jews were said to have perverted the Christian concept of redemption, that Christ's blood brought salvation.

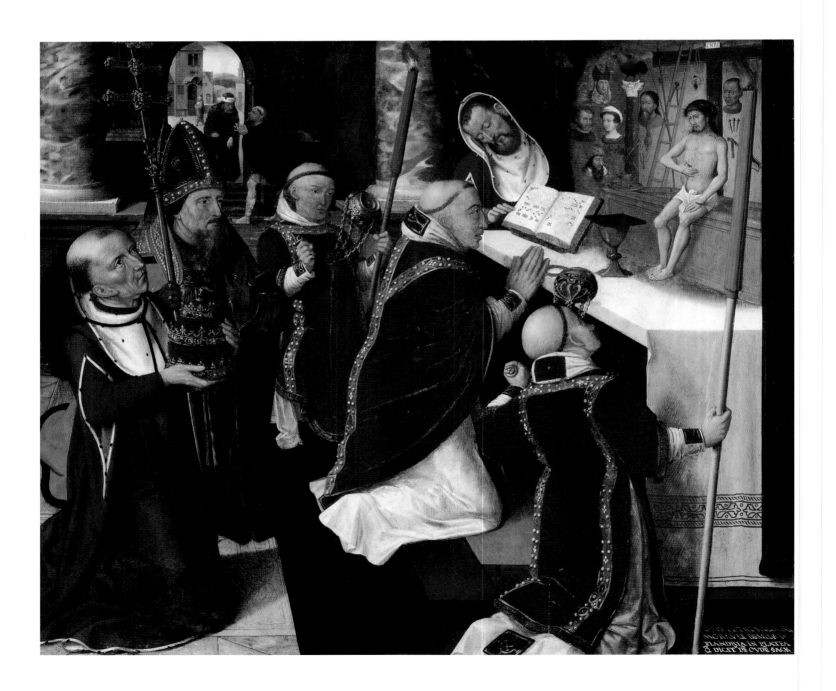

9. Petrus Nicolai Moraulus (ca. 1499–1576), *Mass of Saint Gregory*, ca. 1530, oil on panel, Houston, Sarah Campbell Blaffer Foundation

The desire to recrucify (which was discussed in the vernacular publicly in strong and unqualified language) lay at the roots of the accusation of ritual murder, which spread in Europe in the twelfth and thirteenth centuries.[4] Here several strands met in the late Middle Ages to produce a powerful tale, one that, although it never received official, papal endorsement, was nonetheless powerfully enacted, and supported by religious and ecclesiastical leaders in several regions in Europe—and this despite the fact that it was well known that Biblical Judaism abolished human sacrifice and forbade strictly and explicitly the consumption of blood. For, according to the Bible, blood contains the soul, thus life, and therefore belongs to God.

Parallel to the veneration of desecrated hosts, the late thirteenth century witnessed the growth of cults based on the belief that Jews required Christian blood for the completion of the Passover rituals, the baking of the *matsa*, the unleavened bread eaten for eight days. Thus every year a Christian boy was said to have been sought and killed by a Jewish community, and the blood was

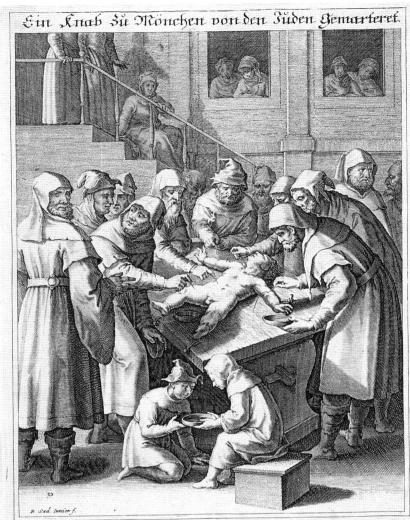

Ein Knab Su Mönchen von den Jüden Gemarteret.

Was roittet ihr wider die Christliche Kinder, Was thut euch ein Kind so ihr also hinrichtet
Beschnittene Bossroicht! kein winkel der welt Euch wöhret der Männer, mit besserem fug:
Vor euch ist mehr sicher: Ihr blinde Leitschinder, Was von den Megæren die alte gedichtet,
Ihr werdet bald sür men, das siergten Gesell. Wahr mache an Christen die Reidige sünd.

shared with other Jews (see Fig. 11). Among the best-known cults are those of Wernher of Bacharach and Simon of Trent, whose legend was not only included in Hartmann Schedel's *Weltkronik* (World Chronicle), but was also depicted on the bridge tower in Frankfurt, where it was still visible in Goethe's day (see Fig. 13).[5] The accusation of ritual murder was thus a travesty reflecting the image of Christ's self-sacrifice, which otherwise Christian believers might scarcely comprehend. It made perverted use of the Jewish people's involvement in the Crucifixion story and thus laid claim to veracity. This conspiratorial horror story also contained other elements of abuse, as the killing of the Christian child was habitually presented as a reenactment of Christ's Passion, to which were sometimes added elements of torture and attention to the prepubescent genitals. In early versions of the narrative, the Jew and his family who test the Host are converted by the miracle. As the story evolved and the accusations became more elaborate and far-fetched, the outcome was nearly always enacted at the stake.

The kernel of a tale that grew in the telling can be found in the accounts of a Host desecration that is said to have occurred in Paris during the Holy Week of 1290. In this account, a Jew tempted a poor Christian woman in the parish

of Saint Jean-en-Grève by offering to waive a debt if she brought him the Host from the Easter Communion. Once in his possession, the Jew "tested" the Host through a series of injuries, which included cutting it with a knife, piercing it with nails, and throwing it into the fire. Despite these insults, the Host continued to bleed miraculously. Finally, he threw it into a cauldron of boiling water, which miraculously turned red, and the Host transformed into a crucifix, which hovered above the steaming water. A Christian woman discovered the blasphemy and called the neighbors and the priest. The Jew was tried, condemned, and burned at the stake, while his wife and children converted to Christianity. Throughout Europe this original tale was soon retold and embroidered, as accusations of Jewish desecration of the Host fed on existing prejudices and suspicions.

Jews and blood in the Host were to produce a precious object, which came to be revered by the Burgundian dukes and their subjects. A Host claimed to have been desecrated by a Jew was given as a gift by Pope Eugenius IV to the Duke of Burgundy in 1435, and around it a sacred space and several images were created in the following centuries. Unquestioned was the image itself, a host—white, wheaten, and pristine—that had been cut through, and, as if wounded, sported reddish-brown stains. The image of the relic became a focus of the court's worship, and was exported to the House of Anjou through prestige objects and private devotional books (see Fig. 1).

The juxtaposition of child and blood—a juxtaposition which we have seen in the relatively benign context of *The Madonna of the Firescreen* (Fig. 5) and in the less benign context of the Sijena Altarpiece—is a horrifying one, and its power was exploited by preachers, poets, printers, and painters, who described it in words and depicted it in images. The lust for blood imputed to the Jew echoed the desire for the blood of Salvation in the Christian. Since the Jews had no approved way of procuring it, they came to be seen as blood merchants. Lurid tales described the many attempts, surgical in their precision, to bleed Christ's body, from the moment of the Crucifixion, to the repeated scenes of torment that were allegedly perpetrated in the streets of Europe. Devotional texts about the Crucifixion presented the Jews as blood merchants, and blood was regarded as a precious commodity. In the fifteenth-century English *Charter of Christ*, a redemptive contract is written out on Christ's skin (parchment), in his own blood (ink), with a pen (scourges with which he was tormented) (Fig. 12). In another text of the same period, the Jews are shown at the Crucifixion as physicians expertly drawing blood from Christ's body—veins, arteries, organs—all in keeping with prevailing Galenic medical theory, with its enthusiasm for bloodletting. The link between sacrifice and blood, blood and Jews, was one that would linger on in the European imagination, and be elaborated upon time and again.

When examining the wide variety of associations with blood in late medieval devotional culture, it is crucial to maintain an awareness of the vast regional differences in devotional styles and representational habits. In late thirteenth-century Franconia, accusations of host desecration against Jews led to regional massacres and miraculous events, which were commemorated in such chapels as those at Iphofen and Lauda. As a consequence, some Franconian towns, such as Röthingen, Würzburg, and Nuremberg, came to be known among the Jews as "blood cities." In Bavaria and Austria, cults of Holy Blood shrines

abounded. In Spain blood came to be the carrier of identity, an indelible attribute of religious and ethnic adherence, which was supported by the concept of limpid, pure blood (*limpieza de sangre*). This tendency in some parts of Europe to associate blood with identity, and to see in spilt blood the genesis of life, is also evident in representations of the Fountain of Life, an image with the Lamb of God at its heart, the sacrificial object, whose blood is turned into pure, life-giving water.

The imaginings, hopes, and fears surrounding the mystical and sacramental qualities of the Communion wine came to be challenged repeatedly in the late Middle Ages by groups who questioned and even ridiculed the sacramental arrangements around sacrifice and redemption, which had been formulated and enforced quite widely in previous centuries. Bohemian Hussites demanded access to the bread and wine for the laity, just as priests received the sacraments "in both kinds" (Utraquism). Although concessions were made to them by the Papacy, their leader, John Huss, was executed during the Council of Constance in 1415. English Lollards doubted the relationship between priestly virtue and the effect of sacramental celebration. Could a sinning priest still work the miracle that transformed the Communion wine into Christ's own blood? Was not every true believer a Christ of sorts, a potential priest?

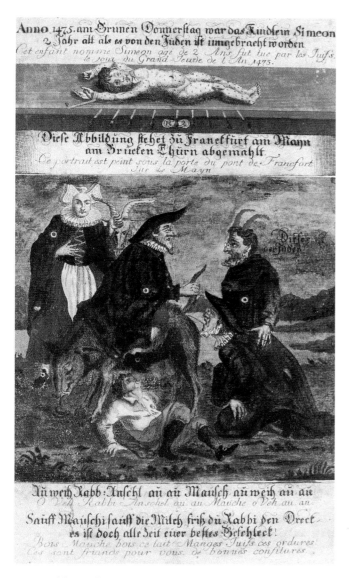

13. Broadsheet, *The Appearance of the Martyred Simon of Trent on the Frankfurt Bridge Tower* (upper part); "Judensau" (lower part), 18th century, engraving, Frankfurt am Main, Historisches Museum

The tradition of complaint, anticlericalism, doubt, and sacramental scrutiny came to be expressed in the powerful criticism of a number of theologians and preachers now called Protestant, who gained acceptance and developed followings in parts of the Holy Roman Empire, the Low Countries, and soon afterward in England, in the early sixteenth century. With its criticism of the doctrine of transubstantiation, of the use of imagery in worship, and of the cult of saints and martyrs, Protestants were to do away with many of the occasions for the contemplation of blood in vast regions of Europe. In these areas identity and salvation came to be understood in new ways, as belief in the power of sacramental renewal gave way to the doctrine of predestination and the routines of biblical absorption, and self-scrutiny. At roughly the same time as the Protestants began to reform the Church in several regions, the medical orthodoxy of Galen too came under renewed attack. Paracelsus and others began to challenge Galen's belief in the four humors, and in the efficacy of bloodletting. Scarcely one hundred years after Luther nailed his theses to the church doors, challenging, among other things, the doctrine of transubstantiation, William Harvey's investigations into the circulation of the blood provoked a radical reevaluation of the role of blood in human physiology.

Blood and violence—the violence of birth, of sacrifice, the violence deployed in defense of perceived channels to holiness and redemption—were enfolded in complex images and rituals of the Catholic tradition as developed in the High Middle Ages and ultimately transformed for many Europeans in the course of the sixteenth-century reformations. Where Protestants redesigned the ritual of remembrance of Christ's sacrifice, and indeed removed the blood from its appearance, in reformed Catholicism the devotion to the Eucharist, the memory of sacrifice, the habitual repetition of the Passion in devotions and prayers were enhanced. This is the religion that was to spread in the centuries to follow, as Corpus Christi was brought to new peoples and new lands. From Spain to New Spain the sacrificial God came to meet people whose deities demanded sacrifice and purging through bloodshed.[6] The sacrificial Blood of Christ was to be reimagined, again.

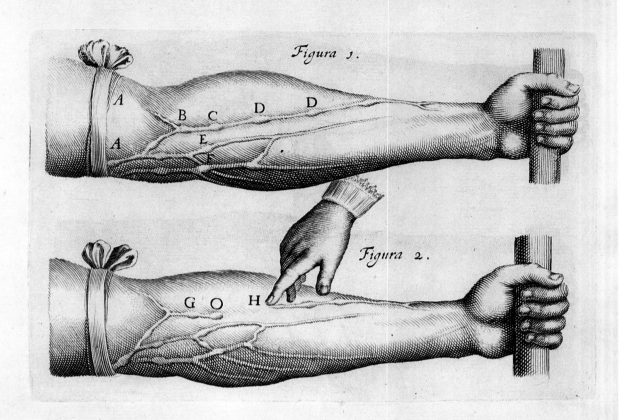

Figura 1.

Figura 2.

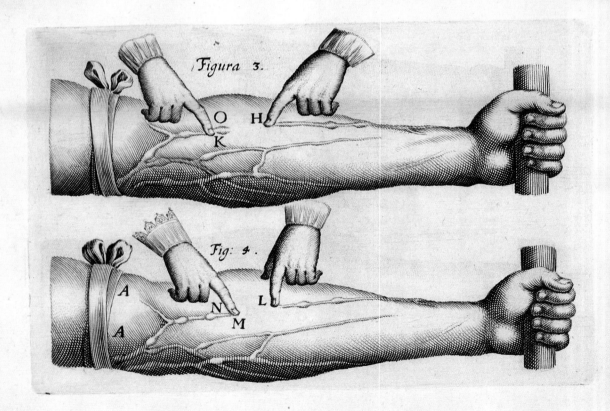

Figura 3.

Fig: 4.

The moment when man first suspected that what he did was the result of hidden things getting done must have changed his whole view of the sort of thing he was. The suspicion that his effectiveness or agency was caused by something other than his conscious urge to be effective, and that he himself had no real control over this, constitutes an almost inconceivable leap of the imagination, and one can only conclude that it was largely the result of drawing an analogy between himself and his own technological artifacts. In primitive societies, where technical images are few and far between and very simple at that, most explanatory metaphors are drawn from nature. In the effort to understand his own make-up, primitive man inevitably resorts to images of wind and water, breezes and tides, floods, fruits, and harvests. But the development of technology created a new stock of metaphors—not simply extra metaphors, but ones altogether different in character. Once man succeeded in making equipment that performed—looms, furnaces, forges, kilns, bellows, whistles, and irrigation ditches—he was confronted by mechanisms whose success or failure depended on the efficiency of their working parts: things that could block or break, silt up or go out, mechanisms that were intelligibly systematic and systematically intelligible. By mechanizing his practical world, man inadvertently paved the way to the mechanization of his theoretical world.

The Pump: Harvey and the circulation of the blood
Jonathan Miller

The success of modern biology is not altogether due to the technology with which we pursue it; the number of technical images we now have for thinking about it play an almost equally important part. An American scientist once said that the steam engine had given more to science than science had to the steam engine, and the same applies to telephone exchanges, automatic gun-turrets, ballistic missiles, and computers. Whatever these devices were designed to do, they have incidentally provided conjectural models for explaining the functions of the human body. And the effectiveness of this process grows by geometrical progression. After all, butchers, priests, and augurs have been disemboweling animals since the dawn of time, and the battlefields of Antiquity would have given ample opportunity for looking inside the human body. One of the reasons why the anatomy and physiology of the heart took so long to develop was the lack of satisfactory metaphors for what was seen. Of course, the written evidence of early Greek science is so fragmentary that it gives an unreliable picture of what was known or believed. Modern scholars continue to disagree about the authorship of these tantalizing fragments, and since much of it takes the form of poetry rather than discursive prose it is almost impossible to get a coherent picture of what the Greeks of the sixth century BC knew. The organs contained in the chest had already been identified, and the idea that blood ebbed and flowed in the various vessels was also entertained, but there was no consistent doctrine and no argued conviction about its mechanism. Until the end of the fourth century BC, no one distinguished between arteries and veins, and even then the distinction did not carry the systematic significance that it does now.

**1. William Harvey, *De Motu Cordis*, 1628,
private collection, London**

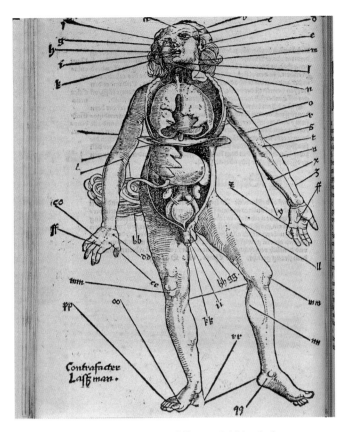

2. Hans von Gersdorff, anatomical figure, *Feldtbuch der Wundartzney*, Strasbourg, H. Schott, 1530, fol. 16v, London, The Wellcome Institute, Early Printed Books Collection. Photo: Wellcome Library, London

It would be a mistake to assume that early Greek physiology was as incoherent as the ruined evidence might lead one to believe. Galen inherited a vast treasury of texts and, although most of these are lost to us, the way in which he repeatedly acknowledges the work of his ancient predecessors implies that he was not the first scientist to visualize the blood vessels as part of an intelligible working system (for a detailed account of the development and transmission of Galen's ideas, see Valentina Conticelli's essay "Sanguis Suavis," pp. 55–63). Nevertheless, the weight and cogency of what he had to say is so immeasurably greater than what came before that one is forced to conclude that Galen had some peculiar advantage over his Greek predecessors. And although the remarkable naturalism of the Roman art of his time indicates that an intense interest in the appearance of the physical world had an important part to play, it is not unreasonable to deduce that this advantage was connected with the technological ingenuity and richness of Roman civilization.

According to Galen, some of the blood leaving the liver overflowed or was diverted into the right side of the heart, where it came into immediate contact, or so he supposed, with air, which had been drawn in through the lungs and along the pulmonary veins. The encounter produced a mysterious incandescence, a biological flame, which heated the blood and gave it the fertile warmth that is so characteristic of the living body.

Galen likened the heart to a lamp, fed by the oily fuel supplied by the liver. The smoky fumes exited through the flues of the pulmonary veins and the windpipe—anyone could see that breath steamed or smoked in the cold air. But it was more than a heating-system. The blood was not only consumed by the cardiac fire, it was transformed and refined: converted from the thick, purple ooze supplied by the liver into the swift, scarlet stream that issued from the arteries. In this respect, the heart resembled a smelter's furnace, burning off the combustible impurities that were present in the food, leaving a purified residue, which was enriched with the peculiar pneumatic principle said to be present in air. The leaping red fountain that shot from the left side of the heart differed from the turbid material entering it from the right not simply in its lack of combustible impurities, but in its possession of a weightless substance that Galen called "Vital Spirits." This superlative substance was distributed through the arterial system, some of it going to the general tissues, where it presumably reinforced the effect of the "Natural Spirits," and some of it going to the brain, where it underwent further refinement and became "Animal Spirits"—the material responsible for converting thought into action.

This elaborate theory brought together and reconciled the scattered theories of Antiquity, organizing them into an intelligible system; an industrial plant half-way between a brewery and a blast-furnace. It seemed to make sense not only of the various pipes and tubes that were known to exist, but of the various material intakes and outputs of the living body. It explained the source, function, and distribution of nourishment, the purpose of breathing, and the spontaneity of the living body. Its dependence on technological metaphors is self-evident: the most notable feature of the system is the emphasis on manufacture and transformation, cooking, brewing, and smelting—processes that convert, purify, and refine tangible substances. The heart, like the liver, is simply another part of the factory.

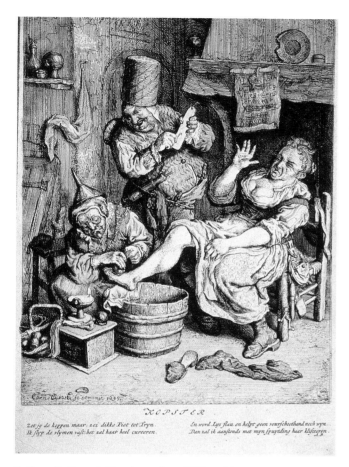

3. Cornelis Dusart, blood cupping, 1695, etching,
Washington, DC, National Library of Medicine

4. A. Ducotés, *Doctors Cuchillo and Sangrado
Prescribing for Brittannia*, 1833, lithograph,
Washington, DC, National Library of Medicine

The recognition of the propulsive role of the heart was delayed for nearly 1,500 years, although the necessary evidence was just as available to Galen as it was to William Harvey. The difference between the two men is not one of ingenuity and skill—in fact, if these were the sufficient conditions of scientific progress, Galen rather than Harvey might have been the discoverer of the circulation of the blood. But seeing is not all that there is to believing; belief determines the significance of what is seen. The difference between Harvey and Galen was one of metaphorical equipment. When Galen tried to systematize the relationship between the blood and the breath, the cooperation between the liver, the lungs, and the heart, the processes on which he modeled his theory were the most conspicuous features of the world in which he lived. There were no better analogies than those of the lamp or the smelter's furnace: they were the most intelligible images of transformation and change. One can only assume that Galen's inability to see the heart as a pump was due to the fact that such machines did not become a significant part of the cultural scene until long after his death. The heart could be seen as a pump only when such engines began to be widely exploited in sixteenth-century mining, fire-fighting, and civil engineering.

In the absence of a more plausible metaphor, Galen's industrial model inevitably monopolized the imagination of late Antiquity, blinding men to inconsistencies that later became self-evident. For instance, the furnace model required the blood to move directly across the heart from right to left, in spite of the fact that its passage is quite obviously blocked by the thick, muscular wall that separates the two ventricles. We now know that the only way for the blood to get from one ventricle to the next is by going the long way round through the lungs, and that, as we saw in the previous chapter, the transformation from purple to scarlet takes place there rather than in the heart. Galen's system placed little or no emphasis on pulmonary circulation, dismissing it as a lubricant trickle that nourished the bellows of the cardiac furnace. Since his theory depended on a direct transit across the heart, he insisted that the septum, which divides the two ventricles, was perforated by channels. He admitted that these channels were too small to allow the passage of thick, unrefined blood, but since his theory also insisted that the blood was refined by its encounter with air this did not pose a problem.

This casuistry shows how persuasive a metaphor can be, and how, once an idea lodges in the imagination, it can successfully eliminate or discredit any evidence that might be regarded as contradictory. No special technique was needed to show that the septum is impermeable: although its surface has an irregular, corrugated appearance, which might give the impression that it is pitted with the mouths of small vessels, a quick poke with a bristle would have shown that these pits lead nowhere—certainly not from one side to the other. Galen could have performed this experiment just as easily as his successors did. The great sixteenth-century anatomist Andreas Vesalius did perform it, but since he, too, was under the spell of the traditional theory, he insisted that the blood "sweated" across the muscular wall through pores which were admittedly too small to allow the passage of a bristle.

Philosophers of science sometimes imply that scientific thought is a simple alternation between conjecture and refutation, and that contradictory evidence automatically discredits an otherwise plausible hypothesis. The history

5. Bloodletting scene, late 17th century, engraving, Washington, DC, National Library of Medicine

6. Wounds man, 15th century, woodcut, Washington, DC, National Library of Medicine

of cardiac physiology shows that this is an over-simplification, because it over-looks the criteria used to decide what will count as a contradictory finding: if a theory has found favor with a scientific community, it is the anomalous finding rather than the theory itself that becomes discredited. This is exactly what happened in the experiment with the bristle. It was only when the pulmonary circulation was accepted as an established fact that the results of this experiment could be recognized as significant. Meanwhile, as is so often the case, it was more convenient to make an ad hoc modification of the existing theory. The history of science is full of such examples. If a theory is persuasive enough —and the reasons for any given theory being so persuasive are often hard to list— scientists will accommodate inconsistent or anomalous findings by decorating the accepted theory with hastily improvised modifications. Even when the theory has become an intellectual slum, perilously propped and patched, the community will not abandon the condemned premises until alternative accommodation has been developed.

The same principle applies to the problem of blood flow in the veins, especially to the valves that are to be found in these vessels. Galen could have seen these structures just as easily as his successors did. You have only to open the veins to see that there are little flaps on the inside wall and, from the way these flaps are facing, their valvular function now seems obvious. To us, as to Harvey, they are the most significant contradiction to Galen's theory that the blood could flow hither and thither in the veins: as Harvey saw, the flaps are arranged so that the blood can flow only one way through them. He proved that the flow was one-way by a dazzlingly simple experiment (see Fig. 1). He tied a tourniquet round the upper part of his arm, just tight enough to prevent the blood flowing back to the heart through the veins but not tight enough to prevent blood entering the arm through the arteries. The veins swelled up below the tourniquet and remained empty above it, which implied that the blood could be entering them only through the arteries. By carefully stroking the blood out of a short length of vein, he saw that the vessel filled up only when the blood was allowed to enter it at the end, which was furthest away from the heart.

These experiments are so simple that it seems surprising that they weren't performed before. But it would not have occurred to anyone to perform an experiment like this unless he suspected that there was something wrong with the traditional theory, or that there was an alternative theory whose implications required such an experiment as confirmation. But alternative theories can be conceived only against a background of well-established tradition. One of the reasons it took so long to overthrow the Galenic theory was not that men were overawed or enslaved by it, but that they were not fully acquainted with it. For more than one thousand years after Galen the bulk of Greek scientific literature was either lost, forgotten, or neglected, and most of Galen's work remained untranslated until the revival of ancient learning marked the beginning of the Renaissance.

But the way in which a scientist remembers and publishes his arguments is not necessarily the order in which the idea originally occurred to him, and since Harvey did not log his daily thoughts we shall never know for certain how the notion of a continuous circulation first occurred to him. Scientists are notoriously forgetful about the origin of their most interesting conjectures, and although the existence of valves confirmed Harvey's hunch that the blood flowed

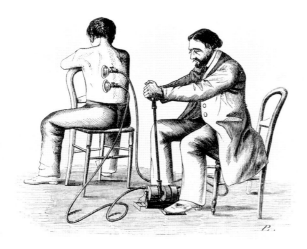

7. Patient being cupped by a physician, 19th century, engraving, Washington, DC, National Library of Medicine

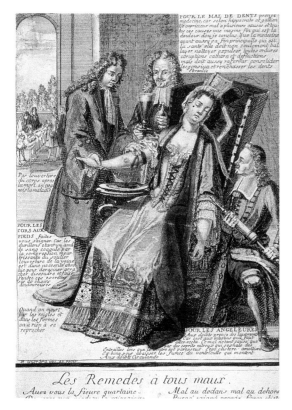

8. Nicolas Guerard the Younger, *Les Rémèdes à tous maux*, late 17th century, engraving, Washington, DC, National Library of Medicine

one way through the veins it seems likely that he had already recognized the existence of a one-way circulation, and that this made him realize that the flaps on the inside of the veins had to be valves.

As far as one can tell, his most fruitful insight was his recognition of the propulsive power of the heart, coupled with the experiments that confirmed it. By cutting arteries, Harvey showed that the rhythmic spout of blood invariably issued from the end nearest to the heart and that it coincided with the moment when the heart contracted and whitened. By tying ligatures at strategic points throughout the circulatory system, he showed that the vessels became empty and pulseless beyond the block, swollen and engorged with blood behind it.

As I have already pointed out, Harvey would not have been prompted to perform such experiments unless he had already had a hypothesis that forecast their outcome. How did he first entertain an idea that so systematically contradicted all that had been suggested previously? His personal observations of the heart's actions played an indispensable role, and it was certainly a stroke of genius to think of examining slow hearts. But once again the influence of technological metaphor must not be overlooked. By the end of the sixteenth century, mechanical pumps were a significant part of the developing technology of Western Europe. Coal and metal mines were being deepened to supply the needs of growing cities. Engineers were bedeviled by the problems of seepage, and forceful pumps were the only way of keeping the shafts empty. Contemporary handbooks of metallurgy included pages of pumping mechanisms. The hydrostatic principles were also applied to the design of ornamental fountains, and in 1615 Salomon de Caus published *Les Raisons de forces mouvantes*, describing a machine for putting out fires:

> The said pump is easily understood: there are two valves within
> it, one below to open when the handle is lifted up and to shut
> when it is down, and another to open to let out the water; and
> at the end of the said machine there is a man who holds the
> copper pipe, turning it from side to side to the place where
> the fire shall be.

Historians still disagree about the influence of the fire-pump, but it seems unlikely that Harvey would have departed so radically from the traditional theory if the technological images of propulsion had not encouraged him to think along such lines.

Harvey marshaled all his arguments into a single book of one hundred pages. It was originally published in Latin, but even in English translation it has the force of great literature (Fig. 1). What strikes the modern reader is the inexorable march of its reasoning, the simplicity of its conjectures, and its unflinching determination to develop all its implications in an experimentally checkable form. Naturally, the work is incomplete. It was left to Harvey's immediate successors to find out why the blood circulated through the lungs, but by proving so conclusively that it did he posited a soluble problem—which is the least that any scientist can demand of one of his colleagues.

He failed to find the tiny vessels that linked the arteries to the veins, and it was only when the Italian microscopist Marcello Malpighi turned his lens on to the lungs forty years later that the existence of the capillaries was even

Ventouses.

9. Bloodletting instruments: cupping bells and scarificators, 19th century, engraving, Washington, DC, National Library of Medicine

suspected (see Fig. 1, p. 108). If anyone before Harvey had discovered these vessels they would have found it impossible to explain their function, and when the function of something is not recognized its visible appearance is often misrepresented as well. Things tend to look like what we know they are for— and if we don't know what they do, we often find it hard to say how they look. Harvey might have discovered these vessels for himself if he had possessed a microscope: his theory demanded their presence, and it is a characteristic feature of fruitful scientific theories that they suggest the existence of objects or processes that may not be discovered until the appropriate instruments reveal their presence.

Like all good theories, Harvey's bristled with unfinished business, and the fact that he was unable to finish the business himself does not diminish his greatness. All subsequent investigations have been framed by his basic assumption, and, although Harvey would have been puzzled by the sophisticated electronic and biochemical methods now used to pursue these investigations, he would certainly have understood their significance. He might have been mystified by the anaesthetic techniques that enable a modern surgeon to enter the chest and open the heart, but his own theory dictates the replacement of a damaged valve by an artificial substitute: since he explained the function of the walls that separate the various chambers of the heart, he would have understood and applauded the repair of congenital holes.

The only point where it could be said that Harvey made a positive mistake was in explaining the physiological origin of the heartbeat itself. He claimed that the action of the heart was not spontaneous, but rather arose from the origin of all spontaneity—the living blood. In his investigations of a developing chick, he detected a pulsing spot of blood whose rhythmic flashes seemed to precede those of the heart. If his lenses had been better, he would have seen that the pulsation was caused not by the blood, but by the transparent heart that enveloped it. His error was not entirely due to faulty observation. Like his colleagues and predecessors, he was susceptible to ancient dogma, and, although he was able to take an altogether mechanical view of the function of the heart, he could not shake off the traditional belief in the existence of vital principles. In the seventeenth century, the spontaneity or "go" of living things could be explained only by referring back to some spiritual prime mover, and in Harvey's case this energetic agent was not merely to be found in the blood, it was identical with it.

10. Pseudo-Galen, *Anatomia*, England, mid-15th century, WMS 290, London, The Wellcome Institute, Western Manuscripts Collection. Photo: Wellcome Library, London

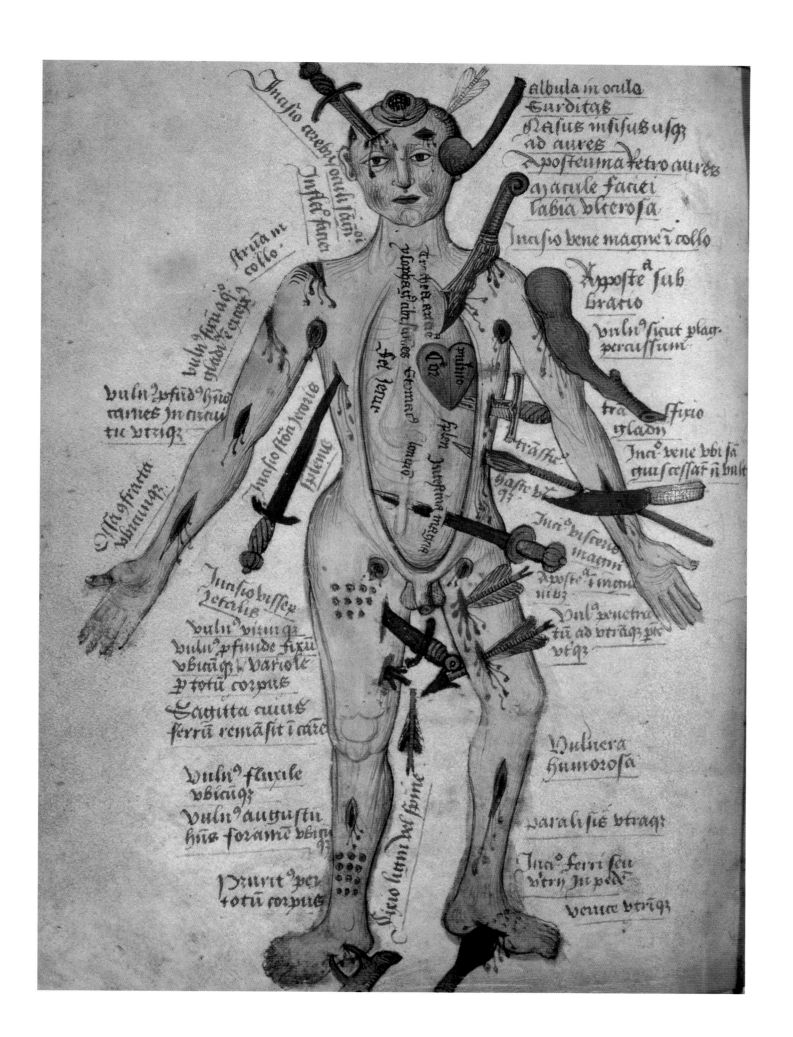

If breath is the most recognizable sign of life, pinkness has always been regarded as one of the most reliable indications of health. We instinctively associate redness with vitality, and automatically assume that anyone with a ruddy complexion or red lips is vigorous and robust. The vital importance of blood has always seemed self-evident; from the earliest times man was aware that "this pure cleare lovely and amiable juyce is the special thing that conserveth every living creature in his being and ... that this treasure of life must most carefully be conserved because it is of all humors the most excellent and wholesome."

For such reasons blood has always been regarded as a form of natural wealth: a rich liquid asset settled on each individual as a birthright, a priceless deposit that can neither be spent nor accumulated, only lost or dispersed through injury or ill health. There are no plutocrats, only paupers. Adequacy is abundance.

Blood: The pure, clear, lovely, and amiable juice
Jonathan Miller

Perhaps the most dangerous consequence of injury is the loss of blood. The efficiency of the heart and of the circulation depend on the maintenance of an adequate blood pressure, or fluid volume, and, if more than a pint or two is lost in a short space of time, the system goes into a state of almost irreversible hydraulic shock. It is like a rubber syringe that, if it is filled and then squeezed, produces a powerful jet of fluid; but if the bulb is not replenished the jet becomes feebler at each succeeding squeeze, and eventually the pressure falls below the level where it can overcome the resistance of the tubes through which it has to pass. In the body, if this happens faster than the system can replace the loss, certain vital organs begin to fail for want of oxygen and nourishment. The most delicate organ, the brain, fails first—which is why people feel faint and lose consciousness when they lose blood rapidly. Further loss endangers the kidney, which needs a high head of pressure to perform its essential function.

Therefore, when all strategic and tactical measures have failed—when the skin breaks in spite of prudence, cringing, wincing, and flinching—it is essential to have standby mechanisms that stop the flow of blood at the earliest possible opportunity.

One of these is the reflex shrinkage of the cut vessels themselves. Arteries, in particular, which have a thick muscular wall, can automatically shut down and limit the outflow. This is reinforced by an elaborate response on the part of the blood itself. Through a complex chemical mechanism, certain proteins in the blood are automatically transformed when they pass over a damaged surface. At the site of the injury, a skein of elastic fibers is woven in the blood. This rapidly forms a clot, which organizes itself into a plug, preventing further bleeding. Although there are limits to the effectiveness of the plug, it deals adequately with most of the minor causes of blood loss. People whose clotting mechanism is impaired run the risk of harmful if not lethal bleeds unless they avoid the normal hazards of life. The hereditary disease known as hemophilia

1. Marcello Malpighi, *De pulmonibus observationes anatomicae*, Bologna, 1661, illustration of frog lung, showing capillaries, EPB MSL/D/MAL, London, The Wellcome Institute, Early Printed Books Collection

Malpighi was among the very first scientists to use the newly discovered microscope to investigate the body

2. Albert Wilhelm Hermann Seerig, various types of bloodletting instruments, 1838, lithograph, Washington, DC, National Library of Medicine

3. Guillaume van den Bosch, woman applying a leech to her forearm, 1639, woodcut, Washington, DC, National Library of Medicine

is the most famous example of such a condition, but there are many chemical factors involved in successful clotting, and hemophilia is only one of a number of "bleeding diseases."

Blood requires just as complicated a mechanism to prevent it from clotting as it does to make clotting occur. If it clots spontaneously, which is what happens in patients who lie sluggishly in bed after an operation, and is also one of the recognized risks of the contraceptive pill, the person runs the risk of plugging his or her own circulation from the inside. The clotting mechanism has to be in a state of hair-spring readiness so that it can provide a clot at the moment of injury and no later, but it must also have an elaborate fail-safe device that prevents it from being launched inappropriately. Although normal clotting is punctual and self-limiting, it prevents bleeding only in vessels where the pressure is comparatively low: in a major artery the clot is dislodged as fast as it forms and, unless a tourniquet is applied, the patient runs the risk of bleeding to death. The body is unable to stop a major hemorrhage, but up to the last moment it strenuously adjusts itself to the continuous loss by a process of reallocation. As the blood pressure starts to fall, organs that have a less urgent need for oxygen and nourishment are put on short rations: the arteries, which let blood into the skin, for instance, shut down and limit the blood flow, shunting it to the more vital parts of the circulation. This is why patients with hemorrhage go white and feel cold to the touch.

In the early stages of hemorrhage these and other compensations are quite successful, but if the loss continues, or if it goes faster than it can be artificially replenished, it eventually overwhelms even the most stringent acts of redistribution, and the patient goes into the state known as shock. This should not be confused with the anxiety and mental distress that go by the same name. Surgical shock is what happens when the process of compensation fails to keep up with the rate of blood loss—when the heart can no longer maintain the pressure needed to irrigate the vital organs, and the circulation begins to collapse. The patient is deathly cold to the touch, his pulse becomes rapid and thready, and his blood pressure drops to the point where it becomes unrecordable. The circulation is now powerless to maintain itself by differential shrinkage, and unless the blood loss is replaced artificially by a transfusion the shock becomes irreversible: either the patient dies or his kidneys and brain suffer irreparable damage.

Shock is the consequence of an underfilled circulation. In the first instance at least, the system is failing for want of volume, and the most important priority is the restoration of fluid bulk. If the loss is sufficiently slow, the body can do this on its own behalf by diluting the blood. Fluids are withdrawn from the tissues; there is an automatic reduction in the output of urine and an increased intake of water by the mouth—hemorrhagic patients are characteristically thirsty.

If the patient survives the period of shock, the volume of circulating blood returns to normal within twenty-four hours of a serious hemorrhage. But the rate at which new cells can be manufactured is much slower than the speed at which fluid can be restored, so the blood count is much lower than normal. Instead of having 5 million cells per cubic millimeter, the patient may have only 3 million: his blood pressure may be adequate, but he is now anemic. The process does not stop there, however: anemia acts as a stimulus to the tissues

4. Daniel Ricco, zodiac man, 1690, woodcut,
Washington, DC, National Library of Medicine

that produce new red cells. The marrow of such a patient begins to pour out more than the usual number. This process is elegantly self-limiting: the more successful it is, the less need there is for subsequent production, and when the red cell count has been restored to its normal level, the activity of the marrow subsides.

It does not, however, subside to zero. The only reason why the marrow is able to make up for unexpected losses of circulating red cells is because it is busily engaged in replacing the chronic losses of the normal circulation. The reaction to hemorrhage, therefore, is like the light touch on the accelerator of a rapidly moving car. Similarly, the way in which the blood vessels react to hemorrhage is indistinguishable from the variations by which they compensate for the normal stresses of daily existence.

The most immediate threat to life is not shortage of blood, as such, but an inadequate volume of fluid. In the first stages of hemorrhage, when the circulation falters for want of sheer bulk, the doctor's first task is to reprime the pump before its mechanics fail irreversibly. The administration of plasma —the straw-colored fluid in which the red cells float—or plasma substitute, is an acceptable stop-gap in the early stages, since it imitates the natural tendency of the body to restore the bulk of the blood at the expense of diluting it. But the transfusion of whole blood is obviously the treatment of choice, since it telescopes the two phases of natural recovery, restoring both the quantity and the quality of what has been lost.

Medicine took a great leap forward when William Harvey discovered the way in which this precious substance circulated and recirculated through the body of the living individual. Unlike the wealth of a miser, which accumulates without its doing any useful work, the value of blood can be exploited only if it is kept ceaselessly on the move. It is useless when stationary, but it is beyond price as long as it visits and revisits every part of the body. How does this treasure work? In what currency are its transactions conducted? What are its denominations? Such questions would have made no sense to Harvey, for the value of blood was self-evident, and since he regarded it as indivisible the very suggestion that it might have denominations would have seemed absurd. But if you take

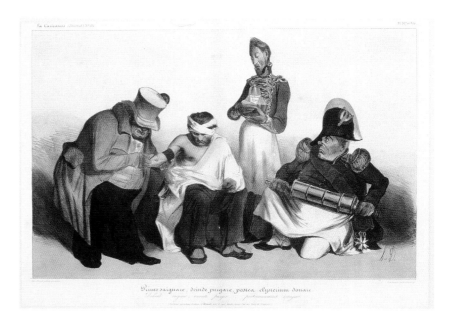

5. Honoré Daumier, "Primo saignare, deinde purgare, postea clysterium donare," ca. 1840, lithograph, Washington, DC, National Library of Medicine

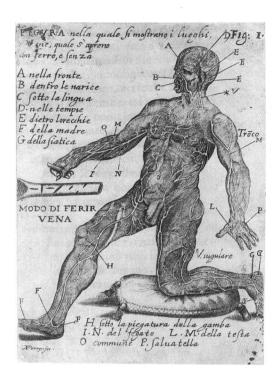

6. Cintio d'Amato, vein man, 1671, woodcut, Washington, DC, National Library of Medicine

a spot of normal blood, spread it in a thin film and examine the slide under a microscope, you can immediately see that the fluid has a texture. It is not just a uniform pink substance: there are millions of tiny pink particles. And if you flood the slide with a special stain, the picture immediately springs into sharp relief. The field is crowded with flat pink discs, all of which are the same size, shape, and color. Blood, it seems, is a population, and the redness is confined to the millions of cells that crowd the field from side to side—the featureless, yellow fluid in between is quite empty.

If this film is compared with one taken from a pale, anemic patient—say, from a pregnant woman who has not been eating the right diet to satisfy the iron requirements of her growing child—certain differences are immediately apparent. All the cells are different sizes, and the color of each seems to be much less intense than it is in the normal film. Is the paleness of the cells enough to explain the pallor of the patient, or are there also fewer cells than there should be? Is this under-populated blood, or blood with an under-colored population?

Modern hematologists can distinguish many different types of anemia: ones where there are fewer red cells than usual, although each cell has a normal size and color, and ones where each cell is the wrong size and the wrong color. There are many combinations of error, each one of which has a different cause, and each of which produces a distinct clinical picture. For the hematologist, the anemic patient is sometimes pale, but invariably interesting.

Such an interest would have mystified the scientists of the seventeenth century. As far as they could see with the naked eye, blood was a simple, homogeneous red fluid—a ruby flood. And even when the newly invented microscope showed that there were millions of particles floating in it, it was more than two hundred years before anyone recognized the need to count, measure, classify, and name these. Such indifference was partly the result of the poverty of the primitive microscope. Until the middle of the nineteenth century, lenses were so crude that they were incapable of resolving a clear image. The images seen down such early microscopes were so blurred that it would have been impossible to distinguish misleading artifacts from interesting structures.

But it is not simply a question of bad optics. It would be wrong to assume that if a seventeenth-century scientist had been given the opportunity of looking down a twentieth-century microscope he would automatically have discovered the existence of red blood cells—even if he had happened to use that word to mention what he had seen. As it happens, the English scientist Robert Hooke did apply the word "cell" to the little compartments which he saw when he turned his lenses on to thin slices of cork and elder pith, and, since the appearances which he mentioned do in fact coincide with the entities we now call cells, it could be said that in a sense Hooke "discovered" them. But it could equally be said that he did nothing of the sort.

Words or names are not simply straightforward labels stuck on to items of luggage in the natural world, and the mere fact that two people apply the same word to the same visual experience does not mean that they are referring to the same thing. Names are alternatives to an elaborate and often long-winded description of the thing they mention or refer to, and the description that one man has in mind when he uses such a word may be altogether different from the one someone else is thinking of. For a seventeenth-century microscopist, the word he used to describe what he saw down his microscope would refer

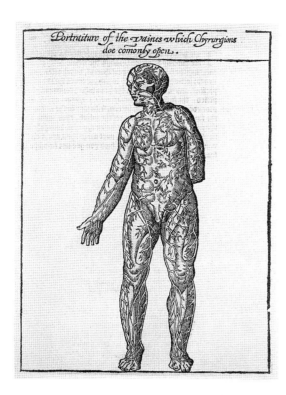

7. Peter Lowe, "Portraiture of the vaines, which chyrugions doe comonly open...," 1612, woodcut, Washington, DC, National Library of Medicine

to its appearance and little more, whereas when a twentieth-century scientist identifies something as a cell, he is recognizing what he sees as an instance of something that has properties over and above the ones which can be detected at that particular moment. In fact, his belief in the existence of these properties may be so strong that it actually shapes and alters the appearance of what he sees.

Good visibility, then, may be a helpful condition for making discoveries, but it is neither necessary nor sufficient. If someone already knows what he is looking for, he may recognize it even when the visibility is appalling: but if he has no preconceptions of what to look for, he may misconstrue or completely ignore what he is looking at.

These are some of the difficulties associated with looking at a blood film down a microscope. Unless you were already familiar with the modern notion of cells and all that the word implies, you might not attach any importance to these pink blobs, and unless you had good reason for knowing that they ought to look sharp you might accept their fuzziness as part of their natural appearance. When it came to naming or labeling what you had seen, the word you chose would almost invariably convey theoretical notions about what sort of object it was. For instance, the word "globule" might be used. But although such a word is much more noncommittal than "cell," it still has overtones of identification. Globules of what? Strictly speaking, the word means nothing more than "spherical," but it is usually applied to particular sorts of substances and is not quite as noncommittal as its etymology suggests—by long association the word "globule" implies fat or oil, so that when it is applied to the pink patches that appear in a blood film, it calls forth all sorts of associations that may or may not be justified. On the other hand, if you lived in a world that was entirely made up of perforated sheets or membranes, you would probably see this film as more of the same—as a brilliant white surface punctured with holes through which you could just see vistas of a pink beyond.

Everyone approaches the world with ontological assumptions, confident presuppositions about what there is. According to one philosophical view, the universe is a vast array of nameable things—rocks, lakes, mountains, clouds, and people; teacups, clock faces, and soup spoons—although other philosophers insist that the universe is really a single, indivisible whole. There is the ancient idea that the universe has nothing in it but basic elements—substances that shape themselves into an infinite variety of transient forms. There are those who insist that even substances are an illusion and that the only knowable things are certain palpable qualities—wetness, dryness, coldness, and heat. The most abstract idea of all is the one which says that the only real things in the universe are arithmetical numbers: unity and zero, twoness and trinity, duets and quartets.

These theories are not necessarily incompatible. The scientists of the early seventeenth century inherited a curious hotch-potch of such ideas from their Greek predecessors, and when they looked at blood they interpreted what they saw and saw what they looked at in the light of these assumptions. Blood to them was a simple, irreducible substance—one of four primary fluids that duplicated in the human body the natural elements of the physical world. For more than two thousand years, European scientists had been enchanted by the Ancient Greek theory of the four elements that, mixed in various proportions, could produce any of the known forms of physical matter.

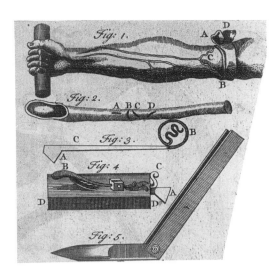

8. Instructions on how to let blood, 18th century, engraving, Washington, DC, National Library of Medicine

This theory combines three of the ontological notions I have just mentioned. It suggests that the world is composed of substances rather than things. It implies that these substances—earth, air, fire, and water—express the qualities of cold, dryness, heat, and wetness. Fire, for instance, was the elemental expression of hotness and dryness, whereas earth was the result of mixing coldness and dryness. Finally, it celebrates the arithmetical number four, a digit that has always held a peculiar fascination, recurring in all sorts of familiar, symbolic quartets —seasons, winds, times of the day, points of the compass, and ages of man.

Since the Greeks regarded man as a small replica of the natural world, they assumed that each of the four elements would be represented in the living body. The Hippocratic authorities claimed that there were four physiological fluids or humors: blood, phlegm, and two forms of bile—one yellow and the other black. Blood corresponded to air and expressed the combined qualities of heat and wetness; phlegm duplicated the element of water, since it was cold and wet: yellow bile or choler corresponded to the dry heat of fire, while the cold dryness of earth was represented by black bile or melancholy. Health depended on the equal proportion of these four humors, although a perfect balance was never found in any living individual—Christian writers assumed that they had never recovered their equal representation in the human body after the Fall of Adam. Slight disproportions produced the familiar variations of the so-called temperaments: a modest excess of yellow bile made a man irritable or choleric; a slight imbalance in favor of black bile caused the melancholy temperament; a surplus of the cool wet humor made a man stolid and phlegmatic. A vast excess of any of the four humors, however, led to recognizable disease.

For obvious reasons, blood was regarded as a privileged member of the quartet, and the sanguine temperament was looked on with special favor. When William Harvey reconsidered the matter in the middle of the seventeenth century, he disregarded the other three humors, insisting that blood alone was the sovereign principle of life:

> It is unquestionable and obvious to sense that blood is the first engendered part when the living principle in the first instance gleams forth. We conclude that blood lives of itself and that it depends in no wise upon any parts of the body. Blood is the cause not only of life in general but also of longer or shorter life, of sleep and of watching, of genius, aptitude and strength. It is the first to live and the last to die.

To some extent, Harvey had arrived at this conclusion as a result of his famous investigations on the developing chick, when he mistook the pulsating embryonic heart he saw for a pounding spot of blood and attributed the pulsation to the blood's innate liveliness. He regarded blood as a pure substance, recognizing at the same time that it was imbued with a volatile principle that would evaporate as soon as it was shed:

> When this living principle escapes, the primary substance of blood is forthwith corrupted and resolved into parts. First into cruor or gore ... afterwards with red or white parts. And of these parts some are fibrous and tough, others ichorous and serous in which the

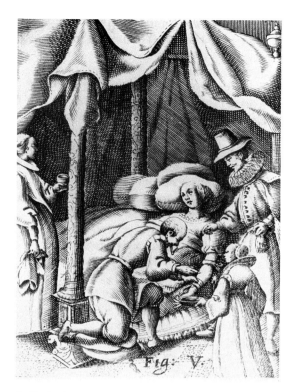

9. Cintio d'Amato, venesection of a female patient, 1671, woodcut, Washington, DC, National Library of Medicine

mass of the coagulum is wont to swim. But these parts have no existence severally in living blood, and it is only in that which has been corrupted and resolved by death that they are encountered.

Harvey's view of blood bears a remarkable resemblance to the eucharistic view of communion wine.

The invention of the microscope a few years later showed that the situation was somewhat more complicated than he had supposed. Blood was seen to have a texture: it had parts; it was several; it was plural. But this discovery did not lead to the recognition of cells, and there is no reason why it should have. Scientists still believed that the body was made out of primary substances, and the fact that one of these substances was now shown to have a texture did not significantly undermine their basic assumption. Presumably, it was no more remarkable than finding through a telescope that a wall was made of bricks rather than being a single mass of baked clay—or that a tapestry is composed of separate stitches, or that a mosaic portrait is made of colored tiles. But when a modern biologist looks at a blood slide, he sees it in an altogether different way. He regards living organisms, man included, as a republic of cells—an orderly multitude of separate living individuals assuming the form of a single person. Oddly enough, less than ten years before Hooke began to use his microscope, the political philosopher Thomas Hobbes had represented society as a great Leviathan in which a multitude of individuals acted together as a corporate person. But it was two hundred years before this metaphor was usefully applied to the body of the living individual. In 1858 the great German pathologist Rudolf Virchow declared that

> The structural composition of any living body of considerable size, a so-called individual, always represents an arrangement of a social kind in which a number of individual existences are mutually dependent but in such a way that every element has its special action.

Such components do not spring into existence spontaneously, nor do they crystallize from a uniform substance. Less than a year after the publication of Charles Darwin's *The Origin of Species*, Virchow announced a fundamental principle that we can usefully regard as the origin of individuals:

> We no longer have any reason to accept the idea that a new cell can arise from a non-cellular substance. Whenever a cell arises, there a cell must previously have existed. Throughout the living world, plant or animal, whether in part or whole, there is a law of continuous development. All developed tissues can be traced back to a cell.

The objects to be seen on a microscope slide, therefore, are related to one another not like bricks or pots that have been molded from the same piece of clay and then fired together in the same kiln, but like brothers and sisters who share the same parents and descend from the same ancestors. According to Virchow's principle, every cell must have a parent. Where are they to be found?

In order to economize on the use of materials, to keep the mechanics as light as possible, vertebrates have evolved hollow bones with all the structural elements arranged around the edge. The hollow space is occupied by a red marrow, and this is the nursery of the blood. In a spongy maze of blood vessels, there are islands and archipelagos of tissue, representing infant blood cells in various stages of their development. Among these, it is possible to distinguish the so-called stem cells, from which the red blood corpuscles take their origin. Each of these stem cells continues to multiply and duplicate offspring, which in turn divide further. But the products are not immediately released into the bloodstream; the offspring have to mature and acquire the correct amount of red pigment, and this process is not complete until several successive divisions have taken place. At each division, the young cells shrink and become progressively redder, and at the moment when they are about to enter the bloodstream they lose their nucleus. They are now ready to be enrolled as fully fledged members of the circulation. Here, they have a short, useful life, which lasts about 120 days. Then, like sputniks in orbit, they run out of fuel, become fragile, drop out of orbit, and are retrieved and scrapped by scavenger cells situated in the liver and the spleen, which strip them there of scarce and valuable components such as iron, which are recycled for the manufacture of fresh cells.

This process may be interrupted or upset at any stage, and each type of interruption produces its own recognizable type of anemia.

The stem cells may be destroyed by poisons, drugs, or radiation, so that the whole process is aborted at the outset. Red cells no longer enter the circulation fast enough to make up for the ceaseless process of exhaustion. As the normal rate of drop-out continues, the blood count falls progressively, and the patient begins to suffer from what is called aplastic anemia.

Production of red cells may also be held up for want of essential ingredients: iron, proteins or vitamins. When iron is in short supply, the cells are characteristically smaller and paler than usual. If the patient is unable to absorb Vitamin B12, he or she develops the characteristic picture of pernicious anemia, in which the cells are larger than usual and have anomalous shapes.

In the so-called hemolytic anemias, the cells are destroyed at a much more rapid rate than usual, either because they are congenitally fragile, as in the sickle-cell disease found among black Africans, or because the bloodstream contains destructive substances, the commonest of which are the antibodies found in rhesus incompatibility (the RH factor).

Each of these anemias produces its own characteristic pattern of clinical symptoms. But one duet of symptoms is common to almost all of them, and the consistent recurrence of these two helps to explain one of the most important functions of blood. Seriously anemic patients are always pale and almost invariably breathless. Why should the color of blood be associated with the appetite for air?

Towards the end of the nineteenth century—by which time the chemistry of organic substances was undergoing detailed analysis—pathologists successfully identified the pigment contained in the red blood cells as a substance that they called "hemoglobin." Within a few years it was demonstrated that this pigment had an unusual capacity for picking up oxygen when exposed to the air and for yielding it up again when exposed to the tissues that required it. The color of blood, it seemed, was more than a cosmetic feature designed

to keep roses in the cheeks: it was a transport mechanism, mediating between the air and the tissues. The red cells were oxygen rafts, and that was the main reason why blood had to be kept on the move, had to circulate.

When Harvey discovered the circulation of the blood, he regarded the movement as the just and equitable distribution of a natural treasure. He had no understanding of its underlying value, and, even though his immediate successors showed that the circulation had something to do with the distribution of a substance snatched from the air, it was more than two hundred years before anyone realized what this substance was and how it was carried. Now that we know the essential function of oxygen and how it is ferried to and fro by the red corpuscles, it is easy to understand why breathlessness is so frequently associated both with pallor and with blueness. In both cases, the tissues are suffering from lack of oxygen, and in breathing more strenuously the body is automatically trying to compensate for the shortage. If this compensation fails to accomplish its task, the regeneration of ATP—the energy source of the cell—is seriously endangered, and the tissues that depend upon this energy reserve begin to fail. The patient may start to feel muscular pains or become aware of the exertion necessary to breathe, and in severe cases there may even be angina, as the heart begins to asphyxiate.

At this point a vicious circle is established: as the oxygen shortage becomes more acute, the heart begins to beat faster in the effort to distribute what little oxygen there is. But since these increased efforts also involve the expenditure of energy and, therefore, the demand for oxygen, the whole system starts to pursue a downward spiral. In the face of such deterioration, the compensatory resilience of the body is both defeated and self-defeating, and a fatal outcome can be prevented only by identifying the factor that is responsible. In the case of anemia, the cause must be identified and corrected—the missing iron or vitamins restored. If the patient is blue, the factors preventing him from being red must be recognized. The management of pathology presupposes the understanding of physiology.

Just as the heart and lungs attempt to compensate for the failure of the blood, healthy blood can compensate for failures of the heart and lungs. When lung disease frustrates the intake of oxygen, the bone marrow, operating on the same homeostatic principle as the respiratory center in the brain, makes up for the shortage by multiplying the birthrate of new red cells and sending them into circulation to snatch whatever oxygen is available. Patients with chronic bronchitis and emphysema, for example, are often found to have a raised red-cell count: there may be as many as 8 million cells per cubic millimeter, as opposed to the 5 million found in normal blood.

A shortage of atmospheric oxygen produces the same effect. At high altitudes, respiration automatically deepens in the attempt to compensate for the smaller amount of oxygen contained in each normal breath. This is, however, a relatively inefficient adaptation: the subject is usually distressed by the strenuousness of his own breathing, and the extra muscular effort consumes so much oxygen that it tends to defeat its own purpose. If the subject stays in such a thin atmosphere for more than a few days, the body must undertake a more rewarding form of acclimatization. After a few weeks, the blood therefore begins to show a recognizable increase in the number of circulating red cells, and by the end of six months the count may be as high as 10 million cells per

cubic millimeter. The extra hemoglobin that is now circulating through the lungs guarantees an effective uptake of what little oxygen there is, which relieves the respiratory center of the full burden of compensation. This is why a new arrival in the Andes is prostrated by breathlessness while the local inhabitants are able to do heavy work and even play football without any sign of respiratory distress.

Such a high blood count is an expression of furiously energetic activity on the part of the bone marrow. But since the extra output is superimposed on a comparatively high level of normal activity, the achievement is not quite as impressive as it seems. The blood is constantly renewing and turning over the circulating population of red cells. Each cubic millimeter loses more than 20,000 of its 5 million cells every 24 hours. The output needed to compensate for such wastage is so enormous that it takes only a comparatively small bulge in the birthrate to raise the count by the amount I have just mentioned. As with so many of the processes by which the body adjusts itself to occasional threats and stresses, the activity is no more than an amplification of the one by which normal function is maintained. Like the skin and the intestine and all the other tissues whose cells retain and exercise the ability to go on dividing, the bone marrow continues to grow throughout adult life. But since the chronic wear and tear keeps pace with the rate of multiplication, the growth does not result in an increase in size. Nevertheless the process is identical with the one by which the creature does enlarge and achieve its mature form. So in a very important sense the maintenance of the structure is simply a continuation of the method by which that structure first came into being. Maturity is the point at which a balance is struck between growth and decay.

This immediately raises the question: why is the creature not immortal? If so many of its tissues are capable of renewing themselves, and if by amplifying these processes they are capable of repairing all but the most overwhelming injuries, why does life not continue indefinitely? There are two possible answers to this question. First, not all tissues do retain the capacity for unlimited growth; the cells of the nervous system, for example, cease to divide once the mature structure has been achieved, and whenever cells reach this stage they begin to accumulate uncorrectable metabolic errors. Although the body can accommodate itself to a certain number of these failures, there comes a point when the system as a whole is so incoherent that the homeostatic capacities begin to falter, and the creature becomes fatally inefficient. Second, the retention of cell division is not quite such an effective guarantee of immortality as it was once thought to be. Biologists such as Alexis Carrel in the earlier part of the twentieth century originally claimed that any cells that retained the capacity to go on dividing were potentially immortal and any tissue that was made up of such cells automatically renewed its vitality by multiplying fresh offspring.

This is now known to be untrue. There appears to be an upper limit to the number of times any cell can reproduce itself, and modern biologists are beginning to suspect that senescence is built into the biochemical instructions of the living cell, and that the ability to divide and reproduce is just as susceptible to metabolic error as all the other functions. If this is so, we must regard death as an intrinsic feature of life and not merely an unavoidable interruption of it.

But our reappraisal of the situation may have to be even more radical than this. We tend to think that birth and reproduction are nature's way of overcoming

death, whereas it may be that death is nature's way of giving free rein to the creative opportunities offered by birth. If all creatures were immortal and preserved the same functions and abilities throughout their endless lives, they would preempt the possibility of improvement or adaptation. Sexual reproduction, however, gives the species the recurring opportunity of bringing together unprecedented combinations of genetic material, and, with the further novelties that are added by mutation, the species can audition untried newcomers. In the absence of senescence and death, these young hopefuls would enter an overcrowded stage. By modest withdrawal from the scene one generation acknowledges and gives way to the unforeseeable talents of the next.

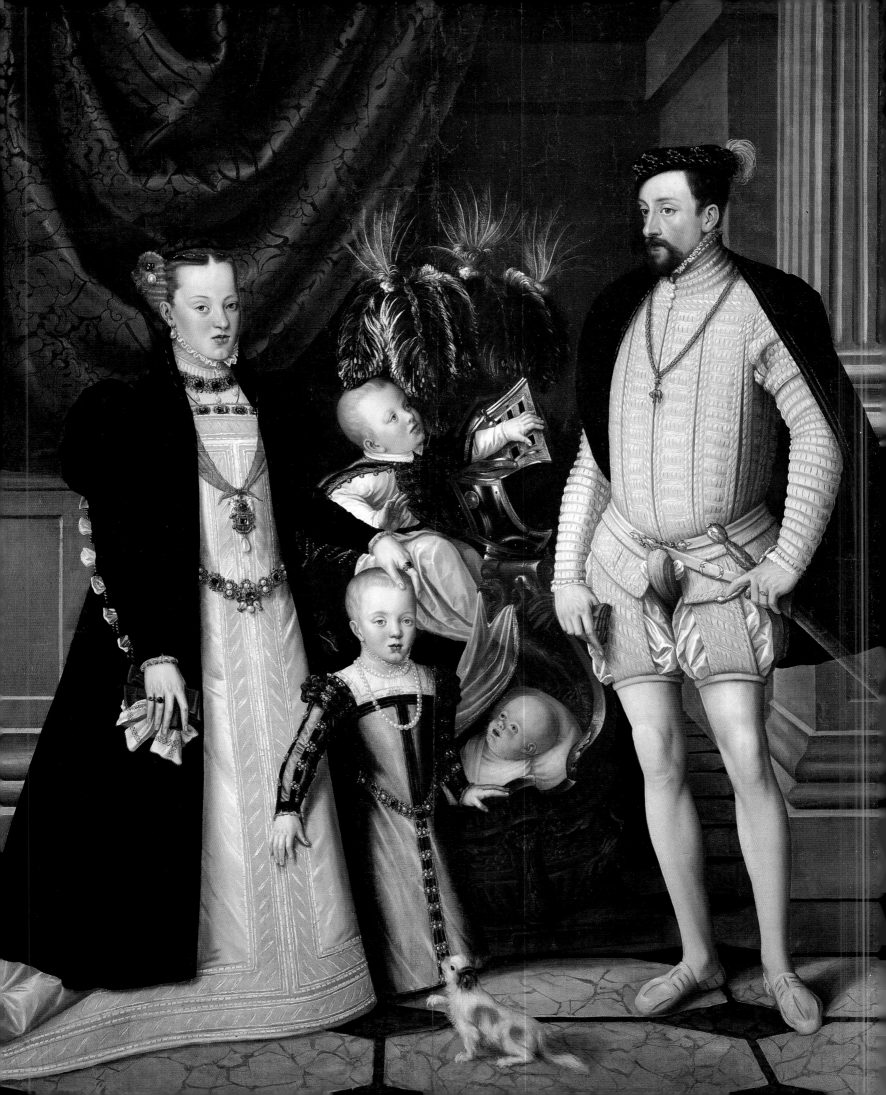

In the late Middle Ages, when the Habsburgs first entered the arena of power, their marriage policies were no different than those of other European dynasties, that is, their primary motive was to increase their power. But what was the spiritual, moral, or ideological justification?

European politics as such, which ultimately led to division into states that exist today, has its origin in the establishment of Germanic tribal rule in the territories of the West-Roman Empire as a result of the migration of peoples from the East. To begin with, we must fully appreciate the far-reaching consequences of this historic event, which took place during the fifth century, and was consolidated by the beginning of the sixth century.

"The predestination of our Habsburg dynasty": Habsburg marriage policies and the phenomenon of "pure blood" in European dynasties
Georg Kugler

The Ostrogoths conquered Italy, the Visigoths usurped southern Gaul and the northern part of the Iberian Peninsula, while the Sueves and Vandals occupied the southern and western sections of the peninsula; the Vandals set off in a different direction and conquered the islands of the western Mediterranean as well as the Roman provinces in North Africa; Burgundians and Franks reigned in Gallic territory. To the north and east, in what would later become East-Frankish, i.e., German lands, Frisians, Saxons, Thuringians, Alemanni, and Bavarians established domains of their own, which were exposed to the threat of advancing Slavs. Angles and Saxons crossed to Roman Britain, opposing the Danes and Normans crossing the North Sea from Scandinavia and Normandy.

The Bavarians pushed south, reaching the foothills of the Italian Alps and the Adriatic, where they were stopped, on the one hand, by Venice, the sole republic of the millennium, and by the Lombards, who had settled in northern and central Italy as successors to the Ostrogoths.

The Byzantine Empire retained the upper hand in southern Italy and along the Mediterranean coast until it was forced to cede most of its power to the Islamic Caliphate, which also conquered the Visigoth Empire in the early eighth century AD. Celtic tribes—the Irish, Scots, Bretons, and Basques—were able to maintain their independence on the periphery of Europe.

The population of Roman settlers, Greeks (Middle Eastern), and Celts far outnumbered their Germanic rulers in all these empires in central, western, and southern Europe. They tilled the fields, ensured the flow of goods, and practiced their crafts and trades. Members of the former upper class also retained their important posts in the supra-territorial Church. Thus the population was supporting the state, yet at the same time alienated from it, and excluded from participation in government or military service. Only members of Germanic royal clans and their heirs (*stirpes regiae*) held power—indeed, they ruled for nearly a millennium, for they retained their uncontested positions even after Charlemagne had conquered, occupied, and finally usurped a large part of their domains.

1. Giuseppe Arcimboldo (1527(?)–1593), *The Future Emperor Maximilian II and His Family*, before 1564, oil on canvas, Vienna, Kunsthistorisches Museum

2. Chalice of Emperor Frederick III, silver, gilt, 1438, Vienna, Kunsthistorisches Museum

Although Charlemagne's empire is understood as the result of *translatio imperii*, that is, a revival of the Empire of Antiquity, it had little in common with the ancient Roman Empire. Europe, however, could in subsequent centuries quite legitimately point to him as the first Emperor of the West while the Frankish-Germanic kingdoms and the ruling aristocracy continued to exercise their control over Europe.

The division of the Carolingian Empire among Charlemagne's heirs sparked a process of territorial fragmentation in the kingdoms of the West-Franks, Burgundians, East-Franks, and the Italian Empire. Political life was defined by regional prerequisites and individual ambitions, while daily life was shaped by personal, or rather, family feuds, predatory raids, and military campaigns. Bravery was the noblest virtue, experience in battle the aspiration of every ruler. The Church practiced the earliest critique of this truly heathen attitude by launching a peace movement at the turn of the first millennium. Peace in God (*Pax Dei*) was declared to protect individuals and towns against the anarchy of the feudal system.[1] Needless to say, the autocratic rulers took little notice, unless they saw some profit for themselves.

From the twelfth century onward, territorial expansion was the principal counter movement to the continual division of property.[2] To prevent further fragmentation through inheritance, royal houses instituted laws on hereditary succession, and marriage contracts between dynasties were made in the interests of power politics. Family connections became more crucial for political history than ethnic, geographical, or economic factors. The European territories developed into areas of dynastic rule. This development called for a structured system of relationships, most importantly, the adherence to strict marriage contracts or the preferred status of the first born.[3]

The Church also reacted to these developments by passing new laws on incest at the Lateran Council of 1215. Papal dispensation had to be obtained for marriage between partners who were too closely related (second cousins)—a restriction not without political significance.

Military conquest was a proven means of increasing territorial power, but marriage and succession offered peaceful alternatives. The two methods were closely linked: marriage contracts were frequently components of a peace agreement and put the seal on the intention to terminate a war; on the other hand, the same contracts were frequently challenged or ignored when the time for establishing succession arrived. Lands to which dynastic claims were made had to be taken—or at least retained—by force of arms.[4]

The hegemonic aspirations of the dynasties led to national conflicts. Clashes erupted not only along mutual borders, but also at distant sites, owing to alliances that had been forged beforehand.

Among the multitude of competing dynasties, a few achieved leading positions and laid the foundations for early modern European states by amalgamating several territories.

What was the dynastic principle, this reliance on the nation-building and empowering force of marital alliance between members of certain royal families, families who became ever more closely related from generation to generation?[5]

Equality of rank or birth as a guarantee of continuing the line of "royal blood" was a tradition among the Germanic tribes. Their descendants controlled Europe for almost a thousand years. It was in fact a small group that claimed

3. Berhard Strigel (1460–1528), *Emperor Maximilian I and His Family*, 1515, oil on panel, Vienna, Kunsthistorisches Museum. Photo: studio milar, Vienna

direct descent from Germanic rulers right up to the threshold of the modern era. The rulers married only blood relatives in all aforementioned territories established in the former Roman Empire, but also in Scandinavian countries, where the Vikings set out to establish what would later become Russia and expanded their rule to the French coast, southern Italy, Sicily, and the Middle East. For this purpose male and female relatives held equal rank. Geography played no part. We can trace the migration of Burgundian princesses to Spain well into the High Middle Ages, that of Spanish princesses to Central Europe, Lombard princesses to France, English ones to the Continent, and even down to Sicilian, Russian, and Scandinavian ones to all West and North European countries. The European ruling class developed a powerful sense of a common bond not only through countless marriage connections, but also by a constant stream of correspondence and untiring travels. No measure of wealth could help any upstart in trying to connect with these high-born, even if some had neither much power nor land. The offspring of illegitimate unions were demoted to the "lower rank."

The heathen concept of "demigods" persisted in Christian Europe, transposed from mythology into state law. Even far into the modern era, the most important dynasties maintained their claim to descending from Germanic heroes (i.e., heroes from Antiquity), demigods, even pagan gods; indeed, kings had to prove their descent to their own courts and subjects. The genealogies of all medieval German kings and emperors, all English, French, Spanish, and Polish kings, as well as those of the Guelph, Ascanian, Babenberg, Brandenburg, Thuringian, Lorraine and Zähringer families, prove the effectiveness of these unwritten rules of a hereditary European nobility based on bloodline.[6] The family tree of Saint Louis of France (1226–1270) contains only one non-Germanic ancestor in seven generations of 128 ancestors. To understand the exclusivity maintained by this ruling class, we need only follow the genealogical "career" of Saint Louis. He figures over one hundred times as an ancestor of King Henry IV of France (who lived 350 years after him) and approximately 100,000 times as an ancestor of the present head of the now defunct royal house of France. And when we learn that the Habsburg Emperor Maximilian I is listed nearly five hundred times in the genealogy of Queen Beatrix of the Netherlands, we may understand how the seemingly insurmountable religious barriers were cast aside when a dynastically important marriage was at stake[7]—a phenomenon usually ignored in general studies on history.

All European royal houses and ruling classes also have a few Celtic ancestors from Scottish and Breton families; another few dynasties have some Middle Eastern ancestors due to marriages with Greek princesses. One notable example is the marriage of Otto II to Theophano. In the thirteenth century, the last of the Babenbergs actually had more Hungarian and Greek blood than German, though it must be remembered that the Babenbergs reigned in a border area like the Spanish dynasties, who even married Moorish princesses.

Changing times: Newcomers marry in to the aristocracy

During the thirteenth century—even earlier in Italy and France (twelfth century)—drastic changes took place in the way people lived together, first in urban centers and then at court. In Italy the Church was the first to breach the unyielding laws of equality of rank. This move occurred at a time when the Church sought to

4. Hans Schöpfer (b. 1610), *Archduchess Maria,*
Married at the Age of Thirteen, **oil on canvas, 1564,**
Vienna, Kunsthistorisches Museum. Photo: feilfoto,
Axams

dispel Germanic, that is, heathen elements from its institutions, in particular the aristocratic prerogative of marriage for priests, and the occupation of the most important dioceses, abbeys, and other lucrative church benefices. The political consequence was that the popes and Lombard towns engaged in battle with German kings and emperors. The *Guelphs* (Welfs) opposed the aristocracy of blood, but the *Ghibellines* (Waiblingen/Hohenstaufen) defended the order of ranks established since the great migrations.

Although these changes were not introduced deliberately within the bounds of the state and the cities, which increasingly determined Italian political life, they were nonetheless effective. The nobility began to employ jurists who were commoners as civil servants, and university professors attained prestige and power, as did the leading great merchants and bankers. Condottieri followed the example of their Germanic rulers by founding new dynasties, which ascended to positions of power. City oligarchs, the *Signori* and *Capitani* of common or peasant background, were able to claim descent from the demigods by marriage. The Gonzaga and Medici are prime examples of this strategy.[8]

These developments considerably changed the genealogical structure of the upper levels of society. Those with a bloodline very different from that of the ruling class, and which had been kept at bay and excluded for many generations, began to rise to the top. This new group rejected the "northern" conquest philosophy by a warring ruling class, replacing it with new values of communal life. These were: a written code of law, deep respect for intellectual values and for the skill and labor of farmers, an admiration of art, and public support of artists. Italy discovered its own identity and built a new realm of art. Ignoring the barbaric Middle Ages it succeeded in establishing a link to the glorious times of Antiquity. This new conception of life first reached France, then the Spanish kingdoms that were independent from the Moors, and finally England, Germany, and Hungary.

With the election of the head of their family, Rudolf, as German King, and subsequent investment with the fiefs of Austria and Styria, the Swabian Counts of Habsburg had attained the foremost rank of Princes of the Holy Roman Empire. However, that was only a political rank, not a dynastic one. They were separated from the ancient German kings not only by the political fact of the Great Interregnum, but also by genealogy. Still, the German princely electors, later simply called electors, all descended from the female line of the Ottonian royal house, and, therefore, were of equal rank to the Hohenstaufens. The secular electors were thus entitled by blood—therefore by inheritance—to elect the king.[9] The ecclesiastical electors were called to be electors by virtue of their sacred office. After the interregnum, the immediate relations of the king were greatly diminished in number. In 1273, when the leading electors delegated Frederick of Zollern to offer the crown to Rudolf of Habsburg, they relinquished the privilege of putting forward a candidate from their own dynasties on one remarkable condition: that each of them would be given one of the daughters of the new king in marriage. And thus it happened: on Rudolf's coronation day, October 24, 1273, the marriages of Duke Louis II of Bavaria with Mathilda and that of Albert II of Saxony with Gertrud (Agnes), were celebrated. In 1279, Margrave Otto of Brandenburg married the King's daughter Hedwig, and Duke Otto III of Bavaria her sister Katharina. Rudolf's daughter Guta was promised to the child king Wenceslas II of Bohemia, who held the highest rank

5. Justus Sustermans (1597–1681), *Princess Eleonore de Gonzaga (1598–1655), Daughter of Duke Vincenzo I of Mantua and Eleonora de' Medici, Portrayed as the Bride of Emperor Ferdinand II*, oil on canvas, 1621, Vienna, Kunsthistorisches Museum.
Photo: Kunsthistorisches Museum, Vienna

6. Justus Sustermans (1597–1681), *Emperor Ferdinand II, Son of Archduke Charles and Maria of Bavaria*, ca. 1635, oil on canvas, Vienna, Kunsthistorisches Museum

among the German electors. His sister Agnes was already wed to Rudolf of Austria, the youngest brother of this bevy of sisters. Politics were controlled by dynastic thinking to such a degree that even the most ancient and noble houses deemed it necessary to merge with the bloodline of the new royal house, thereby securing their claims to inheritance. The Wittelsbachs (in Bavaria and the Palatinate) and the Ascanians (in Saxony and Brandenburg) became branches of the family of the first Habsburg king. In 1298, the secular electors and their chosen candidate, Albert of Austria, constituted the entire German community of heirs to Rudolf of Habsburg! And whom had Albert taken in marriage within a year of his father's coronation? Elizabeth of Tyrol! Only historians engaged in a pragmatic search for political intentions could maintain that this was yet another example of marriage among neighbors. On the contrary. Elizabeth's mother, Elizabeth of Wittelsbach, was the widow of the Hohenstaufen King Conrad IV. This daughter from her second marriage, to Meinrad of Tyrol, was therefore a Hohenstaufen *uterina*, born from the same womb as the last of that line, Conradin.

7. Lorenzo Lippi (1606–1665), *Empress Maria Leopoldina (1632–1649), Daughter of Archduke Leopold V of Tyrol and Claudia de' Medici, Wife of Emperor Ferdinand III*, oil on canvas, 1649, Vienna, Kunsthistorisches Museum

8. Lorenzo Lippi (1606–1665), *Claudia de' Medici, Wife of Emperor Ferdinand III Portayed as Saint Christine of Bolsena*, ca. 1646/48, oil on canvas, Vienna, Kunsthistorisches Museum

Doctoring the evidence: The importance of being Habsburg

In 1077, when the German princes elected Rudolf of Rheinfelden, Duke of Swabia, as anti-king in Forchheim, they forced him to declare explicitly that his heir(s) could lay no claim to the throne. Yet some two hundred years later, the Habsburgs could assume that the election of Rudolf I, in 1273, had elevated their entire house to royal status. Still, they sought to obliterate any stigma of being upstarts, because lack of royal blood was also regarded as a political danger. The marriage bonds with high-ranking nobility were of great significance for the future—we shall return to this topic later—but it was equally important to "polish up" the lineage leading into the past. The chosen approach was by historical misrepresentation, owing to the value placed by contemporaries on "scientific," or rather, antiquarian evidence.

We need only remember the admiration heaped on Petrarch at the Prague court of Emperor Charles IV for his judgment—as reliable as it was scornful—of the forgery of the *privilegium maius*, commissioned by Duke Rudolf IV of Austria in 1359, to trace the Habsburg claims to power all the way back to Julius Caesar.

As we can see, even the first Habsburgs in Austria tried to prove their ancient and noble provenance; it is more than likely that their provident "historical researchers" were heralds of their Swiss homeland.[10] Though a family connection to the Hohenstaufens could be traced only in a roundabout way and was not conclusive, they fared better in maintaining descent from an old Roman patrician family. Lhotsky has demonstrated that the Habsburgs believed themselves to be a German branch of the Colonnas from approximately 1300 onward.[11] This connection made particular sense, because the Colonnas had insisted from the eleventh century onward that they were descendants of the Julian Emperors.

Since the Habsburgs were unable to trace their lineage to the medieval "Kings of the Holy Roman Empire," they endowed themselves with ties to a family that claimed to go back to the first "Emperor," Julius Caesar. Around 1300, family connections between Austria and Troy were also fabricated, and another version of the Habsburg legend was created—later embellished for Emperor Maximilian by Jacob Mennel[12]—to justify the genealogical claim to Hungary of the Emperor's grandson, the future Charles V.[13] By circumventing the Romans, this Trojan-Frankish origin of the first Habsburgs—legendary figures, of course—established ties between the Habsburg House and all who could indisputably pride themselves on their direct descent from the Merovingians, or rather from Charlemagne. With this tale, the Habsburgs wished to legitimize themselves vis-à-vis the French royal house as the true heirs of the Franks. The Colonna legend also demonstrated their desire to secure a connection to the medieval Popes; this goal was pursued by yet another pseudo-scientific construct. By claiming descent from the Roman patrician Pierleoni family, and thence to the ancient Roman Anicii, it was possible to include such important figures as Pope Gregory the Great and Saint Benedict in the Habsburg tribe. A family tree should display not only heroes, but saints too![14]

These stories were kept alive throughout the fourteenth century, pursued somewhat half-heartedly as long as no other lines of marriage that might promise an elevation in rank were on offer, and were finally elaborated into a genealogical-

9. Jan van den Hoecke (1611–1651), *Emperor Ferdinand III*, ca. 1645, oil on canvas, Vienna, Kunsthistorisches Museum

10. Frans Luycx (1604–1668), *Empress Eleonore, Wife of Ferdinand III as Diana*, 1651, oil on canvas, Vienna, Kunsthistorisches Museum

11. Charles Brendel, *Archduchess Eleonore, Daughter of Ferdinand III and Eleonore Gonzaga*, 1684, oil on canvas, Vienna, Kunsthistorisches Museum

historical construct by the circle of Humanist scholars in Maximilian I's circle. Artistically they were represented in manuscripts and painted family trees, culminating in the Emperor's grandiose tomb at Innsbruck.

"All the noble blood of Europe ...": The Habsburg's dynastic strategy

In the beginning, the Habsburgs found marriage partners among the old German dynasties, the Ascanians, Wittelsbachs, Luxembourgs, and finally also in the very ancient houses of Naples (Anjou), Aragon, and Portugal.

In this respect, the marriage of (Duke) Frederick I, called the Handsome, to Isabel, daughter of King James II of Aragon, in 1313, was the first significant achievement. There was no thought of attaining political advantages of power here, but rather the desire to bring the blood of these ancient rulers into the family. Isabel's mother was Blanca of Sicily, a royal Princess of the House of Anjou, and her grandmother was Constance, daughter of King Manfred of Sicily and a Hohenstaufen.

Two hundred years later, Emperor Maximilian I (see Fig. 3) could state that "... all the noble blood of Europe is reunited in the Habsburg line ...," because his father Emperor Frederick III had married Princess Leonora of the House of Aviz in 1452, the daughter of King Edward (Duarte) of Portugal and his wife Princess Leonora of the House Trastámara, daughter of King Ferdinand I of Aragon. The latter's grandson, also Ferdinand, became a powerful partner in Maximilian's Spanish testamentary contracts.

This Habsburg Holy Roman Emperor was already of half Spanish-Portuguese blood; his grandsons, Charles V and Ferdinand I, were to have seven out of eight forebears from the southern- and western-European houses of Aviz, Trastámara, Burgundy, and York. Only their great-grandfather Frederick III of Austria had Habsburg, Masovian (Lithuanian), and Italian ancestors, but he

12. Joseph Heintz (1564–1609), *Archduchess Anna, Daughter of Duke Wilhelm V of Bavaria (Married to Ferdinand II)*, **1604, oil on canvas, Vienna, Kunsthistorisches Museum**

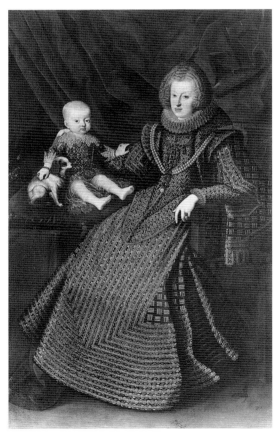

13. Friedrich Stoll, *Infanta Maria Anna, Wife of Ferdinand III, with Her Firstborn Son, the Future Ferdinand IV*

was the Emperor, so his political position overruled the dynastic connections. Spanish attitudes certainly exerted considerable influence on the thinking of the Habsburg family.

Pure blood: Unattainable ideal, uncomfortable reality

A mystical veneration of the blood of Christ played a remarkable role in Spain from at least the twelfth century onward. At that time, the legend of the Holy Grail seems to have evolved in Spain and southern France out of oriental and Christian elements. The Grail was the name given to the vessel in which Joseph of Arimathea collected the blood of the crucified Christ. A large, ancient agate bowl was among the Habsburg possessions, probably inherited from the Burgundians, which in 1564 had been declared a permanent treasure of the Austrian House in a contract of inheritance, and, to this day, is stored in the Vienna treasury. Many people believed this bowl to be the Holy Grail. The value of pure blood had great significance in Spain, but it is difficult to determine whether the growth of this idea was also connected with the myth of the Holy Blood, widely disseminated throughout Europe since the fourteenth century, or whether it simply reflected the popular Spanish notion of *limpieza de sangre*, which originally was also based on religion.[15]

Many baptized Jews lived in the areas not occupied by the Moors and played an important role in society, both economically and culturally. Some of these *conversos* had assumed significant positions in the Church because of their extraordinary intellectual capacities, and there were culturally integrated and extremely wealthy Jews who even married into the ranks of nobility. This was criticized primarily by the numerous, and generally poor, nobles, the *hidalgos*, and also by the Church. An anti-Semitism emerged, which was at first based on religion. That it soon acquired a "racist" tone is evident in the fact that proof of pure blood was demanded for admission to the religious orders of knights, which meant that *conversos* were refused membership. These orders of knights were held in high esteem by the population, and because of their political importance, these barriers of admission were enforced mostly by the impoverished nobility. Thus, the minor nobility insisted on the dubious advantages of pure blood, the *limpieza de sangre*, while the high nobility enjoyed great riches thanks to their marriages with the *conversos*.

The original task of the Inquisition (*consejo de la Suprema y General Inquisicion*), introduced in 1483 in Castile, was to gain state control over the violent pogroms directed against Jews and Moors, such as the massacre of 1371 committed by a crowd incited by preachers. But then the officials also kept the *conversos* under surveillance to determine whether they truly lived a Christian life, and if not, to persecute them.[16] The Inquisition was very popular among ordinary people and the *hidalgos*. They had nothing to fear, but the "big wigs" of State and Church trembled for their lives! We need only recall the fate of the last Confessor of Emperor Charles V, who was Archbishop of Toledo, but a descendant of *conversos*. After the Emperor's death he was brought before the Inquisition and then imprisoned. In Spain the Habsburgs—and especially Charles who had been made King—were faced with political and social conditions and prejudices among ordinary people, which were all religiously motivated, and at the same time with a highly stylized concept of honor among the high-ranking

14. Giovanni Maria Morandi (1622–1717), *Archduchess Claudia Felicitas (1653–1676), Daughter of Archduke Ferdinand Charles of Tyrol and Anne de' Medici, as Diana*, 1666, oil on canvas, Vienna, Kunsthistorisches Museum

15. Juan Pantoja de la Cruz (ca. 1553–1608), *Queen Margareta, Wife of Philip III with Their Daughter the Infanta Anna Portrayed as the Virgin and an Angel*, 1605, Vienna, Kunsthistorisches Museum

nobility. Ultimately, a dynastic haughtiness became established that put to shame even the seemingly unparalleled arrogance of the Dukes of Burgundy.

In the final analysis, blood purity was a myth, but its requirement was a political and social reality. It was considered a prerequisite for reaching the pinnacle of society and state. Blood, as the most crucial, life-preserving bodily fluid, was also given a dynastic significance. The noble blood had to be preserved, procreation of heirs by means of marriage contracts had to be guaranteed, because the most excellent qualities and the entitlement to rule had to be passed on by heredity. And the legitimate ruler had to govern, even if his qualifications were otherwise anything but excellent. From the late eighteenth century, this fundamental dynastic principle was considered politically and socially outmoded, and scientifically invalid from the nineteenth century onward. But its political significance and peace-bringing effects were already being questioned at the time when the Habsburgs first reached out for world power, indeed, doubted quite officially by Erasmus of Rotterdam.

The education of Christian princes: Dynastic marriage as political strategy

Commissioned by Margaret of Austria, Governor of the Netherlands, the great Humanist wrote a handbook for the education of a Christian prince, which he entitled *Institutio principis Christiani* (*The Education of a Christian Prince*), for Charles and Ferdinand, the two Archdukes of Austria and Infantes of Spain.[17] At that time, in 1515, both these heirs of the Houses of Habsburg and Trastámara were at the threshold of astonishing political careers, thanks to the marriage agreements and succession settlements that their grandfathers had negotiated. The grandfathers—King Ferdinand of Aragon and Emperor Maximilian—were still alive and holding the reins of power. Ferdinand, a ruler of Machiavellian character, reigned not only in Aragon and Naples, but also in Castile, the country of his late wife Isabella, because his depressive daughter Juana, the nominal Queen, was thought unfit to rule. Maximilian had been able to retain for his children and grandchildren the Burgundian realm of his late wife Mary, and was now in the process of preparing the splendid Vienna Congress, which was entirely dedicated to signing the contracts between the Habsburg and Jagiellon dynasties.

The curtain was rising on the destinies of the two brothers: on the Spanish-Sicilian domains and countries beyond the sea, on the Holy Roman Empire with its German, Dutch, and Italian countries, including the Burgundian homelands west of the Rhine, and the Austrian homelands between the Danube and the Adriatic. Still obscured as the potential future domains of the House of Austria were the realms of the Jagiellon royal house, Hungary and Bohemia.

The image we have painted was not a fantasy, but rather the anticipated result of a dynastic policy enacted by the ruling houses of Trastámara and Habsburg, although one might call it fanciful or even frivolous.

In the two decades between the death of Isabella the Catholic in 1504 and the death of Louis II of Bohemia and Hungary in 1526, the contracts of inheritance favoring the Habsburgs were to come into effect.

The reality for the two boys (Charles and Ferdinand) was that they took up the reins of power, step by step, in distant countries, which they had never even visited, deciding the fate of people whose language they did not speak and

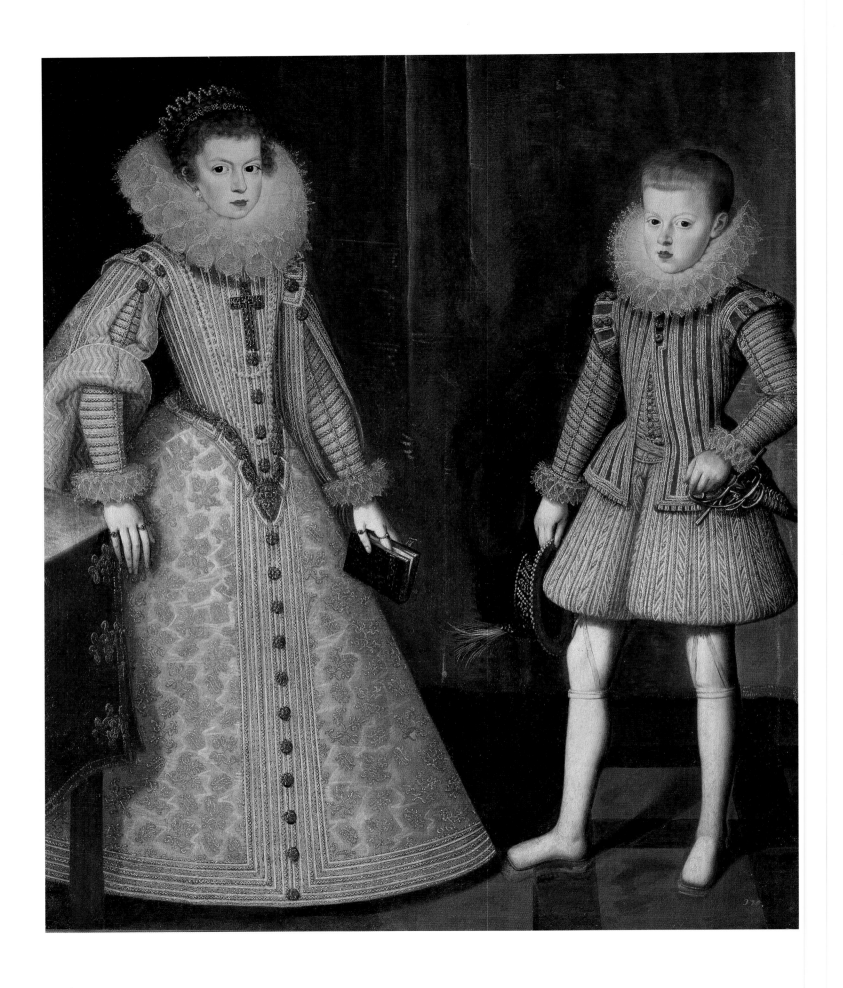

16. Benjamin von Block (1631–1690), *Emperor Leopold I (1640–1705),* *Son of Ferdinand III and the Infanta Maria Anna, Portrayed as* *a Fieldmarshal in Armor,* **1672, oil on canvas, Vienna, Kunst-** **historisches Museum**

whose appearance and customs were completely foreign to them. This is a typical result of dynastic policies, and Erasmus of Rotterdam was probably the first to discuss the problems arising from such policies. In his work on the education of a Christian prince, a chapter headed "De principium affinitatibus," he deals with the marriage policies of ruling houses, as indicated by the title. Erasmus states that a ruler's marriage is a personal matter, but that it can attain unexpected significance for political developments and that many subjects may "experience [a fate] similar to those of the Greeks and Trojans with Helena."[18]

In the end, Erasmus questioned the peacemaking principle of kinship ties among rulers, and warned his two young readers not to regard dynastic inter-marriages as a guarantee of political harmony, as the common people were still in the habit of doing. Furthermore, such peaceful ties based on dynastic unions could be torn asunder by the death of a single person.

This attitude is further proof of the far-sightedness of the author of *Querela pacis* (1517; *The Complaint of Peace*) and the fact that it is contained in a guide to education for princes is truly astounding, as it differs significantly from other contemporary concepts of State and ruler, which tended to lean towards Niccolò Machiavelli's *Il principe* (1513; *The Prince*). Happily, Erasmus was never to experience the bloody wars of succession that were to devastate Europe during the late sixteenth century, and especially in the seventeenth century, and again in the eighteenth century.

In fact, when Erasmus pronounced royal marriage a private matter, he contradicted what the rulers themselves were claiming. Thus, in the contract of Emperor Maximilian with King Wladyslaw, the succession agreement between the Habsburg and Jagiellon dynasties was described as being concluded "to honor God and reproduce the royal blood."[19] Marriage among the nobility was not concerned with the relationship of a particular man to a particular woman, but rather with the relationship between two dynasties. Its purpose was to produce heirs, who, in the event of the extinction of one dynasty, would be able to replace it with one of equal birth—because blood-related. Death, so greatly feared and unpredictable, was always included in the calculations.

What was the more frightening prospect—the death of an only son and heir, or the birth of too many sons who might divide the inheritance and there-fore put the political position of the dynasty at risk? Worse still to think that they might fight each other as cruelly as the Princes of York and Lancaster of the English royal house. To prevent such an outcome, one or several younger brothers were frequently launched in ecclesiastical careers, but without being ordained, so that they might be brought back into politics in order to preserve the dynasty, if the oldest son were to die or have no heirs. For example, Emperor Maximilian II (see Fig. 1) assigned positions in the Church to three of his six sons: Maximilian, Albert, and Wenceslas. But neither the oldest son, Emperor Rudolf II, nor his brother, the Archduke Ernest, married, and the late marriage of Matthias to his cousin Anna produced no children. When Archduke Ernest died, his brother Albert, by then a Cardinal and Archbishop of Toledo as well as Viceroy of Portugal, became Governor of the Spanish Netherlands, renounced his religious office and married his cousin, the Infanta Isabella Clara Eugenia, daughter of King Philip II of Spain. But this marriage also remained without children. Six sons but no grandson, who could have foreseen such a dynastic catastrophe? The younger, so-called Styrian or Tyrolean line then assumed the succession.

17. Bartolomé Gonzales (1564–1627), *The Elder Children of King* *Philip III and Archduchess Margaret, the Infante Philip and Infanta* *Anna,* **1612, oil on canvas, Vienna, Kunsthistorisches Museum**

18. Diego Rodriguez Velázquez (1599–1660) and workshop, *Queen Maria Anna (1635–1696), Daughter of Ferdinand III and the Infanta Maria Anna, Married in 1649 to Her Uncle Philip IV*, 1652, oil on canvas, Vienna, Kunsthistorisches Museum

Marrying "in": Preserving the Habsburg destiny

The Habsburgs felt that their claims to power and rulership were linked to their predestination, and they placed great value on the family inheritance of special qualities and abilities. In accordance with the medical teachings of Antiquity, all qualities and abilities were assigned to the four temperaments, and these, in turn, were put down to the effectiveness, or rather, the varying mixture of the four cardinal humors, blood (*sanguis*), phlegm (*phlegma*), choler (*cholos*), and melancholy (*melas cholos*). The Habsburgs considered themselves melancholics. Melancholy was the heroic temperament ascribed to Hercules, and already Maximilian I declared himself a melancholic, since he deemed it the most suitable temperament for a ruler, military commander, artist, and scholar.[20]

Naturally every ruler wanted to be seen as a victor, but Maximilian aspired to the role of Apollo Musagetes. Charles V, who incorporated the Pillars of Hercules into his heraldic device and allowed himself to be represented in the image of the hero some one hundred times, was considered the greatest of the Habsburgs. His qualities were highly valued as dynastic inheritance, even though they were cause for ridicule by his contemporaries, such as the much-

19. Joachim von Sandrart (1606–1688), *Archduchess Maria Anna, Daughter of Ferdinand II and Maria Anna of Bavaria*, oil on canvas, Vienna, Kunsthistorisches Museum

20. Juan Carreno de Miranda (1614–1685), *Queen Maria Anna (1635–1696), Daughter of Emperor Ferdinand III and the Infanta Maria Anna, Portrayed as the Widow of King Philip IV, and Regent for her Son Charles II,* **ca. 1670, oil on canvas, Rohrau, Graf Harrach'sche Gemäldegalerie**

21. Juan Carreno de Miranda (1614–1685), *King Charles II of Spain (1661–1700) Wearing the Insignia of the Order of the Golden Fleece,* **ca. 1677, oil on canvas, Rohrau, Graf Harrach'sche Gemäldegalerie**

discussed overbite, owing to which the Emperor could not speak clearly or chew properly, only gobble his food. But melancholia was certainly also regarded as an illness, which is why its most effective remedy, the bezoar stone, was frequently found in the Habsburg treasuries of the sixteenth and seventeenth centuries. Even diseases were desirable as qualities of "chosen" persons. Family peculiarities were virtually considered embellishments, even when they were obviously a burden. Therefore, all distinctive family traits were to be passed on according to the theory of temperaments. However, blood was undoubtedly considered the very "essence of life." In this regard, there were constant efforts to renew the family ties among closest blood relatives. The circle of suitable persons was naturally very small. Candidates for marriage were those members of the House of Austria who were more or less of suitable age, and the princes and princesses from houses of equal rank, whose politics and religion had to be acceptable.

We should remember the marriage policies of Emperor Charles V, which took absolutely no notice of the physical or psychological traits of the marriage candidates. Having exhausted the possibilities among the Archdukes and Archduchesses of the German Habsburgs for marriage with his children, or rather, the members of the older Spanish line of the house, Charles chose partners from western-European royal houses. His son Philip II first married his Portuguese cousin, and then Mary Tudor, Queen of England, who was his father's cousin by way of her mother, Catherine of Aragon. Philip's third marriage was to Elizabeth of Valois, who was the daughter of King Henry II of France and Catherine de Médicis.

Considering later family developments among the Habsburgs, it must seem tragic that only Philip II's fourth marriage to his Austrian niece Anna produced a son, Philip III, who carried on the line. Anna's mother, Maria, was Philip II's sister, her father Maximilian was his cousin! One marvels that the outcome of such inbreeding manifested itself only in the mental and physical handicaps of Don Carlos, Philip's son from his first marriage to his twofold cousin, Maria of Portugal.

Charles V married off his daughters to very close blood relations, Maria to her cousin Maximilian of Austria, Joanna to her cousin John (Emmanuel) of Portugal, with whom she not only shared the same Habsburg grandparents, but shared great-grandparents from the House of Aragon through her father's grandmother. Margaret, his daughter before marriage, he bestowed as a fourteen-year-old wife on Alessandro de' Medici, son of Pope Clement VII. When Alexander was murdered, leaving her a widow within a year of the marriage, she was immediately given in marriage to Ottavio Farnese, son of Pope Paul III.

The Emperor's brother, Ferdinand, founder of the German line, whose territorial power was concentrated in Central Europe and whose residences were in Prague and Vienna, subordinated himself entirely to Charles V's dynastic plans. Charles wanted above all to benefit from their Italian connections. But even the marriage of one of the Archduchesses with the Duke of Cleves-Jülich was politically calculated, a carefully orchestrated move to secure peace.[21]

To begin with, Ferdinand I's older daughters, Elizabeth, Anna, and Mary, were wed to King Sigismund II (August) of Poland, Albert V of Bavaria, and the above-mentioned Duke William of Cleves, respectively. Then, in 1548, the eldest son, Maximilian, the designated heir and successor, was married to his Spanish

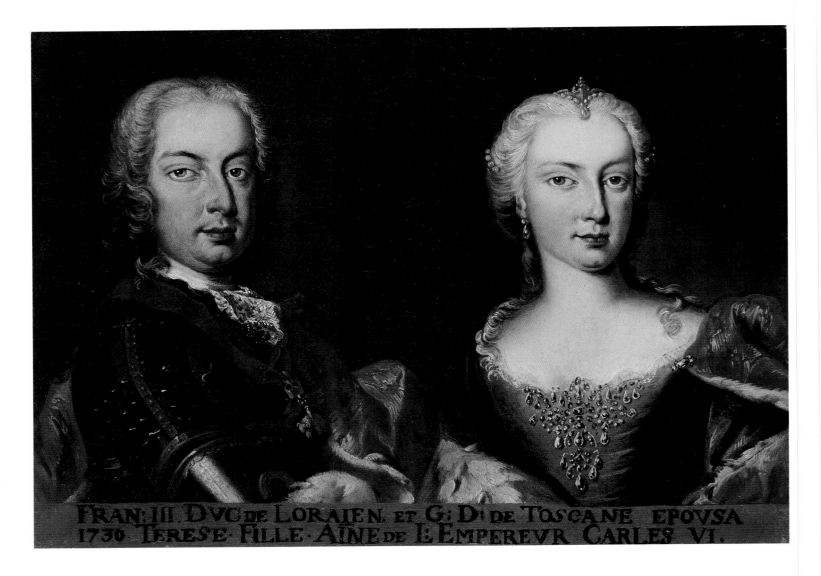

FRAN: III DVGᴅᴇ LORAIEN. ᴇᴛ Gᴅ Dᴅᴇ TOSCANE EPOVSA
1730 TERESE·FILLE·AINE ᴅᴇ Lᴇ EMPEREVR CARLES VI.

22. *Duke Francis Stephen of Lorraine (1708–1765) and Archduchess Maria Theresia (1717–1780) as a Bridal Couple,* oil on canvas, Vienna, Kunsthistorisches Museum. Photo: Bildarchiv Österreichische National-bibliothek, Vienna

cousin Maria. The following year saw the marriage celebration of sixteen-year-old Catherine and Francesco III Gonzaga, Duke of Mantua, who was deemed the most reliable ally and friend of Charles V. When the Duke died a year later, the young widow was instantly wedded to Sigismund August of Poland, who in turn, had already become a widower through the early death of Archduchess Anna.

Simultaneously, the marriage of the next-youngest Archduchess Eleonora to the succeeding Duke Guglielmo III of Mantua was arranged. The wedding was delayed, since the bridegroom was only twelve years old. Next, Archduchess Barbara had to marry the Duke of Ferrara and Modena, Alfonso II d'Este, and the youngest daughter, Joanna, the Grand Duke of Tuscany, Francesco de' Medici. Last was the youngest son Charles, who celebrated his wedding in 1571 to his niece, Maria Anna of Bavaria, his sister Anna's daughter.

In the next generation partners were chosen from the same families, although by now they were already nieces, nephews, and cousins. After three generations, the Houses of Wittelsbach, Gonzaga, and Medici, as well as the Polish royal house, were so intimately related by marriage to the Habsburgs that they were regarded as the closest of blood relations.

To demonstrate the excessive extent to which the Habsburgs chose their marital partners from one or the other line of their own dynasty, here follows a

23. Andreas Möller, *Empress Maria Theresa as an Eleven Year Old*, oil on canvas, Vienna, Kunsthistorisches Museum

portrait of the families of King Philip IV of Spain (1605–1665) (Fig. 17) and Emperor Ferdinand III (1608–1657) (Figs. 9–11, 13). King Philip IV was a son of Philip III and the latter's Habsburg cousin, Archduchess Margareta of Styria (Central Austria) (Fig. 15). The parents of Philip III were uncle and niece, as were the parents of Margareta, the Archduke Charles and Mary of Bavaria, and all their ancestors were descended from Charles V and Ferdinand I.

Emperor Ferdinand III was a son of Ferdinand II, who was a brother of Margareta, the Archduchess of Styria, who had become Queen of Spain. Ferdinand II also married a cousin, Maria Anna of Bavaria (Fig. 12). Moreover, her grandmother, Archduchess Anna, was also sister of Charles of Styria. Thus both rulers were already products of extreme dynastic inbreeding between the Habsburgs and the Wittelsbachs. But they too sought out marriage partners within the family circle. Ferdinand III's first marriage was to the Infanta Anna. The mother of his bride, Queen Margareta, was one of his father's sisters and therefore he was marrying yet another cousin. Finally, Philip IV took for his wife the daughter of this couple, the Archduchess Maria Anna, who was his niece from her mother's side, his cousin from her father's. The children of this marriage were to be the charming Infanta Margaret Theresa, the promising Infante Balthasar Carlos, but also the dreadful cretin who later became king, Charles II of Spain (Fig. 21). The Infanta Margaret Theresa, so often painted by Diego Velázquez, eventually was to marry her twofold cousin, the Emperor Leopold I (Fig. 16).

Where others fought to gain and keep power, happy Austria married. The politics of dynastic marriage was central to the Habsburg strategy, and its success meant that the Habsburgs remained Europe's most resilient Imperial dynasty until World War I. Power came at a price, however, as can be seen from the deterioration of the family's genetic vitality, and the increasing number of unfortunate victims to a strategy that made political sense, but genetic nonsense. The family's fortunes turned, genetically speaking, in the eighteenth century, when Maria Theresa (Fig. 23) married into the House of Lorraine, an event almost unremarked upon at the time, but with striking consequences for the survival of the family. At the end of the day, despite an inadequate understanding of both blood and genetics, the need to preserve the Habsburg dynasty prevailed.

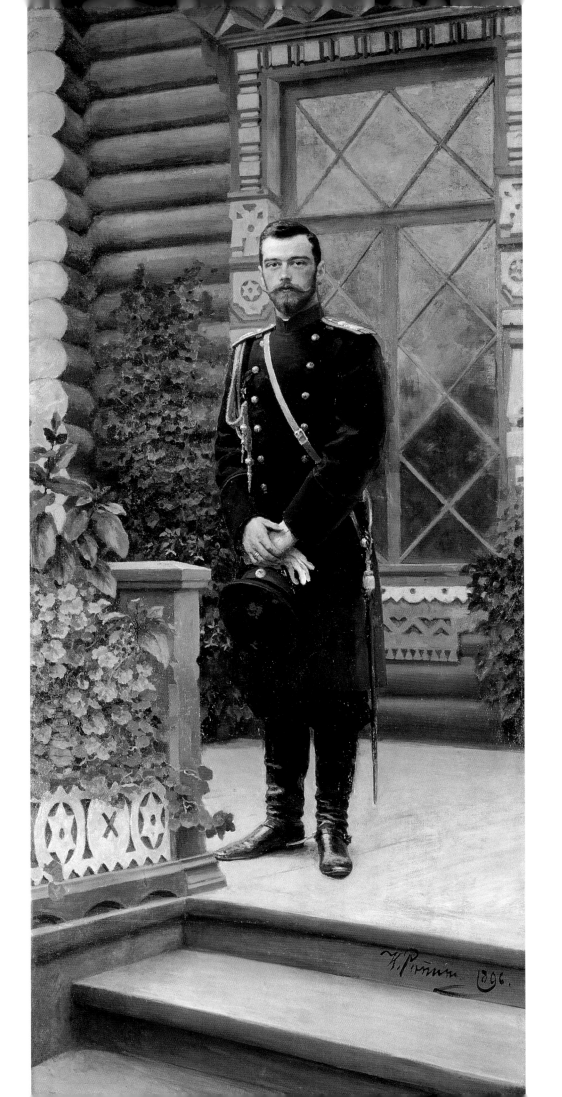

2. Coat of arms of the Romanov Family

For more than three centuries, Russian history was inextricably linked with the name Romanov: the overcoming of the Time of Troubles at the beginning of the seventeenth century, the return of lands seized by neighboring forces, the annexation of the Ukraine, the Baltic region, Belorussia, the Crimea and Novorussia, Transcaucasia, Finland, Poland, Moldavia, Central Asia, and the Near East. Legislators and military leaders, reformers and guardians of traditions, builders of a great political power, which became an empire long before Peter the Great considered it necessary to accept the imperial title officially, the Romanovs strove to safeguard the autocracy while opposing the liberal reforms, which they considered truly fatal for Russia. It is not accidental, therefore, that during the recording of the universal census in 1897, Emperor Nicholas II described his "occupation" as "Master of the Russian land" (Fig. 1).

Not only the sovereigns themselves, but also the children, grandchildren, and great-grandchildren of tsars and emperors always occupied a truly privileged place in Russian society. The special status of dynastic members was reflected in their titles. Having once belonged to the untitled nobility, before their ascension to the throne, the Romanovs adopted the titular rank of the preceding dynasty, while preserving, in particular, the ancient Russian title of Grand Duke, analogous to the Austrian title of archduke used by the Habsburgs. Whoever was first in the line of succession in the Russian empire, be it the eldest son, the brother of the ruling emperor (if the latter did not yet have a son), or a more distant relative of the sovereign, carried the title "Heir-Tsarevich." The titles "Grand

The Blood of Tsars: The Romanovs and the Russian imperial house
Stanislaw Dumin

Duke" and "Grand Duchess" were originally given to the descendants of emperors in the male line, including great-great-grandsons and great-great-granddaughters. By a decree of Alexander III of January 24, 1885, the title of Grand Duke was reserved exclusively for the sons, daughters, grandsons, and granddaughters of emperors. The heir-tsarevich carried the same title, regardless of how distantly related he may have been to the emperor. From 1797 to 1885, the title "Prince and Princesses of Imperial Blood" was set aside for the great-great-grandchildren of the emperor and their descendants in the male line. After 1885, the direct descendants of the emperors carried these titles, beginning with grandsons and granddaughters. The titles "Princess" and "Grand Duchess" were given to the wives of Grand Dukes and Princes of imperial blood; likewise "Prince" and "Grand Duke" were assigned to the husbands of Romanov princesses. In the Russian court, only the wives of foreign kings carried the title of queen.

Although dynastic rules forbade members of the House of Romanov to marry "common mortals," in the eighteenth century the Romanovs, like earlier Russian tsars, selected wives from families of the Russian nobility, for example, from the Dolgorukov princes, the Streshnev nobles, the Miloslavskys, Naryshkins, Grushetskys, Apraxins, Saltykovs, and Lopukhins. By that time the "tsar's blood" was considered sacred, and, therefore, when the sisters of the founder of the dynasty, Michael Feodorovich Romanov (Fig. 3), married leading members of

1. I. Ye. Repin (1844–1930), *Tsar Nicholas II (1868–1918)*, 1896, oil on canvas, Moscow, State Historical Museum

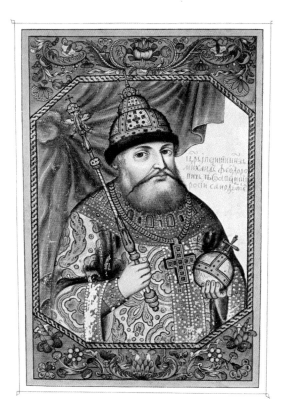

3. Unknown Russian artist, *Tsar Michael Feodorovich Romanov*, 17th century, drawing, Moscow, State Historical Museum

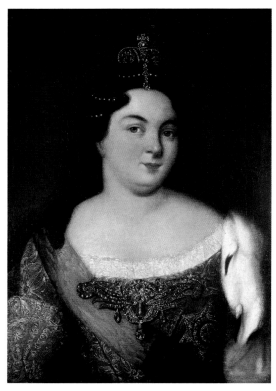

4. Unknown artist, *Tsaritsa Catherine I (1684–1727), Wife of Peter I*, ca. 1726, oil on canvas, Moscow, State Historical Museum

the Moscow aristocracy, no worthy spouses could be found for their daughters and granddaughters, whose attempts to marry eligible European nobles met with the obstacle of religion. As a result, a solitary life in tsarist courts or monasteries awaited the many daughters of Tsars Michael and Alexis.

The first dynastic unions of the Romanovs were not achieved until the reign of Peter I. In 1711, Peter's niece, the Tsarevna Anna Ivanovna, became the Duchess of Courland, and in 1716 her eldest sister, the Tsarevna Catherine Ivanovna, became the Duchess of Mecklenburg. On April 19, 1711, Peter married off the son of his first marriage, Tsarevich Alexis, to Princess Charlotte Christina Sophia of Brunswick, sister of the wife of Charles VI of Habsburg, Holy Roman Emperor. After having sent his first wife, the Russian noblewoman Eudoxia Lopukhina, to a monastery, Peter I himself chose as his second wife a woman of completely unknown origins. Before her conversion to Russian Orthodoxy, Catherine I (1684–1727), daughter of the Lithuanian peasant Samuel Skavronsky, went by the name of Martha. When widowed, her mother moved to Livonia, and Martha was raised in the house of a Lutheran pastor in Marienburg. At age sixteen Martha married the Swedish dragoon Rabe, who on the next day marched off with his troops, leaving his young wife behind. When Russian troops occupied the city, they took the young woman prisoner. She was first placed at the service of commanding officer Boris Sheremetev, then taken from him by a favorite of the tsar, Alexander Menshikov. After converting to Russian Orthodoxy, Martha received the name Catherine. Soon thereafter, however, Peter I himself laid eyes on her and from that point on, to the end of his life, the tsar never parted with Catherine (Fig. 4).

Peter I and Catherine had a number of children who died at a young age. Only two daughters survived to adulthood, Anna (b. 1708) and Elizabeth (b. 1709). Peter and Catherine were not officially married in church until February 19, 1712. Twelve years later, on May 7, 1724, Peter ceremoniously crowned Catherine. The next year, following the sovereign's death, a number of dignitaries, with the active support of the guard, managed to proclaim the former peasant empress. Catherine I interfered very little in state affairs, leaving the management of the country to one of her husband's most loyal subjects, Prince Alexander Menshikov. In 1725 the daughter of Catherine I, the Tsarevna Anna Petrovna, married Duke Charles Frederick of Holstein-Gottorp. It was her son, Emperor Peter III, who was destined to carry on the House of Romanov.

The "Act of Succession," ratified by Emperor Paul I on April 5, 1797, dictated that members of the House of Romanov "not consider a marriage lawful without the permission of the tsar,"[1] but it defined no other limitations. It was presumed that the emperor would decide himself which marriages served the interests of the empire and the dynasty. The concept of an equal, dynastic marriage as an indispensable condition for passing the right to the throne to posterity appeared in Russian law as late as 1820, when it was decreed that only the legitimate children born to reigning or sovereign families were members of the dynasty. What prompted this new decree was the marriage of the second son of Paul I, Tsesarevich and Grand Duke Constantine Pavlovich, who at the time was heir to the throne, since his elder brother, Emperor Alexander I, had no sons.

Constantine was first married to the Princess Julia Henrietta Ulrica of Saxe-Coburg (1781–1860). But in 1820, he divorced his first wife and married

5. Unknown Russian artist, *Tsar Paul I*, late 18th century, engraving, Moscow, State Historical Museum

6. Unknown artist (after the original by J. P. Voile), *Grand Duke Constantine Pavlovich (1779–1831)*, late 18th century, oil on canvas, Moscow, State Historical Museum

the Polish countess Joanna Grudzinska (1799–1831), whom Prince Peter Vyazemsky described as "not a beauty, but more beautiful than any beauty," and of whom one of her contemporaries observed that "no woman, no girl was as pleasing as she, with her remarkable simplicity and elegance, which was reflected in everything—her movements, her gait and in her attire."[2] Having given permission for his brother to divorce, and knowing of his intentions to marry the beautiful Polish woman, on March 20, 1820, Alexander I published a manifesto that added another rule to the previous resolutions concerning the marriage politics of the imperial family: "If a member of the Imperial Family enters into marriage with an individual who is not of a similar rank, that is, who does not belong to a ruling or sovereign family, then that member of the Imperial Family may not confer to the other any rights that belong to members of the Imperial Family, and children born from such a union will not enjoy the right to inherit the throne."[3] The wife of Constantine was awarded the title of the Princess of Lovich (Fig. 8).[4]

As a result of his morganatic marriage (a marriage of unequal partners), on January 14, 1822, Constantine renounced his right to ascend the throne (Fig. 6), thereby leaving his younger brother, Grand Duke Nicholas (Nikolai) Pavlovich, as successor to Alexander I. Because his renunciation remained a secret, however, following the death of Alexander I, from November 20 to December 14, 1825, Constantine was officially considered the emperor of Russia, and the State Council, the Senate, the Saint Petersburg and Moscow garrisons, and even Grand Duke Nicholas swore allegiance to him. The abdication of Constantine and the transfer of new allegiance created an interregnum, of which the members of secret patriotic societies sought to take advantage. With difficulty, the young emperor Nicholas I managed to quash the uprising of a section of the guards who gathered on the square before the Senate on December 14, 1825.

With Alexander I's (Fig. 7) decree of 1820, the formation of Russian dynastic rights was complete. Henceforth only the descendants of members of the dynasty through equal marriages were to become the heirs to the Russian throne. These limitations applied not only to individual Grand Dukes, princes, and princesses of imperial blood, but even to the tsar himself. In accordance with article 36 of "The Fundamental Laws of the Russian Empire," "children born of marriage between a member of the Imperial Family and an individual who does not enjoy the same merit, that is, who does not belong to any ruling or sovereign house, is not entitled to inherit the throne."[5]

Following the death of his first wife, and without waiting for the official end of the mourning period, on July 6, 1880, Emperor Alexander II (Fig. 10) married his beloved Princess Catherine Dolgoruky, a former maid of honor to the deceased empress, in the church in the royal palace at Tsarskoe Selo. Catherine Dolgoruky and her children, born prior to the marriage, were awarded the title the Princes Yurievsky (Fig. 9). Thus they never became members of the dynasty. Similar cases are known. For example, the children of Grand Duke Paul Alexandrovich from his second, unequal marriage received the title Princes Palei. Sometimes morganatic marriages led to family tragedies, such as the expulsion of three Romanovs from Russia—Grand Duke Michael Mikhailovich (in 1891), Paul Alexandrovich (in 1902) and Michael Alexandrovich (in 1911)—who violated "clan discipline" by marrying "common mortals." Although most of them were later forgiven, their wives were not elevated to the status of dynastic

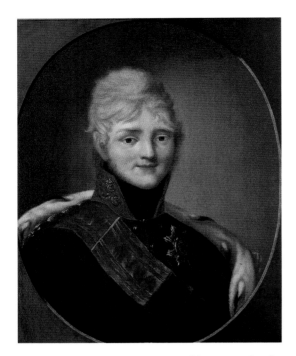

7. Unknown artist (after the original by G. Kügelgen), *Tsar Alexander I (1777–1825),* **early 19th century, oil on canvas, Moscow, State Historical Museum**

8. V. A. Tropinin (1776–1857), copy of a lithograph dating from the 1820s, *Princess Ioanna Antonovna of Lovich (1795–1831), Morganatic Wife of Grand Duke Constantine Pavlovich,* **oil on canvas, Moscow, State Historical Museum**

members. The youngest Romanovs, the princes and princesses of imperial blood, received official permission from the head of the House of Romanov to enter into morganatic marriages in 1911, but their descendants were excluded from the dynasty and did not even receive the right to carry the dynastic name of Romanov. Not only marriages to commoners and common noblewomen, but even unions with aristocratic families like the Yusupovs, Golitsyns, and Counts Sheremetev were considered unequal.[6]

Consolidating the link between the Romanovs and other ruling houses, dynastic marriages became an indispensable condition for the preservation of dynastic rights. Dynastic marriages were often concluded between close relatives. The Russian Orthodox Church did not approve marriages between first cousins, but it permitted them in individual instances, as in the case of the sister of Alexander I, Grand Duchess Catherine Pavlovna, who met with no resistance when she married the prince of Oldenburg, whose mother was the sister of Catherine's mother. In 1905, however, Nicholas II originally forbade his first cousin, Grand Duke Kirill Vladimirovich (Fig. 11), to marry their first cousin, the Princess Victoria Melitta of Saxe-Coburg, Great Britain, and Ireland (Fig. 14), who was also the granddaughter (on her mother's side) of Emperor Alexander II, and the granddaughter of the English Queen Victoria (on her father's side). The two lovers violated the prohibition and married abroad, after which Kirill fell into disgrace for several years. Victoria's first husband was her other first cousin, the Grand Duke Ernst of Hesse, brother of Empress Alexandra Feodorovna. Within circles of the nobility, the specific cause of Kirill's and Victoria's disgrace was her divorce from the brother of a Russian sovereign. The emperor acknowledged their marriage officially only in 1907, whereupon Kirill's wife received the title Grand Duchess and their descendants retained dynastic status.[7]

Marriages between an uncle and his niece or between second cousins, by contrast, occurred in the Romanov family rather often. For example, the sister of the emperor, Grand Duchess Xenia Alexandrovna, the great-granddaughter of Nicholas I, married her uncle, Grand Duke Alexander Mikhailovich, the grandson of Nicholas I. Several Romanovs intermarried with Greek princes and princesses, such as the children and grandchildren of Queen Olga Constantinovna, who was the granddaughter of Emperor Nicholas I and the daughter of Grand Duke Constantine Nikolaevich; and several others intermarried with the princes and princesses of Oldenburg, the descendants of Grand Duchess Catherine Pavlovna.

The grand and imposing beauty of terrestrial Gods: The troubled legacy of blood

Peter I and his grandson Peter III were distinguished by their great height and leanness, which was also inherited by Peter III's grandson, Nicholas I (Fig. 12). In 1826 one contemporary noted the following characteristics of Nicholas:

> Tall, lean, with a broad chest and rather long arms, a clean, somewhat oblong face, bare forehead, a Roman nose, a medium-size mouth, a quick glance, resonant voice, approaching a tenor, but with rather rapid speech. In general he was very well-proportioned and adroit.... The freshness of his face and everything in him

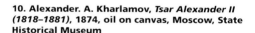

9. Atelier Levitsky & Sons, Princess Ekaterina Yurievskaya (1849–1922), morganatic wife of Tsar Alexander II, 1870, photo on card, Moscow, State Historical Museum

10. Alexander. A. Kharlamov, *Tsar Alexander II (1818–1881)*, 1874, oil on canvas, Moscow, State Historical Museum

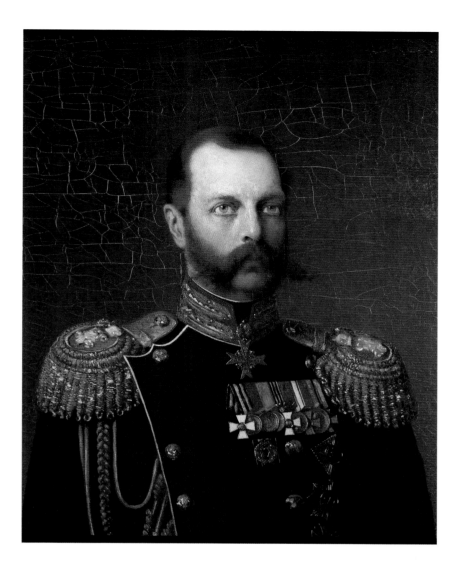

manifested iron health, and served as proof that his youth had not been a pampered one, that he led a sober and moderate lifestyle.[8]

"No one was better made for the role of autocrat than he," recalled Fräulein Tiutchev, his Maid of Honor. "His grand and imposing beauty, his majestic bearing, the stern correctness of his Olympian profile, his masterful gaze … everything in him breathed of a terrestrial god, an all-powerful sovereign."[9]

The majority of Nicholas' descendants inherited his great height and striking facial features. Members of the dynasty stood out in a crowd, even when they preferred to remain incognito, as one diarist describes in the following episode: "Strolling along the boulevards [in Paris], I noticed before me a tall man. Those passing by him stopped upon seeing him, and several even exclaimed, 'What a handsome man!' When I approached him, I recognized the Grand Duke, in civilian clothes, with purchases in his arms." That was the Grand Admiral Alexis Alexandrovich, son of Alexander II.[10] His brother, Alexander III, was also described as "a handsome, fair-haired giant."[11]

Some of the traditional "Romanov" features eluded the children of Emperor Alexander III because of his marriage to Empress Maria Feodorovna (born Princess Dagmar of Denmark). At first she was the bride of his eldest brother, Tsarevich Nicholas; but after his sudden death from tuberculosis, the

11. Grand Duke Cyril Vladimirovich of Russia (Tsar 1918–1938), ca. 1900. Photo: Moscow, State Historical Museum

12. Unknown artist (after the original by Orest A. Kiprensky, 1816), *Future Tsar Nicholas I (1796–1855) as Grand Duke in the Uniform of an Officer of the Guard*, 1820s, oil on canvas, Moscow, State Historical Museum

dynastic union was concluded with the heir to the Russian throne. "None of the children of Princess Dagmar was as tall as the preceding generation of Romanovs. The generation of Nicholas II lacked the majestic bearing for which the generation of Alexander II was praised."[12]

Even when arranged with selected candidates, however, these dynastic marriages could also lead to tragedy. The royal blood of the tsars carried not only memories of ancestors, but also hereditary diseases. One such hereditary disease, which afflicted the family of Nicholas II, was hemophilia, a disease of the blood, which passed to the Empress Alexandra Feodorovna from her grandmother, the English Queen Victoria.

Emperor Nicholas II, son of Alexander III and Maria Feodorovna, ascended the throne very early, at the age of twenty-six (see Fig. 1). The wedding of the young emperor took place soon after the burial of his father. Nicholas and his wife, Empress Alexandra Feodorovna (Fig. 13), were bound together by sincere, tender feelings for each other. Their marriage was concluded despite the hostility of the future tsar's parents toward him, the result of Alexander's opposition to marriage with German royalty and his desire to wed his son to the Princess Helen of Orléans. They had four daughters, all distinguished by excellent health, but the emperor needed a son and heir, otherwise the throne would have to pass to one of his brothers or cousins. No one could have suspected that the birth of Tsarevich Alexis (Fig. 21), the long-awaited heir, would become the source of family tragedy. As Grand Duke Alexander Mikhailovich wrote:

> the healthy blood of the Romanovs could not vanquish the diseased blood of Hesse-Darmstadt, and the innocent child had to suffer because of the carelessness with which the Russian court selected the bride of Nicholas II. The regime which exiled Grand Dukes for marrying healthy women of insufficiently well-known pedigree neglected to look into the history of the House of Hesse-Darmstadt.... For his regal parents, life lost all meaning. We were afraid to smile in their presence.... The emperor tried to become absorbed in tireless work, but the empress refused to submit to fate. They spoke incessantly of the ignorance of doctors, and gave preference to charlatans instead. She turned all her thoughts to religion.[13]

The heir's disease was one of the reasons for the collapse of the Russian empire. Together with the unwillingness of the imperial family to accept the inevitable—according to the diary of the tsar's sister, the Grand Duchess Xenia Alexandrovna, it was only in 1912, eight years after the birth of her son, that the empress informed her closest relatives of his illness—the disease drew quacks and faith-healers to the court, the most famous of which was Grigory Rasputin. This undermined the authority of imperial power. It was the incurable disease of the tsarevich that forced Nicholas II, in March 1917, to abdicate from the throne not only on his own behalf, but also—in violation of the law—on behalf of his son, an act that considerably weakened the constitutional monarchy in Russia.

According to the laws of the Russian empire, criminal intentions against the honor, health, and personal inviolability of all members of the Imperial House,

13. Tsaritsa Alexandra Feodorovna in the regimental uniform of the Imperial Guard, ca. 1900. Photo: Moscow, State Historical Museum

14. Grand Duchess Victoria (Melitta) Feodorovna, wife of Grand Duke Cyril Vladimirovich, ca. 1910. Photo, reproduce with the kind permission of her Highness Grand Duchess Marie Vladimirovna of Russia

regardless of their distinctions of title, were understood as an insult to His (or Her) Highness, and thus were punished with significantly greater severity than an infringement against "common mortals." Yet it was precisely their special position that made members of the dynasty a target of revolutionaries, who were enemies of the established order. The blood of the tsars attracted revolutionaries, and many Romanovs had to pay a terrible price for their privileges.

Sacrifice and self-sacrifice: A history written in blood

The history of the Romanov dynasty is marked by many tragic events. Even their ascent to the throne was the result of several tragedies in the family of preceding sovereigns of Moscow, the last rulers of the Rurik dynasty. The eldest son of Tsar Ivan the Terrible and Anastasia Romanov, Tsarevich Dmitry Ivanovich (1552–1553), drowned while his parents were on a pilgrimage to northern monasteries. Their other son, Tsarevich Ivan Ivanovich (1554–1581), was killed by his father in a fit of uncontrolled anger. As indicated earlier, the third son of Tsaritsa Anastasia and Tsar Ivan the Terrible, Tsar Fyodor Ivanovich, left no descendants, and his brother-in-law and potential heir, Tsarevich Dmitry Ivanovich, the youngest son of Ivan the Terrible from his seventh marriage, perished from knife wounds as a child in the city of Uglich, the victim either of a murder, according to one version, or of accidental impalement during an epileptic fit, according to a second version (like a martyr, he was canonized by the Russian Orthodox Church). By the will of his father, the eldest son of Peter I, Tsarevich Alexis, was condemned to death and died in the Peter-and-Paul Fortress in 1718, either from strangulation or torture. The abdicating Emperor Peter III, grandson of Peter I, was murdered by the retinue of his wife, the new Empress Catherine II, and two years later the great-grandson of Tsar Ivan V, Emperor Ivan VI (Antonovich, 1740–1764), died in prison.

By the testament of his grandmother's sister, Empress Anna Ivanovna, the newborn son of Princess Anna Leopoldovna and Prince Anton Ulrich of Brunswick-Bevern-Lüneburg was proclaimed emperor on October 17, 1740. His mother became regent while he was still a child. But on November 24–25, 1741, the daughter of Emperor Peter I, Tsarevna Elizabeth Petrovna, personally directed guards loyal to her in the court arrest of the regent, her husband, and her children. On December 12, 1741, they were all sent to Riga, for Elizabeth agreed to send them abroad in exchange for their abdication of all rights to the throne. Plans for a counter-revolution soon came to light, however, and the empress resolved to leave her dangerous competitors in Russia. In December of 1742 the arrested family was transferred to a fortress in the city of Dünamünde (Daugavgriva), where they spent two years before being transferred to the city of Ranenburg (Ryazan province). In 1744 the empress ordered the "Brunswick family" moved to the north, to the Solovetsky monastery, but they were transported only as far as Kholmogory, where they remained.

By that time Ivan VI was completely isolated from his family. In Kholmogory the hapless prisoner spent twelve years in complete solitude. At the beginning of 1756 it was ordered secretly to transfer him to Shlisselburg garrison. There Ivan was again placed in solitary confinement under the conditional name of "the well-known prisoner." Only three officers of the guard knew his identity. Ivan remembered his origins, however, and called himself sovereign. Despite strict

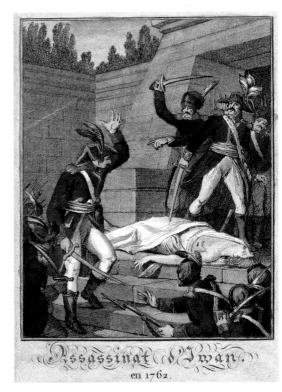

15. François Anne David (after a drawing by Charles Monet), *The Murder of Tsar Ivan Antonovich on July 4, 1764,* **illustration taken from the** *Histoire de Russie, représenté par figures [...] gravées par F. A. David d'après les dessins de Monet,* **Paris, 1813, colored engraving, Moscow, State Historical Museum**

16. Unknown artist (after a portrait by F. S. Rokotov, 1750s), *Tsar Peter III (1728–1762),* **1762, oil on canvas, Moscow, State Historical Museum**

prohibition, with someone's assistance he managed to learn to read, whereupon he received permission to read the Bible. In 1762, after Catherine II ascended the throne, it was ordered "not to give the prisoner up to anyone, and should there arise an opportunity for his escape, then he should be killed rather than surrendered alive."

Upon learning the secret of the mysterious prisoner, second lieutenant Vasily Mirovich decided to liberate Ivan and pronounce him emperor. Aided by a false manifesto from the Senate, on July 4–5, 1764, Mirovich won the soldiers over to his side, arrested the commandant, and demanded the release of the prisoner. After resisting at first, the guards surrendered, having already murdered Ivan.[14] The jailers "drew their swords and attacked the unfortunate prince, who awoke from the noise and leapt from his bed. He resisted their blows, and in spite of a wound to his arm, broke one of their swords. Nearly naked and without any weapon, but animated by desperation, he continued to resist until they finally overcame him and wounded him all over. At last he was killed by one of the officers, who impaled him completely from the back. (Fig. 15)"[15]

The Russian poet Alexander Pushkin relates a curious story about the horoscope of Prince Ivan which two distinguished mathematicians had written at the behest of Empress Anna Ivanovna: "They composed it according to all the rules of astrology, although they did not believe them. The conclusion they reached frightened both mathematicians, and they sent the empress a different horoscope, one which predicted all kinds of good fortunes for the newborn child. Euler preserved the original horoscope, however, and showed it to Count K.G. Razumovsky when the fate of the unfortunate Ivan Antonovich was accomplished." By a sentence of the court, Mirovich was beheaded on September 15 in Saint Petersburg, and that evening his body was burned, together with the scaffold. Many contemporaries of those events believed that Mirovich may have been the witting or unwitting agent of Catherine II. According to several sources, Mirovich was confident of his own impunity for the crime, and until the final moment expected a messenger to arrive with a pardon from the empress.[16]

Emperor Peter III (Fyodorovich, 1728–1762), who was Duke Charles Peter Ulrich before converting to Russian Orthodoxy, as indicated earlier, was the son of Duke Charles Frederick of Holstein-Gottorp and Tsarevna Anna Petrovna (Fig. 16). This grandson of Emperor Peter I was the great-nephew of the King of Sweden, Charles XII, and under certain conditions could have become a candidate both for the Russian and the Swedish thrones. The mother of the prince died in 1728, soon after his birth. After the death of his father in 1739, the eleven-year-old boy became the reigning Duke of Holstein. On November 15, 1742, the aunt of Charles Peter Ulrich, Empress Elizabeth Petrovna, declared him the heir to the Russian throne with the title Grand Duke. He was called to Russia, accepted Russian Orthodoxy, and received the name Peter Fyodorovich. In 1745, on the insistence of the empress, Peter married his second cousin, the Princess Sophia Frederica Augusta of Anhalt-Zerbst, who in Russian history subsequently earned the venerable title of Catherine the Great.

Peter III ruled only from 1761 to 1762. He was overthrown by a conspiracy led by his wife, Catherine, who exploited the guards' dissatisfaction with the tsar's attempt to send troops on a campaign against Denmark, forcing his abdication. After that the emperor was taken to the city of Ropsha, where he remained under the close surveillance of persons who were particularly loyal

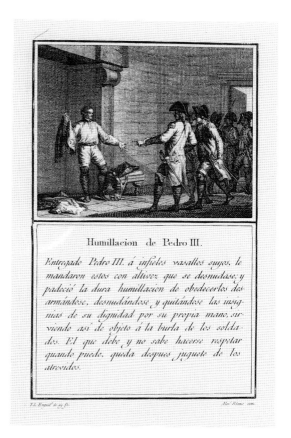

17. Alexandro Blanco (after Tomas Lopes Engividanos [1773–1814]), *The "Humiliation of Tsar Peter III,"* **illustration taken from the** *Historia Universal,* **Lisbon, late 18th century, engraving, Moscow, State Historical Museum**

18. F. V. Morozov (after a drawing by an unknown artist, late 19th century), "A Criminal Attempt on the Sacred Person of the Lord Emperor Alexander Nikolaevich, Explosion of the second shell on March 1, 1881," late 19th century, lithograph, Moscow, State Historical Museum

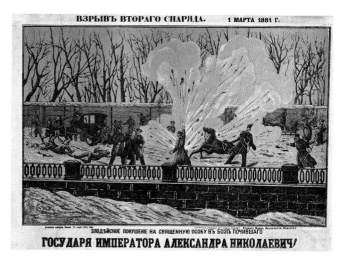

to Catherine. There survived a number of notes from Peter III to his wife, in which he repeatedly asks to be released to his country and not to be treated "like the greatest criminal." The condition for his resignation was apparently the promise to allow him to leave Russia for Holstein (Fig. 17); however, nothing was done to fulfill that promise. When they finally became convinced that she secretly wished to be rid of her spouse, Catherine's entourage decided to murder the former monarch. The final act of the drama took place on July 6. Before dinner that day, glasses of vodka were served. Peter's vodka contained poison. Suspecting foul play, Peter refused to drink, whereupon Alexis Orlov, brother of the new Tsaritsa's favorite, tried to pour the vodka into Peter's mouth by force. Prince Fyodor Baratynsky and Grigory Potemkin, Catherine's future favorite, ran to assist Orlov. They began to choke Peter from behind with his napkin, while Orlov pressed on Peter's chest with both feet. Together they finally strangled the sovereign.[17]

The unexpected death of Peter III generated many legends of his miraculous rescue. There appeared many pretenders who identified themselves as Peter III—"False Peters"—including the leader of the powerful peasant uprising, Emelian Pugachev, who would end his days on the executioner's block. Among the forty or so False Peters that are known, nearly all of them appeared during the reign of Catherine II, and all of them, like their prototype, died a violent death.

In 1801, Emperor Paul I (Fig. 5), the son of Peter III and Catherine II, and the great-grandson of Peter the Great, was strangled by conspirators in his own bedroom in Mikhailovsky Palace in Saint Petersburg. Within twenty years, members of secret Russian revolutionary societies, preparing to overthrow the monarchy, planned the murders not only of Emperor Alexander I, but also of the entire imperial family, including women and children. The uprising of December 14, 1825, failed, but in place of the "Decembrists" arrived new generations of revolutionaries who chose terror as their main weapon.

In the 1870s and 1880s, the "People's Will" revolutionary organization undertook a systematic hunt for Alexander II, the "tsar-liberator" who had abolished serfdom. After miraculously avoiding several attempts on his life, he was mortally wounded by a bomb on March 1, 1881, the same day on which he informed his closest aides of his intention to grant Russia a constitution. The first bomb exploded alongside the carriage, and the emperor remained unharmed; but when Alexander emerged from the carriage, considering it his duty to approach and speak to those who had been wounded, another terrorist threw a second bomb, which achieved its goal (Fig. 18): "Another deafening explosion resounded, a column of debris and snow shot up from the ground. The Sovereign and those surrounding him all went down and everything fell still for a moment. Groans and cries of the injured were heard as twenty people, all seriously injured to one degree or another, lay on the sidewalk and the bridge.... The collar and another small portion of the Sovereign's overcoat remained; the rest of it had been blown apart by the explosion. Blood poured from his shattered, naked legs, and his face was covered with bruises and traces of blood. Dozens of arms lifted Him from the ground.... Sledges set off for the palace, transporting the wounded Sovereign in a semi-unconscious state.... When His Highness was lifted out of the carriage near the palace entrance, such an enormous quantity of blood remained in the carriage that later it had to be poured out."[18] As a sad monu-

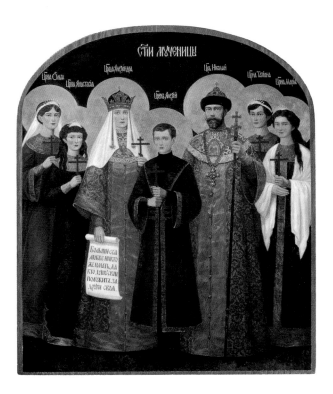

19. Contemporary icon of the "Noble Martyrs" (Emperor Nicholas II, his wife, Empress Alexandra Feodorovna, and their children; after an unknown artist), 2000, printed paper pasted on board, varnish, Moscow, State Historical Museum

ment to this tsar-reformer, the Church of the Resurrection—the "Church on Blood"—was constructed at the site of the assassination, near the Ekaterinsky Canal in Saint Petersburg.

In 1905, one of the youngest sons of Alexander II, Grand Duke Sergei Alexandrovich, was blown to bits in the Moscow Kremlin by a bomb. After the fall of the empire and the October Revolution of 1917, "hunting season" on the Romanovs opened in the former Russian empire. Over the course of two years, eighteen persons—men, women, girls, adolescents—were murdered. On July 17–18, 1918, in Ekaterinburg, a city in the Ural Mountains, Emperor Nicholas II, his wife Empress Alexandra Feodorovna, their daughters, Grand Duchesses Olga, Tatiana, Maria, Anastasia, and their son, fourteen-year-old Alexis, as well as their loyal servants who accompanied them in exile, were all assassinated. On the same night, Grand Duke Sergei Mikhailovich, Grand Duchess Elizabeth Feodorovna (the widow of assassinated Grand Duke Sergei Alexandrovich and sister of the empress), Princes Igor, Ivan and Constantine Constantinovich, who at that time were in the city of Alapayevsk, not far from Ekaterinburg, were abducted and thrown down a mineshaft. Grand Duke Paul Alexandrovich, the youngest son of Alexander II, and three other Grand Dukes, Dmitry Constantinovich and the brothers Nicholas and Georgy Mikhailovich (the brothers of the assassinated Sergei), the four grandsons of the emperor Nicholas I, who were incarcerated in Peter-and-Paul Fortress, were shot during the "Red Terror" in January 1919.[19] This bloody sacrifice to the cruel god of revolution, intended to consolidate the dictatorship of the Bolsheviks, was only one of the many hundreds of thousands of equally bloody sacrifices made in Russia during those tragic years.

Together with the other Romanovs who perished during the revolution, the imperial family was canonized abroad by the Russian Church in 1982. A ceremonious canonization of Emperor Nicholas II and his family by the Moscow Patriarchate took place in August 2000. Many Russian churches today contain icons depicting Nicholas II, his wife, and children, the "Noble Martyrs" (Fig. 19).

20. Atelier de Jongli frères, Tsar Alexander III (1845–1894), Empress Maria Feodorovna (1847–1928), Tsarevich Nicholas (the future Emperor Nicholas II) with members of the Romanov family, Paris, early 1890s, photo mounted on cardboard (silver gelatin print), Moscow, State Historical Museum

21. Court photographer K. Gan, The Grand Duke, Tsarevich Alexis (1904–1918), on a tricycle, photo mounted on cardboard (silver gelatin print), Moscow, State Historical Museum

The presumed remains of Nicholas II, along with the members of his family and most loyal subjects, who shared his exile and his fate, were discovered not far from Ekaterinburg. For several years they were analyzed by an official commission. Relying in part on blood samples obtained from relatives of the emperor and empress on the female side, principally Prince Phillip, the Duke of Edinburgh and the husband of Queen Elizabeth II, genetic experts confirmed that the remains belonged to the Romanovs.[20] Yet the results of these studies are still disputed by several independent experts. Both the Moscow and foreign Russian Orthodox Churches also refused to acknowledge the findings. Thus although on July 17, 1998, for the eightieth anniversary of the tragedy, the remains from Ekaterinburg were ceremoniously interred in the burial vault of the Russian tsars, located in the Peter-and-Paul Church within the fortress of the same name in Saint Petersburg, the old dispute continues. Even today, the final chapter of the story of the blood of the Romanovs is not closed.

22. The Romanov family tree

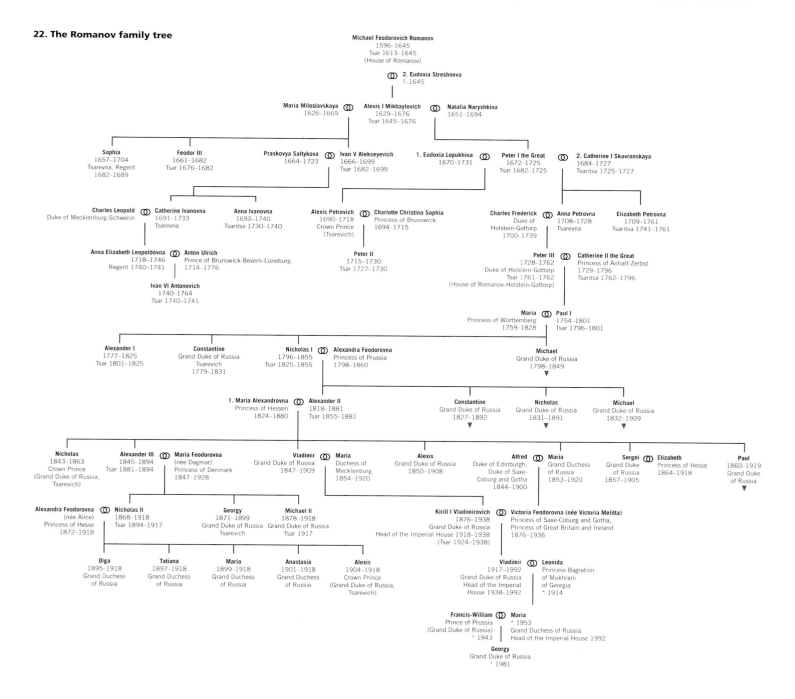

The idea of circular renewal is one of the oldest themes in European culture. Men had only to open their eyes to see that the sun and moon rose and fell beneath the horizon, appearing, disappearing, and reappearing every twenty-four hours. The heavens revolved in their vault, and the seasons repeated themselves; the clouds poured their rain on to the earth, which then gave it back to the heavens in the form of vapor. Nature spent and replenished herself with majestic regularity. These cycles seemed so universal that poets and philosophers came to regard them as outward signs of some deep, metaphysical principle of giving, receiving, and returning, which applied not only to nature but to human morality as well. The popular image of the Three Graces, for instance, personifies the recurrent phases of generosity: one gives, another receives, while the last returns her gift to the original donor—a circular entanglement of charity.

Self-made Man: The shift from blood to genetics
Jonathan Miller

Since the ancients regarded the human body as a miniature replica of the cosmos, it seemed inevitable that they would find counterparts of this rhythmic circularity in all physiological processes. Hippocrates and Plato visualized the movement of the blood as something prefigured in the drift of stars. And although we now think of William Harvey as the first exponent of scientific physiology, he was also inspired, as Isaac Newton was, by the metaphysical doctrines of Antiquity. His physiological researches were directed by mechanical considerations, but in demonstrating and proving the existence of a circulation, he, at the same time, satisfied his almost religious commitment to the occult significance of the circle. It is not surprising, therefore, that in later life he turned to one of the other great rotations of nature: the endless cycle of growth, death, and reproduction:

> In this reciprocal interchange of Generation and Corruption consists the Eternity and Duration of mortal creatures. And as the Rising and Setting of the Sun, doth by continued revolutions complete and perfect Time; so doth the alternate vicissitude of Individuums, by a constant repetition of the same species, perpetuate the continuance of fading things.

Like his predecessors, Harvey was struck by the fact that individuals earned their immortality by proxy, perpetuating their otherwise impermanent form by handing it on to the generations that followed, and that this process repeated itself with orbital regularity. Unfortunately, the link between successive generations was invisible, and there was no mechanical metaphor with which to bridge the gap. In order to explain how the reproductive mystery fulfilled itself, Harvey reverted to the ancient doctrine of the shaping supremacy of the soul, an idea that he had inherited from Aristotle, who was himself expressing one of the most universal intuitions of the human mind. Living in a body that acts so faithfully in obedience to his will, man has found it almost impossible to shake off the conviction that the changes of the physical universe are the

1. "Mendel's Rat Banner," The Eugenics Society, ca. 1930, London, The Wellcome Institute, Contemporary Medical Archives Collection. Photo: Wellcome Library, London

outcome of mental processes like his own and that any alteration in the state of things is the expression of agency as opposed to causality; in short, that all events are actions.

Aristotle saw the universe as a creative partnership between mind and matter. Matter, an inert compound of four primeval elements, was shaped and ordered by an insubstantial power that could imagine and bring into material existence an infinite variety of forms or ideas. As in the Old Testament, a spirit brooding on all possible forms moved over the surface of the shapeless matter and drew it out into the familiar beings of nature. In his great work *On the Generation of the Animals*, written in the fourth century BC, Aristotle made it clear that this cosmological process was repeated on a small scale in the conception and development of living organisms: the male sperm was the spiritual agency that conjured limbs and organs from the menstrual blood provided by the female—just as mountains, rivers, and continents had been molded from formless matter by the soul of the universe. Embryology and cosmology mirrored each other: both were examples of inventive handicraft. At this stage in human thought, art and craft were the only available metaphors for making the experience of transformation understandable. The most intelligible instances of change were those wrought by man himself, who cooked, brewed, baked, wove, hammered, sawed, and smelted his ideas into physical existence, quarrying the inert materials of the physical universe and giving body to his concepts.

By the end of the seventeenth century, the rising prestige of so-called mechanical philosophy made scientists reluctant to accept explanations based on the continuous action of psychic powers. Everything was done to exclude mental urges, and before long this attitude began to influence theories of generation and development. Many biologists reverted to the ancient doctrine of preformation, insisting that the primordial germ already contained a miniature replica of the adult organism, and since this had only to enlarge and unfold itself there was no need to invoke a supervising craftsmanship. Enlargement and unfurling could easily be interpreted in mechanical terms. All that the fetus had to do was to absorb and appropriate the physical nourishment that surrounded it in the womb or the egg.

This still left the problem of where the original effigy arose, and opinion divided itself just as it did in the case of the epigenesists. Some thought that the *petite icône* was inherited from the father, others that it was a maternal bequest. With Antoni van Leeuenhoeks' discovery of microscopic spermatozoa in 1677, the controversy between the ovists and animalculists became more intense than ever. Some biologists even managed to persuade themselves that they could see the preformed miniature huddled like an astronaut in the forward hatch of the sperm. And when their opponents pointed out that there was no such creature to be seen, the preformationists declared that it was transparent in the early stages of development and was therefore bound to escape detection.

The scientists who took preformation to its logical conclusion committed themselves to an infinite regress of miniature forms, packed inside one another like a nest of Russian dolls. If all the details of the adult form were represented in the miniature effigy contained either in the egg or in the sperm, it was necessary to assume that the germ cells of the adult were already included in the fetus. These in turn presumably prefigured the unborn adults of the generation to follow, and so on, back to the first moment of recorded time.

2. Distribution of blood group B among the world's native populations, from P. F. W. Strengers and W. G. van Aken, eds., *BLUT: Von der Magie zur Wissenschaft*, Heidelberg, 1996

25–30 % ■
20–25 % ■
15–20 % ▨
10–15 % ▨
5–10 % ▨
< 5 % ▢

This arrangement made continuous creation unnecessary, but it did so only by attributing the whole concentric design to a single burst of creative activity on the part of God. The theory of *emboîtement*, as it was called, implied that the details of posterity were already prefigured in the first occupants of Eden, and some scientists even went to the lengths of calculating the number of individuals represented in miniature in the womb of Eve. Scientists who were unable to tolerate the continuous creativity of an anonymous craftsman found it easy to accept an abrupt and self-limiting outburst of craftsmanship on the part of Providence.

What made this theory attractive was the fact that it reflected the mechanistic Deism of the early eighteenth century. In physics and astronomy scientists were trying to avoid explanations that invoked the actions of spirits or souls, but the only way they could reconcile this with Christianity was to suppose that God's creative influence was limited to the dawn of time and that, having manufactured and wound up his cosmic clockwork, he abstained from all further action and amused himself by listening to its regular chimes. Preformationism was simply an extension of the same idea.

There were, however, some awkward drawbacks to this theory. It made no allowance for the unexpected occurrence of congenital abnormalities—unless one were to assume that God had mischievously included an occasional grotesque. Detailed preformation also made it hard to explain the phenomenon of healing and regeneration. If everything were performed, it was impossible to account for the growth and replacement of lost parts unless one made the baroque assumption that all future accidents were anticipated in the design and that each potentially losable part was backed up by an infinite regression

of replacements. The most serious objection, however, was that the theory made no intelligible allowance for the way in which offspring often bore such striking resemblances to both parents and that family features were inherited and distributed in a piecemeal fashion. The preformationists could not provide satisfactory answers to these objections as long as they remained committed to a pictorial or iconic view of the developmental process. Admittedly, the only way of avoiding a psychic agency was to postulate a material predeterminant —some structure whose previous existence in the fertilized egg controlled and directed the developing outcome. What they failed to see was that the outcome of a process can be physically predetermined without having to be visually prefigured.

We now know that the specifications that control the manufacture of an object need not resemble the end product. When a modern engineer wants to reproduce an elaborate component, he does not have to draw a diagram of it: he has only to write a set of peremptory commands, and as long as these are obeyed in the order in which they are printed, the object will automatically take the required shape. The instructions can be fed directly into a machine in the form of a punch-tape, where the pattern of perforations dictates the movements of the cutting edge. The machine effectively translates the instructions into the movements needed to bring about the desired shape. When a television picture is transmitted, there are no ghostly images flying through the air: the picture is converted into a series of visually unrecognizable radio pulses, and when these are picked up by the domestic aerial, they cause variable deflections of a flying spot on the television screen and thus reconstitute the original picture. In both these cases—and there are many other examples—a linear code dictates the construction of a visible object.

The twentieth century has exploited this principle in almost every field of technology, but the notion had been intuitively recognized and in some cases explicitly understood for many years. René Descartes appreciated that the written signs that conjure up pictures in the mind's eye do not resemble the images which they provoke. Musical notation bears witness to the same principle. By decoding and obeying a line of conventional signs, a competent musician can re-create a melody without ever having heard it. Musical boxes simply automate this process. When Mozart wrote rondos for jeweled automata, he did not have to hum the tunes to the mechanical pianist: the composition was translated into a pattern of prickles mounted on a revolving cylinder. As this turned, a comb made of metal teeth was plucked in the appropriate order, and the melody was reconstituted. In the early nineteenth century, the same idea was applied for the first time to an industrial process. The French engineer Joseph-Marie Jacquard invented a loom that wove elaborate patterns by automatically following a linear program of instructions stamped on to hinged cards. Although the holes are arranged in a pattern that bears no visual resemblance to the pictures on the carpet, their linear sequence determines the appropriate movement of the shuttles.

In all these processes, the notion of information takes the place of illustration. The performance is guided by instruction rather than by example. This principle presupposes the existence of a formal or conventional notation whose characters can be combined in unlimited variety. It is not even necessary to have a large number of characters. Jean Racine and William Shakespeare were

able to distinguish themselves from each other using a repertory of twenty-six alphabetical symbols. Arnold Schönberg was able to make an unprecedented contribution to musical form without having to break out of the musical notation that was available to Johann Sebastian Bach. The advantage of such an arrangement is that it allows one to vary the performance character by character, whereas a system that depends on pictorial example is committed to the indivisible entirety of the preexisting model.

The biological relevance of this principle did not become apparent until the end of the nineteenth century, partly because it was not widely recognized as a principle, for technologists often succeeded in creating profitable mechanisms without appreciating the abstract idea that they exemplify. But even if eighteenth-century biologists had identified the principle of linear programming, they could not have applied it usefully to the problem of heredity. What they lacked was a knowledge of, first, the notation in which such instructions might be written, second, a site that would bear the inscription, and, third, the intervening processes that would translate and execute the program.

From what was then known about the nature of living matter, creative craftsmanship and preformation were the only conceivable ways in which form could be imposed upon substance. Pure matter was structureless; whereas form was insubstantial. Until some intervening level of organization could be visualized, the controversy between preformation and epigenesis was bound to remain unresolved.

With the discovery of the cell, biologists identified in one and the same entity the site of the instructions and the agent that executed them. Until the end of the seventeenth century, the various parts of the body were regarded as gross compositions, varying only in consistency and texture. Anatomists recognized that certain organs were spongy and others firm and gelatinous; some were fibrous and closely woven, and others dense and rigid. There were elastic strings and glistening membranes; there were bags, balls, and tubes. But, as the microscope became more widely used, it was apparent that these simple distinctions could be broken down still further, and by the end of the eighteenth century biologists were confident that they had found a fundamental unit common to all the tissues of the body—a simple, irreducible element that could be put together in various ways to produce all the known textures. This unit was the fiber, a microscopic thread that could be woven into loose meshes or dense, impermeable sheets, tightly bound into tendons or loosely bundled to form muscles. By 1800 the body was seen as an elaborate textile, a garment of hemps, worsted, and linens—the fact that the term "tissue" was introduced at that time indicates the persuasiveness of the metaphor.

The resolving power of the microscope continued to improve and biologists discovered that there was yet another level of organization, a hidden arrangement of living matter that turned out to have a different biological status from that of the fiber; something more important than mere grain or texture. They became aware that all tissues were made up of assemblies of small, globular masses: each one anatomically distinct, each one housing a darker center or nucleus. It soon became apparent that the globules or cells were not decoratively embroidered on to some underlying fabric like buttons or sequins, but that they actually were the fabric and that it was the shape, character, and arrangement of these entities that gave each organ and tissue its characteristic consistency and function.

The discovery of fertilization had already cast doubts on the existence of a preformed image, since it was difficult to see how the individual unity of such an image could be reconciled with such a patently dual origin—unless one assumed that the effigies were brought together in two halves, in which case maternal characteristics would invariably be distributed down one side of the body with the father's features on the other. In any case, microscopic observation had already shown that, although the nucleus had a complicated structure, the material bore no resemblance to the adult shape but took the form of minute ribbons or chromosomes. From the way in which these entities reduplicated themselves and were accurately shared out each time the cell divided, scientists could not help but conclude that these were the sites of the genetic inscription. And although no one had yet discerned, let alone deciphered, the characters, it was almost self-evident that the instructions were assembled in a factorial rather than a pictorial manner.

If scientists had heeded the plant-breeding experiments of an obscure Moravian monk in the 1860s, the factorial view might have established itself forty years earlier than it did. Until Gregor Mendel, almost no one had recognized that bodily characteristics could be inherited and distributed among the offspring in a strictly arithmetical manner. By carefully choosing characteristics that displayed themselves in a discrete all-or-none manner, and by working with breeding populations that were large enough to display convincing arithmetical trends, Mendel was able to prove conclusively that the hereditary material—of which he had no immediate knowledge—was composed of genetic particles that could be transmitted independently of one another. Such experiments, with their unprecedented commitment to the statistical method, would have dealt a death blow not only to preformationism but to the whole controversy that had dogged embryology since Harvey and before. By the end of the nineteenth century, however, the discovery of chromosomes all but compelled the rediscovery of Mendel. And by 1900 the stage was set for a new genetic theory.

3. Lovis Corinth (1858–1925), *Othello*, 1884, oil on canvas, Neue Galerie der Stadt Linz, Wolfgang-Gurlitt-Museum, Linz

The shift from blood to genetics

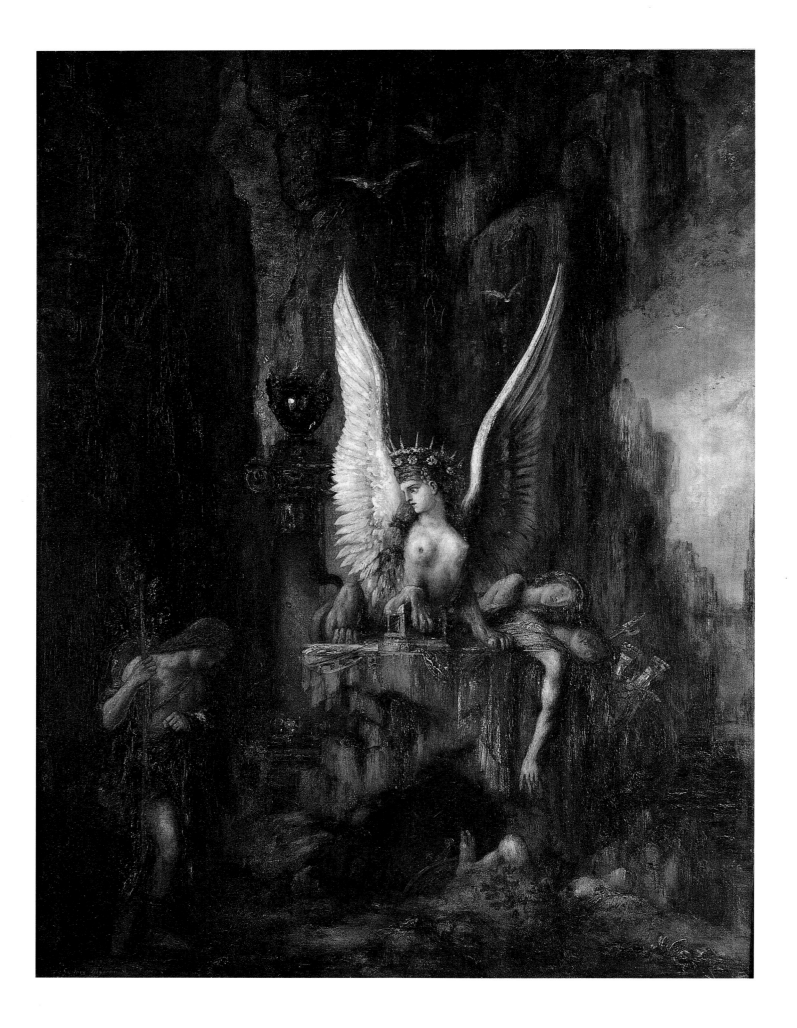

The intellectual reorientation brought about by the French Revolution promoted the development of what in the nineteenth century became biology-dominated thinking—paradoxically entrenching the blood myth as well. As the embodiment of the life force, blood was associated with many disciplines. Besides medicine, it touched on religion and literature, and even economics, because the circulation of money was comparable to that of blood.

The first part of *Faust*, Goethe's most famous play, which appeared in 1808, provides ample evidence that the renewed fascination with the blood myth coincided with the emancipation of the bourgeoisie.[1] To the nineteenth century, Faust's ambition to buy his way to new, unheard-of experiences at the price of his own blood seemed the very symbol of modern man, willing to risk even his own bliss to realize his Utopian ideal of knowledge. The French painter Eugène Delacroix accordingly dramatized the encounter between Faust and Mephistopheles in 1826 with garish splashes of blood red for highlights, the color of the Passion symbolizing the perilousness of the pact (Fig. 2). The blood

"Blood is a most particular fluid": Blood as the object of scientific discovery and Romantic mystification
Annette Weber

pact denied the necessity for ethical standards in the search for knowledge, apparently promising absolute freedom. Nonetheless, the denial of Christianity-based ethics and the question of whether knowledge might be pursued at all without ethics urgently needed answering, as the middle-class society then developing justified the acquisition of knowledge as indispensable for universal well-being, and saw advances in science and technology as necessary preconditions for general social development.

One answer was positivism, as propounded by the French philosopher and mathematician Auguste Comte (1798–1857). He demanded an intellectual and moral revival based on scientific discovery, and assumed that there would one day be such comprehensive knowledge available as to allow all social problems to be solved and thus enable a definitive organization of nature and society.[2]

At the heart of scientific discovery was, by the nature of things, the exploration of the human body in the disciplines of human biology, physiology, and genetics, which naturally entailed the study of blood. Paradoxically, despite research undertaken on the circulation and composition of blood, their functions remained as much a mystery as ever in the modern era. As in biblical times, blood was considered the life and soul of man, and the powers attributed to it grew as knowledge of its physiology increased. Moreover, blood continued to be associated with magic, and was thought to be endowed with destructive as well as healing powers. Anyone rattling at the cage of these traditional concepts posed a threat to the social consensus on the role of blood, and could, therefore, expect to be marginalized. This was what happened to the London obstetrician James Blundell, who was the first to carry out a person-to-person blood transfusion. As a result, he was seen not only as an inspired doctor but also as a dangerous charlatan (see Kim Pelis' essay "Transfusion, with Teeth," pp. 175–91).[3] The

1. **Gustave Moreau (1826–1898), *Oedype Voyageur*, 1864, oil on canvas, Metz, Musée des Beaux-Arts. Photo: J. Munin**

2. Eugène Delacroix (1798–1863), *Mephistopheles and Faust*, **1826, oil on canvas, London, Wallace Collection**

very fact that, thanks to his discoveries and his medical apparatus, he was able to revive life and thus "meddle in God's work" made him highly suspect.

At the same time, the Church was attempting to bring Jesus closer to believers by promoting the contemplation of his heart in the form of a "modern," i.e., medically accurate, image of the organ. In keeping with the spirit of the motto "Salut par le sang," the French government commissioned the young Delacroix in 1821 to paint a huge altarpiece for the cathedral of Ajaccio showing the Virgin holding Jesus' heart (*Vierge au Sacré Cœur*). He depicted the Virgin as an allegory of faith, displaying the organ to be worshipped like a trophy.[4] By promoting such highly naturalistic representations, the Church hoped to stimulate faith, but intimated clearly that it retained sovereignty of interpretation over the process of creation as before. For the same reason, in the later nineteenth century, the Church renewed its interest in blood mysticism, and pushed for the worship of stigmatization, singling out, for example, such figures as the virgin Katharina Emmerich.[5] In a popular documentary account Clemens Brentano recorded her revelatory visions of the Passion. In 1885, Gabriel von Max painted a highly realistic version of the vision she experienced: the picture shows a hysterical woman afflicted with stigmata in quasi-diseased form (Fig. 3).

3. Gabriel von Max (1840–1915), *The Ecstasy of Katharina Emmerich*, **1885, oil on canvas, Munich, Neue Pinakothek. Photo: Artothek, Peissenberg**

4. Eugène Delacroix (1798–1863), *Greece on the Ruins of Missolonghi*, 1826, oil on canvas, Bordeaux, Musée des Beaux-Arts

Delacroix and the growth of Orientalism in Europe

Delacroix's paintings *Mephistopheles and Faust* and *La Vierge au Sacré Cœur* reflect the nineteenth century's fascination with the irrational power of blood, which can ultimately be traced back to Christian ideas in the Middle Ages. In view of this, the pictures would seem to be Romantic counterparts of the rationalism demanded by science. Nonetheless, Delacroix was just as enthusiastic about revolutionary theories of nature as posited by his friend Georges Cuvier, the founder of paleontology and zoology. His ideas about the development of species influenced not only the artist's animal studies but also his view of mankind, which is particularly apparent in the moral characterization of his figures. In this, Delacroix followed a trend that was typical of the nineteenth century: a new interpretation of the world and history was expected of science so that theories of nature could mutate into a substitute religion.[6]

The extent to which Delacroix was influenced by these ideas can be gathered from his oriental scenes. The Orient fascinated European society

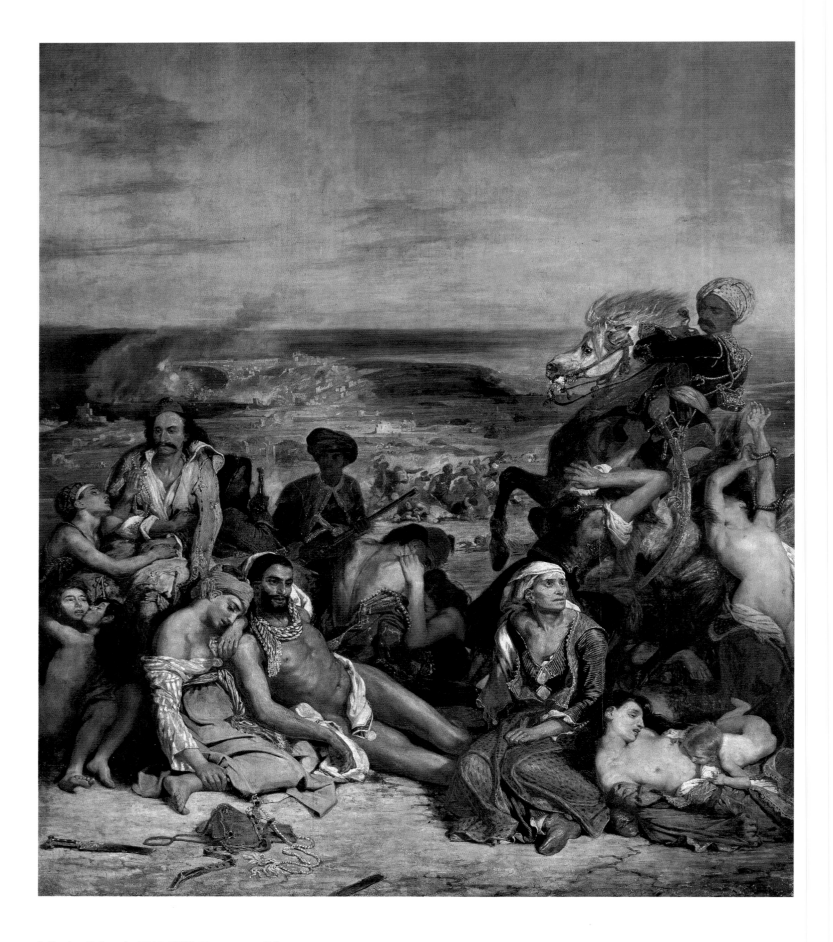

5. Eugène Delacroix (1798–1863), *Massacre on Chios,*
1824, oil on canvas, Paris, Musée du Louvre.
Photo: RMN, Hervé Lewandowski

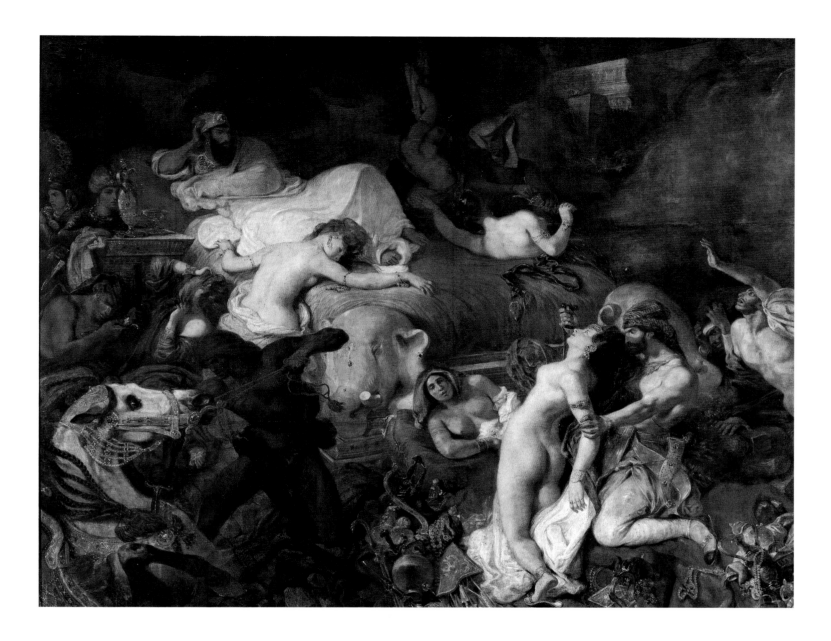

6. Eugène Delacroix (1798–1863), *Death of Sardanapalus*, **1827, oil on canvas, Paris, Musée du Louvre. Photo: RMN, Hervé Lewandowski**

throughout the nineteenth century, from Napoleon's Egyptian campaign to the turn of the twentieth century. The East beckoned as the first objective of colonialization, not just as the focus of economic and political interest but also as the object of scientific study. At the same time, it was considered the cradle of humanity and was, therefore, a fashionable travel destination. The literati and artists, on the other hand, regarded it as a mystical, exotic place full of romance, hidden wisdom and passions, as well as cruelty and primitiveness. In the imagination, the Orient became both the reflection of new world experiences and a cultural antithesis to civilized Europe.[7] Orientalism thus called for picturesque street scenes that evoked images of Antiquity. In addition, scenes containing elements of eroticism or bloodthirsty cruelty were painted, in which Eros and blood featured as symbols of the power of the irrational. These themes became all the rage in the nineteenth century, not just out of a desire to shock the exhibition-going bourgeoisie by depicting unbridled passions in an unusually daring fashion—the occasion for moral indignation also served to confirm the superiority of European civilization.

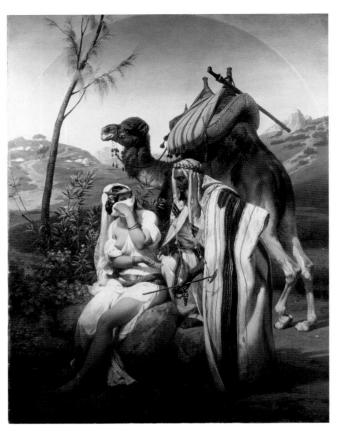

7. Horace Vernet (1789–1863), *Judah and Tamar*, 1840, oil on canvas, London, Wallace Collection

Oriental themes are also present in Delacroix's early pictures of the Greek wars of liberation, inspired by Lord Byron's poetry. Examples are the *Massacre on Chios* (1824) and *Greece on the Ruins of Missolonghi* (1826) (Figs. 4 and 5). Both paintings denounce the Turkish occupation as oriental barbarism, which threatened to destroy the cradle of Western civilization that is Greece. Slated by critics for the goriness of the *Massacre*, Delacroix justified his broadly conceived horrors as realistic, pointing out that the newspapers would represent the same view. To support his notion of Orientals being inherently cruel, he could have cited contemporary anthropologists and Orientalists as well.[8]

The idea that people from the Orient were inferior by virtue of their blood and race is particularly clearly represented in Delacroix's famous picture *Death of Sardanapalus*, an orgy of violence in tones of bloody red (Fig. 6). Painted in 1827, the picture shows the Assyrian despot Sardanapalus (Assurbanipal) awaiting the imminent storming of his palace and ordering his wives, dogs, and horses to be killed and his possessions and property burned before finishing himself off. A high point in Romantic painting, it generated an immense uproar when it was exhibited at the Salon in 1827/28. The new paint quality itself caused a stir, but the grisly goings-on depicted had still greater impact, even if the message of the picture, namely that Oriental rulers were degenerate by blood and for this very reason inclined to bloodthirstiness, was generally accepted (in fact, Charles Baudelaire explicitly mentioned this notion with approval when he later reviewed the painting).[9] For the general public, the scandal was that Delacroix had employed such virtuoso means to paint such a morally depraved scene.

In the wake of *Sardanapalus*, the pictorial formula blood = immorality, irrationality, and passion in oriental scenes caught on. Henri Regnault's *Execution without Judgment* of 1870, for example, carries an explicitly moral message in the title (Fig. 9) and at the same time confirms the European prejudice that cruelty and revenge replaced the law in the east.

In combining moralizing intent with painterly indulgence in the exotic, Delacroix pioneered a new vision of orientalist painting in the nineteenth century.[10]

8. Eugène Delacroix (1798–1863), *Women of Algiers*, 1834, oil on canvas, Paris, Musée du Louvre. Photo: RMN

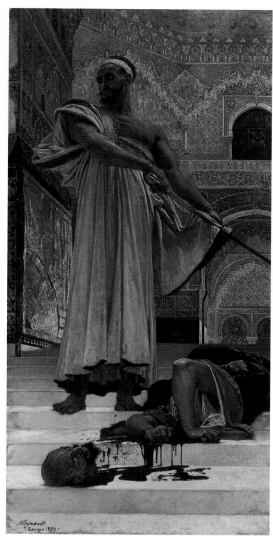

9. Henri Regnault (1843–1871), *Execution without Judgment***, 1870, oil on canvas, Paris, Musée d'Orsay. Photo: RMN, Jean Schormans**

People of other continents were presented not just as visually fascinating but were also subjected to moral evaluation. Depending on the painter's intention, exotic could mean inferior or primitive or even sexually dissipated, as Delacroix implies of the *Women of Algiers* (1834), idling with lascivious indolence in the harem as they spend the day waiting for their master (Fig. 8). A similar scene is depicted in Joseph Ange Tissier's *Algerian Woman and Slave Girl* (1861). In his painting *Judah and Tamar* (1840), even Horace Vernet, who viewed the Orient as a reflection of biblical times, shows the woman as an indecently clad, importunate oriental whore offering herself to her father-in-law to tempt him to incest (Fig. 7). The hotbloodedness imputed to oriental women and especially odalisques is interpreted as a lack of morality, and is used to indulge erotic fantasies, to which Delacroix's *Femme au divan* (1826) provides very direct invitation.

All these pictures convey the implicit message that oriental cultures remained in a condition of ancient naturalness and were, therefore, innately more primitive. For the same reason, they were thought to show their feelings more openly than Europeans, who claimed to have more control over their emotions because they were "civilized." To what extent such views were accepted as a matter of course is made clear by contemporary European attitudes to nineteenth-century colonialization. Europeans justified their colonializing efforts by claiming moral and civilized superiority, which they ultimately sought to justify in biology with the assertion that the white races were superior by blood.

Read blood: Blood from a physiological and anthropological view

Propositions of this sort, which are nowadays considered to be hubris, were nourished by the belief that scientific and technological achievements of Europe would lead to a completely controllable and, therefore, malleable world. They reveal the apparently rationally oriented nineteenth century, in which faith followed reason, to be a time of profound intellectual schizophrenia in which scientific discoveries still valid today featured alongside ethnological ideas now deemed patently absurd. Mankind—and especially the white race— was considered the "crown of creation" and therefore had the right to subjugate the world (a belief that the Americans would later call "Manifest Destiny" in an effort the legitimize their colonization of the American West). Body and soul were considered mechanical instruments. You needed only to understand how they worked and what drove them to have the essence of human nature itself in your hand.

In view of what was expected of scientific discovery, it is no surprise that theoretical and experimental interest in human biology and the appearance, heredity, and genesis of the various human types was very high. Empirical anthropology in the age of colonialism supplied material for new observations on the diverse forms of human appearance, which qualified as races with blood-determined differences. Blood was deemed the bearer of both hereditary physiological material and qualities of character.

This notion was ultimately based on the concept of four "cardinal humors" or body fluids described in ancient times by the Hippocratic school (for a detailed account, see Valentina Conticelli's essay "Sanguis Suavis," pp. 55–63,

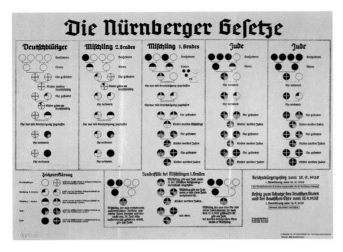

10. Poster elucidating the 1935 race laws (the so-called *Nürnberger Blutschutzgesetze*), Berlin, Deutsches Historisches Museum

and Jonathan Miller's essay "Blood: The pure, clear, lovely, and amiable juice," pp. 109–19). A person's individual temperament depended on the organic conditions of these fluids (i.e., bile, lymph, nerves, and blood) or on the measure of liquid allocated to these organs by heredity.

In the second part of his *Anthropologie in pragmatischer Hinsicht abgefasst* (Pragmatic Anthropology), written shortly before 1800,[11] Immanuel Kant went a step further, associating blood with the four humors, i.e., sanguine (= light-hearted, literally light-blooded), melancholy (= serious, literally heavy-blooded), choleric (= warm-blooded), and phlegmatic (= cold-blooded). Thus, by the nineteenth century, blood was not only the carrier of race, as it had always been, but the bearer of character traits as well.

Half a century later, the French scholar Prosper Lucas fleshed out this concept in his influential *Traité philosophique et physiologique de l'hérédité naturelle*, published in 1847.[12] Lucas asserted that the basic features of every human race were hereditarily preconditioned in respect of appearance, character, and morals, and were, therefore, passed on as standard. However, environmental influences determined to what extent predisposition could develop, which left room for individuality. Lucas provided no scientific evidence for the assertion that physiological and moral qualities were inherited via the blood, attempting instead to prove it by citing examples of behavior from zoology. Analogous to breeding pure-bred horses, whereby the aim is to optimize not just physiological features of "pure-bred blood" but also behavior, he took pure inherited blood also as the cause of specific qualities or disadvantages of a human race.[13] He went so far as to assert that the various racial qualities would even show up as a specific chemical quality in the blood, for example, people of black African origin would have to have darker blood than Europeans, i.e., Caucasians. In his view, this postulate would be provable in future investigations with an improved apparatus.[14]

Almost contemporaneously with Prosper Lucas' treatise, the racial blood theory was posited by Arthur Gobineau in his *L'Essai sur l'inégalité des races humaines*, published in 1853.[15] A writer and poet with ambitions in the history of philosophy, Gobineau postulated that blood was the decisive factor in the historical and civilizational development of mankind, with the blood of the Caucasian type, i.e., the white race, but particularly the Aryans, being superior to all others. Some figures of the Semitic race, particularly from biblical times, were conceded the same status. Indeed his overall assessment of the aptitude of the Semitic race was very high—after all, it had produced the Bible. The fact that the scientific world received Gobineau's *Essai* coolly because of its obvious lack of proofs and inadequate scientific analysis did nothing to harm its success as a publication. The book went through many editions and had ominous after-effects, culminating in Nazism.

The Nazis based their ideological program on the idea of a blood-conditioned potency of race, and translated the concept into political reality with the so-called *Nürnberger Blutschutzgesetze* (Nuremberg Blood Protection Laws) of 1935. Marriages between "German-blooded" and "alien-blooded" persons, especially Jews, were severely restricted or totally banned on the grounds that the supposed "purity of blood" of the German nation needed safeguarding (Fig. 10). In addition, citizenship was linked to a blood classification that was never really defined, thus creating a tool for arbitrarily marginalizing

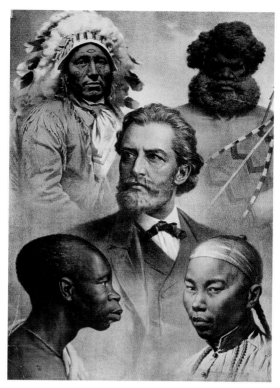

11. School wall chart showing the five principal human races, Dresden, late 19th century, Zetel, Nordwestdeutsches Schulmuseum Bohlenbergerfeld. Photo: Manfred Kötter, Frankfurt am Main

12. Geopolitical and anthropological wall charts with an emphasis on the evangelical mission, Calw, 1883, Stuttgart, Universitätsbibliothek

all ideologically or politically undesirable groups. These laws, set up with all the paraphernalia of legitimate law-making, were widely approved in Germany and are still of consequence today. We need look no further than the recent difficulties in trying to get a rationally based citizenship act passed. Formerly, German citizenship was granted solely on the basis of blood—to be German one had to have German parents—irrespective of one's place of birth. Conversely, being born in Germany did not automatically confer the right to German nationality. The current German law concerning nationality adds to the old concept of a citizenship based exclusively on blood relationship the possibility of acquiring German nationality by birthright. Each child born in Germany of non-German parents living in Germany for at least eight years has the right to obtain German citizenship. The public response to the introduction of this new law was a widespread fear of Germany being overwhelmed by "a flood of foreign blood." It appears that the idea of the importance of blood draws its appeal from the very absence of a rational definition, as only such irrational terminology can be used for a claim to absolute superiority that defies logical foundation.

It has been discussed whether the racial blood theory owed its success to the fact that it attempted to marry new scientific discoveries with old thought patterns to create a modern—supposedly rational—conception of the world with the same future certainty as that of the pre-Revolutionary Christian concept. And indeed Gobineau's thesis that the purity of blood and potency of race ultimately determined the development of mankind was based on the same idea of the predetermined course of human history as found already in the biblical story of creation. He thus managed to defuse the latent explosiveness of scientific issues that threatened to blow the determinist worldview apart by a new form of constructed harmony of blood and race. Moreover, the mystification of blood counteracted the uncertainty brought about by rapid changes in science and technology, and thus could serve as ideologically conservative self-reassurance for positions that could lead directly and indirectly to political misuse.

Blood and race: Effects on history, literature, and the economy

The extent to which the debate about the development of species, race, and blood left its mark on the nineteenth century can be gathered from the fact that the discussion of this ideology, thinly veiled in scientific robes, was not confined to the intellectual elite but gained access to a wide public via a print medium that was growing rapidly in importance. It influenced literature and art as much as religion, education, and economics. A remark by Gustave Flaubert makes clear how enduringly literature was affected by the new biology-dominated philosophy that assumed the natural inequality of man: "Le dogme tout nouveau de l'égalité que prône le radicalisme est démenti expérimentalement par la physiologie et par l'histoire"[16] (The wholly new dogma of equality advocated by radicalism is contradicted experimentally by physiology and history). In his portrait of *Othello* (1884; Fig. 3, p. 154), Lovis Corinth illustrates the same idea: the crude physiognomy and awkward pose convey an emphatically uncivilized, almost bestial savagery. Despite all due empathy with the man depicted, the artist's eye is influenced by racial prejudices.

While literature and art popularized these speculations by presenting them with graphic clarity to gain broad public acceptance, historiography had

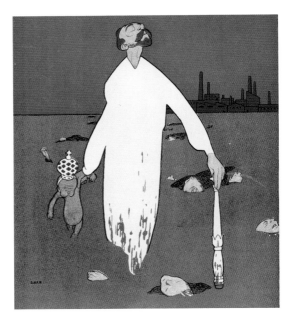

13. Olaf Gulbransson (1873–1958), *The Blind Tsar*, from "Aus meiner Schublade" (From My Drawer), ca. 1905, lithograph, private collection

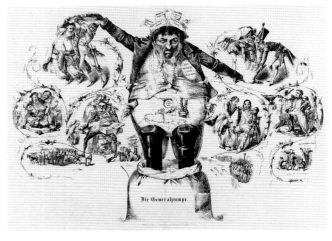

14. *The General Pump*, 1848/49, lithograph, Frankfurt am Main, Historisches Museum. Photo: Seitz-Gray

to find new ways to generate a social consensus about the unprovable theses underlying them. In France it was mainly François Guizot (1787–1874) and Augustin Thierry (1795–1856) who revolutionized the understanding of history by means of explanatory models that they had borrowed from the sciences.[17] In his essay "Du Gouvernement de la France depuis la restauration et du ministère actuel" (Concerning the Government of France since the *Restauration* and the Current Ministry) published in 1820, historian and politician Guizot transformed the old concept of "races," traditionally used to designate ancient class differences between the Frankish nobility and Romance-speaking burghers (= *deux races*), by tracing the singularities of parties in contemporary French politics back to qualities of the *races humaines*. At about the same time, journalist and historian Augustin Thierry used the term *race* as a new anthropological concept. In his essays *Nouvelles lettres sur l'histoire de France* written between 1817 and 1827, he made the first attempt to interpret the history of France genetically by applying the new concept of race to such culturally distinct peoples as the Franks, Gauls, Normans, Angles, and Saxons. Each of these, he said, had distinguished itself by different blood-conditioned qualities of character that had been the real precondition for achievement and powers of accomplishment and, therefore, for success. Ultimately the races that asserted themselves were those that had best adapted to the given historical circumstances and passed on their legacy most successfully through their blood. These theses were supported by comprehensive quotes from a careful study of the sources, which constituted a methodological novelty in French scholarship.[18]

The effect of the new historical picture was not confined to France, but also influenced public opinion in England and Germany, because Thierry and Guizot were notable journalists of the *Restauration* period and July monarchy. Guizot was also a highly regarded Minister of Education under Louis Philippe. In the end, the effects of their theories trickled down to school teaching in the form of ethnological wall charts and historical picture books, which presented the world from the supposedly superior perspective of the white man, making race an educational concept that became a permanent fixture in the classroom (Figs. 11 and 12).

Notions of race also migrated via literature and historiography into politics, and featured especially in stories about social conditions of the time. In his novel *Coningsby*, no lesser a figure than the English politician and novelist Benjamin Disraeli attributed a central role to the idea that moral and intellectual capabilities were determined by the quality of the race and the purity of its inherited blood.[19] Published in 1844, the story justifies the special position of one of its principal characters, the banker Sidonia—presumed to be a character portrait of Lionel de Rothschild—by his noble (i.e., Spanish) origin and descent from an ancient Jewish family. He derives their superior intellectual, social, and economic capabilities, which have marked out the family for centuries, from the idea that the Hebrews as a part of the top-ranking Caucasian race had never intermarried with others and thus were specially pure-blooded. Their outstanding position in the history of human civilization was based on biological advantages: "An unmixed race of a first-rate organization are the aristocracy of Nature." By virtue of this heritage, which may also be termed Oriental, Disraeli stylizes the banker Sidonia as a prototypical modern man, who together with a nobleman of pure Norman descent, who overcomes the confines of his class by marrying into the

15. Thomas Theodor Heine (1867–1948), "In Darkest Germany," *Crimmitschau, Simplicissimus*, 1904, caricature, Munich, Stadtmuseum. Photo: Wolfgang Pulfer, Munich

16. Thomas Theodor Heine (1867–1948), "In Darkest Germany," *After the Demonstration, Simplicissimus*, 1910, caricature, Munich, Stadtmuseum. Photo: Wolfgang Pulfer, Munich

bourgeoisie, lays the foundations of a new society.

The tangible fascination of Disraeli with a Jewish family as socially and economically successful as the Rothschilds contributed to consolidating not only their individual myth but also general confidence in a middle-class society's ability to develop. Such hopes were dashed by the outbreak of revolution in numerous European countries in 1848, and the fascination with social climbers, which the general public had always viewed with a mix of admiration and envy, turned to open antipathy. Jews—and above all the Rothschilds—were portrayed as the progenitors of capitalism, which was thought to have enslaved large parts of the population to create a new money-based world order and destroyed traditional models of social order, such as the monarchy. The power of race and its blood was adjudged as sinister and demonic as the power and myth of money. The circulation of money was equated with that of blood, and the Jewish banker transmogrified into the heart of capitalism and its indefatigable pump (Fig. 14). Increasing economic and political polarization in the second half of the nineteenth century reinforced racism. Jews were accused of damaging human society as a whole. Anti-Semitic resentment peaked in the Alfred Dreyfus affair in 1894. Dreyfus was a Jewish officer in the French Army unjustly sentenced to imprisonment. This led to Emile Zola's impassioned essay "J'accuse!" which made the case a *cause célèbre*, and to the creation of vicious political cartoons depicting Jews as capitalists and blood-sucking, vampire-like monsters.

At the same time, blood was now also associated with the workers' struggle for their rights and a decent existence. Blood red was not only the color of worker party insignia, but was also used in caricatures to represent violence, as exemplified by Thomas Theodor Heine's bitter satires in *Simplicissimus* commenting on the futile strikes by the Crimmitschau textile workers in 1903/4 and the outbreaks of labor unrest in Wedding, Berlin in 1910 (Figs. 15 and 16).[20] Blood red was likewise the emblem of Russian people's struggle for more rights. Following the suppression of the uprisings of 1904/5, Olaf Gulbransson shows the Tsar with his small hemophiliac son wading blindly through a sea of blood, as both perpetrator and victim (Fig. 13).

In literature, Emile Zola (1840–1902) gives detailed treatment in his novel *L'Argent* (Money) to the subject of the capitalist of Jewish origin, who sits like a spider in his web sucking money from others like blood. This is one of a monumental series of twenty genre novels about the Rougon-Macquart family, written between 1868 and 1893. In *L'Argent*, banker Gundermann becomes the instrument of ruin for Saccard Rougon, whose degraded blood lures him into speculating. Zola's intention was to depict the blood-determined degeneration of a whole family over several generations.[21] Its hereditary stigma is traced back to a previous adultery, which Zola calls a *crime contre le sang* (crime against the blood). The adulterous relative *Tante Dide* is blamed for passing on her impure, corrupted blood to all her descendants. The result is that the innocent but feeble-minded and hemophiliac great-grandson perishes, as does the physician, Pascal, who is of course able to identify the familial degeneration as blood-determined but dies, driven mad by his studies of the family trees and its effects. Instead of the punishment of God, Zola wheels on Nature as the avenger, punishing moral transgressions with degeneration. In this, he reveals himself a loyal disciple of the new determinist scientific ideology. This allows him to contrast the stigma of the Rougon-Macquart family, which may but need not occur, with the stigma

17. Charles Landelle (1821–1908), *Jewess from Tangiers*, ca. 1860, oil on canvas, Reims, Musée des Beaux-Arts. Photo: Musée des Beaux-Arts de la Ville de Reims, De Vleeschauwer

of the Gundermann figure, which is predetermined as racially inferior and therefore admits only morally depraved behavior.

Loose and depraved: Women as the epitome of degenerate blood

Zola's great series of novels presented heredity as the determining factor of human fate, thereby reflecting the current debate on the subject of race, blood, and heredity, which was given new impetus by the publication of Charles Darwin's *Origin of Species*, in 1861. The debate led to a reassessment of society as a whole, and involved not only Jews but also other outsiders, such as criminals, whose misdemeanors the famous criminologist Cesare Lombroso deemed to be partly determined by blood. It therefore followed that a criminal disposition was innate and might therefore be inheritable.[22]

Yet the most enduring effect of this reassessment was on the perception of women. The influential French historian Jules Michelet (1793–1874) —and, taking a cue from him, Lombroso said much the same in 1893— declared that female menstruation was a mark of women's natural *débilité mentale et physique* (mental and physical debility). In his widely debated essay *L'Amour* (1859), Michelet went on to add that menstruation made women less capable of work than men, and generally they were of unsound mind and even dangerous.[23] They were certainly quite incapable of intellectual activity—particularly not "in the presence of men"(!). Thus, under the cloak

18. Viktor Müller (1829–1871), *Salomé with the Head of John the Baptist*, ca. 1870, oil on canvas, Berlin, Staatliche Museen—Preussischer Kulturbesitz. Photo: Karin März

19. Gustave Moreau (1826–1898), *L'Apparition,* ca. 1875, oil on canvas, Paris, Musée Gustave Moreau

of supposedly scientific discoveries, new social taboos were established. Because of their supposedly flawed nature, women were virtually declared mentally defective minors, meaning they required permanent supervision like children or criminals.

This idea of women's innate inferiority found resonance in almost all the great French novels of the nineteenth century, especially in those that depict heroines trying to break free from the tightly restrictive corset of bourgeois prosperity. In Balzac's *Splendeurs et misères des courtisanes*, first published in 1831, Esther Gobseck escapes the life of a prostitute to become a lover, and wishes she could change her blood so as to wipe out her past as a Jewess and courtesan. Thereupon she is taken to a monastery by the patron of her lover, the convict Jacques Colin, who poses as priest, to be converted and get a Christian education. The very use of the term "beautiful Jewess" to describe Esther, adopting virtually the same stereotype as painted by Charles Landelle in the *Jewess from Tangiers* (ca. 1860; Fig. 17), indicates clearly that her wish is doomed to failure:

> Esther came from that cradle of mankind, the homeland of beauty —her mother was a Jewess. Although the Jews have lost so often in their contact with other nations, there are still clans among its numerous tribes in which the sublime type of Asiatic beauty has been preserved. She … had hair whose abundance no hairdresser could subdue.… Her skin was as fine as handmade Chinese paper, … Esther's origin was revealed in the oriental cut of her eyes with their Turkish lids. They were slate gray and, depending on the lighting, could take on the bluish tones of black raven's feathers.… Only races that come from the desert have magical power over everyone in their eyes.… Her forehead was firm and proudly vaulted. Her nose was fine like those of the Arabs, narrow with well-formed, laterally high-arched oval nostrils. Her red, fresh mouth was like a spotless rose …[24]

Balzac justifies his statement that her beauty was determined by race and environment by referring to Jean Lamarck's theory of the transformation of species, which he exemplifies in the context of Esther's description with the behavior of races of sheep in the pasture. He also uses this scientific explanatory model to justify making Esther's natural, i.e., blood-conditioned, sensuality intractable to civilization, which means that as a beautiful Jewess she was born to be a courtesan.[25]

In 1834/5, Balzac published *La Fille aux yeux d'or* (The Girl with the Golden Eyes), a story dedicated to Delacroix, with descriptions influenced by the sensuality of his Oriental scenes. Balzac probably had Delacroix's painting *Femme au perroquet* (Woman with Parrot) (ca. 1826) in mind even for Paquita, the protagonist of the novel (Fig. 21). Stimulated by the painting of the odalisque surrounded by luxury, ready for erotic seduction but at the mercy of the whims of a male master, the picture of the woman is here lent the more somber aspect of the *femme fatale*, whose dark female power leads to the bloodbath of her own murder.

Analogous to the question of the status of scientific discovery, art and

20. Horace Vernet (1789–1863), *Judith,* 1843, oil on canvas, Pau, Musée de la Ville de Pau

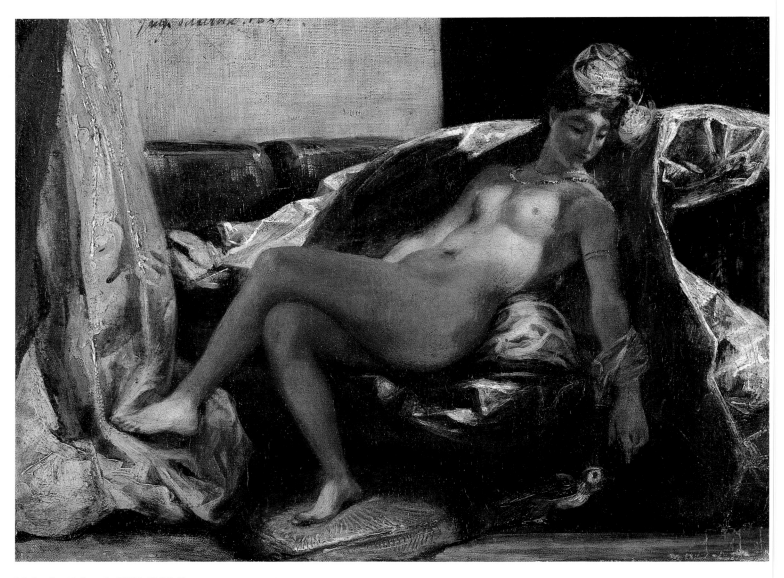

21. Eugène Delacroix (1798–1863), *Femme au perroquet* (Woman with Parrot), ca. 1826, oil on canvas, Lyons, Musée des Beaux-Arts. Photo: Studio Basset

literature responded to the defamation of the biological characteristics of women with a counter image that draws life from the appeal of degeneration. They created an individual typology of the *femme fatale*, who despite her weakness has the ability to attract men and plunge them into ruin. In popular literature she might take the form of a female vampire drinking a man's life blood away in order to instill new vigor into her own anemic blue blood. Sarah Bernhardt played with this *idée fixe* frequently and mockingly, presenting herself as a bust with vampire wings.[26]

Especially favored as examples of murderous *femmes fatales* and the very embodiment of female destructiveness were not only scheming women in the harem (Fig. 22) but also biblical or classical heroines such as Judith (Fig. 20), Salomé, Medea and Cleopatra, seen in gory destruction of their victims or themselves. Thus, Hans Makart's *Cleopatra* finally kills herself, poisoning her degenerate blood with snake venom. In Gustave Moreau's *chef d'œuvre* called *L'Apparition* (ca. 1875), a spectrally white, bloodless Salomé appears to conjure up the bloody, dripping head of John the Baptist by her lascivious dance (Fig. 19), whose spirituality nonetheless remains beyond her grasp. Moreau turns the archetypal tale of the depraved seductress into a symbol of the modern *femme fatale*, who causes chaos through her immorality, the consequence of her anemic

blood. Only the male spirit can bring order and control this chaos because it retains its effectiveness beyond death.[27]

At the *fin de siècle*, women predominated as examples of the depraved and decadent, as in Gustav Klimt's *Judith II* (1909), in which the head of the slain Holofernes serves as proof of her fatal powers of attraction, or in Lovis Corinth's *Salomé* (1900), who has the head of John the Baptist brought to her as a trophy, and savors the slaughter she has brought about by raising the eyelids of the murdered man, who is no longer able to perceive the seductive female charms thus offered him (see Fig. 1, p. 174–75).[28] The arcane painting and intellectual subject matter highlight the tone of mockery in the treatment of cruelty and decadence. Far from negating the pleasure in morbidity, the sophisticated setting intensifies it. More than a hundred treatises, the painting illustrates that blood remains, as ever, a magic element—a "most particular fluid."[29]

22. Fernand Cormon (1845–1924), *Jalousie au sérail* (Jealousy in the Harem), 1874, oil on canvas, Besançon, Musée des Beaux-Arts et d'Archéologie. Photo: Musée des Beaux-Arts, Besançon, Charles Choffet

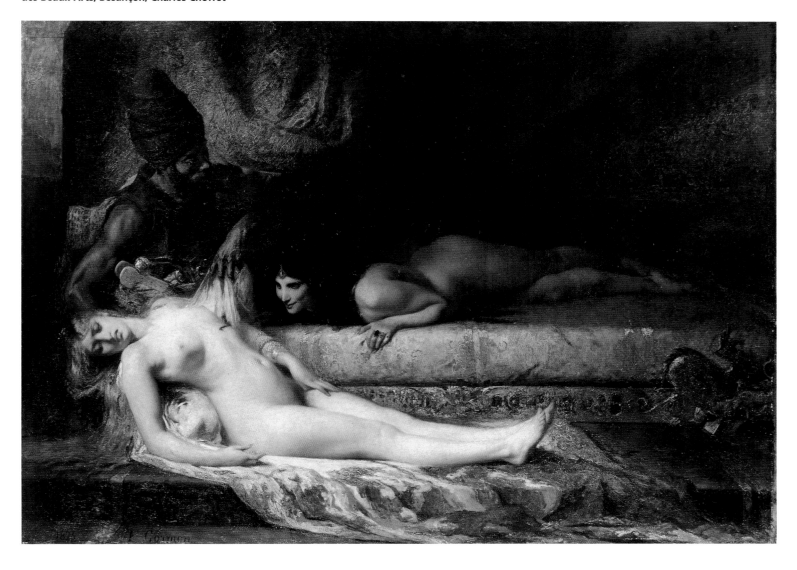

Indigo: "He's dead! He can't talk!"

Miracle Max: "Look who knows so much! Well, it just so happens that your friend here is only mostly dead. There's a big difference between mostly dead and all dead.... Mostly dead is slightly alive. Now all dead, with all dead there's only one thing you can do."

Indigo: "What's that?"

Max: "Go through their clothes and look for loose change."

The Princess Bride

When respiration is once stopped, she is gone beyond the reach of known remedy, under received methods of management—not even transfusion itself can save her—a solemn pause follows, presently broken by ejaculations scarcely audible; some dear friend sobbing and in tears, exclaims, "Can you do nothing? Is there no hope?"

James Blundell, 1827[1]

Transfusion, with Teeth
Kim Pelis

In 1818, London accoucheur[2] and physiologist James Blundell (Fig. 2) suggested that persons dying of hemorrhage might be saved by the timely transfusion of blood from a willing human donor. Although his first trial, conducted later that same year, was on a man dying from an ulcer, Blundell soon became convinced that the procedure should be limited to women on the verge of death from uterine hemorrhage. Here, he believed, transfusion held great therapeutic promise. Through the 1820s and 1830s, a small group of British accoucheurs carried out transfusions on such women, publishing accounts of their efforts—many of them apparently successful—in medical journals, such as the controversial *Lancet.* Successful case histories often told of how such women were veritably reanimated by transfused blood. By 1825, the potential of transfusion had become the subject of intense debate in British medical circles.[3]

Blundell himself provided two suggestions of how he came to think of the movement of blood between bodies as potentially therapeutic. First were the animal transfusion experiments of fellow Edinburgh medical school alumnus John Leacock (1816), and second was the sympathy he felt for hemorrhaging women.[4] Certainly, both of these factors encouraged the young accoucheur's thinking. Yet, in 1818, transfusion was in its second century of prohibition, having been banned from medical practice after the death of a recipient in 1667.[5] Moreover, bloodletting was still seen as a therapeutic procedure, which

1. **Lovis Corinth (1858–1925),** *Salomé II*, **1900,**
oil on canvas, Leipzig, Museum der bildenden Künste

2. *Portrait of James Blundell*, etching by Cochran after H. Room

could even be used to *treat* uterine hemorrhage. How, then, did Blundell come to think of blood's transfusion as therapeutic? The question centers on the nature of a medical innovation; its answer may be found in the culture in which transfusion was devised. Culture conventionally refers to ideas, ideologies, and institutions; I wish to highlight, too, the material culture of instruments devised to move blood between bodies.

Many members of the early nineteenth-century British cultural elite were concerned with the significance of the dramatic changes that had accompanied the close of the eighteenth century. Revolutions in French politics and chemistry, physiological discoveries of resuscitation and galvanism—all suggested that the natural order might be revealed, dismantled, and reassembled.[6] Such concerns, and their possibilities, fed the imaginations of a group of writers loosely dubbed "the Romantics."[7] Further, they inspired elite medical practitioners, intent on distancing themselves from "lesser" healers in the active "medical marketplace," to devise a Romantic professional self-image: that of the lone creative genius, obsessed by his search for truth to penetrate uncharted territories and "unveil" nature.[8]

Perhaps the central "uncharted territory" concerning these Romantically inclined medical elite was death itself. Resuscitation and galvanism helped open a conceptual space between life and death that was ideally suited for definition by medical authority.[9] Known as "apparent death," this space encouraged these practitioners to take on a new, interventionist role at the deathbed, as it charged their aspirations for professional power. On the most general level, then, Blundell's innovation may be read as a Romantic reanimation of the apparently dead.

In 1818, the very year that Blundell introduced his transfusion, Frankenstein's monster was "born"; and, in 1819, the vampire was introduced to polite literary society.[10] The monster and the vampire are on one level images of Romantic genius gone awry—attempts to control life instead turning into forces of evil.[11] Upon examining parallels between the substance of blood and electricity, and the form of the instrumental manipulation of vital forces, one may also understand transfusion as the Romantic end of a continuum with the Gothic. Transfusion is the heroic channeling of the vital principle: the monster, the evil potential inherent in an act of such hubris.

A third reading of transfusion's introduction into medical practice draws upon medical self-definition and Romantic imagination. Blundell, a licensed physician, was not only a practicing man-midwife, but also one of England's most popular obstetrical lecturers. Much has been made by medical historians of forceps and the man-midwife's rise to power. With Blundell's transfusion, the medically trained man-midwife gained further justification for a prominent place in the birthing chamber. In a sense, then, one might present transfusion as an obstetrician's efforts to control the potentially fatal effects of uterine hemorrhage, and thereby play midwife to the rebirth of the birthing mother.

James Blundell: A romance?

I begin the story of Blundell's life and transfusion work with a kind of "historical fiction" in the voice of a plausible character—a former student of Blundell's. This stylized narrative voice is in fact composed of a chorus of Blundell's champions, including his most vocal advocate, Charles Waller.[12] I have chosen

this unconventional approach to underscore how easily the historical facts of Blundell's work fit into patterns then characteristic of the Romantic (medical) genius.

September, 1834

> I write, dear Brother, with the sad news that my teacher and friend, Dr. James Blundell, will be leaving Guy's Hospital, to teach—he swears it—no more.[13] I know you have been diligently preparing to join me here in London so as to learn from the Master—indeed, that your arrival is imminent—and so I must regretfully suggest that you follow your original plan. Meet me here in a year's time. We should both be in a better situation, and I shall have had time to find a new guide for your medical studies.

October, 1834 Dear Eddy,

> Indeed, I shall be happy to tell you more of our Blundell. I have enticed you to leave Edinburgh and join me here with only the vaguest references to his physiological teachings and surgical innovations. Now, I may elaborate upon these and reveal other qualities he possesses—qualities that I believed would appeal to you even as they did to me.[14]

First, some background. Blundell was born here in London in December of 1790. The quality of the classical education given him by the Rev. Thomas Thomason is evident to anyone fortunate enough to have heard him speak. Following in the path of his beloved uncle, John Haighton (Fig. 3), Blundell studied "at the Southwark united hospitals of St. Thomas and Guy's, where he had for teachers Sir Astley Cooper and Mr. Cline,"[15] as well as Haighton himself. You have certainly heard tell of Haighton's contributions to obstetricy and of his controversial physiological experiments—for which some have dubbed him "the Merciless Doctor."[16] Apparently, his nephew has not been deterred by such criticisms, as he has since unflinchingly supported animal experimentation conducted in the service of physiological inquiry. His hospital training completed, Blundell went to our own town's medical school—Edinburgh University, where he took his degree in 1813. Returning thereupon to London, and to Guy's and St. Thomas', he assisted his uncle with his teaching duties—succeeding Haighton as "Lecturer upon Physiology and Midwifery" in 1818. To my knowledge, he has never been married, remaining instead wholly committed to his science.

James Blundell always drew a crowd, whether to his obstetrical or to his physiological lectures. Perhaps it was in part the legacy of being Haighton's nephew. Perhaps the crowds came because of his oratorical skills. An apt classical reference or Latin phrase would often provide the eloquent edge of a cutting remark he would wield to expose the absurdities of many an accepted —but untested—medical assumption.[17] Then again, it may have been the evident joy with which he challenged the medical profession to go beyond its standard practices and into forbidden realms such as blood transfusion and abdominal surgery. He is certainly one of a very few men in England teaching physiology and reporting unapologetically on animal experiments—and has as

3. *Portrait of John Haighton*, male midwife at Southwark United Hospital and Uncle of James Blundell

such drawn the acclaim and the wrath of medical journals and societies alike. James Blundell is indeed a rare kind of man—a creative genius, passionate in his pursuit of truth.

In his lectures, "Dr. Blundell soars to the loftiest regions of romantic impossibility."[18] Never shall I forget his inspiring charge:

> Can a man have his abdomen laid open and recover? Physiology teaches us that he may. Can life be restored when the patient is dying from bleeding, by the transfusion of new blood into the veins? Physiology teaches us that it has been so restored. Can a fourth part of the human body be cut away, by the amputation of the thigh at the hip joint, and the expanse of wounded surface heal by the first intention? Physiology teaches us that it may. This is the crown of physiology—by putting us in possession of the powers of natural bodies, by reading us a lecture, as it were, on the jurisprudence by which those powers are regulated, and by thus making us acquainted with those laws and powers, she enables us, to a certain extent, to mold the material world at our pleasure, and to work on natural bodies at our will. Realizing, in some degree, the tales of romance, she leads us, like Vathek, into the intimate recesses of nature, and puts into our hands the talismans by which her operations are controlled.[19]

What possibilities his words opened to my mind! Might we, I wondered, unveil nature and direct its power? On that same day, I resolved to learn the science of physiology, to use it to push back the tide of death and restore life. We might even control the vital principle. This is precisely what I knew Blundell to have done. Indeed, I was witness to it. And, as I know you share my deep interest in the possibilities inherent in the transfusion of human blood, I shall tell you more of Blundell's investigations.

Transfusion, although an old—even ancient—idea, rests on new knowledge that experimental study has provided us, into the nature of death and the role of the blood in the body. "We know," Blundell has explained, "that in hanging or submersion, death, at first, is apparent only, and not real; for a certain period after respiration stops, resuscitation is still possible. Now, that death from bleeding may also for a time be apparent, is by no means unlikely; and it is not impossible, therefore, that transfusion may be of service, if performed within a given period even after the breathing has been stopped."[20] The blood's "passive vitality" provides a kind of galvanizing force that we are now able to marshal to serve our reanimating desires.[21] Taken from a member of the same species—and preferably from a male of the species, as men "bleed more freely and are less liable to faint"[22]—and injected slowly into women "apparently dead" of hemorrhage, the blood has the power to restore life itself.

Blundell often commented on how it was sympathy that had first compelled him to use transfused blood in an effort to restore life to women sinking under uterine hemorrhage. Yet, only when I first attended such a woman did I understand what he meant.[23] By the time I was summoned to her bedside, "she resembled a person actually dead."[24] My examination showed, however, that some life remained. "The countenance of the patient ... was completely

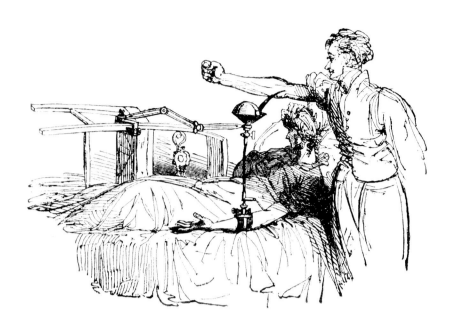

blanched, not the least appearance of redness being observable in the cheeks or lips, the extremities cold, the breathing very laborious, the pulse excessively feeble, the whole surface of the body was cool, and the skin had a soft yielding feel, and indeed her general appearance was that of a woman sinking from exhaustion."[25] Immediately, I sent for her husband, and for Blundell.

By the time Blundell arrived with his "Gravitator" transfusion device, the small room was quite crowded. I was instructed to prepare "the husband, a hearty coal-heaver,"[26] for venesection, as Blundell attended the patient and set up his equipment. The apparatus itself was quite a marvel: it consisted of a cup into which the husband was to be bled (Fig. 4). This cup was attached atop a long brass tube, or staff, that allowed blood to flow by the force of gravity into a cannula more than a foot below. A band firmly attached the cannula to the woman's arm, and a vice, affixed to a nearby chair, provided support to the whole of the system. Blundell explained that he had designed his Gravitator so that the blood retained its vital powers as it moved from vein to vein (an unnatural, but necessary, circuit) through the metal.[27] Animal tests, he assured us, had long since convinced him that the artificial materials themselves would not make the blood unfit for passage.[28]

The equipment, donor, and patient prepared, we proceeded with the operation. "Two ounces of that fluid were drawn from the arm of the patient's husband … and transferred to her. The result was surprising, the patient immediately opened her eyes, which had been shut, and the pulse became sensible; the extremities recovered a little heat, and the countenance improved."[29] We then provided her with stimulants. When she later declined, we repeated the procedure, throwing in another "two ounces and a half from the arm of the woman's husband." The result was astonishing: "life seemed to be immediately reanimated as by an electric spark."[30] It shall perhaps come as no surprise to you, dear brother, if I confess this to have been "the most gratifying case that has ever rewarded my professional solicitude."[31]

I make this assertion with the deepest possible conviction: "the profession and the public at large are under deep and lasting obligations to Dr. James

Blundell"; his name shall be handed down "to posterity, as one of the greatest benefactors of *womankind*." Not all, however, have seen the genius of his contributions, and have, out of ignorance or envy, instead treated his work "with neglect, opposition, and ridicule, still he was not to be deterred from his purpose till the remedy had experienced a fair trial."[32] Indeed, members of the Medical Society of London, and even editors of certain medical journals (chief among these the editor of the *Medical Repository*, "generalissimo of the opposers of his operation"), have allied themselves in resistance to Blundell's work; and, were it not for staunch supporters, such as the editor of the *Lancet*, I fear our cause would long ago have been lost.[33] I am particularly at a loss to explain how a profession so recently under attack for purchasing "resurrected" corpses for medical study could so easily dismiss a procedure that gives it the power to steal back life from death itself. Thus it is with some dread that I witness my teacher quit his position, as his untimely departure will leave the operation of transfusion, still in its infancy, an orphan.

> I hope, upon my return to Edinburgh at Christmas, to have final
> news concerning possibilities for your education. Meanwhile, I send
> a gift—a slim volume, penned by another Edinburgh medical
> graduate, John Polidori. It is called *The Vampyre,* and is much
> in the Byronic spirit of which we are both so fond. Meanwhile,
> I remain, Yours, C.

The structure of this particular historical fiction is borrowed with little shame (if less poetry) from the first section of *Frankenstein*. It has been applied to underscore the close fit between Blundell's life story and transfusion work and the narrative structures of Gothic romance. Blundell is presented, both in autobiographical asides and by his followers, as a solitary genius, driven by his quest to unveil nature, and ostracized by society as a result. In short, his is the story of the Romantic hero who, examined from a slightly different angle, shades into the Gothic.[34]

Apparent death and "Romantic" doctors

How do we recognize death? More specifically, how can we differentiate between someone who appears to be dead, and someone who really is dead? To say that an incorrect judgment would bring about unfortunate consequences is certainly an extreme understatement. The fear of premature burial is ancient and profound; it has been tied to a host of funeral rituals and folk tales—including the myth of the undead, or the vampire.[35] At the historical moment of the reintroduction of transfusion to medical practice, life and the body were undergoing studies that had profound consequences for the perception of the line separating life and death. The guiding question seemed to be not so much where to find a preexisting line between life and death, but rather, whether experimental knowledge now had the power to determine where it was to be drawn.[36] Resuscitation, galvanism, and physiology all had formative consequences for the rising medical significance of apparent death.[37]

The formation of Humane Societies from 1767 drew great attention to the phenomenon of apparent death. These societies focused on the prevention

of premature burial and the resuscitation of the drowned—and disseminated this information to the public. The public had, at the same time, been introduced to the mysteries of electricity, as Leyden jars shocked salon-goers throughout Britain and Europe.[38] With the work of Luigi Galvani, the movement of electricity through living bodies took on new scientific respectability. His famous studies on animal electricity examined the nature of the "nervous fluid" that appeared to stimulate the movement of living bodies. In addition to "galvanism's" extension of electricity into physiological realms, it also brought current electricity to bear on the public imagination. For, upon Galvani's death, his nephew, Giovanni Aldini, assembled a kind of electrical traveling show to vindicate his uncle's ideas. Accordingly, he animated severed calves' heads and the bodies of hanged criminals before numerous audiences.[39]

In France, physicians were exploring the consequences of political revolutionary upheaval in the reorganization of medical structures that facilitated the rise of the "Paris Clinical School."[40] If resultant therapies were few, future possibilities seemed limitless. It was the famous French clinician and pioneer of tissue pathology, Xavier Bichat, who at this time articulated his famous definition of "life" as those forces that opposed death. In Britain, a group of like-minded medical men participated in the "Animal Chemistry Club," where they discussed the consequences of physiological and chemical investigations of the nature of life.[41] At this same time, a renewed interest in vitalism became evident in the thinking of medical elites. As manifested in physiological inquiry, early nineteenth-century vitalism no longer considered the life principle to be a kind of "seat of the soul." It was instead a kind of "vital materialism" that located any potential "vital principle" in the material of the living body.[42] While this position was not purely reductionistic, it did alienate those who espoused a strict Cartesian dualism and the separate existence of a rational soul. Notwithstanding, "vital materialism" left open the working analogy between blood, electricity, and life. It also charged medical men and literary women to imagine a world in which science might be used to expand the definition of "apparent" as applied to "death."

Ludmilla Jordanova has described Mary Shelley's famous experimenter, Victor Frankenstein, as embodying qualities that characterized the ideals of the early nineteenth-century British medical elite: reclusive, passionate, thirsty for knowledge (although perpetually unsatisfied in attempts to attain it), drawn to things "marginal, contentious, or on the boundaries of what could be controlled."[43] It is precisely these qualities, she argues, that elite medical practitioners were drawing upon in an effort to create a powerful, persuasive, and coherent professional identity. Jordanova refers to the medical quest to blaze uncharted intellectual territories as "unveiling nature"; to the identity that medical men were constructing, she attaches the label "Romantic." The connection of these medical men to Shelley's Frankenstein is described as a kind of continuum, which shades from the Romantic (espoused by the medics) to the Gothic (embodied by Frankenstein).[44] In a sense, these extremes are linked in the fashion of the normal and the pathological. The link itself is the quest to unveil nature, and the kinds of knowledge this quest might reveal.[45]

The Romanticizing medical elite was particularly fond of coupling its professional aspirations with power over death. It is generally accepted that the "reanimating" sciences—resuscitation, galvanism, aspects of physiology—were important to Romantic thinkers, both literary and scientific.[46] The knowl-

edge they uncovered helped open the space between life and death. Within this space, "apparent death" increasingly became a place of promise, where medical intervention might be possible.[47] For medical men, who were at this time actively competing for dominance in what has been called a teeming "marketplace" of healers, and who traditionally had no professional role at the deathbed, Romantic control over apparent death offered both a new potency and a new place. As Jordanova argues, even if these medical men could as yet *do* little more to stave off death than could their predecessors, the possibility that they *might*, could be channeled into a professional image that effectively increased their power.[48]

James Blundell was steeped in these Romantic professional aspirations. He represents a second generation of the British medical elite to hold these ideals and, as such, perhaps held them less self-consciously than did the first generation. An avid supporter of individual thought and creative genius, Blundell's epithet could well have been, "think for yourself." He compared the physiologist's aspirations to the penetrating adventures of Vathek, the main character in William Beckford's 1786 "oriental tale," in which Caliph Vathek descends into hell in his quest for forbidden knowledge.[49] This quest necessarily entails the sacrifice of more than a few lives; the story itself influenced many a Romantic writer, in addition to Blundell.[50] The *Lancet* twice described Blundell's "personal appearances" at social functions and, in both, Blundell struck an "oriental" pose. At the first, he delivered the aforementioned "soaring romantic" speech in which he spoke of the "sun of medicine, sinking into the western hemisphere, to be soon plunged for ever into the interminable empire of darkness," and of "pyramids, that survive the wreck of time, and smile amidst surrounding desolation."[51] Shortly thereafter, he is described as appearing at a costume party dressed as a "turban'd turk."[52] Clearly, Blundell adopted both the style and the content of Romantic critiques then being leveled against a West that ignored the mysterious potential of "oriental" cultures.

In addition, Blundell cited many a Latin verse and Greek mythical or philosophical example, even in formulating his own life's struggles. Shortly before he left Guy's Hospital, for example, he compared his plight to that of a famous Greek seeker of truth: "Notwithstanding the sneers of his comic countryman, who placed him among the clouds, it was the just boast of Socrates, that he had brought down philosophy from her airy speculations, into the commerce of mankind."[53] He saw himself as having attempted to do the same with physiology: "If I have myself any claim, however small, to rank among the supporters of transfusion, it lies entirely in this: that, undeterred by clamor or skepticism, I have made it my endeavor, again, to bring the operation into notice." With Vathek and Frankenstein (and even Faust himself), James Blundell sought to penetrate the veil of nature, behind which he hoped to expose blood and reveal the cavities of the body. He, too, felt that the world turned against him when he succeeded in so doing.

Although he was not directly so, Blundell could well have been the model for Victor Frankenstein. For, up until the moment Blundell quit his job and walked permanently away from his experimental crusade, his life's story fits strikingly into those narrative structures. Like Victor Frankenstein, James Blundell was a solitary man obsessed by a vision of controlling nature—even eschewing romantic contact of "the other sort" while so doing.[54] Before turning

5. Edvard Munch (1863–1944), *Vampire*, 1895, lithograph, Oslo, Munch Museum

finally to a contextual interpretation of Blundell's transfusion work, then, it is necessary to say a bit more about the twin antiheroes of Gothic romance: Frankenstein's monster and "The Vampyre."

The long night of modernity: Romancing the vampire

The story of the night that conceived modernity's most influential monster myths —Frankenstein's monster and the vampire—is both famous and contested.[55] It is known to have taken place at Lake Geneva in mid-June 1816 among Percy Shelley, Mary Godwin, Lord Byron, and Byron's physician, John Polidori. Apparently, Byron suggested that each of the assembled individuals devise a ghost story—a challenge that *eventually* gave rise to Mary Shelley's *Frankenstein* and Polidori's "The Vampyre."[56] At some point either immediately before or after Byron issued his challenge, Shelley, a long-time devotee of the natural sciences, had been discussing the finer points of galvanism and the possibilities of re-animating the dead. While it is evident from Polidori's diary that he and Shelley had engaged in such a conversation, it is unclear whether Shelley's partner in this particular conversation, to which Mary Godwin was a silent witness, was Byron—as Godwin herself later remembered it—or Polidori. Polidori, a recent medical graduate of Edinburgh University, would have been well versed in medical electricity and its uses, as a result of his education and of his membership of Edinburgh's famous debating society, the Speculative Society.[57] Regardless of the interlocutor's identity, Godwin was greatly impressed by the potential powers of electricity, later attributing the inspiration for her popular novel to this discussion.

In Mary Shelley's work, one can see the wedding of efforts to control nature as a general cultural angst over the postrevolutionary dismemberment of the body politic and over the more concrete dismemberment of resurrected bodies.[58] The result is a kind of corpse, stitched together and reanimated through the applications of experimental knowledge. At one point, Victor Frankenstein describes the desire that moved him to create his monster: "I entered with the greatest diligence into the search of … the elixir of life…. Wealth was an inferior object; but what glory would attend the discovery, if I could banish disease from the human frame and render man invulnerable to any but a violent death!" He

then proceeds to describe a thunderstorm he had witnessed, in which an old oak tree was struck by lightening and "reduced to thin ribbons of wood"—thereby introducing to his already-charged mind the powers of electricity.[59] Finally, into this primordial scientific soup, Frankenstein adds University study of chemistry and physiology: "After days and nights of incredible labor and fatigue, I succeeded in discovering the cause of generation and life; nay, more, I became myself capable of bestowing animation upon lifeless matter."[60]

Subsequently, Frankenstein invades the "dissecting room and the slaughter-house" in his quest to "renew life where death had apparently devoted the body to corruption."[61] The pieces collected and assembled, a feverishly obsessed Victor "collected the instruments of life around me, that I might infuse a spark of being into the lifeless thing that lay at my feet."[62] Unlike the film versions that followed a century later, the book gives no account of exactly what these "instruments of life" were, or how they might have been used. Instead, Shelley leaves our imaginations to fill in details from the hints Victor has dropped of physiology, chemistry, and splintered oaks. That these instruments were effective is evident as the "lifeless thing" comes to life—ultimately to effect the demise of its creator.

Victor Frankenstein's vital experiment exemplifies what has come to be identified as "Romantic creativity." James Twitchell neatly dissected this concept and came up with four essential parts: "the artist, the audience, the object of art (artifact) and the subject of art." In this context, creation is "the movement of energy (life, imagination, attention) from one part to another."[63] Victor is the ideal Romantic creator. He has sacrificed his own vital force (his declining health and feverish state are often alluded to, both as he creates the monster, and as he later pursues it) and has supplied a powerful current of energy to animate the dead. His monster is at once "object of art" and product of an experimental science that has successfully understood, and thereby controlled, nature. The "forces opposing death" have redrawn the boundaries of life.

Such creative movement of energy is precisely the dynamic of the vampiric relationship—and, like Frankenstein's monster, the thing created is a kind of dark life force. Not coincidentally, the vampire made his move from folk tales to literature through the pen of another member of that small Romantic gathering at Lake Geneva: Dr. John Polidori. Polidori had by the time of this June evening fallen out with his employer. Borrowing from a story fragment articulated by Byron himself, Polidori fleshed out a brief tale that introduced the aristocratic, amoral, and life-draining vampire, Lord Ruthven, and a handsome and precocious young man "of high romantic feeling," Aubrey.[64] Little imagination is required to recognize in the characters Byron and Polidori, respectively, and in their tale, Polidori's story of their relationship.

In the tale itself, an unsuspecting Aubrey travels through Europe with Ruthven until he is finally made aware of his companion's malicious nature. Parting company with Ruthven, Aubrey flees to Greece, where he meets the elf-like Ianthe. True to folk tradition, Ianthe tells Aubrey of the existence of vampires (in which she wholly believes). Aubrey comes to see similarities between his former travel companion and the demonic souls of Ianthe's tales, but remains skeptical about such improbable connections. That is, until the day when poor Ianthe is killed by a vampire, and Ruthven follows close behind. Aubrey collapses. When Ruthven himself nurses him back to health, Aubrey

again doubts his fears; and soon thereafter, when Ruthven dies of a gun-shot wound, Aubrey dismisses his suspicions and returns to London—as he ponders what might have happened to his friend's body, which has mysteriously disappeared.

In London, Aubrey returns to Society with his sister, who is courted by a mysterious stranger. The stranger, of course, proves to be Ruthven, who had solicited a solemn oath on his deathbed that Aubrey would tell no one of his death. Bound by his oath, Aubrey again falls ill, until finally he breaks his oath. He is dismissed as insane. Ruthven completes his revenge by effecting the fall of the house of Aubrey. Thus the modern vampire was born. In its birth are many of the themes we have since come to associate with the vampire: aristocratic background, hypnotic power over women, drinking of blood, eternal life, sociopathic destructiveness. The book was published in 1819, a year after Mary Shelley's *Frankenstein* and Blundell's first human transfusion. Initially appearing under Byron's name, "The Vampyre" became a highly influential success.[65]

Another tale in this genre—Edgar Allan Poe's *The Oval Portrait*—helps illuminate the similarities and differences between Frankenstein's monster and Polidori's vampire, and at the same time sets up the transformation from the vampiric to the scientific movement of blood between bodies. In it, an artist, fixated on painting his wife's image, does not notice that the woman's health is depleted in direct proportion to the progress he makes on the portrait. In Twitchell's words, "just as the painter finishes his work, he exclaims, 'This is indeed *Life* itself!' Enraptured, he turns from the painting to his wife, and, irony of ironies, she is dead."[66] The painting itself acts as a kind of creative force, draining vitality from its subject and thereby attaining life. Frankenstein's monster, also the object of art, comes to life through the combined vital forces of Victor and nature. And the vampire?

To cite Twitchell again, "vampires are not always foamy-mouthed fiends with blood dripping from extended incisors, but rather can be participants in some ghastly process of energy transfer in which one partner gains vitality at the expense of another."[67] The vampire draws vital energy, in the form of blood, from its subject, to re-create its own life. The vampire, the perverted personification of Romantic creativity, is its own creation. In other words, Frankenstein's monster was reanimated by an instrumentally guided electricity, whereas the vampire was reanimated more directly by another kind of vital substance: blood.

In the Romantic tales of Shelley and Polidori, as in the investigations of physiologically inclined medical men, blood and electricity are vital forces. Moreover, for both groups, blood and electricity are not *created*, but *creative* —they are preexisting vital forces that are harnessed by those who have learned their secrets. Such would also be the case of transfused blood.

Life's blood

As did the medical unveilers who raised him, Blundell used apparent death and reanimation to create a place for himself at the deathbed. This place, however, took on a more distinctly material form for Blundell than it did for his teachers. For, from his own formulations, it is evident that Blundell thought of transfusion as a procedure capable of manipulating apparent death and directing it toward

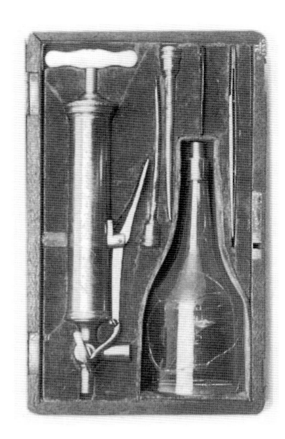

6. Medical equipment for transfusion designed by Savigny after plans by James Blundell, London, Science Museum

life. He explicitly compared its functions to resuscitation after submersion, and lamented the fate of those who did not receive its revitalizing benefits before apparent death became real and irreversible.[68]

To appreciate the meanings transfusion is likely to have held for Blundell, let us look first at the recipients of transfusion in the 1820s. Primarily, these were women suffering and near death from uterine hemorrhage. At a time when man-midwives were still attempting to consolidate their power over the birthing process, Blundell offered another technical procedure—until now ignored by historians—that legitimated, even necessitated, a male practitioner's place in the birthing chamber. The transfusion-proficient accoucheur presided over the rebirth of the birthing mother. Descriptions of transfusion recipients, which consistently tell of their "death-like appearance," support this interpretation of transfusion as reanimation of the apparently dead.[69] Witness Blundell's Romantic description of the state of his transfused patients:

> After floodings immediately, women sometimes die in a moment,
> but more frequently in a gradual manner; and over the victim death
> shakes his dart, and to you she stretches out her helpless hands
> for that assistance, which you cannot give, *unless by transfusion.*
> I have seen a woman dying for two or three hours together, con-
> vinced in my own mind that no known remedy could save her;
> the sight of these moving cases first led me to transfusion.... The
> fatal termination is principally foreshown by a certain ghastliness
> of the countenance.[70]

One must not, however, wait *too* long to transfuse, or the woman will move from corpse-like to actual corpse—and will then be beyond blood's saving power.[71]

Compare this image of the woman in need of transfusion with Polidori's description of the murdered Ianthe in "The Vampyre": "There was no color upon her cheek, not even upon her lip; yet there was a stillness about her face that seemed almost as attaching as the life itself that once dwelt there." The cause of her unfortunate state is determined by the "marks of teeth having opened the vein" of her neck—placed there, we are told, by a "vampyre."[72] The vampiric Lord Ruthven is himself described as being of "deadly hue."[73] The analogies with blood transfusion are striking. A woman, corpse-like from loss of blood, lies near death. Now, however, she may yet be saved if the blood of a strong and healthy man is transfused *into* her. Moreover, this man might, in consequence of venesection, also grow pale and even be made to swoon: such is the nature of energy exchange by blood.

Beyond its application to apparent corpses, there is yet another place at which transfusion intersects with energy-exchanging reanimation. The striking scenes of women reanimated by transfused blood read as if they came from Shelley's pen—or Galvani's experimental accounts. Like the assembled pieces of diverse corpses or the dissected muscles of ambiguous frogs, these pale and transfused women suddenly jump to life, as if "reanimated by an electric spark."[74] In a culture attuned to the marvels of resuscitation and electrical stimulation, such reaction would at least have drawn medical attention, even convincing some of the reanimating potential of blood.

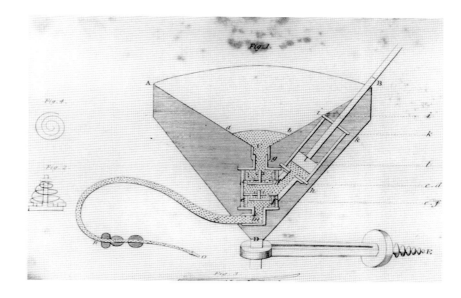

Turning now to the blood itself: what part did vitalistic notions of the blood play in early transfusion? Blundell's writings suggest that it was precisely his vital-materialist conception of blood that allowed him to consider transfusion as an effective therapeutic procedure. The very opening of his introductory physiology lecture of 1825 clearly sets forth his views on vital principles:

> When, again, directing our attention to the natural objects with which the globe abounds, we come to examine them with a little care, we find that a part of them, small in bulk though not in number, are in possession of powers of generation, and of taking up within themselves substances which are afterwards assimilated to their own nature; while others are destitute of these powers, and destitute also of that organization and vital energy on which these powers depend.[75]

As we have seen, Blundell believed that physiological experimentation alone provides insight into the workings of these natural substances and allows us to manipulate them.

Blundell's vitalistic conception of blood itself is evident in the way he practiced, and justified, transfusion—specifically, in the quantity of blood he used, and the concerns he expressed about the instruments with which he intended to move it between bodies. Concerning the amount of blood used, the *Lancet* reported a case in which Blundell supplied only four ounces, and afterward admitted that some would question whether so little blood "really saved the patient. The Doctor, however (and he has seen a great deal of hemorrhage), is decidedly of the opinion, that this timely supply of vital fluid turned the scale in the patient's favor, and rescued her from death."[76] Indeed, it was precisely the small amount of blood transfused that Blundell's critics, assembled for a debate in 1825 at the Medical Society of London, questioned as "not sufficient to explain the improvement of the patient."[77] Blundell persevered in his commitment to relatively small amounts of blood, which he thought sufficient to sustain life.[78] He also believed that the blood had a nutritive role in the body, and that transfused blood sustained the system accordingly.

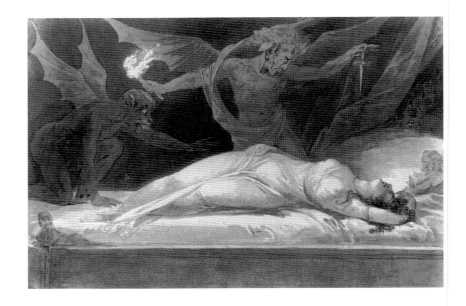

8. Vinzenz Georg Kininger (1767–1851),
The Dream of Eleanor, ca. 1795

Further evidence of Blundell's vitalistic perception of blood is suggested by his conception of the instruments with which he transfused it. Unlike the seventeenth-century transfusers, Blundell used blood from *human* donors. Animals might be subjected to arterial bleeding into quills or lengths of intestines connected to the veins of human recipients; however, as Blundell himself noted, "there are few perhaps but would object to the opening of an artery."[79] Consequently, he devised various instruments intended to replace the normal, artery-to-vein circulation (Fig. 6). His first concern in devising these glass-and-brass instruments was whether "the blood would remain fit for the animal functions after its passage through the instrument."[80] Would the inanimate materials of instruments, he wondered, somehow destroy the very living qualities that gave blood its particular revitalizing power? Each of his three transfusion apparatuses—the syringe, the "Impeller," and the Gravitator—he devised precisely to preserve the blood in its artificial movement from donating to receiving vein. The Impeller, introduced in 1824, relied on a receiving cup into which a maze of passages had been added, so as to preserve the motion of the blood as it was impelled by syringe through the cup (Fig. 7).

That Blundell's primary concern in constructing these elaborate pieces of apparatus was for preserving the blood's fitness in transfusion is evident in his stark admission that, "should it be found hereafter, by numerous pointed, and therefore decisive experiments and observations, that human blood may lie out of the vessels in the cup for several seconds, without becoming thereby unfit for the vital purposes ... transfusion may be accomplished, by the syringe alone ... on account of its greater simplicity."[81] Impellers and Gravitators, constructed in order to preserve the blood's fitness, would become superfluous. Accordingly, it is clear that Blundell's was no simple quantitative belief in a direct replacement of hemorrhaged blood, but instead a more qualitative understanding of blood as life.

To complete my contextualizing argument for the reintroduction of transfusion to British medical practice, I need to make a further, instrumental link. For, it could be argued, a great difference exists between Victor Frankenstein's rational manipulations of electrical nature and the vampire's rather folkloric sucking of blood. Where precisely does transfusion fit? Blundell's transfusion

effectively shifts the movement of blood between bodies from the literary-sensuous to the clinical bedside. In other words, much like Victor Frankenstein, James Blundell has created instruments capable of directing vital forces toward chosen, reanimating ends. Let us recall again the few details of Frankenstein's creative moment with which Mary Shelley provides us: "I collected the instruments of life around me, that I might infuse a spark into the lifeless thing that lay at my feet."[82] Such could easily be a passage from one of Blundell's case histories of transfusion.

Indeed, the portrayal Blundell himself provided of transfusion by Gravitator makes my connecting case to Frankenstein clearer. The 1828 Gravitator model dispensed entirely with the syringe, relying instead on a tall tube and—as the name implies—the force of gravity, to move the blood at a "proper" rate into the body. Pictured in the accompanying image are donor, receiver, and instrument (including stream of blood). Like the Romantic genius/artist, Blundell, the Creator, is absent from the scene. He was its channel and now, what remains is the object of art—the transfusion scene—that he facilitated. Blundell *is* Victor; transfusion is Frankenstein's monster; both art-objects arise from proper understanding and instrumental channeling of nature's vital forces. One might even argue that James Blundell's instrumental interventions completed the vampire's movement from folk to Romantic figure. And, like Victor, Blundell was ultimately ostracized from society as a consequence of his hubris.

Does this mean that I read Blundell's medical innovation as a kind of Gothic tale-in-action? Not entirely. Comparison with the other famous Gothic myth, the vampire, illustrates this qualification. Vinzenz Georg Kininger's painting *The Dream of Eleanor* (ca. 1795; Fig. 8) is one in a genre of deathbed scenes that began with Henry Fuseli's famous *The Nightmare* (1781–82; Fig. 10) and would be appropriated by nineteenth-century vampire enthusiasts.[83] I have selected this particular permutation on Fuseli's image because "death," true to Blundell's descriptions, holds his dart above the woman (and her throat at that!). The similarities between Kininger's and Blundell's images do not end there. In both, the bed is the stage upon which the drama unfolds. The woman lying on the bed is the recipient of the drama's action; the male figure looming above her, the agent of that action. At this point, however, the images diverge. For, in Kininger's piece, the woman's pose is one of sexual exhaustion. This posture contrasts strikingly with Blundell's transfusion recipient, who lies passive, chaste, and near death. Blundell's transfusion recipient is perched on the edge of the

9. René Laënnec's stethoscope, ca. 1820, London, Library of the Wellcome Institute

Victorian age: the worthy mother in her bedchamber, rather than the saucy victim of the vampire. Moreover, Kininger's agent is the cause of his victim's exhaustion, whereas Blundell's agent is the heroic restorer of energy otherwise lost. In short, the contrasting male figures embody the power of evil and of good.

The means by which transfusor and vampire move blood is also strikingly contrasted: connecting man and woman is no lusty blood-kiss or threatening dart, but a scientifically designed instrument. Rather like René Laënnec's device for auscultation (Fig. 9), Blundell's Gravitator provided an acceptable social distance between donor and recipient of blood, which moved through rationally designed and arranged instruments.

Blundell's innovation of transfusion relies on a reanimating conception of blood similar to the one that guides Polidori's vampire. At the same time, it asserts an alternative scenario—a clearly heroic place for the life-giving movement of blood between bodies. For Blundell, who was formed by the very London physicians who were busily creating a heroic professional image, presented transfusion in a decidedly Romantic fashion. More than this, it is likely that the same reanimating sciences that encouraged elite medical practitioners at once to aspire to Promethean power over the line between life and death and to devise Romantic self-narratives, also provided the context in which blood transfusion made sense. Blundell's transfusion is a Romantic reanimation of the apparently dead. Cultural medical image fed substantive medical manifestation —rather like Odysseus feeding blood to the shades of Hades. Still, the Gothic remains, embodied in the ambiguous potential of an emergent biotechnology.

In this spirit, I would like to suggest a plausible "after" sketch of Blundell's somber transfusion scene. The hero-husband would now be seated, his head, perhaps, in his hands, as he attempts to restore his lost energy. The woman would certainly be wide-eyed and flushed. She might even be sitting upright as she exclaims to awe-struck medical witnesses: "By Jasus! I feel as strong as a bull!"[84]

10. Henry Fuseli (1741–1825), *The Nightmare*, ca. 1781–82, oil on canvas, Frankfurt am Main, Freies Deutsches Hochstift, Goethemuseum

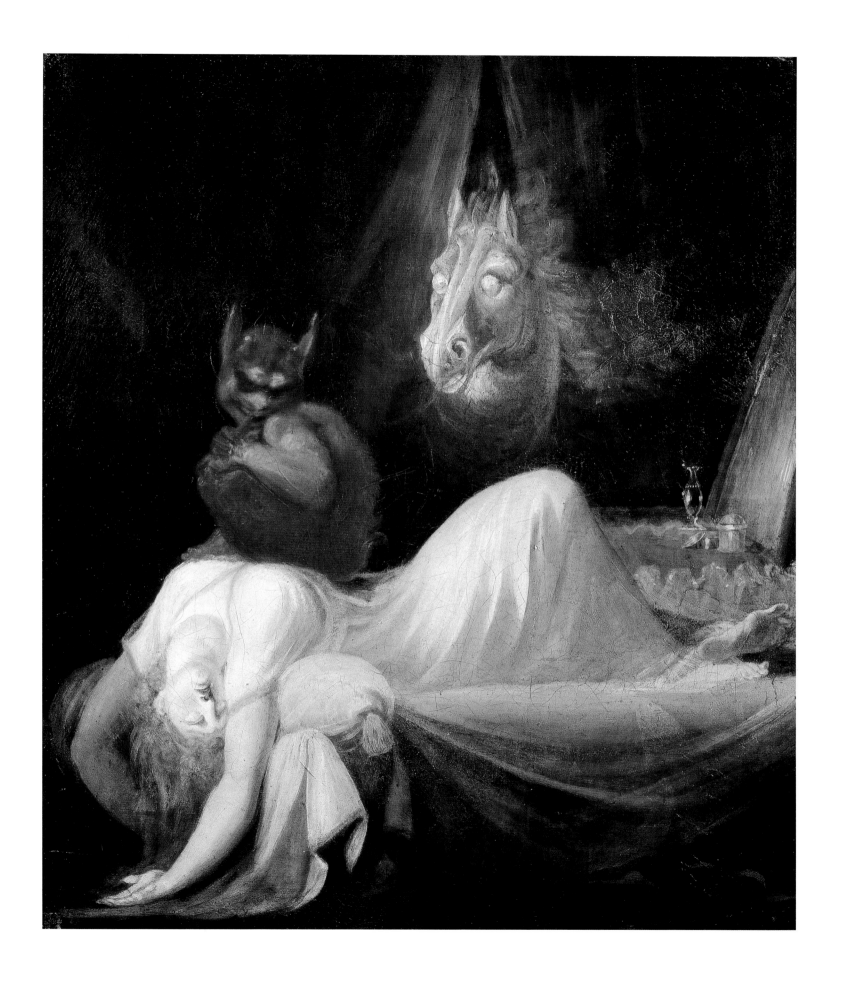

"Man has nothing more precious than his blood. Blood is something much warmer, redder and more alive than the breath that goes in and out of his mouth, a most particular fluid, as creatures notice when they have none, liquid life, as it were —the scarlet quintessence of life that is spilt in death and perishes, not preserved like the soul and vanishes with the rest of the personality."[1]

Blood-Transmitted Diseases
Claudia Eberhard-Metzger

1. Tsetse fly. Photo: Eye of Science, Reutlingen

When Pope Innocent VIII was near death, his personal physician ordered three ten-year-old boys to his bedside so that they could give their blood to the sick cleric. Young blood, the zealous medico believed, could revive the ailing pontiff and restore him to vigor. The boys failed to survive the rejuvenation experiment, the pope remained as infirm as ever and departed this life shortly after the children. This is supposed to have taken place in 1492, though medical historians have their doubts as to the story's credibility. Nevertheless, it is a graphic illustration of the importance that people have ascribed to blood from time immemorial and how they attempt—then as now—to make use of its inherent life-giving characteristics.[2]

In past centuries, medical men had particular faith in the beneficial and cleansing abilities of the blood of innocent animals. Lamb's blood was especially popular, but calves were also well thought of, for example, in order to treat mental illnesses. Doctors believed that "the freshness and gentleness of the animal could calm the heat and surges in a patient's blood."[3] Injecting animal blood into humans (see Fig. 2) may seem wanton to our modern eyes, but according to the state of medical knowledge at the time, it was the obvious thing to do. Blood, whatever its origin, was simply the carrier of life itself: "For the life of the flesh is in the blood," it says in Leviticus 17:11.

The reviving effects of animal blood featured, for example, in the medical armory of Jean-Baptiste Denis, one of Louis XIV's personal physicians, in 1667. After a few experiments with dogs, he decided to make use of the "mild, commendable blood" of animals to inject into humans. He excluded the use of human blood because this was corrupted by "excesses and immoderate eating and drinking" and was quite unsuitable for healing purposes.[4]

For his first experiment, Denis chose a sixteen-year-old boy who "was suffering from a persistent raging fever."[5] In June 1667, Denis cut open the neck of a lamb and allowed nine ounces of blood to flow into the underarm vein of his young patient. But instead of the expected improvement, the boy developed an unexplained illness that subsequently afflicted him for the rest of his life. Other spectacular experiments at rejuvenation, strengthening, and healing also misfired, or ended with precisely the opposite result—the "patients" became gravely ill, many of them dying from the acquired "vital fluid."[6] In 1670, the French *parlement* finally banned all transfusions. When two men died in Rome as a consequence of a blood transfusion, the Pope likewise banned the procedure.[7]

Why the "liquid life" with all its supposed magic powers proved not beneficial but pernicious to health the casually experimenting physicians of the time could not explain. It would last until the beginning of the twentieth century before mankind took the first major steps back from the mystery of blood and looked at it coolly as a biological phenomenon. In 1901, the Austrian doctor Karl Landsteiner (1868–1943) discovered that blood is not just blood but a very personal matter (Fig. 3). There are various blood groups, and during a transfusion

2. A patient receiving a transfusion of lamb's blood, from Douglas Starr, *Blut: Stoff für Leben und Kommerz*

3. Karl Landsteiner (1868–1943), discoverer of blood types, from Douglas Starr, *Blut: Stoff für Leben und Kommerz*

these must match if a fatal reaction is to be avoided. "Mild, commendable" animal blood does not even come into the frame for this purpose because it contains proteins that are quite alien to human blood. They trigger off violent defensive reactions, which can end in a fatal shock.

Another discovery also emerged very clearly at the turn of the century —transfusion of the "vital fluid" could also transfer things that are responsible for the generation and dissemination of grave diseases. These "things" are not indefinable evil body fluids or nasty emanations from the soil, marshes, or water but small living organisms, which the Italian physician Girolamo Fracastoro (1478–1553) had already suspected of causing infectious diseases.[8] This idea had been taken up again in the first half of the nineteenth century by the German doctor Jakob Henle (1809–1885), who spoke cautiously of *contagium vivum* (contact with living things), while his colleague Robert Koch (1843–1910; see Fig. 6) talked of "pathogenic agents." During the twentieth century, these would be uncovered as, in fact, a plethora of single-cell microorganisms, such as bacteria and animal parasites. They notably included certain other strange beings, which even now biologists do not yet rightly know whether to attribute to the realm of the living or the dead, viz. viruses.

"A virus is a piece of genetic matter wrapped up in a sheath of protein."[9] That is the biological definition of these microorganisms, which can be made out only with an electron microscope. The Latin word *virus* literally means "poison," "slime," or "spittle," which represents more graphically what these "protein sheaths" can do to humans. They are the ultimate pathogens[10]—and they often use blood in order to reproduce in their "host" and then swarm in search of further victims. Among serious virus diseases transmitted via the bloodstream are immune deficiency (AIDS) and—less prominently but no less important—hepatitis.

Hepatitis, the silent scourge

Scientific research of the hepatitis virus dates back to the 1930s and 1940s. The pathogens involved were at that time a complete mystery—but there were already various clues suggesting that an "agent" was transferred with blood and gave rise to typical symptoms of the illness, such as jaundice. One indication of this, for example, was a strange epidemic that the German medical officer A. Lürmann describes in the *Berliner Klinischer Wochenschrift* in 1895. His report relates to August 1883, when 1,300 workers at a shipyard in Bremen were inoculated against smallpox. A few months later 191 of them went down with jaundice. Lürmann visited the factory to establish the cause but initially came to no conclusions: "The etiology of this epidemic is unclear. Many believe it is caused by poisonous fumes. Others think that the disease is a form of gastrointestinal catarrh."[11]

Lürmann was not satisfied with this explanation. His detective work finally led him to consider "the inoculation itself as an etiological cause of the jaundice epidemic." As it turned out, the inoculation material used was produced from human lymph—i.e., the vaccines were a blood product. The doctors put a drop of it on the skin of the patient and scratched the fluid in with a—presumably unsterile—needle. That is how the pathogen was transmitted. Time and again until well into the twentieth century there were injection-related outbreaks of hepatitis, such as those among diabetics, who injected

4. Hepatitis B virus. Photo: Eye of Science, Reutlingen

5. Hepatitis B virus. Photo: Eye of Science, Reutlingen

insulin hormones to reduce high blood sugar levels. But it was not until about forty years after the first conspicuous outbreaks of the disease among the shipyard workers that it was known to scientists to be a virus in the blood or blood products that transmitted the hepatitis.

The medical term "hepatitis" literally means "inflammation of the liver." In most cases it is viruses that cause the inflammation. They get into the liver via the bloodstream, lodge in the cells of the liver, and reproduce there. The cells of the immune system try to render the pathogens harmless by destroying the affected cells. During this defensive action, the liver gets inflamed, which combined with the virus attacks can have ominous consequences.

So far, scientists have discovered five kinds of hepatitis virus (it is not yet clear whether a recently discovered sixth hepatitis virus is of any importance medically). The viruses—designated by the letters A to E—have distinctive appearances and are different in their dangerousness to the body and their method of infection. Hepatitis viruses A and E get into the human body via drinking water or foodstuffs and cause acute inflammation of the liver, which generally passes off harmlessly and is cured within a few months. The best-known symptom of acute liver inflammation is jaundice. Skin and eyes turn yellow, urine becomes brown, and stool turns noticeably light in color.

Migrating from blood to blood

The B, C, and D viruses (Figs. 4 and 5) are more dangerous. They are all transmitted via blood-to-blood contact. To gain entry, minimal quantities of blood are required that come into direct contact with the bloodstream. The viruses trigger off a long-term, chronic liver inflammation, during which the liver suffers increasing damage, liver tissue dies, and the liver atrophies and is scarred. Cirrhosis of the liver may develop and cancer of the liver cells may ensue— the consequences are very serious, especially for anyone infected with the hepatitis C virus (HCV).

The hepatitis C virus was discovered as late as 1988 by American scientists. Sensitive genetic engineering techniques were required to trace HCV in the blood. Initially, researchers were inclined to underrate the virus, but now HCV is considered a particularly dangerous type, especially as, unlike all other hepatitis viruses, no vaccination against it is yet in sight. The National Institutes of Health in the USA forecast that the HCV-related death rate will triple in the next two decades. It is estimated that worldwide 170 million people are infected with the virus. The experts assume that the hepatitis C virus causes more chronic liver disease than alcohol abuse, and most liver transplants already involve HCV sufferers. The virus is also insidious in that the infection rarely causes physical complaints. Only in a quarter to a third of the patients do symptoms of indisposition, weakness, loss of weight, or yellowing of the skin show up. Most sufferers have no idea that they are infected.[12]

As the disease is often identified at a late stage, the chances of a cure are poor. Doctors treat hepatitis C with interferon alpha, the only drug currently achieving any degree of success. This has a success rate in removing the virus long-term in only about a quarter of the sufferers. The prospects of a cure were later enhanced to about 50 percent by doctors using interferon in combination with another virus-inhibiting drug.

6. Malaria expedition to New Guinea: Robert Koch with the governor of German New Guinea, 1900.
Photo: Archiv für Bild und Kunst, Berlin

However, the primary concern is still to prevent the disease from occurring in the first place. Researchers have meanwhile set themselves the task of developing an effective vaccine against HCV, but at present success is not in sight.[13]

High risk: The transmission channels

One of the most common means of transmission in industrial countries is syringe and needle-sharing among drug addicts. It is estimated that between 65 percent and 95 percent of drug addicts are HCV-positive. HCV has also been transmitted via bottled blood and blood products (coagulation factors, immunoglobulins). Since the beginning of the 1990s, however, all blood products have been carefully tested, so that the risk of becoming infected with the hepatitis C virus by a blood transfusion has been largely eliminated. HCV can also be transmitted to people working in the health service via accidental needle pricks, as only minimal quantities of blood are required for infection. Transmission of HCV during unprotected sexual intercourse is possible but very rare.[14]

There is another, hitherto unsuspected, source of infection, namely tattooing, as Chinese researchers reported in early 1996 in the *Lancet*. In China, it is considered modern to have eyebrows and eyelids tattooed in beauty parlors. The needles used for this are often used several times and are inadequately sterilized. This proved the undoing of three young women. Two months after the tattooing, they complained of feeling unwell and of suffering from nausea and loss of appetite. The hepatitis C virus was subsequently discovered in all three women.

Fatal immune deficiency

In May 1980, a young man was carried into Mount Sinai Medical Center in New York. He was short of breath and extremely emaciated; his skin was covered with lumps that were discolored violet and sometimes oozing blood. He complained of numerous remarkable symptoms: pains, heavy bouts of perspiration, agonizing burning in the mouth, gullet, and windpipe, loss of balance, fever, tiredness, and exhaustion. He had already been treated for months by his local doctor for an un-defined fever, prominent lymph node swellings, strange skin rashes, sustained loss of weight, diarrhea, heavy coughing, and emaciation—but of course with-out the doctor being able to diagnose the cause.

The disease the patient was suffering from even the doctors at the hospital were unable to identify. They examined him closely and found bacteria in the lungs and fungus in the bowels. The "rashes" were identified as Káposi's sarcoma, a rare tumor of the skin. The hospital staff fought desperately to save the man's life, but he died after a few more weeks of agony. What of, the doctors still did not know. "Only those that could hear the grass growing appreciated then as practicing doctors that they had been witness to events that would soon have incalculable consequences," recalls the German AIDS expert and epidemiologist Michael Koch.[15]

The syndrome afflicting the young man who finally succumbed to his mysterious illness is considered the presumed start of the "clinically visible" part of a new epidemic, which since 1984 has acquired the official name of AIDS (acquired immune deficiency syndrome). The grave immune deficiency is caused by a virus that is transmitted by blood and sperm that attacks and destroys certain white blood cells called helper T lymphocytes. These cells are extraordinarily important for the defensive capacity of the immune system. Without helper T lymphocytes, the human organism is defenseless against the armies of bacteria, viruses, and parasites. Infections that pass by harmlessly when the immune system is intact become life-endangering threats.

The perpetrator is uncovered

In 1983/84, scientists Luc Montagnier at the Institut Pasteur in Paris and Robert Gallo of the National Cancer Institute in Bethesda near Washington, DC, finally identified the "human immunodeficiency virus" (HIV). The first "mugshots," produced with the help of an electron microscope, showed the HIV to be a tiny little sphere with a round core, caught in the act of swarming out of an infected immune cell in order to attack other cells.

The HI virus, whose opportunities for reproducing are greatest with and in blood, is classed as a retrovirus and is approximately 100 nm in size, i.e., one ten-thousandth of a millimeter wide. It consists of an external sheath, from which numerous loops project. Inside this unique "packaging" is the genetic infor-mation of the virus, stored as ribonucleic acid (RNA). The loops are receptor molecules, which enable the virus to dock into the membrane of its victims, the helper T lymphocytes. As soon as the virus has penetrated the membrane into the cell, brisk activity ensues.

Initially the virus converts its RNA into DNA (deoxyribonucleic acid), the carrier of human genetic information. The name "retrovirus" refers to this process:

7. Zephania Tschuma, *Rude man Sitting on Her*, Zimbabwe, 1992, wood and shoe polish. Photo: Haus der Kulturen der Welt, Berlin. This figure is intended to warn people against the dangers of unprotected sexual intercourse

**8. *Anopheles* mosquito, Science Photo Library.
Photo: Agentur Focus, Tony Brain**

the information from the RNA is "written back" into DNA. The HI virus is able to do this because it brings a "translator" with it—the reverse transcriptase enzyme. After the reverse transcriptase, the virus's own genetic language, is translated into that of the human cell, the brazen intruder can insert its genes like a cuckoo's egg directly into the human hereditary matter. Sooner or later the virus genes take over: they force the cell, against its own vital interests, to keep producing new viruses.

In this way, the virus ruins one helper T lymphocyte after another. And with every cell, the powerful army of the immune system's defense loses punch. Once the number of helper T cells falls from the normal 4,000 to 6,000 per milliliter of blood to under 500, the final stage of the HIV infection begins—the AIDS disease. In its full-blown form, the disease is manifest in a pronounced loss of weight, considerably impaired brain functioning, the body is attacked by parasites, viruses, bacteria, and fungi, and tuberculosis, pneumonia, and tumors develop.

Since 1996, doctors have been able to offer their patients multiple therapy, where a cocktail of two or three different drugs is used. With this "antiretroviral combination therapy" the viruses can be driven back. The treatment does have considerable side effects. It has also become apparent that, though with the optimum multiple therapy the viruses are no longer traceable in the blood, they remain lodged in the lymph and nervous system. Furthermore, because the viruses are constantly changing, they quickly develop strategies to resist the effects of the drugs. This rapid formation of resistance is the reason why the success of the combination therapy sometimes dramatically falls after a while. Despite great research input, there is still no vaccine against the HI virus. Researchers are, moreover, confronted with the problem that the enormous adaptability of the viruses enables them to elude successfully all vaccination strategies.

A problem and its dimensions

It is now two decades since the AIDS disease was first observed. Since then, more than 40 million people worldwide have been infected with the HI virus, and over 12 million have already died of AIDS. About three million people were infected with the AIDS-generating virus via blood products or blood transfusions. 40,000 of them were hemophiliacs. Even today, two hemophiliacs are dying every day in the US who were infected in the early 1980s, before the HI virus was even identified. In France, 4,333 people were infected by blood transfusions contaminated with the virus, even though there has been a test for AIDS since 1985. Over 1,000 of them have since died. Every day, another 16,000 people become infected with the virus, 90 percent of them in developing countries.[16] Especially in Africa— where in 2000 about 25 million people were infected with the virus—and in a series of Asiatic countries, the epidemic has, in the estimation of the World Health Organization (WHO), spiraled completely out of control.

From pan to pandemic

Where does the virus come from? An article in the British scientific periodical *Nature* on February 4, 1999, called "From *pan* to pandemic" clarified the matter, quashing all possible rumors, including one claiming that the virus was

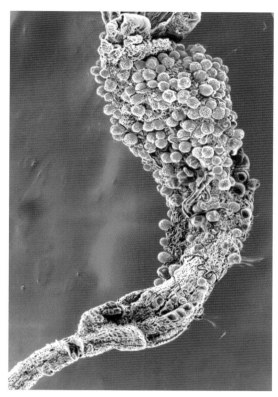

9. Malaria parasite in the intestinal tract of a mosquito, London School of Hygiene and Tropical Medicine/Science Photo Library. Photo: Agentur Focus, Tony Brain

a genetically engineered construct originally intended for biological warfare which had subsequently escaped from the genetic engineering laboratories. This "explanation" of where the HI virus came from was confuted by the very fact that the oldest blood sample found to contain the virus dates from 1959, a time when genetic engineering was not even thought of (it was invented in 1972). This blood sample—which came from the Congo—was one of the first indications that the world-encompassing epidemic or pandemic might have originated in west Central Africa. The assumption was indeed borne out. Scientists now assume that the HI virus was originally an ape virus that migrated from chimpanzees (its scientific name is *pan troglodytes*) to humans. Transmission probably took place during a chimpanzee hunt—the animals are considered a delicacy in Central Africa, and the crude hunting methods make contact with chimpanzee blood virtually inevitable. The virus does the chimpanzees no harm. However, in human beings it found a host that was both highly sensitive and highly receptive—ensuring its reproduction worldwide. From the virus's point of view, that is the best thing that can happen to it.

Distinguished virologists reckon that a still more successful virus might once again come down from the trees. Eighteen types of ape are known to scientists to be infected with the SIV (simian immunodeficiency virus), the ape equivalent of HIV, without the animals dying from it. "What would happen," asks virologist Reinhard Kurth, head of the Robert Koch Institut in Berlin, "if one of the other SIV strains found its way into mankind?"[17] Kurth is convinced that this has already happened, long since. SIV strains would thus already be in people, but still fighting with the immune system to survive. If only one of these virus wins out, it cannot be ruled out that a still more contagious type of virus will set out to conquer the world.

The torments of malaria

On November 6, 1880, French military doctor Charles Louis Alphonse Laveran discovered a tiny single-celled animal organism in the blood of a fever-stricken soldier stationed in Algeria. Laveran suspected the unicellular organism of causing a major disease, which doctors in earlier days had associated with the disabling "bad air" of marshy districts (*mala aria*). Small animals or *bestiolae* occurring in damp spots had been suspected as a cause back in the first century BC by the Roman writer Marcus Terentius Varro. But the medical establishment of neither man's day gave any credence to their ideas. After all, how could the beastie get into the blood?

The solution to the puzzle was found near the end of the nineteenth century by the British doctor Major Ronald Ross, a member of the Indian Medical Service. He discovered by means of a simple experiment that mosquitoes of the *anopheles* genus (Fig. 8) transmitted the unicellular parasites into the human body when sucking blood. First, Ross protected malaria patients with mosquito nets from the outside world and allowed mosquitoes to fly under the nets. The mosquitoes fell on the poor experimental patients and sucked their blood. Thereupon Ross gathered up the mosquitoes, dissected them and examined them under a microscope. On August 20, 1897, "Mosquito Day," he found what he had hoped to find: in the stomach wall of an *anopheles* fly he discovered the freshly sucked human blood together with the malaria pathogen (Fig. 9).

Gradually it was established how the incredibly complicated reproduction cycle of the parasitic unicellular creature of the *plasmodium* genus takes place partly in the human body, partly in the female *anopheles* mosquito. If an infected female *anopheles* mosquito bites a human being, the malaria pathogens pass from the salivary gland of the mosquito into the human body. If someone with malaria is bitten by an as yet uninfected mosquito, it sucks up the dangerous pathogens along with the human blood and passes them on. In 1902, Laveran and Ross were awarded the Nobel Prize for Medicine for their discoveries and insights.[18]

A scourge of mankind since time immemorial

Malaria is a very ancient scourge of humanity. It has been known in Europe at least since the days of Hippocrates, i.e., 2,500 years. The best-known victim of the disease was Alexander the Great, who died in 323 BC in Babylon aged thirty-three, most probably from malaria. The disease has remained a scourge of humanity down to the present day. In the view of malaria expert Professor Heiner Schirmer of the Tropical Medicine Group at Heidelberg University, "there is in fact no disease that has exercised a greater influence on the genetic make-up, behavior, and history of mankind."[19] Currently, mainly tropical Africa, but also southern Asia and Central and South America, are afflicted by the disease. Almost half the world's population is in danger of infection. Every year, 300 million cases of the disease are registered, while over two million people—especially children under the age of five—die amid the torments of malaria.

The disease becomes evident with violent bouts of fever. In the case of *malaria tertiana*, high fever develops every third day, with *malaria quartana* every fourth day. With *malaria tropica* (the most dangerous variety) the fever is irregular. The bouts of fever arise when the red blood corpuscles (erythrocytes) —engorged with malaria pathogens—burst, releasing large quantities of alien proteins directly into the bloodstream. This makes malaria the ultimate in blood poisoning. The body reacts by trying to ward off this poisoning with all the means at its disposal.

What an acute attack of malaria means for the sufferer can be illustrated by a report from 1924 concerning the "Health problems in the British Empire":[20] "The patient may suddenly find himself back in the grip of the fever, racked by spasms and then shivering with cold, his teeth chattering like castanets.... The sufferer crawls into bed, wrapping himself up in thick clothes but still frozen to the bone, even though he is running a high temperature. After about an hour, the hot stage begins.... The skin becomes dry and burns, strong headaches set in and the patient throws up repeatedly. In violent attacks he is strongly stressed, and the fever rises to over 104° (40°C). He throws off the covers impatiently and becomes light-headed.... Then follows a phase of perspiration, sweat trickles down the patient's skin, soaking all his clothes and bed linen."

As scientists have in the meantime worked out, every bout of fever consumes up to 5,000 kcal. This high dissipation of calories and the fact that the blood corpuscles attacked by the malaria pathogens use up about hundred times as much energy in the form of glucose as normal cells, a life-threatening exhaustion of the patient's energy reserves may be the result. The malaria syndrome includes not just the fever but also a pernicious feeling of ill health,

strong head and limb pains, and a noticeably enlarged spleen. The organ tries to round up the infected red blood corpuscles and destroy them. If infection by the malaria pathogens recurs repeatedly, the spleen remains distended. A grave complication is "cerebral malaria." This occurs when the erythrocytes attacked by the malaria pathogens block up the blood vessels of the brain. The sufferer is then afflicted by hallucinations, repeated loss of consciousness to the point of coma, spasms, and paralyses. Red blood corpuscles attacked by the parasite can also lodge in the placentas of pregnant women. This "placenta malaria" can harm the growing child and is the cause of premature and defective births.

Even blood corpuscles that are themselves uninfected are detrimentally affected by the parasite, forming clumps and perishing in the process. This explains why serious anemia often develops very quickly in the case of *malaria tropica*. Untreated, *malaria tropica* leads to death in the case of about 30 percent of those infected.[21]

A unique disease

In many respects, malaria is a unique disease. In contrast with other infectious diseases, such as measles or plague, the body is, for example, unable to develop permanent immunity against the complaint. Thus, once infected, a sufferer can go down with malaria time and again throughout his life, almost as if he had never had the disease before. This is due to the parasites' habit of hiding inside the red blood corpuscles and busily setting about reproducing largely unnoticed by the immune system. In addition, malaria pathogens constantly change their surfaces. They cruise about in the blood under constantly changing flags, as it were, and thus escape the defensive strategies of the immune system. This chameleon-style adaptability of the pathogens makes it difficult for scientists to develop a vaccine. Despite decades of research work, an effective vaccine is not expected to be developed in the foreseeable future.[22] In the meantime, even the various drugs available to fight malaria can be successfully resisted by the parasite. At present, there is no longer any drug that provides protection from malaria in all regions of the world. The rule of thumb among tropical medicine experts is that *plasmodium* develops strategies for escaping the effects of a drug within five years of a new antimalaria product being introduced. Wars, mercenary armies, refugees, and expulsions—and even long-distance tourism —contribute substantially to drug-resistant pathogens spreading rapidly in tropical countries.

Because one antimalaria drug after another loses its potency, researchers are currently deploying new molecular biological discoveries and modern methods in an attempt to find substances that grab the pathogens where it hurts and rid the blood of them for good. The demands made of new antimalaria drugs are high: they have to defeat a particularly cunning pathogen, which has so far managed time and again to escape every medical attempt to overcome it. And they have nonetheless to be affordable, so as to be within reach not just of the few rich people threatened by malaria but more especially of the large populations most widely afflicted by the disease.

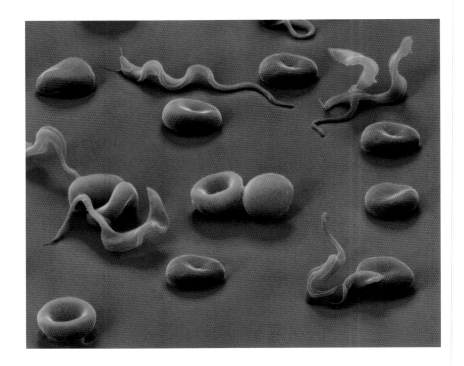

Mysterious "baggage malaria"

People living in the northern hemisphere who think they are safe from malaria could be in for a shock. Two serious cases of *malaria tropica* in Berlin in 1994, for example, have still to be satisfactorily accounted for. They involved two mechanics who became infected with *plasmodium* while working at a sewage treatment plant. Experts excluded the currently known risk factors—neither of the two men had previously traveled to a malarial part of the world or had been given a blood transfusion. No *anopheles* mosquitoes could be found in the environment of the sewage works, while the nearest airport—on several occasions, infected *anopheles* mosquitoes have smuggled themselves in aboard aircraft—was twelve miles away. The only conceivable explanation left was that the infected mosquito had been brought to Germany in a suitcase. A colleague of the two workers had returned from holiday in the tropics shortly before, and could have brought the baggage malaria with him.

Sleeping sickness: On the trail of the Achilles' heel of a murderer

At the beginning of the twentieth century, the disease still terrorized many parts of Africa. By the middle of the century, it was considered almost overcome. Yet at the turn of the millennium, epidemiologists were registering a dramatic rise in sleeping sickness, above all in the areas afflicted by civil war. The WHO estimates that 300,000 to 500,000 people in Africa are affected with the pathogen, and the trend is upwards. In many African countries, there are, according to the WHO, already more deaths from sleeping sickness than from AIDS.

The disease gets its name from the most obvious symptom the sufferer has to put up with if the pathogen—the *trypanosoma* parasite (Fig. 10)—migrates from the blood system to the brain, as a result of which the patient keeps falling into quasi-narcotic sleep. In the late stages, the disease produces many other

neurological symptoms, for example, incoherent speech, loss of mobility and coordination, and spasms.[23]

The dangerous parasite is carried by the tsetse fly (Fig. 1). Most sufferers recall the fly biting them very clearly, because it is very painful. A few days later, a swelling becomes apparent round the bite, which then disappears of its own accord. In the meantime, the trypanosomes are busy reproducing in the blood, which shows up in bouts of fever. If the tsetse fly bites again, the pathogen is absorbed into the blood and carried on.

There are only a few drugs that can cure the early phase of sleeping sickness. Once they have attacked the brain, only a single drug is capable of really getting at the parasites effectively. In this case, serious side effects have to be accepted. Moreover, resistance to the drug is also known, i.e., *trypanosoma* has meanwhile succeeded in resisting the effect of the drugs. All attempts so far to provide a vaccination against sleeping sickness have failed.[24]

New research strategies intended to lead to more effective therapeutic measures use new molecular discoveries about the biology of the pathogen.[25] The better scientists get to know *trypanosoma*, the nearer they will get to their goal of finding the Achilles' heel of a pernicious murderer that feasts on the blood of its victim and if not treated condemns him to a slow, unpleasant death.

A most particular fluid

This is by no means a comprehensive survey of all the diseases that are transmitted by blood. The ghastly list could be extended by adding numerous other pathogens that infect blood and find new victims among men and animals via the bloodstream. In recent times, a completely new type of pathogen, called a prion, has attracted immense interest. It is debated whether it is the cause of BSE (Bovine Spongiform Encephalitis) and the new variant of human Creutzfeldt-Jakob diseases. Transmission by blood has so far not been excluded.

Blood is in many respects a "most particular fluid,"[26] as its history since time immemorial shows. It is the story of a metamorphosis: from Antiquity to the beginning of the twentieth century the "magic" of blood was foremost. After that, it was scientifically stripped down to its individual parts, thereby gaining in biological fascination what it lost in magic appeal.

And yet, despite all rational demystification, blood still carries an aura of magic. This may have to do with the fact that scientists remain unable to unravel the secrets of our only fluid organ as a complex whole.

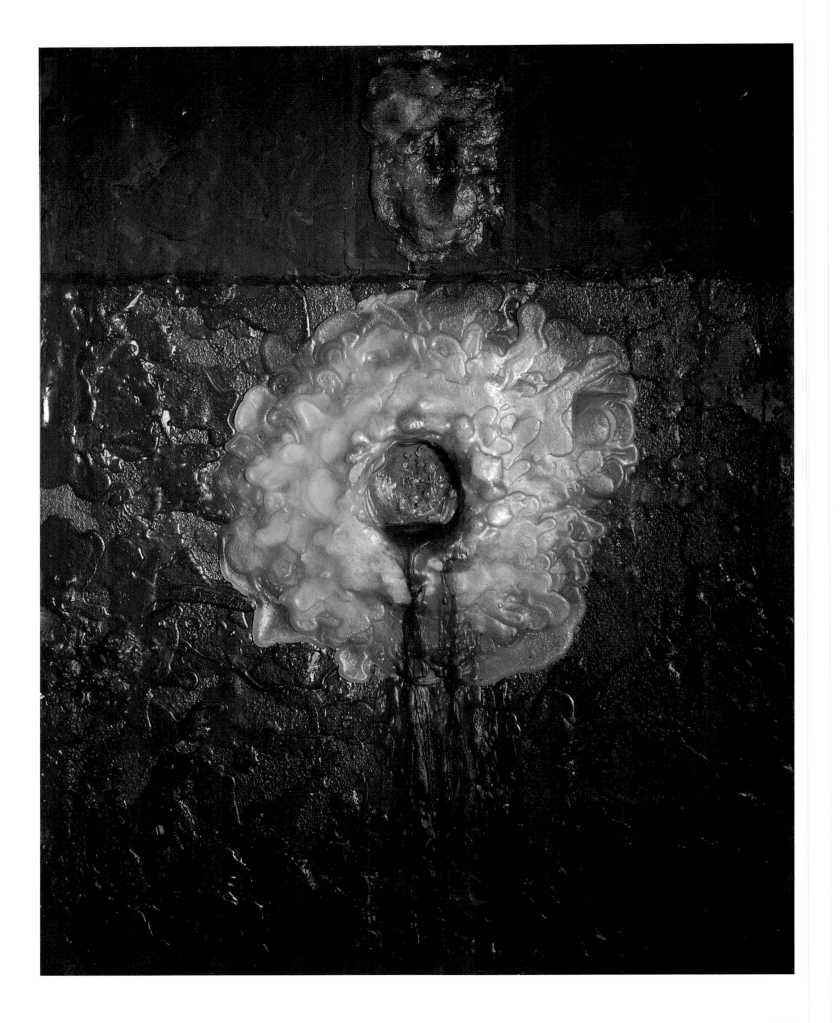

"The body is perhaps the primary metaphor for a society's perception of itself. The individual and spoken language are what make up the social body, the physical body is a kind of boundary between biology and society, between drives and discourse."

The Artist's Body

Reflections on Blood in Contemporary Art
Peter Weiermair

1. Hermann Nitsch (b. 1938), Wax Image, 1960, wax on wood, Vienna, Hummel Collection

During the second half of the twentieth century, the dividing line between art and everyday life was gradually being pared away, with the subject of an artist's work becoming identical with its physical execution. Expressions generated by figures and situations not only became the subject of art, but, because they were real phenomena, took center stage more so than in dance or drama. These physical and vital aspects still mirror crucial issues relevant at the turn of this century: questions of sexual identity, the search for the meaning of life, fear, violence, disorders of the body and its destruction, as well as suffering, anguish, and torture, to name but a few.

This essay considers a subject in the context of art that makes the body the focal point of happenings and documentation in forms other than drawings, sculpture, and painting—namely the crucial bodily fluid required for all animal and human life: blood. As a subject, blood has been treated very differently by the two generations of artists active since the 1960s. For the generation of Action painters and early performance artists, what was crucial was the cathartic quality of their happenings, which confronted audiences with artists adopting extreme positions and inflicting injuries upon themselves; for that generation, the experience of war was fresh as the Vietnam War was still being waged. For the later generation, AIDS and the debate surrounding genetic engineering are the issues dominating discussions about health and life in the future. If the issue for the former group was the opening of the body and the destruction of its integrity, the issue now is that blood is the carrier of danger, of a fateful infection, a modern plague, and the repository for the messages within our genes.

Viennese Actionism and the artists who instigated happenings were interested in removing the dividing line between art and life. In this progression, from the description of an event to the event itself, reference was made to the historical models of Futurism and Dadaism, by this time finally assimilated and thoroughly adopted, as well as to the crucial figures of Marcel Duchamp, Yves Klein, and Piero Manzoni. With regard to radicalism, it must be remembered that the artists—especially those associated with Viennese Actionism—deliberately went beyond the bounds of what was considered acceptable at the time and that it was feminist artists in particular whose symbolic and metaphorical actions, including self-mutilation, drew attention, especially later, to the repressive mechanisms in society. The educational character and the polemic attacks against the lack of freedom, repression, war, torture, and anguish could not be overlooked. Austrian Actionism in particular sprang from an atmosphere that was stifling, conservative, and clerical in character. Its radicalism inspired a whole host of international artists ranging from the Australian Mike Parr to the Czech Petr Stembera. A multiplicity of forms of physical expression became part and parcel of artistic strategies. Artists subjected themselves to physical and psychological *Endurance Tests* that in the United States, where the phrase "body works" was coined, were more behaviorist than the mythological and

**2. Günter Brus (b. 1938), *Endurance Test*, 1971,
from a set of twelve mounted photos, Vienna,
Galerie Heike Curtze. Photo: Ludwig Hoffenreich**

psychologically profound character of the work of European artists, for whom
catharsis was more important.

It is not without reason that an early work by Hermann Nitsch is reproduced on the jacket of this collection of essays. He is, after all, *the* internationally known artist for whom blood was central, particularly in his Orgies
Mysteries Theater (Fig. 3). His theoretical legitimation can be found to a large
extent in a historical context, which is examined in this volume and encompasses
both the sacrificial myths of the Greeks and Maya and the transubstantiation
of the body of Christ in Christian mysticism, as well as the theories of Friedrich
Nietzsche and Sigmund Freud, to name only two philosophers central to his
work. From the start, Nitsch worked with unadulterated animal blood that he
used to pour over his models, and originally over himself. The blood left traces
on the sheets and biers used in his action painting spectacles, which could last
up to three days. The multimedia, synaesthetic event, into which the audience
is not drawn, is represented through video recordings, photographs, and relics
in addition to an olfactory laboratory that refers to the multisensory nature of
Nitsch's work.

After Günter Brus' last *Endurance Test*, in 1971 (see Fig. 2), in which
he inflicted wounds upon himself, the artist turned away from Actionism in favor
of literature and drawing, as did Otto Mühl, who in the following year devised
his own social utopia by founding a commune. Following Rudolf Schwarzkogler's
death in 1969, Hermann Nitsch was not only the leading representative of

Viennese Actionism, but also the only one of its practitioners who could point to a complex body of work embracing literature, painting, and music—not forgetting the records of his numerous happenings. In all his action performances and the resulting "left-overs," blood played a crucial part. Following his early artistic phase, in which he threw and splashed blood, Nitsch devised a "substitute sacrificial rite" in which he lacerated lambs and threw blood on his models—a rite in which the viewer experiences and comprehends the role of the victim (see Fig. 4). As the Vienna-based sexual aestheticist and art historian Peter Gorsen, one of the major authorities on the work of Hermann Nitsch, once wrote, the happening struck a balance between a real event and pure performance aesthetics. It represented a compromise, he said, between something factual and symbolically exaggerated, thus causing a rift between a mythical past and the present.

The theater of Hermann Nitsch is a theater of elemental, sensual feeling that illustrates cruelty and, by means of the austere form of art, is retransformed into life. In his photographic sequences (only partly published), Rudolf Schwarzkogler created suggestive tableaux of early Viennese Actionists, a loose group of friends, that supported the later legend of his castration. His arrangements promote the fiction of amputation and mutilation, death by electrocution, and dreadful torture, but the viewer understands this only by association. Blood is merely suggested. Schwarzkogler, the Apollo among the four protagonists of Viennese Actionism, took his lead from Asiatic meditative practices and from concepts of purity in which the various bodily fluids played an important role.

3. Hermann Nitsch (b. 1938), 6-day play from the Orgien Mysterien Theater (Orgies Mysteries Theater), 1998, video, Prinzendorf, Schloss Prinzendorf. Photo: H. Cibulka

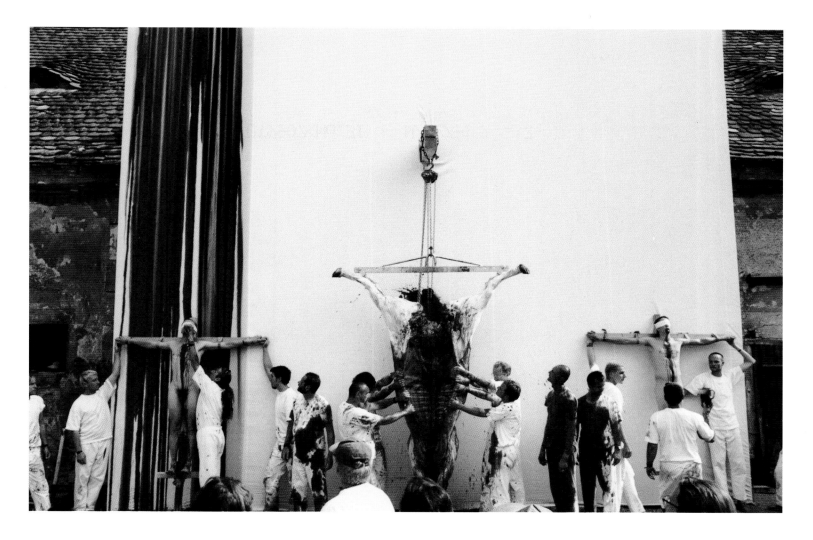

4. Hermann Nitsch (b. 1938), *Image from Poured Fluids*, jute, blood, paint, Prinzendorf, Schloss Prinzendorf

While Nitsch talked about tearing apart lambs and at the same time superimposed Christian ideas onto the myths surrounding Oedipus and Marsyas, first crucifying a lamb, disemboweling it, and changing images back into reality, Brus in fact realized a more radical program. This involved using his body for sculptural processes involving extreme brutality against himself, partly in the form of his *Endurance Test* and early actions, and partly fictitiously through drawings that were created both before and after this experiment. At the time of the "endurance test," created under extreme pressure, he was at a crossroads. Had he translated his much-hyped self-destruction—which was also regarded as a form of litany—into action, suicide would have been the consequence. The *Endurance Test* takes its place in the tradition of artists portraying themselves as martyrs, if not Messianic Christ-like figures. On behalf of the viewer, the artist has experiences that he demonstrates; they are not exhibitionistic excesses, but are experienced vicariously.

Brus is someone who asks fundamental questions rather than performing the type of limited, albeit extreme, psychodrama that differentiates his work from that of Chris Burden. Burden performed a series of actions in California in which he had a friend "shoot" at him (iconographically reminiscent of Saint Sebastian) or, drawing on the image of Christ's crucifixion, was "nailed" not to a cross but to the back of a car. It is here that the difference between Paul McCarthy and Hermann Nitsch becomes apparent: the former's

5. Hermann Nitsch (b. 1938), *Stretcher* (*Cross*), 1984, screen, wood, organic substances, Vienna, Hummel Collection

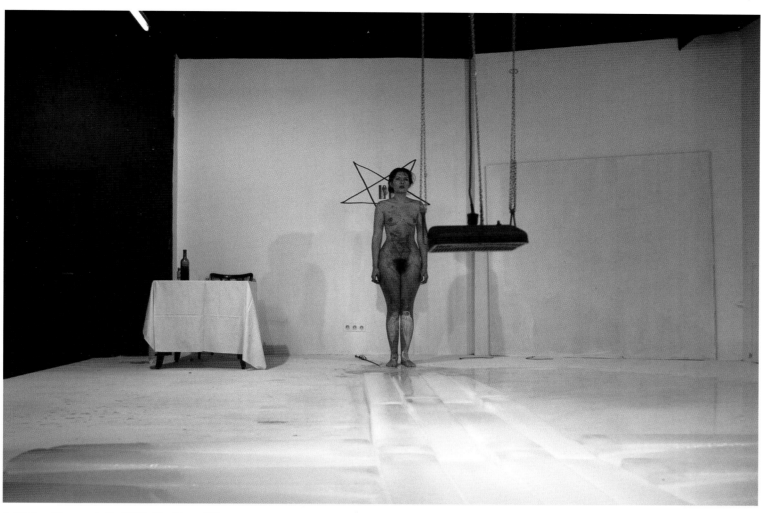

6. Marina Abramovic (b. 1946), *The Lips of Thomas*,
1975, performance, 2001 re-installation, Innsbruck,
Galerie Krinzinger

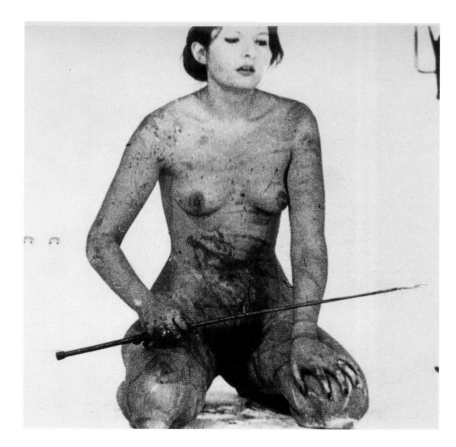

7. Marina Abramovic (b. 1946), *The Lips of Thomas*,
1975, performance (detail), 2001 re-installation,
Innsbruck, Galerie Krinzinger

Reflections on Blood in Contemporary Art

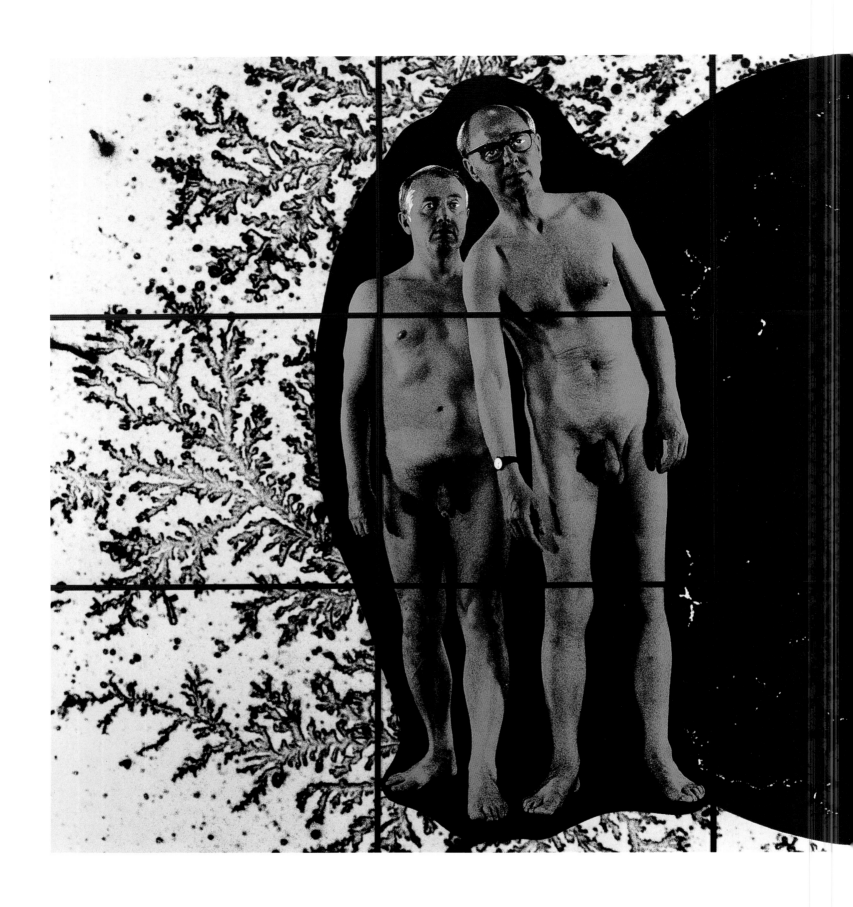

8. Gilbert & George (b. 1943 and b. 1942), *Blood and Tears*, 1997, mixed media, Vienna, Klosterneuburg, Essl Collection. Photo: Archiv Sammlung Essl, © Courtesy of Gilbert & George

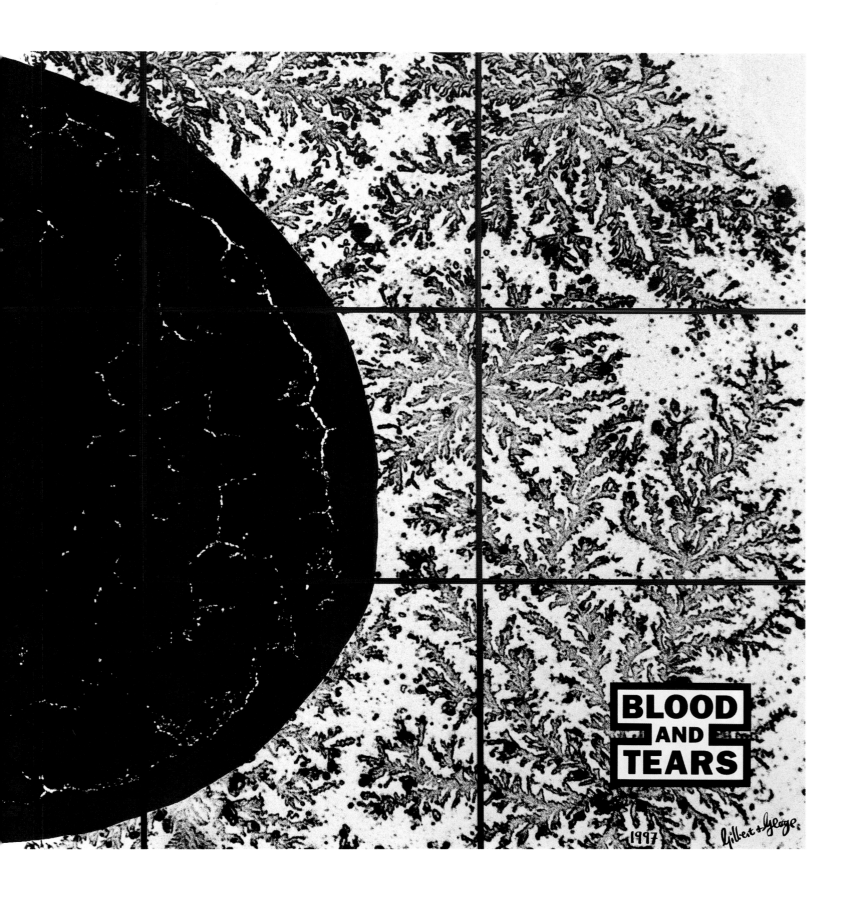

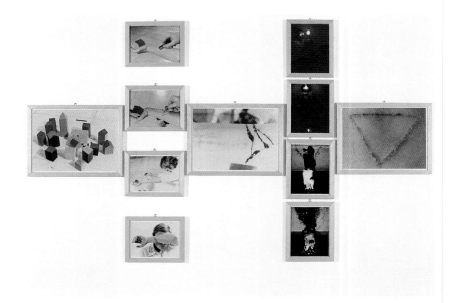

activities were critical of civilization and were directed at the American ideology surrounding cleanliness and Hollywood ideals while the latter's Actionism was driven by classical mythology and Freudian abreaction subject matter. In the work of many women artists, such as Valie Export, Marina Abramovic and Gina Pane, as well as Ana Mendieta and E. Krystufek, great importance came to be attached to vicarious actions whose shock value was intended to enlighten and in which the artists' own blood flowed in real injuries before an audience.

Performance art became established in the 1970s. Within it, minorities worked out their position. Rape and women's suffering are central themes; women are seen as the victims of male oppression. At the start of her career as an artist, Ana Mendieta performed a *Rape Piece* by smearing blood over her back and exhibiting herself half naked, like a rape victim, in a dimly-lit room at Iowa University. For Gina Pane, who died young, self-mutilation of such a sensitive part of the body as the face was an exemplary act with which she wanted to draw attention to the daily oppression of women. By injuring oneself, opening one's body, and spilling one's own blood, the act ceases to be fictional theater and instead becomes "painful reality," a ritual and exorcism that, at least one would like to think, could not be repeated (see Fig. 9). (Marina Abramovic did, in fact, repeat her act of cutting a five-pointed star into her skin.) Gina Pane's compatriot, Michel Journiac—who likewise died young—in his *Mass for a Body* offers us a pudding-shaped body made out of his own blood. Both he and Pane draw attention to the vulnerability of the body, whose fragility becomes apparent when it is opened. The themes of these artists are isolation and loneliness, risk and danger, pain and how to overcome it.

Marina Abramovic's *The Lips of Thomas*, which she "performed" in 1975 in Innsbruck's Galerie Krinzinger, presented a form of exorcism, one in which the artist offered a sacrifice and was the sacrifice herself: Marina Abramovic slowly ate a kilo of honey, drank a liter of red wine, and then crushed the glass in her hand. With the broken glass, she cut a star in her stomach (see Figs. 6 and 7). On all fours, she flogged herself until numb and then lay down on a bed of ice, from which she was lifted by a member of the audience. In an earlier event in

11. Joseph Beuys (1921–1986), *Horn*, 1961, bronze, Ingrid and Willi Kemp Collection, Düsseldorf, Kunstmuseum

the Morra Gallery in Naples, she abandoned herself to the audience and, having sustained severe injuries, was saved by some members of the audience who knew where to draw the line. Public participation is an essential part of Marina Abramovic's real but staged psychodramas. Taking her own experiences to new limits is equally important for her. For Abramovic, but also for Burden, it was important to include the experience of pain, of opening the body, in pushing beyond the limits of their experience.

The Englishman Marc Quinn created his own *memento mori*. Over several months, he collected his own blood and used it to re-create his own face. Using the amount of blood in an average person's body, the artist formed a frozen mold of his head that is now stored in a glass box at -70°C in the Saatchi collection. He has thus created the ultimate self-portrait, composed of the very stuff that is among the body's fundamental components. The cast contains all the data, blood type, and genetic material needed to obtain a DNA sequence. The substance means that the artist Quinn is symbolically present in the shape of his head, even if he is in reality absent.

12. Joseph Beuys (1921–1986), *Siberian Symphony*, 1963, three drawings in one frame, hare's blood applied to brown packing paper, Moyland, Schloss Moyland Foundation, Van der Grinten. Collection—Joseph Beuys Archiv des Landes Nordrhein Westfalen, © Walter Klein, Düsseldorf

In contrast to Joseph Beuys (see Figs. 10–12), for whom blood, lard, felt, and honey were the main symbolic substances, Marc Quinn belongs to a group of artists active in the 1980s and 1990s, which included Andres Serrano or Kevin Clarke. Gilbert & George, although belonging to an earlier generation, staged large exhibitions at that time, too. Their "Blood Pictures" date from the early 1990s. Younger artists are less interested in self-awareness, rituals, and spiritual exercises, but they are clearly aware of the danger posed to mankind by epidemics, in particular AIDS, which is transmitted by blood and semen. Serrano clearly states that his works, large-scale photographs that make an abstract and expressive impression, confront issues of life, death, religion, and sexuality. In "Body Fluids," a series of images from 1985–90, Serrano uses different body fluids as if they were pure color. The beauty of the planes of color contrasts with the known dangers of the substances (Fig. 14).

To grasp the pathos of the message of the "Blood Pictures," for instance those from a morgue, these images must be read from another angle, namely from a figurative and monumental one. Despite their apparent purity, semen and blood transmit AIDS, the plague of the twentieth century, which for this generation of artists in particular represents a terrible and omnipresent experience. A similar experience characterizes Gilbert & George's large tableaux. Sometimes five meters long and two meters high, they incorporate many details reminiscent of Romanesque or Gothic church windows. However, the artists have used microscopic images of blood cells that are combined with urine crystals and huge shapes modeled in human excrement (see Fig. 8). The artists are seen

13. Hermann Nitsch (b. 1938), *Station of the Cross* **(detail), 1962, mixed media, artist's collection**

14. Andres Serrano (b. 1950), *Semen and Blood II*, cibachrome, 1990, New York, Paula Cooper Gallery

striding across their landscapes of blood, excrement, and urine, sometimes naked, sometimes dressed, looking like two Adams or two Dantes in Hell. Notwithstanding the irony and "beauty" of what we usually conceal or cannot see, such as blood cells, Gilbert & George point to the danger posed by blood that, unlike in the Romantic era, indeed even unlike the period thirty years ago, is no longer "visible." Genetic engineering has now also cast its shadow over the portentous church windows of these two Englishmen.

For this reason, Kevin Clarke brings up the rear in this essay with his experimental portraits that mark the last phase so far in his work, in which the portrait plays a central role (see Fig. 4, p. 236; Fig. 6, p. 238; Figs. 12–14, pp. 242–43). Clarke works with the genetic fingerprint obtained from blood. In scientific terms, we are talking about the DNA sequence within the human genome, which determines each person's individuality. Clarke has used DNA sequences since the 1980s, when they could first be shown; they consist of the complicated chemical analytical technique of the polymerase chain reaction and the transmission in sequences of letters or rhythmic curves. He combines this abstract scientific language with his own imagery that paraphrases each of his subjects. Blood has a role to play for Clarke, the representation of a person through physical and pictorial qualities rather than medial codes and clichés.

UNITED COLORS
OF BENETTON.

In 1992, Quentin Tarantino wrote and directed *Reservoir Dogs*, a low-budget gangster film made in the cinematic tradition of earlier films directed by Robert Altman, Martin Scorsese, and Stanley Kubrick. The film opens with a graphic scene in which Mr. Orange (Tim Roth), who has been wounded in a robbery, lies on a barren warehouse floor, slowly bleeding to death. As the film develops, the pool of blood that surrounds his body gets progressively wider until Mr. Orange appears like a small boat set adrift in a river of his own blood. In the industrialized West, popular culture is increasingly marked by blood. From docudramas to the cinema, from mainstream box-office hits to "splatter films," blood has become a leitmotif in a visual culture that uses violence to shock, titillate, and desensitize, but rarely to promote a critical understanding or problematize what forms of agency are put into place by such forms of representational violence.

The Culture of Violence and the Politics of Colorful Sweaters: Benetton's "World without Borders"[1]
Henry A. Giroux

An example of how cinematic representations and "objective" reporting mutually reinforce a narrow, often racial coding of violence can be seen in an incident that happened at a movie theater in Oakland, California, where a group of Castlemont High School students was taken to see *Schindler's List* (1993) as part of the school's effort to deepen their sense of history and oppression, and to broaden their understanding of the struggle for human rights. The students, most of them black and Hispanic, laughed at some of the most violent scenes in the film. The manager of the theater reacted in shock and asked them to leave. The story received national attention in the popular press, and echoed the stereotypical assumption that these students mirrored in their own person-alities the nihilism and pathology that inevitably led to increased disorder and criminality.

Hardly a paragon of objectivity, the media's portrayal of this episode betrays a certain tragic irony in representing black youth as the source rather than the victims of violence. In fact, recent statistics reveal that "young black males constituted 17.7 percent of all homicide victims, even though they made up only 1.3 percent of the US population. [Moreover] black men over age 24 were victims of homicide at a rate of 65.7 per 100,00, compared with 7.8 per 100,00 for white men."[2] The media portrait nonetheless reflects the con-servative mood of the country: treating violent youth as dangerous urban aliens is a guaranteed crowd pleaser; focusing on the devastating effects of (white) racism, rising poverty, and unemployment for a generation of black youth is less popular.[3]

What is so crucial about the above examples is that the largely dominant white media, while critical of the response of the black and Hispanic children to the inhumane consequences of Nazi violence, failed to make any serious attempt to analyze the larger culture of violence that permeates the United States. Such an investigation might not only explain the insensitive response of the school children to the violence portrayed in *Schindler's List*, it would also demand that white society examine its own responsibility and complicity in producing an ever-spreading culture of violence and hip nihilism that makes

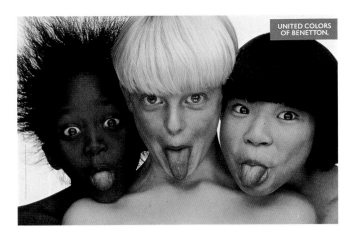

2. Oliviero Toscani, Benetton campaign, Fall/Winter, 1990/91. Photo: Benetton Group

it difficult for anyone to draw a meaningful line between the normal and the pathological. Moreover, as the context and the conditions for the production of violent representations are justified in the name of entertainment advertising revenue and high box-office profits, youth increasingly experience themselves as both the subjects and the objects of everyday violence and brutality. While the relationship between representational violence and its impact on children and youth is not clear, the culture of violence spread by television, videos, and film is too pervasive to be ignored or dismissed. Moreover, this new culture of violence both militarizes vision and makes violence central to the act of consuming.

Promotional culture in the postmodern age

There is a certain irony in the fact that while many social theorists claim that postmodernism is dead, mass advertisers have seized upon the postmodern condition with its celebration of images, its proliferation of differences, and its fragmented notion of the subject to create pedagogical practices that offer a sense of unity amid a world increasingly devoid of any substantive discourse of community and solidarity. It is in its concerted and often pernicious efforts to rearticulate the relationship among difference, human agency, and community that mass advertising increasingly succeeds in its promotional mission: to disguise the political nature of everyday life and appropriate the vulnerable new terrain of insurgent differences in the interests of a crass consumerism.

But there is more at stake here than advertising and commerce joining forces in the postmodern age to commodify through the ritualization of fashion that which has previously escaped its reach. More importantly, mass advertising has become the site of a representational politics that powerfully challenges our understanding of what constitutes pedagogy, the sites in which it takes place, and who speaks under what conditions through its authorizing agency. With the emergence of advertising as a global enterprise, we are witnessing a new form of violence against the public. Images that shocked people in the past have become "the most effective way of selling commodities today." [4] By this I do not mean simply that violence intrudes into designated public spheres as much as I am suggesting a "public whose essential predicate would be violence." [5] At the core of this violence are constituting principles that accentuate individualism and difference as central elements of the marketplace. Underlying this violence of the public is a notion of the social bereft of ethics, social justice, and any viable notion of democratic public cultures. Put another way, mass advertising and its underlying corporate interests represent a new stage in an effort to abstract the notion of the public from the language of ethics, history, and democratic community.

The rearticulation and new intersection of advertising and commerce, on the one hand, and politics and representational pedagogy, on the other, can be seen in the emergence of Benetton as one of the leading manufacturers and retailers of contemporary clothing. Benetton is important not only because of its marketing success, but also because it has taken a bold stance in attempting to use advertising as a forum to address highly charged social and political issues. Through its public statements and advertising campaigns, Benetton has brought a dangerously new dimension to corporate appropriation as a staple of postmodern

aesthetics. Inviting the penetration of aesthetics into everyday life, Benetton has utilized less deterministic and more flexible approaches to design, technology, and styling. Such postmodern approaches to marketing and layout privilege contingency, plurality, and the poetics of the photographic image in an attempt to rewrite the relationship among aesthetics, commerce, and politics. Instead of depoliticizing or erasing images that vividly and, in some cases, shockingly depict social and political events, Benetton has attempted to redefine the link between commerce and politics by emphasizing both the politics of representation and the representation of politics. In the first instance, Benetton has appropriated for its advertising campaign actual news photos of social events that portray various calamities of the time. These include pictures of a bloodied Mafia murder victim, depictions of child labor, a terrorist car bombing, and the bloodstained clothes worn by a Croatian student (Fig. 6) the day he was killed. As part of a representation of politics, Benetton struggles to reposition itself less as a producer of commodities and market retailer than as a corporate voice for a particular definition of public morality, consensus, coherence, and community. One striking example of this position is an advertisement that depicts Luciano Benetton posing nude, the accompanying text urging people of wealth to give away their "old" clothes to charity.[6] Benetton justifies the ad by arguing that "business has to go on for everybody. Rich people should buy new stuff and be pleased that others can profit from [their old clothes]."[7] Justice in this case is appropriated less to regulate the production of consumerism than to legitimate it.

Small beginnings and global controversies

> All over the world Benetton stands for colorful sportswear, multiculturalism, world peace, racial harmony, and, now, a progressive approach toward serious social issues.[8]

In 1965, Luciano Benetton and three siblings established a small business, Fratelli Benetton, near Treviso, Italy. Originally designed to produce colorful

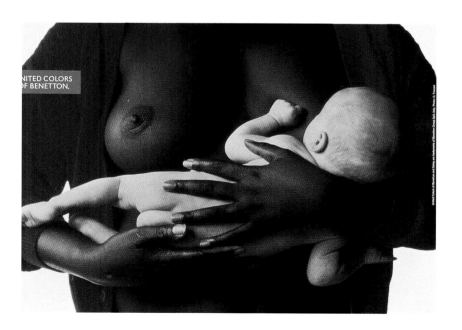

3. Oliviero Toscani, Benetton campaign, Fall/Winter, 1989/90. Photo: Benetton Group

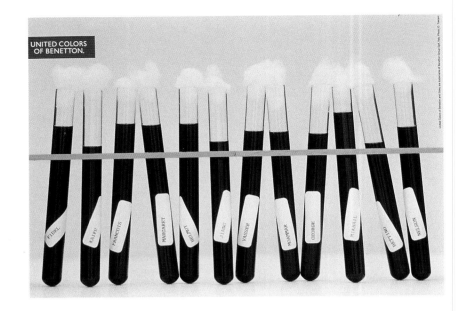

sweaters, the business expanded into a full range of clothing apparel and eventually developed into a two-billion dollar fashion empire producing eighty million pieces of clothing a year for seven thousand franchise stores in over one hundred countries.

Benetton's advertising campaign over the last decade has been instrumental in its success in the fashion world. The advertising campaign is important not merely as a means of assessing Benetton's commercial success in extending its name recognition, it is crucial for understanding how the philosophy of the company has attempted to reinscribe its image within a broader set of political and cultural concerns. In 1984, Benetton hired Oliviero Toscani, an award-winning photographer, to head its advertising campaign. Given a free hand with the advertising budget, Toscani's early work focused on culturally diverse young people dressed in Benetton attire and engaged in a variety of seemingly aimless and playful acts. Linking the colors of Benetton clothes to the diverse "colors" of their customers from all over the world, Toscani attempted to use the themes of racial harmony and world peace to register such differences within a wider, unifying discourse (Fig. 3). In 1990, Toscani adopted the "United Colors of Benetton" as a recurring trademark of the Benetton ideology. In 1991, Toscani initiated a publicity campaign that removed Benetton merchandise from the firm's advertising, and started using its eighty million dollar global ad budget to publish controversial and disturbing photographs in magazines and on billboards. Taking full control of the ad blitz, Toscani personally photographed many of the images that dominated the 1991 Benetton campaign. These included a number of compelling images that created a provocative effect: variously colored, blown-up condoms floating in the air, a nun kissing a priest on the lips, a row of test tubes filled with blood (Fig. 4), and a newborn baby girl covered in blood and still attached to her umbilical cord. In 1992, Toscani embarked on his most dramatic effort to combine high fashion and politics in the service of promoting the Benetton name. He selected a series of highly charged, photojournalistic images referencing, among other things, the AIDS crisis, environmental disaster, political violence, war, exile, and natural catastrophe. These appeared in various journals and magazines as well as on billboards without written text except for the conspicuous insertion of the green and white "United Colors of Benetton" logo located in the margins of the photograph.

Benetton's shift in advertising strategy between 1983 and 1991 needs to be considered as part of a wider politics and pedagogy of representation. The earlier photographs representing children of diverse races and colors dressed in Benetton clothing have a "netherworld quality that gives the viewers the impression they're glimpsing some fashionable heaven."[9] Depicted in these photographs of children hugging and holding hands is a portrayal of racial harmony and difference that appears both banal and sterile (see Fig. 2). The exaggerated precision of the models and primary colors used in the advertisements render racial unity as a purely aesthetic category while eliminating racial conflict completely in this two-dimensional world of make-believe. In addition, these colorful images appear almost too comfortable, and seem at odds with a world marked by political, economic, and cultural conflict. In the early ads difference, then, is largely subordinated to the logic of the marketplace and commerce. At the same time, the harmony and consensus implied in these ads often mock concrete racial, social, and cultural differences as they are constituted amid hierarchical relations of struggle, power, and authority. Benetton's corporate image in this case seems strangely at odds with its own market research, which indicated that its "target customers—18–34-year-old women—are more socially active and aware than any generation that precedes them."[10]

The switch in the ad campaign to controversial photojournalistic images reflects an attempt on the part of Benetton to redefine its corporate image. In order to define itself as a company concerned with social change, Benetton suspended its use of upscale representations in its mass advertising campaign, especially in a world where "denial in the service of upbeat consumerism is no longer a workable strategy as we are continually overwhelmed by disturbing and even cataclysmic events." In a postmodern world caught in the disruptive forces of nationalism, famine, violence, and war, such representations linked Benetton's image less to the imperatives of racial harmony than to the forces of cultural uniformity and yuppie colonization. Moreover, Benetton's move away from an appeal to utility to one of social responsibility provides an object lesson in how promotional culture increasingly uses pedagogical practices to shift its emphasis from selling a product to selling an image of corporate responsibility. Given the increase in sales, profits, and the widespread publicity Benetton has received, the campaign appears to have worked wonders.

The response to the campaign inaugurated in 1991 was immediate. Benetton was both condemned for its appropriation of serious issues to sell goods and praised for incorporating urgent social concerns into its advertising. In many cases, a number of the Benetton ads were either banned from particular countries or refused by specific magazines. One of the most controversial ads portrayed AIDS patient David Kirby on his deathbed, surrounded by members of his grieving family (Fig. 5). The Kirby ad became the subject of heated debate among various groups in a number of countries. In 1995, Benetton once again traded on the photographic juxtaposition of human suffering, the spectacle of human blood, and name-brand promotion by putting the Benetton logo next to a picture of the bloodstained clothes of a Croatian college student named Marinko Gargo, who was shot and killed by enemy fire in Bosnia-Herzegovina in July of 1995 (Fig. 6). Claiming that the purpose of the ad was to enlighten the world about the Bosnian war, Benetton ignored critics who claimed that the company was once again capitalizing on and sensationalizing human tragedy

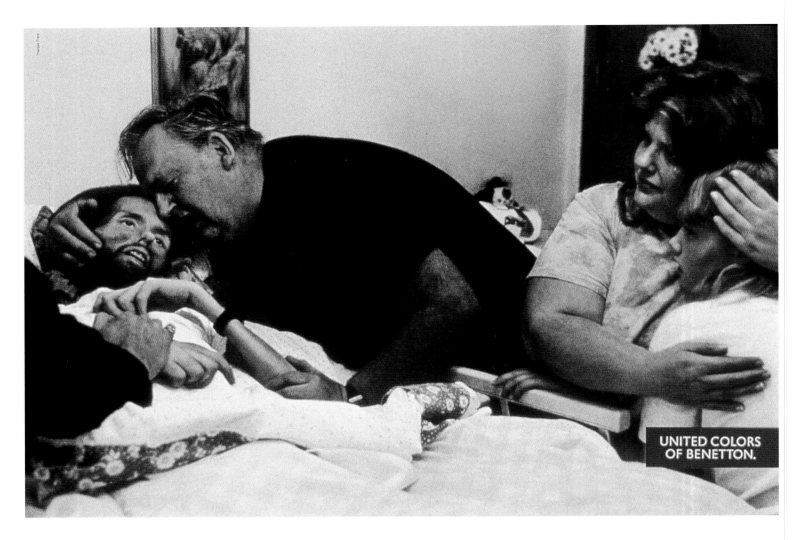

5. Oliviero Toscani, AIDS patient David Kirby on his deathbed, surrounded by his family, Benetton campaign, Spring/Summer, 1992, billboard, Frankfurt am Main, Museum für Moderne Kunst

for profit. In spite of the criticism and perhaps in part due to it, the company's sales have doubled in the last few years, reaching more than $1.8 billion in the United States alone. The Benetton name has even infiltrated popular literary culture, with Douglas Coupland coining the phrase "Benetton Youth" in his novel *Shampoo Planet* to refer to global kids whose histories, memories, and experiences began in the Reagan era of greed and conspicuous consumption. *Adweek* reports that because of the success of the Benetton campaign, Toscani has become something of a commercial "star," and has been asked by American Express to develop marketing concepts for them. Benetton's stock is up because of the visibility of the company, and David Roberts, an analyst with Nomura International/London, claims that Benetton's "name recognition is approaching that of Coca-Cola."[11]

Benetton's practical response to the controversy has been threefold. First, Benetton and its spokespersons have reacted aggressively within a number of public forums and debates in order to defend its advertising policies by either condemning the criticism as a form of censorship or criticizing other ad companies for producing advertising that merely engages in the most reductionistic forms of pragmatism. Second, it has used the debate to redefine its identity as a corporate force for social responsibility. Third, it has seized upon the controversy itself as a pretext for further marketing of its ideology in the form of books, magazines, talks, interviews, articles, and the use of stars such as Spike Lee to endorse its position in the debate.[12]

Benetton has attempted to articulate and defend its position in the popular press, in material published in its own books and newspapers, and even in campaign copy sent to its various retail stores. One particularly interesting example of the latter can be found in campaign copy that appeared in the fall/winter and spring/summer of 1992. Moreover, it has attempted to defray criticism of its ads by allowing selected executives to speak in interviews, the press, and various popular magazines. The three major spokespersons for Benetton traditionally have been Luciano Benetton, founder and managing director, Oliviero Toscani, creative director, and Peter Fressola, Benetton's director of communications in North America. All three provide different versions of a similar theme: Benetton is not about selling sweaters but social responsibility, and it is a company that represents less a product than a lifestyle and worldview.

While serving as a Senator to the Italian Parliament in the early 1990s, Luciano Benetton emerged as the principle ideologue in the Benetton apparatus. He is chiefly responsible for defining the structuring principles that guide Benetton as both a corporate identity and an ideological force. His own political beliefs are deeply rooted in the neo-liberal language of the free market, privatization, the removal of government from the marketplace, and the advocacy of business principles as the basis of a new social ideal. Hence, it is not surprising that in addition to defending the ads for their evoking public awareness of controversial issues, Luciano Benetton readily admits that the advertising campaign "has a traditional function, ... to make Benetton known around the world and to introduce the product to consumers."[13] More than any other spokesperson, Luciano Benetton articulates the company's position concerning the relationship between commerce and art and acts as a constant reminder that the bottom line for the company is profit and not social justice.

Peter Fressola, on the other hand, promotes Benetton's ideological position, and claims that the ad campaign does not reflect the company's desire to sell sweaters. He argues, "We're not that stupid. We're doing corporate communication. We're sponsoring these images in order to change people's minds and create compassion around social issues. We think of it as art with a social message."[14] Of course, the question at stake here is whose minds Benetton wants to shape? In part, the answer lies in its own advertising material which makes it quite clear that "[V]arious studies have shown that ... consumers are as concerned by what a company stands for as they are about the price/value relationship of that company's product."[15] There is nothing in Fressola's message that challenges the legacy of the corporate use of communications to advance, if only tacitly, "some kind of self-advantaging exchange."[16]

The moral high ground that Benetton wants to occupy appears to be nothing less than an extension of market research. When questioned about the use of the Benetton logo imprinted on all the photographs, Fressola, Toscani, and other spokespeople generally reply by evading the question and pointing to the use of such photographs as part of their support of art, controversy, and public dialogue around social issues. But the presence of the logo is no small matter. In light of their market research, which stresses what Raymond Loewy called the need for designer corporate symbols to index visual memory retention, the presence of the Benetton logo partakes of a powerful advertising legacy. It asserts that, regardless of the form it takes, the purpose of advertising is to subordinate all values to the imperatives of profit and commercialization. Loewy's

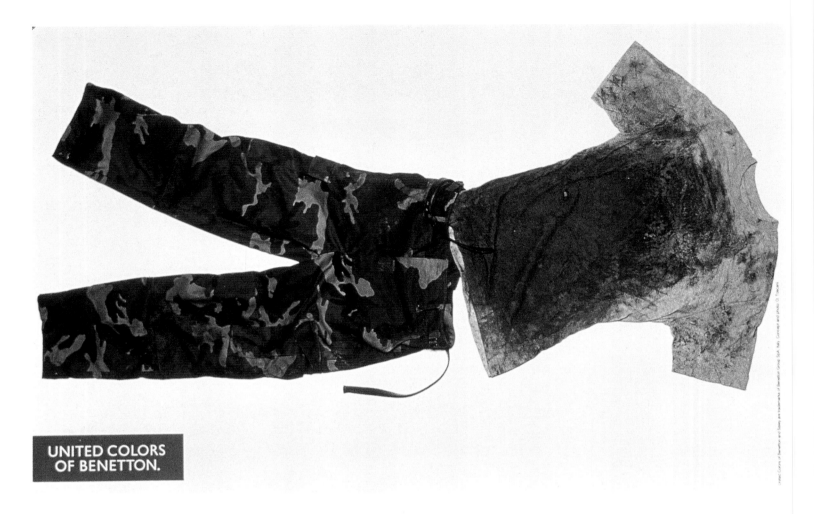

UNITED COLORS
OF BENETTON.

6. Oliviero Toscani, Bloodstained clothes of a Croatian student killed by enemy fire, Benetton campaign, Spring/Summer, 1991, billboard, Benetton Group

argument, "We want anyone who has seen the logotype, even fleetingly, never to forget it, or at least to forget it slowly,"[17] provides a powerful indictment of Benetton's rationale and the claim that Benetton is engaging in a *new* form of corporate communication. By refusing to disrupt or challenge this haunting and revealing legacy of designer logos, communication in these terms appears to do nothing more than link the commodification of human tragedy with the imperatives of brand recognition while simultaneously asserting the discourse of aesthetic freedom and the moral responsibility of commerce. This is captured in part in a statement that appeared in their fall/winter 1992 advertising campaign literature.

> Among the various means available to achieve the brand recognition that every company must have, we at Benetton believe our strategy for communication to be more effective for the company and more useful to society than would be yet another series of ads showing pretty girls wearing pretty clothes.[18]

Toscani goes so far as to separate his economic role as the director of advertising from what he calls the process of communication by claiming rather blithely, "I am responsible for the company's communications; I am not really responsible for its economics."[19] Toscani appeals in this case to the moral high ground, one that he suggests is untarnished by the commercial context that informs the deep structure of his job. Should we assume that Benetton's market research in

identifying target audiences has nothing to do with Toscani's creative endeavors? Or, perhaps, that Toscani has found a way to avoid linking his own corporate success to the rise of Benetton's name recognition in a global marketplace? Toscani is well aware of the relationship between representation and power, not to mention his own role in giving a new twist to the advertising of commodities as cultural signs in order to promote a particular system of exchange.

Politically, Benetton develops a strategy of containment through advertising practices using journalistic photos that address consumers through stylized representations whose structuring principles are shock, sensationalism, and voyeurism. In these images, Benetton's motives are less concerned with selling particular products than with offering its publicity mechanisms to diverse cultures as a unifying discourse for solving the great number of social problems that threaten to uproot difference from the discourses of harmony, consensus, and fashion.

Representations of hopelessness

> Many people have asked why we didn't include a text that would explain the image. But we preferred not to because we think the image is understandable by itself.[20]

> I think to die is to die. This is a human situation, a human condition.... But we know this death happened. This is the real thing, and the more real the thing is, the less people want to see it. It's always intrigued me why fake has been accepted and reality has been rejected. At Benetton, we are trying to create an awareness of issues. AIDS is one of today's major modern problems in the world, so I think we have to show something about it.[21]

In defense of the commercial use of sensational, journalistic photographs, which include the aforementioned dying AIDS patient, a terrorist car bombing, a black soldier with a gun strapped over his shoulder holding part of the skeletal remains of another human being, and representations of convicted killers on "Death Row," Benetton's spokespeople combine an assertion of universal values and experiences with the politics of realism. Arguing that such images serve as a vehicle for social change by calling attention to the real world, Benetton suggests that its advertising campaign is informed by a representational politics in which the "truth" of such images is guaranteed by their purchase on reality. From this perspective, "shocking" photos register rather than engage an alleged unmediated notion of the truth. This appeal to the unmediated "truth-effects" of photographic imagery is coupled with a claim to universal truths ("to die is to die") that serve to deny the historical, social, and political specificity of particular events. Ideologically, this suggests that the value of Benetton's photos resides in their self-referentiality, that is, their ability to reflect both the unique vision of the sponsor and their validation of a certain construction of reality. Suppressed in this discourse is an acknowledgment that the meaning of such photos resides in their functions within particular contexts.

Before discussing specific examples of Benetton's advertising campaign, I wish to comment briefly on some of the structuring devices at work in the use

of the photojournalistic images. All of Benetton's ads depend upon a double movement between decontextualization and recontextualisation. To accomplish the former move, the photos militate against a reading in which the context and content of the photo is historically and culturally situated. Overdetermined by the immediacy of the logic of the spectacle, Benetton's photos become suspended in what Stewart Ewen has called "memories of style."[22] That is, by dehistoricizing and decontextualizing the photos, Benetton attempts to render ideology innocent by blurring the conditions of production, circulation, and commodification that present such photos as unproblematically real and true. By denying specificity, Benetton suppresses the history of these images and, in doing so, limits the range of meanings that might be brought into play. At stake here is a denial of how shifting contexts give an image different meanings. Of course, the de-politicization that is at work here is not innocent. By failing to rupture the dominant ideological codes (i.e., racism, colonialism, sexism) that structure what I call Benetton's use of hyperventilating realism (a realism of sensational-ism, shock, and spectacle), the ads simply register rather than challenge the dominant social relations reproduced in the photographs.

The viewer is afforded no sense of how the aesthetic of realism works to mask "the codes and structures which give photographs meaning as well as the historical contingencies (e.g., patriarchal structures which normalize notions of looking) which give such codes salience."[23] There is no sense here of how the operations of power inform the construction of social problems depicted in the Benetton ads, nor is there any recognition of the diverse struggles of resistance that attempt to challenge such problems. Within this aestheticization of politics, spectacle foregrounds our fascination with the hyper-real and positions the viewer within a visual moment that simply registers horror and shock without critically responding to it. Roland Barthes has referred to this form of representation as one that positions the viewer within the "immediacy of translation."[24] According to Barthes, this is a form of representational politics that functions as myth, because it abolishes the complexity of human acts, it gives them the simplicity of essences, it does away with all dialectics, with any going back beyond what is immediately visible, it organizes a world that is without contradictions because it is without depth, a world wide open and wallowing in the evident, it establishes a blissful clarity: things appear to mean something by themselves.[25]

Isolated from historical and social contexts, Benetton's images are stripped of their political possibilities and reduced to a spectacle of fascination, horror, and terror that appears primarily to privatize one's response to social events. That is, the form of address both reproduces dominant renderings of the image and translates the possibility of agency to the privatized act of buying goods rather than engaging forms of self and social determination. This process and its effects becomes clear in analyzing one of Benetton's more controversial ads, the Kirby photograph.

As I noted above, this image involves a double movement. On the one hand, it suppresses the diverse lifestyles, struggles, and realities of individuals in various stages of living with AIDS. In doing so, in the Kirby image it reinforces dominant representations of people with AIDS, reproducing what Douglas Crimp, in another context, refers to as "what we have already been told or shown about people with AIDS: that they are ravaged, disfigured, and debilitated by the syndrome (and that) they are generally ... desperate, but resigned to their in-

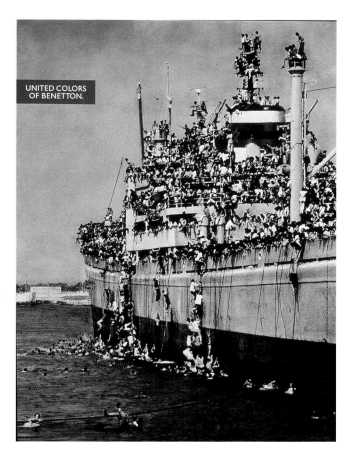

UNITED COLORS
OF BENETTON.

**7. Oliviero Toscani, Benetton campaign, Spring/Summer, 1992.
Photo: Benetton Group**

evitable deaths."[26] The appeal to an aesthetic of realism does little to disturb the social and ideological force of such inherited dominant representations. On the contrary, by not providing an analysis of representations of AIDS as a de facto death sentence, relying instead on the clichés enforced through dominant images and their social effects, the Benetton ad reproduces rather than challenges conventional representations that portray people with AIDS as helpless victims.

The politics at work in the Benetton photographs is also strikingly revealed in its use of photojournalistic images (see Fig. 7) that are decontextualized from any meaningful historical and social context, then recontextualized through the addition of the "United Colors of Benetton" logo. In the first instance, the logo produces a representational "zone of comfort," confirming a playfulness that allows the viewer to displace any ethical or political understanding of the images contained in the Benetton ads. The logo serves largely to position the audience within a combination of realism and amusement. Public truths revealed in Benetton's images, regardless of how horrifying or threatening, are offered "as a kind of joke in which the reader is invited to participate (the 'joke' is how low can we go?), but its potential dangers are also pretty clear: today aliens from Mars kidnap joggers, yesterday Auschwitz didn't happen, tomorrow who cares what happens."[27] Of course, the "joke" here is that anything is for sale and social commitment is just another gimmick for selling goods. In this type of representational politics, critical engagement is rendered ineffective by turning the photo and its political referent into an advertisement. If the possibility of social criticism is suggested by the ad this is quickly dispelled by the insertion of the logo, which suggests that any complicity between the viewer and the event it depicts is merely ironic. The image ultimately refers to nothing more than a safe space where the logic of the commodity and the marketplace mobilize consumers' desires rather than struggle over social injustices and conflicts. In the case of the image of the bloodstained clothes of the Croatian student, the use of the Benetton logo juxtaposes human suffering and promotional culture so as to invite the viewer to position him or herself between the playfulness of commodification and an image of apocalypse rendering social change either ironic or unimaginable. This serves less to situate a critical viewer who can mediate social reality and its attendant problems than to subordinate this viewer to the demands and aesthetic of commerce. Blood circulates in this image as part of an economy of spectacle and fear. Capitalizing upon an aesthetic of irony coupled with a logic of fear, Benetton's representations of blood and human suffering depoliticize and dehistoricize those very images it marks as part of the economy of the social and political.

> By reducing all social issues to matters of perception, it is on the perceptual level that social issues are addressed. Instead of social change, there is image change. Brief shows of flexibility at the surface mask intransigence at the core.[28]

In the second instance, recontextualization appeals to an indeterminacy, which suggests that such images can be negotiated by different individuals in multiple and varied ways. Hence, Benetton's claim that such photos generate diverse interpretations. While such an assumption rightly suggests that viewers always

mediate and rewrite images in ways that differ from particular ideologies and histories, when unqualified, it also overlooks how specific contexts privilege some readings over others. In other words, while individuals produce rather than merely receive meanings, the choices they make and the meanings they produce are not free-floating. Such meanings and mediations are, in part, formed within wider social and cultural determinations that propose a range of reading practices that are privileged within dominant and subordinate relations of power. The reading of any text cannot be understood independently of the historical and social experiences that construct how audiences interpret other texts. It is this notion of reading formation that is totally missing from Benetton's defense of its endless images of death, pain, danger, and shock. Tony Bennett is helpful on this issue.

> The concept of reading formation … is an attempt to think context as a set of discursive and inter-textual determinations, operating on material and institutional supports, which bear in upon a text not just externally, from the outside in, but internally, shaping it —in the historically concrete forms in which it is available as a text-to-be-read—from the inside out.[29]

Conclusion: Pedagogy and the need for critical public cultures

The new postmodern pedagogy of mass advertising poses a central challenge to the role cultural workers might play in deepening their politics through a broader understanding of how knowledge is produced, identities shaped, and values articulated as part of broader pedagogical practice that circulates within an economy of culture and power that exceeds traditional notions of how certain forms of agency are put into place. The struggle over meaning is no longer one that can be confined to programs in educational institutions and their curricula. Moreover, the struggle over identity can no longer be seriously considered outside the politics of representation and the new formations of consumption. Culture is increasingly constituted by commerce, and the penetration of commodity culture into every facet of daily life has become the major axis of relations of exchange through which corporations actively produce new, increasingly effective forms of address.

This is not to suggest that the politics of consumption in its various circuits of power constitutes an unadulterated form of domination. Such a view is often more monolithically defensive than dialectical and less interested in understanding the complex process by which people desire, choose, and act in everyday life than with shielding the guardians of high modernism, who have always despised popular culture for its vulgarity and association with the "masses."[30] What is at stake in the new intersection of commerce, advertising, and consumption is the very definition and survival of critical public cultures. I am referring here to those public spaces predicated on the multiplication of spheres of daily life where people can debate the meaning and consequences of public truths, inject a notion of moral responsibility into representational practices, and collectively struggle to change dominating relations of power. Central to my argument has been the assumption that these new forms of ad-

8. Oliviero Toscani, Benetton campaign (UNHCR), Fall/Winter, 1999/2000. Photo: Benetton Group

vertising and consumption do not deny politics, they simply reappropriate it. This is a politics that "actively creates one version of the social," one that exists in harmony with market ideologies and initiatives.[31] Such a politics offers no resistance to a version of the social as largely a "democracy of images," a public media extravaganza in which politics is defined largely through the "consuming of images."[32]

Artists and other cultural workers need to reformulate the concept of resistance usually associated with these forms of colonization. Such a formulation has to begin with an analysis of how a postmodern pedagogy works by problematizing the intersection of power and representation in an ever-expanding democratization of images and culture. Representations in the postmodern world reach deeply into daily life, contributing to the increasing fragmentation and decentering of individual and collective subjects. Not only are the old categories of race, gender, sexuality, age, and class increasingly rewritten in highly differentiating and often divisive terms, but the space of the social is further destabilized through niche marketing, which constructs identities around lifestyles, ethnicity, fashion, and a host of other commodified subjects. Central here is the issue of how power has become an important cultural and ideological form, particularly within the discourse of difference and popular culture. Cultural workers need a new map for registering and understanding how power works to inscribe desires and identities and create multiple points of antagonism and struggle. Also in serious need of consideration is the creation of a new kind of pedagogical politics and pedagogy, organized through guiding narratives that link global and local social contexts, provide new articulations for engaging popular culture within rather than outside new technologies and regimes of representation, and offer a moral language for expanding the struggle over democracy and citizenship to ever-widening spheres of daily life. Clearly, more is at issue here than understanding how representations work to construct their own systems of meaning, social organizations, and cultural identifications. Cultural workers need to take up the challenge of teaching ourselves, students, and others to acknowledge our and their complicity in the discourse and practice of consumerism while at the same time bringing the hope mobilized by such practices to a principled and persistent crisis. This is not to invoke a vulgar critique of the real pleasures of buying, nor to underestimate the diverse ways in which people negotiate the terrain of the market or reappropriate goods through oppositional practices. Rather these conditions require recognition of the political and pedagogical limits of consumerism, its often active involvement in creating new identities, and its ongoing assault on the notion of insurgent differences in a multicultural and multiracial democracy. Individual and collective agency is about more than buying goods, and social life in its most principled forms points beyond the logic of the market as a guiding principle. It is up to cultural workers and other progressive educators to address this challenge directly as part of a postmodern political and pedagogical challenge.

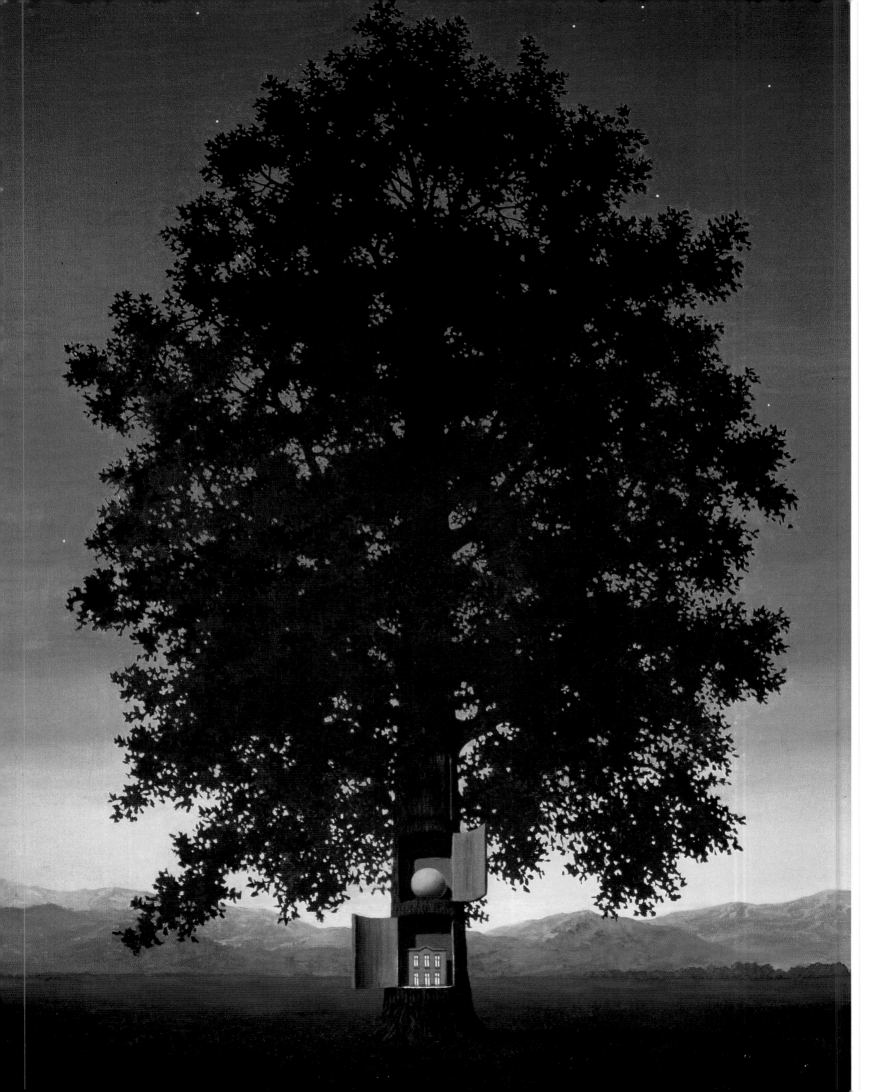

In the nineteenth century, the ways of science parted as blood and genetics came to be treated as separate issues—in contrast to the public understanding, whereby they became even more closely intertwined (see Annette Weber's essay "'Blood is a most particular fluid,'" pp. 157–73). At the beginning of that century, some scientists were already assuming that, important as blood is, there was no question of being a bearer of genetic information. Since the rediscovery of Gregor Mendel's work, the cell, genes, chromosomes, and ultimately DNA, have been proven to be responsible for determining everything from the color of our skin and eyes, to our predisposition to hypertension or to developing certain cancers.

On March 7, 1986, the American scientific journal *Science* published an article that addressed its readers at a time when they were still suffering from the shock of the catastrophe at Cape Canaveral. A few weeks earlier, the space shuttle Challenger had exploded seventy-three seconds after takeoff. All seven crew members died in the accident. Pieces of the wreck were still raining down from the sky into the Atlantic Ocean an hour later. The horrifying impact of the images seen telecast live profoundly shook the faith of humanity in scientific achievement. NASA had to stop its space program for two and a half years.

The World's Legacy is in Our Blood: A look at the first century of genetic research
Joachim Pietzsch

Only thirty-eight days later, in a prominent position in *Science*, Renato Dulbecco, cancer researcher and Nobel Prize laureate in 1975, proposed a scientific project that would be "in its significance comparable to that of the effort that led to the conquest of space"—to decipher the human genetic code. This alone could provide a turning point in cancer research, it was claimed. Dulbecco was not the first researcher to propose a human genome project of this kind. It had been under discussion in specialist circles since 1984, but had not landed on fertile ground with the officials and politicians in Washington until Dulbecco's appeal in 1986. Of course this had something to do with the fact that Dulbecco did cancer research, and that cancer, despite costly government programs, had proven far more resistant to research than space. "If we wish to learn more about cancer, we must now concentrate on the cellular genome," Dulbecco wrote. Such an enterprise should, of course, not be limited to one research team alone, but called for a national initiative. "Even more appealing would be to make it an international undertaking, because the sequence of the human DNA is the reality of our species, and everything that happens in the world depends on those sequences."

Dulbecco's appeal roused the American pioneer spirit. As early as December 1987, Congress approved an annual two hundred million dollars for a human genome project coordinated by the US Department of Energy and the National Institutes of Health and founded in 1988. By 1990 the International Human Genome Project had taken shape. Its objective was to decode the genetic material of the human race within the next fifteen years. Germany did not join the project until 1995.

1. René Magritte (1898–1967), *The Voice of Blood,* 1959, oil on canvas, Vienna, Museum Moderner Kunst Stiftung Ludwig. Photo: Dr. Parisin

When the first working draft reference DNA sequence of the human genome was presented on June 26, 2000, President Clinton spoke at a White House press conference of the "most wondrous map ever produced by humankind." He also mentioned the yet unfulfilled hope of conquering cancer. Thanks to sequencing the human genome perhaps "our children's children will know the term cancer only as a constellation of stars."

Cancer was proclaimed as the "disease of the century" on *Spiegel* magazine's cover in 1965. Genetic research is a product of the twentieth century. It took exactly one hundred years for genetics to be seen as the knowledge that will profoundly affect our future. In retrospect, the history of gaining this knowledge can be divided into four stages: the discovery that heredity is transmitted by distinct units, or genes; the discovery of the molecular structure of genes; the invention of techniques for working on genes; and the development of a survey of the entire human genetic information.

Deciding factors: The rediscovery of genetics in the twentieth century

In the spring of 1900 the reports of the German botanical society published three separate articles that revolved around the same subject: the discoveries made by Gregor Mendel, an Augustinian monk in Brno. Mendel had died in 1884 and he had already published the theory in question in 1865. No one had paid attention to his publication at the time for its contents were far beyond the intellectual horizon of his contemporaries. Only in the spring of 1900 did Carl Erich Correns, Erich von Tschermak, and Hugo de Vries discover Mendel's revolutionary importance for the study of heredity. The results of his crossbreeding experiments with peas in the garden of his monastery, which every schoolchild learns today, led him to a quantitative description of heredity, which had hitherto been ascribed to unidentified or even mysterious vital forces—among them, blood. According to Mendel, the inheritance of certain characteristics, such as color or form, was based on the transmission of factors that could be understood in material terms. These factors exist in pairs, but each parent passes on only one of them, so that the dominance of one of these factors determines which characteristics are pronounced in their descendants. To Mendel's contemporaries these factors belonged to the realm of an abstract imagination, for no one had been able to describe or even see them. Only improved methods of microscopy made many biologists realize that the site of heredity must be in the nucleus of each cell—in structures called chromosomes because of their ability to absorb color. Genetics became increasingly accessible to biological description. The rediscovery of Mendel in 1900 fanned a burning interest in genetic research. The theory of chromosomes was formulated as early as 1903 by Walter Sutton and Theodor Boveri. About 1910 in New York, in the famous fly lab at Columbia University, Thomas Morgan and coworkers located factors in the chromosomes of the *Drosophila* fruit fly that were responsible for the inheritance of such characteristics as wing shape and eye color.

The word "gene" was coined by the Danish biologist Wilhelm Johannsen. It replaces Mendel's "factor" as the unit responsible for hereditary characteristics and lends it a certain thrill. The fascination of genetic research has a lot to do with the suggestive terseness of this term. In its one-syllable form it seems stable,

2. Model of the double helix structure of the DNA (Deoxyribonucleic acid) molecule. Photo: Aventis

robust, self-contained, and, like the atom, impossible to split. On the other hand, its definition suggests something open, something of the mystery of genesis in combination with a vital force attracted to light. Unlike most other scientific terms, the word "gene" encompasses the fundamental preconditions of our existence, the dialectics of being and becoming.

The gene soon captivated the public. It was experienced by Hans Castorp, lying wrapped in warm blankets on the balcony of his sanatorium in Davos on clear moonlit nights in the winter of 1907, studying the essence of nature with the help of all kinds of textbooks. During these nights Hans Castorp also paid his respects to the genes. He was amazed at the thought of the existence of "elementary units of life whose size was far smaller than what was visible under a microscope, which grew spontaneously, spontaneously according to the law that each can only bring forth its own kind, which multiplied and, according to the principle of the division of labor, together served the next higher order of living beings. These were the genes, the bioblasts, the biophores—Hans Castorp was pleased to get to know them by name on that frosty night."

When Thomas Mann wrote this passage in the "Research" chapter of his novel *The Magic Mountain* about fifteen years later, the question of the material correlative of a gene, of the molecule that makes heredity possible, was just as unanswered as in 1907. While physics and chemistry were changing the world and the new science of biochemistry was able to explain more and more metabolic processes, genetic research seemed cut off from such progress. It lacked an approach. How could one have found out how genes are built up and what enables them to store the characteristics of life and pass them on?

It seemed as though reality wanted to agree forever with the assumption made by Hans Castorp during his reading: "He searched thoroughly, he read, while the moon made its measured progress above the crystalline sparkling alpine valley, about organized matter, he read with an urgent concern about life and its sacred-impure secret.

What is life? One did not know."

Used genes: Discovering the grammar of biology

It was only in 1943, one of the darkest years of the century, that people began to understand more about the secret of life that is called heredity. That year two men who had never heard of each other broke the spell that nature had cast around the secret of the gene. One lived in Dublin and provided a metaphor. The other did research in New York and found the material correlative for it.

The physicist Erwin Schroedinger, distinguished in 1933 for his contributions to quantum mechanics with the Nobel Prize, who had emigrated from Germany that same year, gave a lecture on "What is life?" at the Dublin Institute for Advanced Studies in February 1943. Biological systems, said Schroedinger, evidently followed completely different rules from inanimate nature.

All the laws of physics were based on statistical principles with whose help they create order from disorder. Beyond these laws the physicist sees only the aimless, utterly disordered thermal movement of atoms. Its consequences are formulated in the second law of thermodynamics: in closed systems no process can increase a system's order. Its entropy, a measure of the disorder of a system, increases steadily. The secret of life, on the other hand, seemed

to be based on a different ordering principle, altogether foreign to physicists. Here a small group of atoms inside the chromosomes brought about orderly processes that were perfectly attuned to each other and the environment. Here order was created from order. While every process in nature meant an increase in entropy, life as an open system drew its vitality from a movement counter to decaying into a state of overheated randomness, by permanently drawing order from its disorderly environment. Life actually fed on negative entropy.

The control panel of this order lay in the nucleus of the cell. But how could chromosomes manage to create order? Here came Schroedinger's decisive statement: "Since we know the power this tiny central office has in the isolated cell, do they not resemble stations of local government dispersed through the body, communicating with each other with great ease, thanks to the code that is common to all of them?"

Schroedinger was aware of how daring this metaphor was and said: "Well, this is a fantastic description, perhaps less becoming a scientist than a poet." Seeing genetic information as a readable text opened up the possibility of understanding both the stability and the variability of life at the same time, in the same way that a number of letters can be used according to certain rules to write an incredible number of books. What a breakthrough this metaphor of Schroedinger's was shows in how we take it for granted nowadays, just like the yeast in a cake that we enjoy eating without thinking about its origins. Schroedinger's lecture, published as a book in 1944, had an enormous effect on the next generation of geneticists. Francis Crick, a physicist himself, after he and James Watson explained the structure of the DNA (see Figs. 2 and 3), expressly credited the influence of Schroedinger's ideas on his work. Of course this influence could only have become so powerful because Oswald Avery had succeeded that same year (1943) in identifying the molecule that stored the text on genetic information.

Avery was a bacteriologist at the Rockefeller Institute Hospital in New York City. In the early 1940s he had begun to concentrate on the phenomenon of transformation among pneumococcus bacteria. This phenomenon had first been described fifteen years earlier by the English researcher Fred Griffith. Infectious agents of pneumonia were found to be able to transfer their *pathogenicity* (ability to cause disease) onto harmless pneumococcus bacteria. What caused this transformation of a harmless bacterium into a dangerous one had remained vague throughout the 1920s. Not until the development of new preparation techniques and chemical analysis procedures could Avery succeed in finding the transforming principle. He isolated the biologically active, unknown substance from pneumococcus cultures and mixed it with proteolytic and lipolytic enzymes (which normally break down proteins), which were found not to affect its activity. Hence the transforming principle contained neither protein nor fat. Even ribonucleases could not deactivate the substance. Nor could the unknown substance be a carbohydrate, for it broke down in 90-percent alcohol into thin fibers that wrapped themselves around the mixer like thread around a spool. Finally the only candidate left was DNA—Deoxyribonucleic Acid. "Who could have guessed it?" Avery wrote in amazement to his brother Roy. Even Schroedinger could only imagine the carrier of genetic information to be at the most a protein with its wide range of variability—and now DNA, a simple nucleic acid, was supposed to be the stuff that genes are made of? Such a boring molecule? When Avery and

3. The discoverers of the structure of DNA, James Watson and Francis Crick, in their laboratory

his coworkers published their findings in the *Journal of Experimental Medicine*, in 1944, the gates to deciphering the script that Schroedinger had talked about had been thrown open. For Erwin Chargaff, whose research on the bases of the DNA prepared the way for the disclosures of Crick and Watson, Avery's discovery came close to a revelation: "I saw before me the vague outlines of the beginnings of a grammar of biology."

Striding through the gates that Schroedinger, Avery, and Chargaff had pushed open, Watson and Crick discovered the double helix structure of the DNA in 1953, an epoch-making breakthrough, which they published in fewer than one thousand words in the scientific journal *Nature*. The DNA is like a twisted rope ladder whose rungs consist of two bases each. There are four different bases in the DNA, of which two each, abbreviated as A and T and C and G, fit together like teeth in a zipper. It had not escaped their notice, as Watson and Crick put it modestly, that the specific pairing of bases suggested a possible copying mechanism for genetic material. This sentence contained the actual sensation: the function of the DNA determines its form. The major features of this function, evolving from the script stored in the DNA, were explained in the twelve years to follow. Each cell of an organism, whether in the skin, heart, or hip joint, is equipped with the same genetic information. What is decisive for the function of a cell is which genes are active or not. If a gene is active, the DNA zipper opens, a strand is copied and sent as a messenger to the construction site for the proteins outside the nucleus. Three bases then encode for one amino acid each. These, in turn, assemble to form proteins. From the special features and the interaction of these proteins, in the shape of messenger substances, enzymes, receptors, or supportive structures in connective tissue and cellular membranes, all life on this earth is developed and sustained.

Crossing the frontier: The microbiology of cut and paste

Yet what was the use of knowing the structure of the DNA if there was hardly anything that could be done with this sluggish molecule in the lab? Even up to the end of the 1960s biochemists considered the DNA, with its monotonous strands made of sugar and phosphate and always the same base pairs in between, one of the most unapproachable of chemical structures. They now knew that a gene was nothing but a part of the DNA and that its series of bases contained the blueprint for a certain protein. But how should the sequence of the letters standing for the bases of these genes be tracked down? While the DNA could be broken up with mechanical force, how could one gene among the hundreds of thousands of fragments be found and cleaned up?

Bacteria and viruses turned out to provide mankind with the key to solving this problem. Studying viruses that attack only bacteria had shown that bacteria could make these attackers powerless by using special molecular "scissors." These are the restriction enzymes, over one hundred of which have been identified by now, which cut the virus DNA up into small pieces, not arbitrarily but in places precisely specified for every single one of these enzymes. Parallel to the discovery of these molecular "scissors," antibiotics research had produced another disclosure: bacteria can instruct each other how to defend themselves against antibiotic medicines and become resistant by exchanging small ring-shaped pieces of DNA, the so-called plasmids.

4. Kevin Clarke (b. 1953), *Portrait of James D. Watson*, 1998–99, archive color print under acrylic, New York, artist's collection

In the autumn of 1969, thirty-three-year-old Herbert Boyer started working on the restriction enzymes of *E. coli* bacteria in his lab at the University of California in San Francisco (UCSF). He was unaware of the existence of Stanley Cohen, who was brooding in his lab at nearby Stanford University over how *E. coli* bacteria exchange genetic information. Not until November 1972 did the two researchers meet in Hawaii. At a scientific meeting, Cohen reported on the possibility of reproducing ring-shaped plasmids. Boyer's lecture followed later. He reported that he had been able to cut up the DNA with the EcoR1 restriction enzyme such that it could be recombined with other parts of the DNA in a defined order. Cohen was fascinated. What if they collaborated? The two of them sat around at night with their colleagues over corned beef sandwiches and beer in a pub on Waikiki Beach and gave their imaginations free rein. They agreed to give it a try. As soon as they were back in California they put their idea into practice. Plasmids were isolated from bacteria in Stanford and shipped to UCSF. There they were cut up with EcoR1, analyzed, and brought back to Stanford, where pieces of foreign DNA were attached to the plasmid at the incisions and the plasmid replanted into a bacterium. Of course it took a while before everything worked, but by March 1973 Boyer and Cohen were able to demonstrate that genes could be transplanted. This was the birth of genetic engineering. At first it inspired more fears than hopes. Many people thought that interfering with the substance of creation and modifying it was like a second and ultimate version of the Fall—once again Man was tasting the fruit of forbidden knowledge. In any case, it was a huge step across a frontier. More than about the metaphysical issue the participating researchers in particular felt apprehensive about the completely practical question of security. After all, genetic engineering was based on altering bacteria that were already cause for

5. DNA sequence

concern in their unaltered state. What would happen if bacteria turned into dangerous killers unexpectedly through genetic engineering? Or if modified organisms were unintentionally set free and caused an irremediable ecological imbalance? These concerns were not easy to dispel. The geneticists themselves discussed the risks of their discipline when they invited experts and journalists to a security conference in Asilomar, California, in February 1975. Guidelines for handling genetic engineering were subsequently developed, which were enacted as mandatory by American health authorities.

Even in Cambridge, Massachusetts, one of the world centers of innovation as the home of Harvard University and the Massachusetts Institute of Technology, the fear of genetically modified bacteria was so great that Cambridge city council yielded to citizen pressure in 1976 by prohibiting genetic engineering in the municipality temporarily. For nine months no researcher was allowed to touch a gene, for nine months the genetics labs stood still—until, after countless discussions, it was agreed under what conditions and with what security standards genetic engineering could continue. Thus a fierce solution-oriented debate quickly led to a pragmatic consensus. In Germany, however, the discourse on genetic engineering was often tortuous. It began in the 1980s and did not come to an acceptable conclusion for everyone concerned until the law on genetic engineering was amended in 1993.

Genetic engineering opened up undreamed of possibilities for both medical practice and research. It could help develop medicines that had been produced in the past only with great difficulty or not at all. This applies to therapeutic proteins, i.e., endogenous proteins that have essential key functions in our bodies but cannot be synthesized easily. Some of them could be extracted even without genetic engineering in limited amounts from natural substrates, such as the pancreases of pigs for insulin to treat diabetes, or the pituitary glands of corpses for the growth hormone somatotropin to treat dwarfism. These proteins can now be manufactured by genetic engineering in any amount by implanting their genetic blueprint into a bacterium or other microorganism, which then takes over the production of the protein in question. By the same method, other proteins that occur naturally only in tiny amounts could be made available in the first place. These include the interferons, which activate specific cells in the immune system, and erythropoietin, which increases the formation of blood cells.

Genetic engineering also permitted the manufacture of proteins for research purposes. Take receptors, for example. These are the intricately spiraling proteins incorporated like receiving stations in cell membranes in order to receive extracellular signals and transmit them to the cell interior. Receptors are target molecules for many medicines because blocking or stimulating them chemically interferes very effectively with pathophysiological processes. Receptor screening can therefore be used to test promising new active substances. If a substance binds to a receptor or even influences it, it is proven to be effective. However, receptors cannot be synthesized. Producing them specifically for screening new active substances could be accomplished only by genetic engineering.

Now that genetic engineering has expanded biomedical potential, genome research, which could not have been possible methodologically without genetic engineering, has arrived on the scene to lay a new foundation for medicine. At its best, it could help us understand the causes of disease and health.

6. Kevin Clarke (b. 1953), *Portrait of Professor Wilhelm Fresenius,* **archive color print under acrylic, New York, artist's collection**

The Genome Project: Entering the library of life

The staging was impressive and was a bit like the entry of the gods into Valhalla. Pompous and with well-intoned chords, with a bit of sounding brass thrown in. But moving nonetheless. On July 26, 2000, five press conferences were called across the globe to introduce the first working draft reference DNA sequence of human genetic material. "Today, we are learning the language in which God created life," said Bill Clinton at the main press conference on June 26, 2000, in the White House. Joining in by satellite, his colleague in Downing Street, Tony Blair, spoke of a "breakthrough that opens the way for massive advances in the treatment of cancer and hereditary diseases."

Their patronage gave the two powerful leaders an opportunity to bask in the prestige of a great event. They deserved it, after all, insofar as this event could not have taken place without the considerable pressure they had exerted. What had happened was that the International Human Genome Project, officially begun on October 1, 1990, and ultimately occupying twenty research centers in six countries, had got competition back in 1992. Craig Venter, researching for the National Institutes of Health at the time, had become a renegade and founded TIGR, The Institute for Genomic Research, where he was able to sequence the first bacterial genome, in 1995. Venter had then founded his own company, Celera, in 1998 and predicted that the human genome would be decoded within the next three years by using a faster procedure than the public-sector Human Genome Project. While the publicly funded researchers had committed themselves to making their findings accessible to the general public

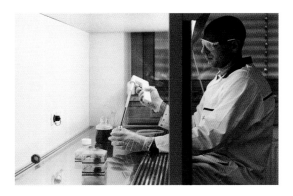

7. Working with cell cultures, Markus Gassmann, Aventis-Martinsried, Genomics Center.
Photo: © Hermann Dornhege, Bad Tölz

8. Working in ultraviolet light, Ulrike Sievers, Aventis-Martinsried, Genomics Center. Photo: © Hermann Dornhege, Bad Tölz

9. Preparation of samples, Aventis-Evry. Photo: © Hermann Dornhege, Bad Tölz

on the Internet within a period of 24 hours, Venter as a private businessman had always insisted on the exclusiveness of his data and declared their profitable commercialization as Celera's aim. There was fierce discussion on whom the sum of genetic information should belong to. Should it belong to all mankind because it is their common heritage, or to private-sector enterprises because they had invested in deciphering it. In March 2000 even Clinton and Blair got involved in the debate and demanded that sequencing data be accessible to the general public while only technical data should be safeguarded by patent law.

Venter took the rebuff lightly, seeing as how he enjoyed the role of the much admired and much scolded hero. He was a challenger, but the Human Genome Project had picked up the challenge. Without Venter's energy the Human Genome Project would not have come to a conclusion that quickly. Without the continually published findings of the Human Genome Project, however, Venter's energy would have gone nowhere.

Apparently reconciled under the cloak of world politics, the two competitors now presented a jointly approved draft sequence of the human genome. "We have developed a map of overlapping fragments that includes 97 percent of the human genome, and we have sequenced 85 percent of this," said Francis Collins, the head of the Human Genome Project. He thereby announced an achievement that none of the initiators of the Human Genome Project would have foreseen as being that rapid. No wonder, for in the mid–1980s the best labs in the world could identify only five hundred bases per day at the most. Fifteen years later automatic sequencers could sequence one thousand bases per second. Increased computer capacity and speed, and above all the invention of the Worldwide Web, were major contributors to accelerating the Human Genome Project. Without the convergence of biotechnology and information technology, and without the Internet in particular, the sequencing of human genetic material could hardly have been realized.

Sequencing means recording the sequence of the about three billion bases in human DNA, which is divided among twenty-three chromosomes in the nucleus of every cell. That is, writing down a text consisting of only four letters, whose total length would fill about three thousand books with five hundred pages each, a library that contains all the blueprints on which our life is based. However, these blueprints cover only seven pages in each of these books—only about 1.5 percent of human genetic material is genes. Most of the rest is still a vague molecular murmur. In this respect the library of life is like Jorge Luis Borges' "Library of Babel": "For every sensible line of straightforward statement, there are leagues of senseless cacophonies, verbal jumbles and incoherence."

The significant sequences are just as hard to understand and to differentiate from the meaningless ones as the alphabet of a foreign language that has never been heard. Only when these sequences can be accorded meaning, when words and sentences can be distilled from the confused sequence of letters, only when functional genomic research can produce an exegesis of all genetic material, will we know what our genome really has to say to us.

We already know some of it now: researchers can attribute certain functions to certain genes and make use of the relationship between blueprint and protein to develop so-called targets for new medicines. Targets are endogenous target molecules, usually receptors or enzymes, which have a causal or indirect

**10. Preparation of samples, Yves Vanbien, Aventis-Evry.
Photo: © Hermann Dornhege, Bad Tölz**

relation to a disease. They are like doors that lead to a certain disease. If the correct key is made for them the disease can be treated or even cured. Such targets can for instance be tracked down by comparing healthy and diseased cells of an organism in terms of their genetic expression. If different genes are active or inactive in a diseased cell as opposed to a healthy one, the difference may reveal genes that are causally related to the disease. The protein that represents the blueprint of this gene is then profiled as a target, and a substance must be developed to inhibit this protein. This method, known as differential display, is very complicated and expensive. But it can be worthwhile. Finding a key to a door is still easier than finding a door for a key. In fact, pharmaceutical research usually used to start out with keys, i.e., substances for which to find a use. Genetic research permits a much more rational procedure. In this respect it has already turned pharmaceutical research upside down.

But why decode the entire genome if comparing genetic expression could also lead to the discovery of a cure for cancer? And if even without knowing the entire genome, research has already identified many genes that are closely related to the disease?

Because people are not satisfied with knowing two cities and one street when they want to explore a newly discovered country and make a map of it. Because big news can come from the forests and villages too. Because only continuous topography makes hastily visited virgin territory into a new country that can be lived in, built on, and made fertile. The genome, the sum of our genetic material, is this kind of virgin territory that needs to be studied fully and properly. Its discovery has just begun.

To be continued: Beyond the horizon of discovery

The view from the top of a mountain is often especially beautiful when it does not range over wide valleys but extends to the series of peaks of a higher massif towering in a bluish shimmer behind the mountain just climbed. Even someone who had hoped to obtain exact information on the topography of the valleys can appreciate such beauty. The panorama of the human genome is much more complex and complicated than expected, considering the earliest thorough analyses of the human genome published in the scientific journals *Nature* and *Science* in mid-February 2001. Instead of plain answers and conclusive causalities our genome presents new questions and an additional dimension of complexity.

We humans have only about 30,000 genes in our genome, far fewer than expected and only just twice as many as that of the *Drosophila* fruit fly. However, these genes do not contain fixed blueprints for merely one protein—most of these genes code for several proteins, in many cases for more than ten. "The assumption that a gene causes a disease or produces a key protein is settled to everyone's satisfaction," commented Craig Venter on this finding. Accordingly, what makes us humans into humans and what differentiates us from the animals is not a larger amount of information stored in our genome but a superior ability to process this limited amount of information in various and flexible ways. Not the hardware but the software is what we are all about. The almost 250,000 different proteins that develop from our multicoded genes are more important than we thought. This proteome balances our genetic load with the demands

**11. Mutations under observation, Wilson Dos Santos,
Aventis-Evry. Photo: © Hermann Dornhege, Bad Tölz**

of daily life. Genetic disposition and environmental exposure are constantly balancing each other in a delicate interplay, whereby the genetic side probably carries less weight than expected.

Our blood, whose cells are the most easily accessible for genetic research, thus has a lighter, less burdensome legacy than it had always been assumed. In fact, a person's freedom to convert his or her genetic heritage is probably greater than we thought. Furthermore, the discoveries of the Human Genome Project set us free from the obsessive notion that people have different and unequal racial characteristics in their blood. Conclusive findings prove that our genome has no gene for race. Of the three billion letters in the human genome, 99.9 percent are the same in all human beings. The tiny remainder responsible for the differences between us often differs more between two people who are apparently similar and from the same culture group than between two people who look different and come from opposite ends of the world. In addition, the Human Genome Project suggests hidden depths: the long stretches of repetitive sequences and apparently insignificant "junk DNA" play a major role in evolution and in the individual development of genetic material, though it is still unclear which.

The chances of discovering etiological agents to fight cancer, i.e., drugs that affect the cause of disease, have increased thanks to human genome sequencing. As cancer is based on mutations in certain genes, it is a genetic disease. Its pathological pattern will be easier to understand and rectify on the basis of the complete genetic map of humanity. Even pharmaceutical research as a whole will find data provided by the Human Genome Project an incentive —though in view of newly discovered complexities many a dream will take considerably longer to come true than hoped.

All in all, the analysis of the first draft sequence of the human genome is cause for humility. The perspective that our genome opens up is breathtaking. This is how the astronauts must have felt when they saw the blue beauty of the earth shining against the dark foil of the universe for the first time. It is true this perspective of genome research is based on reductionist principles, reflecting a scientific stance that reduces the whole to its component parts in order to explain it. This attitude is naturally a long way from a comprehensive understanding. We must not forget that the final, as yet outstanding, result of the Human Genome Project will be a one-dimensional sequence of letters standing for bases. The proteins encoding from these genes, however, develop three-dimensionally—even four-dimensionally, to be precise, because evolving in time is important for their function. On the basis of a one-dimensional gene sequence we cannot predict how proteins twist three-dimensionally. Not to mention how life can read lifeless DNA molecules and structure itself autonomously, nor how an embryo can develop from two cells and turn into a person, nor how consciousness comes about. Now that we have the matrix of the human genome in our hands, we know just as little about what life is and what makes us people, or how to derive a holistic worldview from reductionist limitations, as Hans Castorp did on his Davos balcony in the days of yore. The authors of the Human Genome Project realize this, too. They ended their leading article in *Nature* on February 15, 2001, with an allusion to the famous understatement of Watson and Crick: "Finally, it has not escaped our notice that the more we learn about the human genome, the more there is to explore." The authors then quote the well-known verse from

12. Kevin Clarke (b. 1953), *Portrait of Nam Jun Paik*, 1998/99, archive color print under acrylic, Frankfurt am Main, DG-Bank Collection

13. Kevin Clarke (b. 1953), *Portrait of Nam June Paik*, Frankfurt am Main, DG-Bank Collection

the *Fourth Quartet* by T.S. Eliot: "We shall not cease from exploration. And the end of all our exploring will be to arrive where we started, and know the place for the first time."

Hence we remain explorers. We are still far from having sailed all around all realms. Our human genome is not giving away the secret of creation. Its alphabet is forcing us to make sure where we stand. It will increasingly challenge rather than confirm our claim to the crown of creation. As any great work of literature does, the library of life will change us forever. "He who has read Kafka's *Metamorphosis* and can look into his mirror unflinching may technically be able to read print but is illiterate in the only sense that matters," George Steiner points out. Similarly, the decoded genome invites us to proceed with the courage to face change. Onward to the roots. Along a road that may go round in circles, as in the quote from T.S. Eliot or in Heinrich von Kleist's puppet theater. We may remain curious. As long as we are alive we will feel the pain of this curiosity. In the words of Gottfried Benn, a German contemporary of T.S. Eliot:

> Every hour,
> in every word,
> the wound of creation
> bleeds on forever.

Appendix

Notes

Christian Holtorf

1 Ute Grümbel, *Abendmahl: "Für Euch gegeben?" Erfahrungen und Ansichten von Frauen und Männern: Anfragen an Theologie und Kirche* (Stuttgart, 1997), here p. 301.

2 Ibid., p. 239.

3 Ibid., p. 210.

4 Ibid., p. 155; see also Jutta Voss, *Das Schwarzmond-Tabu: Die kulturelle Bedeutung des weiblichen Zyklus*, 2nd ed. (Stuttgart, 1990).

5 Friedrich Nietzsche, *Also sprach Zarathustra*, KSA 4 (Munich, 1999), p. 48.

6 C.G. Jung, "Das Wandlungssymbol in der Messe," in *Psychologie und Religion* (Olten, 1971), pp. 163–267, here p. 169.

7 See, for example, Eph. 5:2; Gal. 1:4; Heb. 7–10.

8 Hermann Nitsch, *Zur Theorie des Orgien Mysterien Theaters: Zweiter Versuch* (Salzburg and Vienna, 1995), p. 44.

9 Matt. 26:26–28, similarly in Mark. Luke makes the final element more precise by saying: "This cup which is poured out for you is the new covenant in my blood" (Luke 22:20).

10 Jung, op.cit., pp. 163–267, here p. 225.

11 Arnold van Gennep, *Übergangsriten* (Frankfurt am Main and New York, 1986), p. 182.

12 Translated from Jan Kott, *Gott-Essen: Interpretationen griechischer Tragödien* (Berlin, 1991), p. 209.

13 Ivan Illich, *H₂O und die Wasser des Vergessens* (Reinbek, 1987), pp. 71ff.

14 Georg Wieland, "Fleisch wie es der Kunde wünscht" (Munich, ca. 1972), pp. 116ff.

15 Information from Douglas Starr, *Blut* (Munich, 1999).

16 Grümbel, op.cit., p. 157.

17 Gerburg Treusch-Dieter, "Blutsbande, Nachdenken über Flüssiges und Festes," in Regina Nössler and Petra Flocke, eds., *Blut*, Konkursbuch 33 (Tübingen, 1997), pp. 73–86, here p. 73.

18 "There, where women are dying, I am wide awake."

19 Nitsch, op.cit., pp. 31f.

20 Ibid., p. 949.

21 Without the ideas on blood of Frank Hiddemann (Weimar), Godehard Janzing (Berlin), Karl-Heinz Koinegg (Basel), and Stefan Kühne (Vienna) and without the conference "Blood" at the Evangelische Akademie Thüringen in November 1999 this essay could not have been written. To them I wish to extend my heartfelt thanks.

Mino Gabriele

1 *Od.*, X, 524ff.; XI, 34ff.; on motifs in the ancient world, see A. Bouché-Leclercq, *Histoire de la divination dans l'antiquité* (Paris, 1880), vol. I, pp. 332ff.; vol. III, pp. 372ff.; F. Cumont, *Lux perpetua* (Paris, 1949), pp. 30ff., 98ff., 293, 371; C. Zintzen, in *Der Kleine Pauly*, s.v. *Mantik*, 3 vols. (Munich, 1975), col. 972.; L. Fahz, *De poetarum Romanorum doctrina magica quaestiones selectae* remains essential reading (Gieszen, 1904), pp. 110–21.

2 534ff.; there is a famous necromancy scene in *The Persians* by Aeschylus (607–92; see S. Eitrem, "The Necromancy in the Persai of Aischylos," *Symbolae Osloenses* 6 [1928], pp. 1–16), in which the widow of Darius invokes the shade of her husband with libations (milk, honey, water, wine, olives, flowers): in this case, however, the ritual does not include a blood sacrifice.

3 *Aen.*, VI, 248ff.; see E. Norden, *P. Vergilus Maro Aeneis Buch VI* (Leipzig, 1934), pp. 198ff.; R.J. Clark, *Catabasis: Vergil and the Wisdom-tradition* (Amsterdam, 1979), pp. 37ff., 77ff.

4 *Civ. Dei*, VII, 35: "Varro … adhibito sanguine etiam inferos perhibet sciscitari et nekuomanteian Graece dicit vocari, … ubi videntur mortui divinare" (English translation by W.M. Green [London, 1963], pp. 499–503); see B. Cardanus, *M. Terentius Varro Antiquitates rerum divinarum*, Parts I–II (Wiesbaden, 1976), p. 36.

5 *Od.*, X, 513–15; XI, 24ff.

6 From Apollonius Rhodius (III, 1032: but here the trench is round) to Valerius Flaccus (I, 735), from Horatius Flaccus (*Sat.*, I, 8, 28) to Ovid (*Met.*, VII, 245), from Seneca (*Oed.*, 550, 56465, Fig. 6) to Statius (*Theb.*, 451–52), Silius Italicus, XIII, 427, and Elio Aristides, XLVIII, 27; see A.-M. Tupet, *La Magie dans la poésie latine* (Paris, 1976), pp. 372–73.

7 On erotic magic, see Propertius, III, 6, 25–30; IV, 5, 5–18 (consuluitque striges nostro de sanguine); see Fahz, op.cit., pp. 122ff.; Tupet, op.cit., pp. 348ff.

8 Seneca, *Med.*, 771ff.

9 Apollonius Rhodius, IV, 704ff.

10 Ovid, *Met.*, XIV, 408.

11 Virgil, *Aen.*, IV, 621: "Haec precor, hanc vocem extremam cum sanguine fundo"; Servius, *ad. loc.*: "Cum sanguine fundo: quasi imprecationes ipsas suo consecraret cruore." See Tupet, op.cit., pp. 254–57.

12 *Met.*, IV, 500–505.

13 *Phars.*, VI, 480ff.

14 *Aen.*, VI, 232ff.

15 On the Persian and Egyptian precedents, see T. Hopfner, *Griechisch-Ägyptischer Offenbarungszauber* (Leipzig, 1921), p. 208, § 799; S. Eitrem, "Varia," *Symbolae Osloenses* 32 (1957): 110–11.

16 *Sat.* I, 8, 2529 (English translation by H. Rushton Fairclough [London, 1970], p. 99). For an analysis of the passage and for other parallel passages, see S. Sergio Ingallina, *Orazio e la magia* (Palermo, 1974), pp. 95ff.

17 507ff.; Fahz, op.cit., pp. 147ff.; Tupet., op.cit., pp. 13ff., 64ff., 70ff.; for other references, see *Arcana mundi*, ed. G. Luck (Milan, 1997), vol. I, pp. 574–81.

18 Once again Isidore (*Etym.*, VIII, 9, 9) points out that, in necromancy, in order to evoke the dead it was customary to infuse the corpse with blood.

19 750ff.: "Protinus astrictus caluit cruor atraque fovit // vulnera et in venas extremaque membra cucurrit…." (English translation by J.D. Duff [London, 1957], p. 359).

20 *Hist. nat.*, XXVIII, 2: "Sanguinem quoque gladiatorum bibunt, ut viventibus poculis, comitiales morbi, quod spectare facientes in eadem harena feras quoque horror est … illi ex homine ipso sorbere efficacissimum putant calidum spirantemque et vivam ipsam animam ex osculo vulnerum."

21 See Aulus Cornelius Celsus, *Med.*, III, 23, 7; Scribonius Largus, only one work exists by this author 17; Tertullianus, *Apol.*, 9, 10.

22 See E. Rohde, *Psiche* (Bari, 1914–16), vol. I, pp. 51ff.

23 *Od.*, XI, 153–54, 390. See also R. Laurenti, "Il sangue come strumento di conoscenza nella filosofia presocratica," in *Sangue*

e antropologia nella letteratura cristiana, ed. F. Vattioni (Rome, 1982), vol. I, pp. 171–98; R.B. Onians, Le origini del pensiero europeo (Milan, 1998), pp. 72–74, 85–88, 147ff.

24 See J. Bollak, Empédocle (Paris, 1965–69), vol. I, pp. 240ff.; vol. III, pp. 342ff., 427–60; Empedocles, Poema fisico e lustrale, ed. C. Gallavotti (Milan, 1975), pp. 12–13.

25 P. Manuli and M. Vegetti, Cuore, sangue e cervello: Biologia e antropologia nel pensiero antico (Milan, 1977), pp. 55ff.

26 Probably lived in the fifth century AD; for information on his life and his work, see Introduction in Orapollo, I geroglifici, introduction, trans, and annot. M.A. Rigoni and E. Zanco (Milan, 1996).

27 The equivalences are correct: see Sbordone, op.cit., pp. 14–15.

28 I have translated from Horapollon's Hieroglyphica, intro. and comm. F. Sbordone (Naples, 1940), pp. 14–16.

29 Certain motifs were taken up again in the major treatises on symbols written in the sixteenth century, such as the works of Pierio Valeriano, Hieroglyphica (Lyons, 1602; 1st ed. 1556), pp. 212–14, 567–68 (Fig. 7); and Antonio Ricciardi, Commentaria Symbolica (Venice, 1591), p. 184 (Fig. 8).

30 See Sbordone's commentary, op.cit.; also worthy of note is that in Horapollon's Hieroglyphica, ed. C. Leemans (Amsterdam, 1835), pp.151–54. A. Piankoff, Le Cœur dans les textes égyptiens depuis l'Ancien jusqu'à la fin du Nouvel Empire (Paris, 1930), pp. 1–13.

31 For analogy with Greek Pneumatology, see R.B. Onians, op.cit., pp. 69ff., 121ff.

32 See H. Bonnet, Reallexikon der Ägyptischen Religionsgeschichte (Berlin, 1952), pp. 121–22, 296–97.

33 See C. Blum, Studies in the Dream-book of Artemidorus (Uppsala, 1936), pp. 52ff.

34 See the Introduction to Artemidorus, Il libro dei sogni, ed. D. del Corno (Milan, 1975), pp. XLVI–XLVIII.

35 I, 37; V, 58.

36 V, 6.

37 See Il., XIV, 434; XXI, 2.

38 First published in Venice in 1508, this work was then issued again with "supplements," in the

Basel edition of 1552, by the Alsatian scholar Corrado Licostene (Corrado Wolffhart). Still of great value is the learned apparatus criticus and notes in Valerius Maximus, De dictis factisque memorabilibus, et Jul. Obsequens), De prodigiis, cum supplementis Conradi Lycosthenis, rec. Car. Benedictus Hase (Paris, 1822–23), vol. II.2, pp. 1–207.

39 Ibid., chapters 71; 83; 86; 101; 103; 104; 112; 113; 129.

Giuseppe Orefici

1 See Richard E.W. Adams, ed., The Origin of Maya Civilization (Albuquerque, NM: University of New Mexico Press, 1966); Michael D. Coe, The Maya (New York: Praeger, 1967); Robert J. Scharer, The Ancient Maya. 5th ed. (Stanford, CA: Stanford University Press, 1994); and Peter Schmidt, Mercedes de la Garza, and Enrique Nalda, eds., I Maya, exh. cat. (Milan: Bompiani-CNCA INAH, 1998).

2 See Ralph L. Roys, Political Geography of the Yucatan Maya (Washington, DC: Carnegie Institution of Washington, 1957); Wendy Ashmore, ed., Lowland Maya Settlement Patterns, School of American Research (Albuquerque, NM: University of New Mexico Press, 1988); and Patrick T. Culbert and Don S. Rice, eds., Precolumbian Population History in the Maya Lowlands (Albuquerque, NM: University of New Mexico Press, 1990).

3 See Linda Schele and Mary Ellen Miller, The Blood of Kings: Dynasty and Rituals in Maya Art, exh. cat., Kimbell Art Museum, Fort Worth (New York: George Baraziller, Inc., 1986).

4 See Patrick T. Culbert, Classic Maya Political History: Hieroglyphic and Archaeological Evidence (Albuquerque, NM: University of New Mexico Press, 1991).

5 See David Freidel, Linda Schele, and Joy Parker, Maya Cosmos: Three Thousand Years on the Shaman's Path (New York: William Morrow & Co., 1993).

6 See Dorie Reents-Budet, Painting the Maya Universe: Royal Ceramics of the Classic Period (Durham, NC, and London: Duke University Press, 1994).

7 See Patrick T. Culbert, ed., The Classic Maya Collapse (Albuquerque, NM: University of New Mexico Press,

1973) and Jeremy A. Sabloff and E. Wyllys Andrews, eds., Late Lowland Maya Civilization: Classic to Postclassic. School of American Research Book (Albuquerque, NM: University of New Mexico Press, 1986).

8 Linda Schele and David Freidel, A Forest of Kings: Dynasty and Rituals in Maya Art, Kimbell Art Museum, Forth Worth (New York: Quill and W. Morrow, 1990).

9 Popol Vuh: El libro maya de la vida y las glorias de dioses y reyes, trans. from Quiché Dennis Tedlock, trans. into Spanish Debra Nagao and Luís Estrada de Artola (Mexico City: Editorial Diana, 1993).

10 See Schele and Miller, op.cit.

11 See Michael D. Coe, "The Hero Twins: Myth and Image," in The Maya Vase Book, vol. I, ed. Justin Kerr (New York: Kerr Associates, 1989).

12 See Anthony P. Andrews, "The Fall of Chichén Itzá: A Preliminary Hypothesis," Latin American Antiquity I, no. 3 (September 1990): 258–67.

Valentina Conticelli

1 Isidore, Etym., IV, 6 ("Sanguis Latine vocatus quod suavis sit, unde et homines, quibus dominatur sanguis, dulces et blandi sunt"; English translation quoted from Transactions of the American Philosophical Soviety, n.s., vol. 54, part 2: Isidore of Seville: The Medical Writings, trans. and intro. William D. Sharpe [Philadelphia: The American Philosophical Society, 1964], p. 56), but see also XI, 1, 15.

2 The prometheion sprang from the blood of Prometheus, which spilled onto the rocks of the Caucasus as a result of the torture inflicted upon him by the eagle that devoured his liver daily; the moly, on the other hand, was thought to have originated from the blood of Picolos, the giant who was Circe's adversary, and who was killed by Apollo (see S. Ribichini, "Metamorfosi vegetali del sangue nel mondo antico," in Sangue e antropologia nella letteratura cristiana, ed. F. Vattioni [Rome, 1982], vol. I, pp. 233–47). On the legends relating to the birth of the crocus, narcissus, hyacinth, and violet, see I. Chirassi, Elementi di culture precerali nei miti e riti greci (Rome, 1968).

3 For a thorough historical and scientific analysis of the two theories, see P. Manuli and M. Vegetti, Cuore,

sangue e cervello: Biologia e antropologia nel pensiero antico (Milan, 1977), and R. Laurenti, "Il sangue come strumento di conoscenza nella filosofia presocratica," in Sangue e antropologia, op.cit., esp. vol. I, pp. 188–95. See also the opening chapters of K.E. Rothschuh, History of Physiology (New York, 1973). For ancient ideas on the heart and vascular system, see C.R.S. Harris, The Heart and the Vascular System in Ancient Greek Medicine: From Alcmeon to Galen (Oxford, 1973).

4 See Manuli and Vegetti, op.cit., pp. 29–35.

5 H. Diels, Die Fragmente der Vorsokratiker, ed. W. Kranz (Berlin, 1951–52), frag. 24 A 5 (the standard abbreviation DK, followed by the number of the respective fragment, shall be used to indicate subsequent fragment passages quoted here).

6 See "Il cardio-emocentrismo di Aristotele," in Manuli and Vegetti, op.cit., pp. 113–56.

7 DK 31 B 22.

8 DK 31 B 109 (English translation quoted from G.S. Kirk and J.E. Raven, The Presocratic Philosophers [Cambridge, 1962], n. 454, p. 343).

9 A description of the senses according to Empedocles has come down to us mainly through Theoprastus (De sens., 7–24; DK 31 A 86). On these themes, see also Manuli and Vegetti, op.cit., pp. 58–61, and Laurenti, op.cit., pp. 190–92.

10 "And the earth came together with these in almost equal proportions, with Hephaestus, with moisture and with brilliant aither, and so it anchored in the perfect harbours of Kupris, either a little more of it or less of it with more of others. From these did blood arise, and the forms of flesh besides," DK 31 B 98 (English translation quoted from The Presocratic Philosophers, op.cit., n. 441, p. 335).

11 M.P. Duminil, Le Sang les vaisseaux et le cœur dans la collection hippocratique: Anatomie et physiologie (Paris, 1983), p. 247.

12 DK 31 B 105: "[the heart] dwelling in the sea of blood which surges back and forth, where especially is what is called thought by men; for the blood around men's hearts is their thought." This fragment was brought together with DK 31 B 89 ("Knowing that there are effluences of all things that came into being," The Presocratic Philosophers, op. cit., n. 456, pp. 343–44, 458) into a single discourse to give life to an excellent and poetic description of the birth of thought in Empedocles.

Poema fisico e lustrale, ed. C. Gavallotti (Milan, 1975), pp. 12–13. On this theme, see also Laurenti, op.cit., p. 192. The words of Empedocles were frequently referred to in ancient literature. In fact they have come down to us through Cicero, who declares: "Empedocles animum esse censet cordi suffusum sanguinem" (*Tusculanae*, I, 9, 19). By the word *animum* the Latin author means the capacity to feel and perceive and, in the final analysis, to think.

13 J. Bollack, *Empédocle* (Paris, 1965–69), vol. I, p. 252.

14 DK 31 A 85: "according to Empedocles, sleep derives from a moderate cooling of the warmth that is in the blood, and death from an absolute cooling of it." See S. Rocca, "Sangue, circolazione e carattere degli animali nella letteratura latina," in *Sangue e antropologia nella teologia medievale*, ed. F. Vattioni (Rome, 1991), vol. 2, p. 702.

15 Homer, *Od.*, 11, 34–36, 153–54. See also R. Laurenti, op.cit., pp. 193–94.

16 This is also born out by the observations in *De natura hominis*, a Hippocratic treatise, of which we shall speak further, that states: "Those who affirm that man is blood follow the same line of thought: observing the blood flowing from men whose throats have been cut, they deem this to be man's soul," *De nat. hom.*, 6 (see Hippocrates, *Opere*, ed. M. Vegetti [Turin, 1965], pp. 413–30). On the relationship between blood and the soul, see F. Rüsche, *Blut, Leben und Seele: Ihr Verhältnis nach Auffassung des griechischen und hellenistischen Antike, der Bibel und der alten Alexandrinischen Theologen* (Paderborn, 1930), and M.L. Coletti, "Il problema del rapporto anima/sangue nella letteratura latina pagana," in *Sangue e antropologia biblica*, ed. F. Vattioni (Rome, 1981), vol. I, pp. 331–47, on Greek philosophy, with bibliographical references on pp. 331–33.

17 Aristotle, *De an.*, I, 405 b 5 (English translation quoted from *On the Soul*, trans. W.S. Hett [London, 1964], p. 29). See also R. Laurenti, op.cit., p. 196.

18 Manuli and Vegetti, op.cit., p. 64.

19 On the development of cosmographical patterns of four from pre-Socratic times until the Middle Ages, see E. Schöner, *Das Viererschema in der antiken Humoralpathologie*, Südhoffs Archiv für Geschichte der Medizin 58/4 (Wiesbaden, 1964).

20 Even though the Hippocratic doctors were basically encephalocentric, see Manuli and Vegetti, op.cit., pp. 68ff.

21 On this theme, see R. Klibansky, E. Panofsky, and F. Saxl, *Saturn and Melancholy: Studies in the History of Natural Philosophy, Religion and Art* (London, 1964), esp. the first part: *The Notion of Melancholy and its Historical Development.*

22 DK B 4.

23 The first doctors to identify them were Euryphon and Herodicus of Cnidus, who belonged to the Cnidus school (fifth/fourth century BC), the most ancient Greek medical doctrine. See Schöner, op.cit., pp. 11–13; Klibansky, Panofsky, and Saxl, op.cit., pp. 8–9, and intro. by M. Serio, in Ugo di Fouilloi, *La medicina dell'anima*, ed. M. Serio (Turin, 1998), p. 8.

24 On the contents of this text with respect to the formulation of the theory of humors, see Schöner, op.cit., pp. 17–21; for more general information on the pattern of four in Hippocratic doctrines, see pp. 15–58.

25 *Nat. hom.*, 4.

26 *Nat. hom.*, 7; see Schöner, op.cit., pp. 18–19, and Duminil, op.cit., p. 209.

27 *Nat. hom.*, 7; see Duminil, op.cit., p. 213.

28 Ibid., p. 211.

29 Hippocrates, *Cord.*, 7 (see Hippocrates, *Œuvres complètes*, ed. E. Littré [Paris, 1839–61], vol. IX, p. 84). Isidore also bears witness to the success of this metaphor, *Etym.*, XI, 1, 21: "venae dicate, eo quod viae sint natantis sanguinis, atque rivi per corpus omne divisi, quibus universa membra irrigantur." On these themes, see G. Lacerenza, "Il sangue fra microcosmo e macrocosmo nel commento di Šabbatai Donnolo al Sēfer Jeşîrah," in *Sangue e antropologia*, op.cit., vol. I, pp. 389–417, esp. pp. 401–6.

30 See Schöner, op.cit., pp. 36–39.

31 Ibid., pp. 57–58.

32 Hippocrates, *Morb.*, I, 30 (see *Œuvres complètes*, op.cit., vol. VI, p. 200). See also Duminil, op.cit., pp. 241, 244.

33 Ibid., p. 245; *Epid.*, II, 6 (see *Œuvres complètes*, op.cit., vol. V, p. 138), and *Morb.*, III, 10 (see *Œuvres complètes*, op.cit., vol. VII, p. 130).

34 *De part. an.*, 477 a 21–23.

35 *De inc. an.*, 706 b 10 (English translation quoted from *On the Progression of Animals*, trans. E.S. Forster [London, 1968], p. 497); see also Manuli and Vegetti, op.cit., pp. 121–22.

36 *De part. an.*, 651 a 12–17 (English translation quoted from *On the Parts of Animals*, trans. A.L. Peck [London, 1968], p. 141); see also Manuli and Vegetti, op.cit., p. 154, and S. Rocca, op.cit., pp. 703–4.

37 See Klibansky, Panofsky, and Saxl, op.cit., pp. 10–13; M. Serio, in Fouilloi, op.cit., pp. 11–12; and Duminil, op.cit., p. 235.

38 Hippocrates, *Aff.*, 32 (see *Œuvres complètes*, op.cit., vol. VII, p. 248); see also Duminil, op.cit., pp. 248ff.

39 Ibid., pp. 212–13. The author confirms that an excess, or to an even greater extent a lack of, blood was, however, considered by some Hippocratic doctors as a possible cause of disease. See also Klibansky, Panofsky, and Saxl, op.cit., p. 13.

40 Ibid., pp. 52–53.

41 Galen, *In Hippocratem de nat. hom.*, 28 (see Galen, *Opera Omnia*, ed. C.G. Kühn [Leipzig, 1821–23], vol. XV, p. 97); see also Klibansky, Panofsky, and Saxl, op.cit., pp. 57–58. In Galen, however, the properties count for more than the humors in determining constitutions. In fact, according to his theory, there were eight types of complexion, and these were determined by the predominance of one of the four qualities or by a combination of two of them. And it was precisely a combination of two of them that characterized a humor (blood warm and wet, bile cold and dry, etc.), whereas later temperaments were determined on the basis of humors; ibid., pp. 64–65.

42 Galen defines in this way those types with a prevalence of humid heat, and therefore with blood as their predominant humor: "Once they are lost in sleep it is impossible to wake them for quite some time, they are prone to both sleep and to insomnia and they have vivid dreams," *Ars med.*, 8, 3 (*Opera Omnia*, op.cit., vol. I, p. 296). "Their eyes are not particularly sharp and their senses are dull. Although no less disposed towards action (than dry heat types), they do not, however, have a violent nature, but are simply quick to anger," *Ars. med.*, 11 (*Opera Omnia*, op.cit., vol. I, p. 336).

43 Of those texts that convey and codify the theory of the four temperaments, adding further links showing correspondences between microcosm and macrocosm, in addition to those already established by the Hippocratic doctors, the most significant are: Galen's commentary on Polybus' *De natura hominis*; two works of late Antiquity that are difficult to date: the pseudo-Galenic treatise *Of the Cosmos* and another work entitled *Of the Constitution of the Universe and of Man*; another, anonymous treatise dating from the third century BC, attributed to Soranus; Vindician's *Letter to Pentadius* (fourth century), which contributed significantly to the transmission of the doctrine of the four temperaments in the Middle Ages; and *De temporum ratione* by the Venerable Bede (seventh century). For the relevant bibliographical references, see Klibansky, Panofsky, and Saxl, op.cit., pp. 59–61, and for more general information on the doctrine of the temperaments between Antiquity and the Middle Ages, see J. Van Wageningen, "De quattuor temperamentis," *Mnemosyne*, n.s., 46 (1918): 374–82; W. Seyfert, "Ein komplexionentext einer Leipziger Inkunabel (angeblich eines Johann von Neuhaus) und seine handschriftliche Herleitung aus der Zeit nach 1300," *Archiv für Geschichte der Medizin* 20 (1928): 272–99, 373–89.

44 See the system described in Klibansky, Panofsky, and Saxl, op.cit., pp. 62–63.

45 On the meaning of the term *complexio* in the Scholastic tradition, see P.G. Ottoson, *Scholastic Medicine and Philosophy* (Naples, 1984).

46 William of Conches, *Philosophia*, IV, 20 (Migne, *PL*, CLXXII, 93): "Homo naturaliter calidus et humidus, et inter quattuor qualitates temperatus; sed quia currumpiture natura, contigit illas in aliquo intendi et remitti. Si verno in aliquo intendatur calor et remittatur humiditas, dicitur cholericus, id est calidus et siccus.... Sin vero in aliquo intensus sit humor, calor vero remissus, dicitur phlegmaticus. Sin autem intensa sit siccitas, remissus calor, melancholicus. Sin vero aequaliter insunt, dicitur sanguine."

47 Ibid., I, 23 (Migne, *PL*, CLXXII, 55, 56).

48 On these images, see the excellent article by E. Wickersheimer, "Figures médicoastrologiques des IX, X et XI siècles," *Janus* 19 (1914): 157–77.

49 Ibid., and Schöner, op.cit., pp. 99–100.

50 On the basis of the medieval prototypes, this type of image was also to be diffused in the form of printed books during the Renaissance, and the latest example dates from 1607, namely, T. Walkington, *Optic*

Glass of Humors (London). On the Renaissance tradition of cosmographic patterns of four, see S.K. Henninger, Jr., *The Cosmographical Glass: Renaissance of the Universe* (Pasadena, 1977), pp. 103–10.

51 See Klibansky, Panofsky, and Saxl, op.cit., pp. 290–99, and G. Lütke Notarp, *Von Heiterkeit, Zorn, Schwermut und Lethargie: Studien zur Ikonographie der vier Temperamente in der niederländischen Serien- und Genregraphik des 16. und 17. Jahrhunderts* (Münster, New York, Munich, and Berlin, 1998).

52 Galen's ideas on bloodletting are put forth in *De venae sectione, De venae sectione ad erasistratum liber, Galeni de venae sectione adversus erasistrateous romae degentes,* and *Galeni de curandi ratione per venae sectionem* (*Opera Omnia,* op.cit., book XI, XIX). On bloodletting in medicine, see K.J. Bauer, *Die Geschichte der Aderlässe* (Munich, 1870); A. Castiglioni, "Der Aderlass," *Ciba Zeitschrift* 6 (1954): 2186–95; R.E. Siegel, "Galen's Concept of Bloodletting in Relation to his Ideas on Pulminary and Peripheral Blood Flow and Blood Formation," *Science, Medicine and Society in the Renaissance: Essays to Honor Walter Pagel,* ed. A.G. Debus (New York, 1962), pp. 143–75; P. Brain, *Galen on Bloodletting: A Study of the Origins, Development and Validity of his Opinions* (Cambridge, 1986).

53 G. Bezza, *Arcana Mundi: Antologia del pensiero astrologico antico* (Milan, 1995), vol. II, p. 678.

54 The influence of the signs of the zodiac on the different parts of the body and of the planets on the bodily organs is codified in the ancient doctrine of melotesia, which is present in Greek, Indian, Arab, and Latin astrology, and the potential medical applications of astrology were already considered by Ptolemy to be among the main resources of this discipline. Here, we can do no more than supply brief references to complex questions such as melotesia and iatromathematics, and refer you, for sources and bibliography, to the anthology by Giuseppe Bezza, and in particular to the introductions to the chapter dedicated to iatromathematics; ibid., pp. 671–83.

55 By way of an example it is worth noting *Fasciculus medicinae,* an extremely popular text, in which medieval medical traditions were handed down in the Renaissance, and in which it states that if you wish to know the right time for "*minutione,*" it is necessary to take into account

the position of the moon, since bloodletting should never be carried out at the time of either the full moon or the new moon. Furthermore, it is important to remember that parts of the body should not be touched with instruments when the moon is in the sign governing that part of the body, and that it is better to practice bloodletting when the moon is in the air or fire signs than when it is in the earth or water signs. The text also contains a list giving those signs of the zodiac during which it is best to carry out bloodletting. See Petrus de Montagnana, *Degnissimo fascicolo de medicina* (Venice, 1493).

56 On these topics, see K. Südhoff, *Tradition und Naturbeobachtung in den Illustrationen medizinischer Handschriften und Frühdrucke vornehmlich des 15. Jahrhunderts* (Leipzig, 1907), pp. 30–39; id., "Lasstafelkunst in Drucken des 15. Jahrhunderts," *Archiv fur Geschichte der Medizin* 1 (1907/8): 219–28; id., *Beiträge zur Geschichte der Chirurgie im Mittelalter: Graphische und textliche Untersuchungen im mittelalterlichen Handschriften* (Leipzig, 1914–18), vol. I, pp. 144–219.

57 See *Der Fasciculus medicinae des Johannes Ketham Alemmannus,* ed. K. Südhoff (Milan, 1918), p. 47.

James Clifton

1 On this image, see Jeffrey F. Hamburger, *Nuns as Artists: The Visual Culture of a Medieval Convent* (Berkeley: University of California Press, 1997), p. 18.

2 *Canons and Decrees of the Council of Trent,* trans. H.J. Schroeder (Rockford, Illinois: Tan Books and Publishers, 1978), p. 216.

3 Quoted by Larry Silver, *The Paintings of Quinten Massys with Catalogue Raisonné* (Oxford: Phaidon, 1984) p. 101.

4 [Pseudo-Bonaventure], *Meditations on the Life of Christ: An Illustrated Manuscript of the Fourteenth Century,* Paris, Bibliothèque nationale, MS. Ital. 115, trans. Isa Ragusa, ed. Isa Ragusa and Rosalie B. Green (Princeton, NJ: Princeton University Press, 1961), pp. 15, 16, 56, 60–61, 320, and *passim.*

5 Ibid., pp. 328–29.

6 See especially Thomas H. Bestul, *Texts of the Passion: Latin Devotional Literature and Medieval Society* (Philadelphia: University of Pennsylvania Press, 1996); James H.

Marrow, *Passion Iconography in Northern European Art of the Late Middle Ages and Early Renaissance: A Study of the Transformation of Sacred Metaphor into Descriptive Narrative* (Kortrijk: Van Ghemmert Publishing Company, 1979); and Mitchell B. Merback, *The Thief, the Cross and the Wheel: Pain and the Spectacle of Punishment in Medieval and Renaissance Europe* (Chicago: The University of Chicago Press, 1999).

7 In what follows, little attention is given to the specific cultural situations in which individual works arose. This is not to say that the appearance and meaning of works are not deeply embedded in their cultures, nor that the great variety of the works discussed here is not of art historical significance. Not only does the scope of this essay not allow for detailed consideration of individual works or historical moments, but the discussion should point to a remarkable persistence of imagery over a great chronological and geographical expanse.

8 Jacobus de Voragine, *The Golden Legend: Readings on the Saints,* trans. William Granger Ryan, 2 vols. (Princeton, NJ: Princeton University Press, 1993), 1:74.

9 For an example of a different choice of subjects, see Bonaventure's *Vitis mystica,* from the 1260s, which describes the circumcision, agony in the garden, plucking of Christ's beard and cheeks, crowning with thorns, flagellation (curiously placing it out of chronological order), nailing of Christ to the cross, and the centurion piercing his side with a lance; *Vitis mystica seu tractatus de passione Domini,* chapters 36–41, in *Patrologia latina,* ed. J. Migne (Paris, 1974), vol. 184, columns 711–15. On the *Vitis mystica,* see Bestul, op.cit., pp. 45–48.

10 For an introduction to the theme and references to the major works of the vast literature, see Gertrud Schiller, *Iconography of Art,* 2 vols. (London: Lund Humphries, 1971), pp. 197ff.

11 Saint Thomas Aquinas, *Summa Theologiae,* 60 vols. (London, 1964–76), LVI, 68–69 (3a, 62, 5); cited Engl. trans. from *Fathers of the English Dominican Province,* 3 vols. (New York: Benziger Brothers, 1947–48).

12 See Friedrich Ohly, *Gesetz und Evangelium: Zur Typologie bei Zuther und Lucas Cranach, Zum Blutstrahl der Gnade in der Kunst* (Münster: Aschendorff, 1985), pp. 48–59.

13 Gabriele Finaldi, *The Image of Christ,* exhibition catalogue, National Gallery, London, 2000, pp. 182–83.

14 See Ulrich Middeldorf, "Un rame inciso del Quattrocento," in *Scritti di storia dell'arte in onore di Mario Salmi,* 2 vols. (Rome, 1962), 2:273–89; and Anna Padoa Rizzo, "Luca della Robbia e Verrocchio: Un nuovo documento e una nuova interpretatzione iconograpfica del tabernacolo di Peretola," *Mitteilungen des Kunsthistorischen Instituts in Florenz* 38 (1994): 49–67.

15 On catching Christ's blood in chalices, see Maurice Vloberg, *L'Eucharistie dans l'art* (Paris, 1946), pp. 149–58.

16 On this painting, see Leopold Kretzenbacher, "Bild-Gedanken der spätmittelalterlichen Hl. Blut-Mystik und ihr Fortleben in mittel- und südosteuropäischen Volksüberlieferungen," *Bayerische Akademie der Wissenschaften, philosophischhistorische Klasse, Abhandlungen* 114 (1997): 53–54.

17 On the drawing, which may be the design for a tabernacle door or a vestment embroidery, see Finaldi, op.cit., pp. 180–81.

18 On one such confraternity, or *scuola,* see Thomas Worthen, "Tintoretto's Paintings for the *Banco del sacramento* in S. Margherita," *Art Bulletin* 78 (1996): 707–32. He reproduces an illumination of Christ in the Chalice from the statute book of the Scuola del Sacramento of S. Margherita, as well as a sculptured version in the church of S. Polo, Venice.

19 See Uwe Westfehling, *Die Messe Gregor des Grossen: Vision—Kunst—Realität,* exhibition catalogue, Schnüttgen-Museum, Cologne, 1982.

20 On the subject, see Maj-Brit Wadell, *Fons Pietatis: Eine ikonographische Studie* (Göteborg: Elanders Boktryckeri Aktiebolag, 1969).

21 On the window, see Detlef Knipping, "Eucharistie und Blutreliquienverehrung: Das Eucharistiefenster der Jakobskirche in Rothenburg ob der Tauber," *Zeitschrift für Kunstgeschichte* 56 (1993): 79–101.

22 On the triptych, see G.B. Krebber and G. Kotting, "Jean Bellegambe en zijn *Mystiek Bad* voor Anchin," *Oud Holland* 104 (1990): 123–39.

23 On the right wing is Isaiah 12:3: "With joy you will draw water from the wells of salvation." The lowermost

inscription on the left wing is Revelation 7:14: "These are they who have come out of the great ordeal; they have washed their robes and made them white in the blood of the Lamb."

24 Martin Luther, *Luther's Works*, 55 vols. (Saint Louis and Philadelphia, 1955–86), 12:363. Even in a sermon on baptism (*Sermon at the Baptism of Bernhard von Anhalt*, 1540), Luther (51:326) likens the sprinkling of baptism to preaching: "But the sprinkling of which St. Peter [I Peter 1:2] is speaking (and which is signified by this sprinkling [baptism]) is none other than preaching. Holy water or water for impurity is the Holy Scriptures. The tongue of the preacher or Christian is the aspergillum. He dips it into the rosy—red blood of Christ and sprinkles the people with it, that is, he preaches to them the gospel, which declares that Christ has purchased the forgiveness of sins with his precious blood, that he has poured out his blood on the Cross for the whole world, and that he who believes this has been sprinkled with this blood." See also his late (1545) commentary on Genesis (8:258, 268): "For when we teach, we do nothing else than sprinkle and divide the power of the blood of Christ among the people."

25 Wadell, op.cit., p. 74.

26 Confession, which Luther also considered a means of grace, though not a sacrament, is shown directly in front of Christ, but without connection to his blood. See, however, R.W. Scribner, *For the Sake of Simple Folk: Popular Propaganda for the German Reformation*, 2nd ed. (Oxford: Clarendon Press, 1994), pp. 113–15, who defines confession and absolution as also sacramental.

27 Jeffrey Chipps Smith, *Nuremberg: A Renaissance City, 1500–1618*, exhibition catalogue, Archer M. Huntington Art Gallery, The University of Texas at Austin, 1983, p. 272, no. 185.

28 Joseph Leo Koerner, *The Moment of Self-Portraiture in German Renaissance Art* (Chicago and London: The University of Chicago Press, 1993), p. 373, sees the blood as signifying both "the saving waters of baptism" (in passing through the dove of the Holy Spirit, underlined by the presence of John the Baptist beside *Mensch*) and "the ubiquity of Christ, the real presence of his flesh and blood in the sacrament of Holy Communion, a doctrine upheld by Luther in his Marburg Colloquy with Ulrich Zwingli in the year 1529."

29 In the introduction to his *Passional* of 1522, on which see Koerner, ibid., p. 381.

30 In Luther's *Sermons on the First Epistle of St. Peter* of 1522, he does not gloss the phrase in I Peter 1:2 relating to Christ's blood. In 1527, he cites the verse in his *Lectures on the First Epistle of St. John*, relating it to the purification of baptism (Luther, op.cit., 30:314: "here we are said to be baptized through the blood of Christ, and thus we are cleansed from sins").

31 Luther, op.cit., 17:217.

32 Koerner, op.cit., p. 383, implicitly comes close to this interpretation when he writes that "The dove reminds us of that word whose embodiment as gospel is Cranach's theme," but does not connect the motif to Luther's interpretation of I Peter 1:2.

33 It is, in a sense, a curious choice for a text, because Luther rarely referred to it. In his *Lectures on the First Epistle of St. John* of 1527, he of necessity commented on the passage, using it as a source of confidence that sinners clinging to the Word need not despair, but should believe they have been forgiven (Luther, op.cit., 30:228). Later in the same lectures, the passage is used in an anti-Catholic diatribe asserting the efficacy of Christ's incarnation and sacrifice for justification, apart from the Law—a theme relevant to the Weimar altarpiece as well as to the earlier allegories of Law and Grace. (Luther, op.cit., 30:285: "In his bulls the pope condemns the article that we are justified solely by the righteousness of Christ. Yet this is the effect of His incarnation. But Paul contradicts the pope clearly when he says in Rom. 3:28: 'We hold that man is justified apart from the works of the Law.' And our John says in I John 1:7: 'His blood cleanses us from all sin.'")

34 See Koerner, op.cit., p. 407; Ohly, op.cit., pp. 60ff., followed by Koerner, argues that the absence of the chalice represents a rejection of the necessity of ecclesiastical mediation in the sacraments.

35 For this latter point, see Ohly, op.cit., pp. 18, 20, 32, 60ff.

36 Wadell, op.cit., pp. 62–65.

37 See ibid., pp. 65–66.

38 Juliana of Norwich, *Revelations of Divine Love*, trans. M.L. Del Maestro (New York: Image Books, 1977), pp. 102–3.

39 See Jeffrey F. Hamburger, *The Visual and the Visionary: Art and Female Spirituality in Late Medieval Germany* (New York: Zone Books, 1998), pp. 121ff.

40 The classic treatment of the subject is Sixten Ringbom, "Devotional Images and Imaginative Devotions: Notes on the Place of Art in Late Medieval Private Piety," *Gazette des Beaux-Arts* 73 (1969): 159–70.

41 In addition to Hamburger, *The Visual and the Visionary*, op.cit., see Walter Cahn, "The *Rule* and the Book: Cistercian Book Illumination in Burgundy and Champagne," in Timothy Gregory Verdon, ed., *Monasticism and the Arts* (Syracuse, NY: Syracuse University Press, 1984), pp. 139–72.

42 See Hamburger, *Nuns as Artists*, op.cit., pp. 1–2.

43 See especially F.O. Büttner, *Imitatio Pietatis: Motive der christlichen Ikonographie als Modelle zur Verähnlichung* (Berlin: Gebr. Mann Verlag, 1983).

44 On the subject of the Pietà, see especially Joanna E. Ziegler, *Sculpture of Compassion: The Pietà and the Beguines in the Southern Low Countries, c. 1300–c. 1600* (Brussels and Rome: Institut Historique Belge de Rome, 1992).

45 The phrase is Büttner's, op.cit., p. 51.

46 See Caroline Walker Bynum, *Holy Feast and Holy Fast: The Religious Significance of Food to Medieval Women* (Berkeley: University of California Press, 1987), pp. 165–80.

47 Blessed Raymond of Capua, *The Life of St. Catherine of Siena*, trans. George Lamb (London: Harvill Press, 1960), pp. 147–48.

48 On Vanni's drawings, see Lidia Bianchi, *Caterina da Siena nei disegni di Francesco Vanni encisi da Pieter de Jode* (Rome: Centro Nazionale di Studi Cateriniani, 1980); on Cousin's painting, see Claudio Strinati in Józef Grabski, *Opus Sacrum: Catalogue of the Exhibition from the Collection of Barbara Piasecka Johnson*, exhibition catalogue (Warsaw: Royal Castle, 1990), pp. 234–37.

49 See Robert Suckale, "*Arma Christi*: Überlegungen zur Zeichenhaftigkeit mittelalterlicher Andachtsbilder," *Städel-Jahrbuch* 6 (1977): 177–208.

50 "Wer disen krantz wil gewinnen und den mit recht sol tragen der sol jhesum von hertzen minnen und sine süd mit grossen rüwen seufzen und laid klagen." Trans. Schiller, op.cit., 2:195.

51 See Hamburger, *Visual and the Visionary*, op.cit., pp. 252ff.

52 The inscriptions repeat, with some variations (including a missing word), those on earlier works, including a woodcut from around 1490 in the National Gallery of Art, Washington, DC. On this print and the measuring of Christ's wound, see David S. Areford, "The Passion Measured: A Late-Medieval Diagram of the Body of Christ," in A.A. MacDonald, H.N.B. Ridderbos, and R.M. Schlusemann, eds., *The Broken Body: Passion Devotion in Late-Medieval Culture* (Groningen: Egbert Forsten, 1998), pp. 211–38 (the inscriptions are quoted and translated on pp. 223, 225).

53 On Batoni's painting and the Jesuits, see Christopher M.S. Johns, "'That amiable object of adoration': Pompeo Batoni and the Sacred Heart," *Gazette des Beaux-Arts* 132 (1998): 19–28.

54 See Maria Grazia Bernardini and Maurizio Fagiolo dell'Arco, eds., *Gian Lorenzo Bernini: Regista del Barocco*, exhibition catalogue, Palazzo Venezia, Rome, 1999, pp. 285–89, 443–48.

55 Trans. R. Enggass, taken from Irving Lavin, "Bernini's Death," *Art Bulletin* 54 (1972): 160.

Miri Rubin

1 Caroline W. Bynum, *Holy Feast and Holy Fast* (Berkeley, 1987).

2 On this see Leo Steinberg, *The Sexuality of Christ in Renaissance Art and in Modern Oblivion*, 2nd, rev. ed. (Chicago and London, 1996), and Caroline W. Bynum, *Renaissance Quarterly* (1986): 399–439.

3 Miri Rubin, *Gentile Tales: The Narrative Assault on Late Medieval Jews* (London and New Haven, CT, 1999).

4 Ronnie Po-chia Hsia, *The Myth of Ritual Murder* (New Haven, CT, 1988).

5 J.W. Goethe, *Poetry and Truth*, Book XIV.

6 See articles on Spanish heritage and the transformation in New Spain in Antoinette Molinié, ed., *Le Corps de Dieu en fêtes* (Paris, 1996).

Georg Kugler

1 Georges Duby, 27 juillet 1214. *Le dimanche de Bouvines* (Paris, 1973); Otto Brunner, *Land und Herrschaft: Grundfragen der territorialen Verfassungsgeschichte Österreichs im Mittelalter*, 5th ed. (Vienna, 1965), pp. 4ff., 9ff.

2 Brunner, op.cit., pp. 165ff.; Peter Moraw, *Über König und Reich: Aufsätze zur deutschen Verfassungsgeschichte des späten Mittelalters*, ed. Rainer C. Schwingers (Sigmaringen, 1995), pp. 89ff.; Andreas Hansert, *Welcher Prinz wird König? Die Habsburger und das universelle Problem des Generationswechsels* (Saint Petersburg, 1998), p. 31.

3 Hansert, op.cit., pp. 29ff.

4 Erich Zöllner, *Geschichte Österreichs*, 3rd ed. (Vienna, 1966), p. 166.

5 Otto Forst de Battaglia, *Über den sogenannten Ahnenschwund*, Wissenschaftliche Genealogie (Bern, 1948), pp. 155ff., 168ff.

6 Wilhelm Karl Prinz von Isenburg, *Stammtafeln zur Geschichte der europäischen Staaten*, vols. I. and II., 2nd ed. (Marburg, 1953).

7 Battaglia, op.cit., p. 123.

8 Ibid., p. 131; exhibition catalogue *Fürstenhöfe der Renaissance*, Kunsthistorisches Museum Vienna, 1989.

9 Armin Wolf, *Die Entstehung des Kurfürstenkollegs 1198–1298: Zur 700 jährigen Wiederkehr der ersten Vereinigung der sieben Kurfürsten* (Idstein, 1998); summary: *Die Kurfürsten des Reiches*, Exhibition catalogue, *Krönungen. Könige in Aachen: Geschichte und Mythos*, ed. Mario Kramp, 2 vols. (Mainz, 2000).

10 Alphons Lhotsky and Apis Colonna, "Fabeln und Theorien über die Abkunft der Habsburger: Ein Exkurs zur Cronica Austrie des Thomas Ebendorfer," *Mitt. d. Instituts f. österreichische Geschichtsforschung* 55 (1944); rev ed.: *Aufsätze und Vorträge*, vol. II (Vienna, 1971), p. 21.

11 Ibid., pp. 27ff.

12 Alphons Lhotsky, "Doktor Jacob Mennel, ein Vorarlberger im Kreise Kaiser Maximilians I.," *Alemannia, Zeitschrift: für Geschichte, Heimat- und Volkskunde Vorarlbergs* 10 (1936); "Neue Studien über Leben und Werk Jacob Mennels, *Montfort: Zeitschrift für Geschichte, Heimat- und Volkskunde Vorarlberg* 6 (1951).

13 Georg Johannes Kugler, "Eine Denkschrift Dr. Jacob Mennels, ver-fasst im Auftrag Kaiser Maximilians I. für seinen Enkel Karl," unpubl. dissertation (Vienna, 1960).

14 Anna Coreth, "Dynastisch-politische Ideen Kaiser Maximilians I.," *Mitt. d. öst. Staatsarchivs* 3 (1950); Adam Wandruszka, *Das Haus Habsburg* (Vienna, 1956), pp. 28ff.

15 Miguel Angel Ladero Quesada, *La España de los Reyes Católicos* (Madrid, 1999), pp. 312ff., 329.

16 Americo Castro, *La realidad histórica de España (Limpieza de sangre e Inquisicion)* (Mexico, 1954); John H. Elliott, *Imperial Spain 1469–1716* (Harmondsworth, 1963), pp. 107, 223.

17 Alfred Kohler, "'Tu Felix Austria Nube ...' Vom Klischee zur Neubewertung Dynastischer Politik in der Neueren Geschichte Europas," *Zeitschrift für Historische Forschung* 21, no. 4 (Berlin, 1994): 463.

18 Kohler, op.cit., pp. 463ff., 479.

19 Hermann Wiesflecker, *Kaiser Maximilian I.*, vol. III (Vienna, 1977), pp. 334ff.

20 Guido Bruck, "Habsburger als 'Herculier'," *Jahrbuch d. Kunsthist. Slgen. in Wien*, vol. 50 (Vienna, 1953), pp. 192f.

21 Karl Schütz, "Die Beziehungen der Habsburger zu den Gonzaga," *Fürstenhöfe der Renaissance*, exhibition catalogue, Kunsthistorisches Museum Vienna, 1989, pp. 324ff.

Stanislaw Dumin

1 *Nasledovanie rossiiskogo imperatorskogo prestola* (Inheritance of the Imperial Throne of Russia) (Moscow, 1999), p. 99.

2 P.K. Grebel'skii and S.V. Dumin, "Svetleishaia kniaginia Lovich" (Princess of Lovich), *Dvorianskie rody Rossiiskoi imperii* (Noble Families of the Russian Empire), ed. S.V. Dumin, vol. 2: *Kniazia* (Princes) (Saint Petersburg, 1995), p. 17.

3 *Nasledovanie rossiiskogo imperatorskogo prestola*, op.cit., p. 101.

4 Grebel'skii and Dumin, op.cit.

5 *Svod zakonov Rossiiskoi imperii* (Code of Laws of the Russian Empire), vol. 1, part 1: *Svod Osnovnykh gosudarstvennykh zakonov* (Code of Fundamental State Laws) (Saint Petersburg, 1906).

6 S.V. Dumin, "Soveshchanie Velikikh kniazei 1911 goda (neravnye braki v Rossiiskom Imperatorskom Dome)" (The Conference of Grand Dukes of 1911 [Unequal Marriages in the Russian Imperial House]), *Dvorianskii vestnik* (Herald of the Nobility), no. 3 (1998).

7 S.V. Dumin, *Romanovy: Imperatorskii dom v izgnanii: Semeinaia khronika* (The Romanovs: The Imperial House in Exile: A Family Chronicle) (Moscow, 1998).

8 G. Chulkov, *Imperatory: Psikhologicheskie portrety* (Emperors: Psychological Portraits) (Moscow, 1991), p. 175.

9 A.F. Tiutcheva, *Pri dvore dvukh imperatorov* (In the Court of Two Emperors) (Moscow, 1990), pp. 34–35.

10 A.A. Mosolov, *Pri dvore poslednego imperatora* (In the Court of the Last Emperor) (Saint Petersburg, 1992), p. 128.

11 Grand Duke Kirill Vladimirovich, *Moia zhizn' na sluzhbe Rossii* (My Life at the Service of Russia) (Saint Petersburg, 1996), p. 96.

12 Mosolov, op.cit., p. 70.

13 Grand Duke Alexander Mikhailovich, *Vospominaniia*: *Dve knigi v odnom tome* (Memoirs: Two Books in One Volume) (Moscow, 1999), pp. 177–78.

14 P.K. Grebel'skii and A. Mirvis, *Dom Romanovykh* (The House of Romanov) (Saint Petersburg, 1992), pp. 57–58.

15 Ibid., p. 58.

16 Ibid.

17 Riul'er, *Perevorot 1762 goda* (The Revolution of 1762) (Moscow, 1909).

18 "Dnevnik sobytii 1 marta po 1 sentiabria 1881 goda" (Diary of events from March 1 through September 1, 1881), *1 marta 1881 goda: Kazn' imperatora Aleksandra II: Dokumenty i vospominaniia* (March 1, 1881: The Assassination of Emperor Alexander II: Documents and Recollections) (Leningrad, 1991).

19 Grand Duke Gavril Konstantinovich, *V Mramornom dvortse: Iz khroniki nashei sem'i* (In the Marble Palace: From the Chronicle of Our Family) (Saint Petersburg, 1993), pp. 271–72; Dumin, *Romanovy*, op.cit., p. 4.

20 A.N. Avdonin, "In Search of the Place of Burial of the Remains of the Tsar's Family," *Historical Genealogy* 1 (1993): 96–98.

Annette Weber

1 Balzac quotes Faust as the really great man with a "passion for the infinite." See "La Fille aux yeux d'or," in *Histoire des Treize* (Paris: Editions Garnier, 1966), p. 444. See also Barbara Bauer, "Der Neue Mensch und Fausts Streben," in Nicola Lepp, Martin Roth, and Klaus Vogel, eds., *Der neue Mensch: Obsessionen des 20. Jahrhunderts* (Stuttgart: Cantz Verlag, 1999), pp. 17–26.

2 For Auguste Comte, see Roman d'Amat, ed., *Dictionnaire de biographie française* (Paris: Letouzey et Ané, 1961), vol. 9, pp. 418–23.

3 For the complete essay, see Kim Pelis, "Transfusion, with Teeth," in Robert Bud, Bernard Finn, and Helmuth Trischler, eds., *Manifesting Medicine Bodies and Machines* (Amsterdam: Harwood Academic Publishers, 1999), pp. 1, 6–8.

4 See on this point Peter Rautmann, *Delacroix* (Munich: Hirmer Verlag, 1997), pp. 112–15.

5 Frank Paul Bowman, "La Circulation du sang religieux à l'époque romantique," Max Milner, ed., *Sangs, Romantisme: Revue de la Société des études romantique* 31 (1981): 17–37.

6 James H. Rubin, *Eugène Delacroix: Die Dantebarke, Idealismus und Modernität*, Kunststück series, ed. Klaus Herding (Frankfurt am Main: Fischer Taschenbuch-Verlag, 1987), pp. 61–62.

7 Edward W. Said, *Orientalismus* (Frankfurt am Main: Ullstein, 1981), pp. 129ff., about French writers; on the phenomenon, see esp. Chapter II.

8 See Louis-François Girou de Buzareingues, *Philosophie physiologique, politique et morale* (Paris, 1828), and Joseph von Hammer-Purgstall, *Geschichte der Assassinen* (Vienna, 1818); French ed.: Paris, 1833. Both saw bloodthirstiness of Arab temperaments as hereditary degeneration.

9 For Baudelaire, see Barthélémy Jobert, *Delacroix* (Paris, 1998), p. 88, n. 99 (Baudelaire, *Revue anecdotique, Œuvres complètes* 2: 733–34).

10 For the Orient, see the observations in a letter by Horace Vernet of 1840, quoted in *Delacroix: La Naissance d'un nouveau romantisme*, exhibition catalogue, Musée des Beaux-Arts, Rouen (Paris: Réunion des musées nationaux, 1998), p. 62.

11 Immanuel Kant, *Anthropologie in pragmatischer Hinsicht abgefasst*, Part II, published 1798, ed. and intro. Wolfgang Becker (Stuttgart: Philipp Reclam, Jr., 1983), pp. 236–41. On the subject of races, see Kant, "Von den verschiedenen Rassen der Menschen," in *Schriften zur Anthropologie, Geschichtsphilosophie und Pädagogik*, lecture in summer term 1755, *Werke: Immanuel Kant*, vol. XI, ed. Wilhelm Weischedel (Frankfurt am Main: Suhrkamp Taschenbuch, 1968), pp. 11–30.

12 Prosper Lucas, *Traité philosophique et physiologique de l'hérédité naturelle* (Paris: J. B. Bailliére, 1847), intro. p. XXII: "Arriver à saisir et à déterminer les formes élémentaires de l'activité humaine, c'est donc, en quelque sorte, mettre la main sur les formes élémentaires de CELLE (Nature), dont elle est à la fois l'organe et l'image."

13 Lucas, op.cit., pp. 45–51; see also on the same subject Robert C. Olby, "Constitutional and Hereditary Disorders," in W. F. Bynum and Roy Porter, eds., *Companion Encyclopedia of the History of Medicine* (New York and London: Routledge, 1993), vol. 1, p. 416.

14 Lucas, op.cit., pp. 233–35; for different chemical values of the blood of various races, p. 240. However, Lucas negates his own thesis all along with the skepticism with which he treats Virey's tables classifying racial mixtures of white and black blood (see his reference to Virey, *Histoire naturelle du genre humain* II, pp. 185f.).

15 Jean Gaulmier, "Poison dans les veines: Note sur le thème du Sang chez Gobineau," in Milner, op.cit., pp. 198–208.

16 Quoted from Françoise Gaillard, "Le Cas du Docteur Pascal," Max Millner, op.cit., p. 183.

17 Gustav Conrad, "Vom Werden der französischen Nation, dargestellt in den publizierten Schriften und historischen Werken Augustin Thierry's und Guizot's," Ph.D. diss. (Berlin, 1955), pp. 55f., 71.

18 See *Calwer historisches Bilderbuch der Welt* (Stuttgart: Calwer Verlag, 1987), facsimile edition of *Bildertafeln zur Länder- und Völkerkunde. Mit besonderer Berücksichtigung der evangelischen Missionsarbeit* (Stuttgart: Calwer Verlagsverein, 1883). For the school charts with race diagrams, see "Völkerschau im Unterricht: Schulwandbild und Kolonialismus," Nordwestdeutsches Schulmuseum, Bohlen-

bergerfeld, Zetel, 1994. See esp. wall chart no. Wb 22. See also in the same volume Kurt Dröge's essay on the subject, "Zur Volkskunde des schulischen Wandbildes," pp. 17–22.

19 Benjamin Disraeli, *Coningsby* (London: Dent, 1948), pp. 180–84.

20 Albert Langen, ed., *Simplicissimus —Illustrierte Wochenschrift*, covers for vol. 8, no. 43, and vol. 14., no. 52.

21 Zola explicitly confirms this idea in his "Documents et plans preparatoires," p. 1749: "… montrer la 'déchéance dans une famille d'une aïeule qui a failli, et la logique (terrible) de la nature qui a mis un peu de sang de cette aïeule dans les veines de tous les membres'" (quoted from Françoise Gaillard, "Le Cas du Docteur Pascal," Milner, op.cit., p. 189, see also p. 188).

22 Lombroso's views were of critical importance in the reassessment. Works such as *L'uomo criminale,* appearing in 1876, remained valid until long into the twentieth century.

23 Jules Michelet in *L'Amour*, p. 53; see also Thérèse Moreau, "Sang sur: Michelet et le sang féminin," in Milner, op.cit., pp. 151–78. For Cesare Lombroso, see Hilde Orlik, "Le sang impur: Notes sur le concept de prostituée née chez Césare Lombroso (1835–1909)," in Milner, op.cit., pp. 167–69.

24 Quoted from Honoré de Balzac, *Splendeurs et misères des courtisanes*; English ed.: *A Harlot High and Low*, trans. Rayner Heppenstall, Penguin Classics (Harmondsworth: Penguin, 1970).

25 See Philippe Le Leyzour, "Liminaires," and Philippe Monnet, "Balzac et les Salons," in *Balzac et la peinture*, exhibition catalogue, Musée des Beaux-Arts de Tours, 1999, pp. 23, 48.

26 Claudia Balk, *Theatergöttinnen: Inszenierte Weiblichkeit* (Berlin, 1994), p. 110. For *femmes fatales,* see also Jean de Palacio, "Messaline décadente, ou la figure de sang," in Milner, op.cit., pp. 209–28.

27 The author is greatly indebted to Mme. Geneviève Lacambre, Conservateur du Musée Gustave Moreau, for a discussion on this subject. See also the Gustave Moreau exhibition catalogue (Paris, New York, and Tokyo, 1998), cat. no. 222, and Geneviève Lacambre, Peter Cooke, and Luisa Capodieci, eds., *Gustave Moreau: Les Aquarelles*, Réunion des musées nationaux, Paris, 1998, pp. 20f., 84–87.

28 See Lothar Brauner on this subject, in Peter-Klaus Schuster, Christoph Vitali, and Barbara Butts, eds., *Lovis Corinth* (Munich and New York: Prestel Verlag, 1996), cat.no. 30.

29 The author wishes to thank Paul Aston for the many useful suggestions and detailed discussion on the thoughts put forward in this essay.

Kim Pelis

1 James Blundell, "Lectures on the Theory and Practice of Midwifery," *Lancet* 1 (1827–28): 580. The lectures appear throughout the volume.

2 The French term was Blundell's choice, as opposed to the traditional "man-midwife."

3 See Kim Pelis, "Blood Clots: The 19th Century British Debate over the Substance and Means of Transfusion," *Annals of Science* 54 (1997): 331–60.

4 James Blundell, "Experiments on the Transfusion of Blood by the Syringe," *Medico-Chirurgical Transactions* 9 (1818): 56–92.

5 See A. D. Farr, "The First Human Blood Transfusion," *Medical History* 24 (1980): 143–62, with expansion and corrections by A. Rupert Hall and Marie Boas Hall, "The First Human Blood Transfusion: Priority Disputes," *Medical History* 24 (1980): 461–65; Charles Waller, "Uterine Hemorrhage and Transfusion," *Lancet* 10 (1826): 58–62; Simon Schaffer, "The Body of Natural Philosophers in Restoration England," in *Knowledge Incarnate: The Physical Presentation of Intellectual Selves*, ed. Christopher Lawrence and Steven Shapin (Chicago, 1998), pp. 51–82.

6 In his introductory chapter, Chris Baldick (*In Frankenstein's Shadow* [Oxford, 1987]) provides an excellent introduction to the issues concerning postrevolutionary Europe.

7 For introductory purposes, I use the problematic term "Romantic" quite generally, intending it to encompass numerous periods and national styles. For a recent review of the "problematic" aspects of the term in the history of science, see Trevor H. Levere, "Romanticism, Natural Philosophy and the Sciences: A Review and Bibliographic Essay," *Perspectives on Science* 4 (1996): 463–88. I shall qualify the term further below.

8 Simon Schaffer, "Genius in Romantic Natural Philosophy," in *Romanticism and the Sciences*, ed. Andrew Cunningham and Nicholas Jardine (Cambridge, 1990), pp. 82–98; Ludmilla Jordanova, "Melancholy Reflection: Constructing an Identity for Unveilers of Nature," in *Frankenstein, Creation and Monstrosity*, ed. Stephen Bann (London, 1994), pp. 60–76.

9 Luke Davidson, "Raising up Humanity: A Cultural History of Resuscitation and the Royal Humane Society of London, 1774–1801" (University of York, Ph.D. Thesis, 2001); David Knight, "Romanticism and the Sciences," in *Romanticism and the Sciences*, ibid., pp. 13–24; Martin Pernick, "Back from the Grave: Recurring Controversies over Defining and Diagnosing Death in History," in *Death: Beyond Whole-Brain Criteria*, ed. Richard M. Zaner (Dordrecht and Boston, 1988), pp. 17–74.

10 While the vampire enjoyed a long and healthy life in Eastern European folk tradition, it was introduced to "high" culture with John Polidori's 1819 story, "The Vampyre." See Christopher Frayling, *Vampyres: Lord Byron to Count Dracula* (London, 1991); James B. Twitchell, *The Living Dead: A Study of the Vampire in Romantic Literature* (Durham, NC, 1981). The recent academic conference "Frankenfest" testifies to the interest held by historians of science in Mary Shelley's classic tale. See also Tim Marshall, *Murdering to Dissect: Grave-Robbing, Frankenstein and the Anatomy Literature* (Manchester, 1995); Baldick (n. 6).

11 For a review of English themes, see Marilyn Butler, "Romanticism in England," in *Romanticism in National Context*, ed. Roy Porter and Mikulas Teich (Cambridge, 1988), pp. 37–67. On Romanticism and science, see Butler's "Introduction" to Mary Shelley's *Frankenstein, or the Modern Prometheus* [1818 text] (Oxford, 1993); and Jordanova (n. 8), as well as her review "Romantic Science? Michelet, Morals, and Nature," *British Journal for the History of Science* 13 (1980): 44–50.

12 I have filled this out with the words of various contributors of the *Lancet,* the medical journal that staunchly supported transfusion (this during its first decade of publication).

13 The stated reasons for Blundell's unexpected retirement are discussed in a series of letters to the *Lancet*. Apparently, the treasurer of Guy's Hospital named one Samuel Ashwell

co-chair with Blundell—much to Blundell's chagrin and stated surprise. It would seem that political alliances and relations with the *Lancet* itself were also factors in Blundell's departure. See "Dr. Blundell's Reasons for his Retirement from the Medical School of Guy's Hospital," *Lancet* i (1834–35): 28–32. The discussion continues with a reply from his adversary, Samuel Ashwell, pp. 78–79; Blundell's "Second Letter to his Medical Friends," pp. 207–12; Ashwell, again, pp. 259–61; and Blundell's "Third Letter," pp. 418–25.

14 I have taken basic biographical details from the following sources: Charles Waller, "On Transfusion of Blood: Its History, and Application in Cases of Severe Hemorrhage," *Transactions of the Obstetrical Society of London* 1 (1859): 61–72; "Obituary: James Blundell," *British Medical Journal* i (1878): 351–52; "Obituary: James Blundell," *Lancet* i (1878): 255–56; J.H. Young, "James Blundell (1790–1878): Experimental Physiologist and Obstetrician," *Medical History* 8 (1964): 159–69; B.A. Myhre, "James Blundell—Pioneer Transfusionist," *Transfusion* 35 (1995): 74–78.

15 "Obituary," *Lancet* i (1878): 255.

16 *Dictionary of National Biography* (London, 1890), vol. 23, p. 441. This conception is confirmed in "Review, Blundell, *The Principles and Practice of Obstetricy,* by Thomas Castle," *The Edinburgh Medical and Surgical Journal* 42 (1834): 138–55, esp. 140.

17 An amusing example of this particular gift is cited in "One Hundred Years Ago: The Teaching of Midwifery in London in 1814: Haighton and Blundell," *British Medical Journal* ii (1914): 21–23. This article also draws attention to Blundell's success, calling it "phenomenal": "for years he had the largest class on midwifery in London" (p. 21).

18 "Comments on the Speeches at the Anniversary Dinner of St. Thomas's and Guy's Hospitals," *Lancet* 1 (1823–24): 422.

19 "Dr. Blundell's Introductory Physiology Lecture," *Lancet* 9 (1825–26): 118.

20 James Blundell, "Some Remarks on the Operation of Transfusion," in *Researches Physiological and Pathological: Instituted Principally with a View to the Improvement of Medical and Surgical Practice* (London, 1824), p. 69.

21 On "passive vitality," see "Dr. Blundell's Introductory Physiology Lecture" (n. 19), p. 114.

22 Blundell, "Some Remarks" (n. 20), p. 123.

23 I have compiled this fictional case from a number of accounts given in the *Lancet* during the 1820s and early 1830s. See, for example, 9 (1825–26): 11, 295; 10 (1826): 280; 1 (1828–29): 431; i(1834): 156–57.

24 "Transfusion of Blood in Uterine Hemorrhage," *Lancet* i (1834–35): 157.

25 "Case of Uterine Hemorrhage, in which the Operation of Transfusion was Successfully Performed, by Charles Waller, M.D.," *Lancet* i (1833–34): 522.

26 "Successful Case of Transfusion, by J. Howell, esq., Bridge Street, Southwark," *Lancet* 1 (1827–28): 698.

27 James Blundell, "Observations on Transfusion of Blood, with a Description of his Gravitator," *Lancet* 2 (1828–29): 321–24.

28 Blundell, "Experiments" (n. 4), pp. 56–57.

29 "Transfusion of Blood" (n. 24), p. 156.

30 Ibid., p. 157.

31 Jos. Ralph, "Another Successful Case of Transfusion," *Lancet* 10 (1826): 280.

32 Charles Waller, *Elements of Practical Midwifery, or, Companion to the Lying-in Room* (London, 1829), pp. 89, 91.

33 Waller, "Uterine Hemorrhage and Transfusion" (n. 5), p. 60. It is quite possible that the friendly support Blundell enjoyed from Wakley and the *Lancet* played a role in his ultimate retirement from Guy's in 1834. Guy's and St. Thomas's had been the focus of consistent attack—for nepotism, inadequacy, and a kind of medical despotism—by Wakley's journal, with the hospitals' treasurer coming under particular attack. It was this same treasurer who precipitated Blundell's actions. On Wakley, see Ruth Richardson, *Death, Dissection and the Destitute* (London, 1987), pp. 42–50; S. Squire Sprigge, *The Life and Times of Thomas Wakley,* facsimile of the 1899 edition (Huntington, NY, 1974).

34 It is necessary to qualify my use of the loaded but useful term "Romantic." First, the group we now call "Romantic" did not, in fact, apply the term to themselves—it is rather a term conferred upon them

by history. Temporally, the Romantics may be traced back to the 1740s and forward into the 1820s; nationally, they appeared throughout Europe, Britain, and even the nascent USA. Within these differences in time and place, they embraced different ideas and ideologies. They also spanned intellectual disciplines in a way that characterized the fluidity of disciplinary boundaries at that time. The "Romanticism" we see in Blundell's work is closest to the variety expressed by Lord Byron and Percy Shelley. It focused on classicism and the secular study of myth and religion; it championed individual, creative thought and romanticized foreign cultures with "orientalism." "The unknown" was there to feed the imagination and provoke exploration. See, for example, Butler, "Romanticism in England" (n. 11), pp. 37, 56–60; Morse Peckham, *Romanticism and Ideology* (Hanover, NH, 1995), pp. 3–4; Knight (n. 9), p. 13. The classic study of the "orientalizing" tendency and its history is Edward W. Said, *Orientalism* (New York, 1979).

35 In his classic study *The Vampire* (London, 1995), originally published in 1928, Montague Summers examines the connections between this fear and vampire legends in some detail. More recently, historians and anthropologists have attended to funeral rituals of various times and cultures. Richardson gives wonderful descriptive analyses of laying out corpses in *Death, Dissection and the Destitute* (n. 33). For an anthropological perspective, see Nigel Barley, *Dancing on the Grave* (London, 1995).

36 On French "vitalistic materialism," see Owsei Temkin, "The Philosophical Background of Magendie's Physiology," and "Materialism in French and German Physiology of the Early 19th Century," *Bulletin of the History of Medicine* 20 (1946): 10–35 and 322–27, respectively.

37 Knight (n. 9), pp. 19–21; Davidson (n. 9).

38 Marcello Pera, *The Ambiguous Frog: The Galvani-Volta Controversy on Animal Electricity* (Princeton, NJ, 1992), pp. 3–18.

39 Charlotte Sleigh, "Life, Death and Galvanism," unpublished manuscript, presented October 1996, Wellcome Institute Research in Progress Seminar.

40 Erwin Ackerknecht, *Medicine at the Paris Hospital, 1794–1848* (Baltimore, 1967); Toby Gelfand, *Professionalizing Modern Medicine: Paris Surgeons and Institutions in the 18th Century* (Westport, CT, 1980).

41 Knight (n. 9), pp. 19–20.

42 Temkin, "Materialism" (n. 36).

43 Jordanova (n. 8), pp. 61–62. Schaffer connects similar qualities to his description of Romantic genius. Schaffer (n. 8), pp. 93–94.

44 Jordanova (n. 8), pp. 72–73. I would like to add an interesting twist to Jordanova's argument. She dismisses the possibility that Mary Shelley was thinking about surgeons as she conceived her monster, because "surgery was active and manual, but not until the second half of the nineteenth century did it entail much entry into body cavities" (p. 66). This is certainly true on a general level. Blundell, however, was writing treatises on abdominal surgery and conducting animal experiments to show its potential in the 1810s—further substantiating his "frankensteinian" character!

45 I draw this analogy from Butler's arguments about Romanticism and the Gothic novel ("Romanticism in England" [n. 11], pp. 62–63) and Jordanova's accounts of medical self-image and Frankenstein's character (n. 8).

46 Levere (n. 7), p. 466; Jordanova (n. 8), p. 62; Knight (n. 9), pp. 19–20; Schaffer (n. 8), pp. 91–94; Cunningham and Jardine, "The Age of Reflection," in *Romanticism and the Sciences* (n. 8), p. 6.

47 In his dissertation (n. 9) Davidson extensively discusses the cultural consequences of this shift in "apparent death."

48 "Creating a *culture* of medical and scientific power was one way of securing power itself." Jordanova (n. 8), p. 67.

49 Malcolm Jack, ed., *Vathek and Other Stories: A William Beckford Reader* (London, 1995), pp. 27–121.

50 Butler, "Introduction" (n. 11), pp. xxvi–xxvii.

51 "Comments on the Speeches" (n. 18).

52 The famous image of a similarly clad Byron springs to mind. *Lancet* 7 (1825): 146–47. Having described Blundell, the *Lancet* continued: "We are sorry to say many were present who had *no characters.*"

53 Thomas Castle, *The Principles and Practice of Obstetricy, as at Present Taught by James Blundell* (London, 1834), pp. 419, 420.

54 Marriage, at least. Blundell was a life-long bachelor.

55 By "conceived," I refer to their birth into "polite literary society." The vampire myth in particular had long existed in folk tales.

56 Mary Shelley herself appears to have set off the controversy in her introduction to the 1831 edition of *Frankenstein*, in which she essentially dismisses Polidori and his influence on her novel. In his study *Vampyres: Lord Byron to Count Dracula*, Christopher Frayling attempts to restore creative credibility to Polidori's name. The episode is also discussed by Butler ("Introduction" [n. 11]) and Twitchell (n. 10).

57 Franklin Bishop, *Polidori! A Life of Dr. John Polidori* (Kent, 1991).

58 I am referring to the first edition *of Frankenstein*, published in 1818. See Baldick (n. 6), chap. 1.

59 Shelley (n. 11), p. 24. The 1831 edition adds "galvanism."

60 Ibid., p. 34.

61 Ibid., pp. 36–37.

62 Ibid., p. 38.

63 Twitchell (n. 10), pp. 142–43.

64 John Polidori, "The Vampyre," repr. with Shelley's *Frankenstein* (London, 1992), p. 236.

65 Frayling (n. 10) and Twitchell (n. 10) both discuss the literary influence of Polidori's creation.

66 Twitchell (n. 10), p. 166.

67 Ibid., p. 3.

68 See quotations in the works cited in notes 1 and 20.

69 Ralph (n. 31).

70 Blundell (n. 1), p. 614.

71 Blundell experimented with animals to determine how long one might wait to transfuse, and found that at "actual death" the animal was, indeed, too far gone to resuscitate. In 1826, an experiment was conducted by Mr. Scott at Guy's Hospital on a man actually dead; no positive result was noted as a consequence of the transfusion. "Transfusion," *Lancet* 10 (1826): 221. In one of history's wonderful turns, about a century later, cadavers were employed as blood *donors* in parts of Russia—death quickly killed off unfortunate blood-borne infections and staved off co-agulation. The procedure never caught on broadly, though it is nicely documented in the uncut version of the 1941 Paul Rotha film "Blood Transfusion."

72 Polidori, cited in Twitchell (n. 10), p. 110.

73 Ibid., p. 236.

74 "Transfusion of Blood" (n. 24).

75 "Dr. Blundell's Introductory Physiology Lecture" (n. 19), p. 111.

76 "Transfusion," *Lancet* 8 (1825): 343.

77 "Medical Society of London," *Lancet* 9 (1825–26): 134.

78 Blundell (n. 4), p. 75; Waller (n. 5), p. 58.

79 Blundell (n. 4), p. 64.

80 Blundell (n. 20), pp. 56–57.

81 Ibid., p. 127. The Wellcome collections, housed at the Science Museum, London (WC/SM), includes a Blundell syringe-based transfusion apparatus, inv. no. A 43853. *See* Fig. 5.

82 Shelley (n. 11), p. 38.

83 Twitchell (n. 10) examines these images in connection with vampire representations in his first chapter. I am not arguing that Kininger was attempting to portray a vampire in this painting—though the slightly pointed incisors and bat-like wings of the male figure might support this claim. Instead, with Twitchell, I appeal to it primarily because illustrators looking for visual representations of nineteenth-century vampire stories used it, with Fuseli, as a model. Of course, this coincidence of images raises suggestive questions for cultural history—questions that I must, unfortunately, leave aside for the purposes of this essay.

84 "Another Successful Case of Transfusion," *Lancet* 9 (1825–26): 111–12, esp. 112.

This essay was made possible by the generous support of the Science Museum and the Wellcome Trust. Its arguments were strengthened by the suggestions of stimulating audiences at Cambridge University, the University of Manchester, Johns Hopkins University and the 1997 meeting of the American Association of Historical Museums.

© Kim Pelis, "Transfusion, with Teeth," from *Manifesting Medicine: Bodies and Machines*, eds. Bernard Finn, Robert Bud, and Helmut Trischler, Gordon & Breach (Taylor & Francis)

Claudia Eberhard-Metzger

1 Rudolf Kleinpaul, in *Die Lebendigen und die Toten in Volksglauben, Religion und Sage* (Leipzig: Göschen, 1898).

2 P. Strengers et al., *Blut: Von der Magie zur Wissenschaft* (Heidelberg, Berlin, and Oxford: Spektrum Akademischer Verlag, 1996), pp. 2ff.

3 J. Denis, "An extract of a letter ...," *Philosophical Transactions* 2 (November 10, 1667), pp. 617–24.

4 J. Denis, "Concerning a new way of curing ...," ibid. (July 22, 1667), pp. 489–504.

5 Ibid., pp. 501–3.

6 Strengers, op.cit.

7 Douglas Starr, *Blut: Stoff für Leben und Kommerz* (Munich: Gerling-Akademischer-Verlag, 1999), pp. 18ff.

8 Wolfgang Eckart, *Geschichte der Medizin* (Berlin, Heidelberg, and New York: Springer, 1998).

9 Ernst-Ludwig Winnacker, *Viren: Die heimlichen Herrscher* (Frankfurt am Main: Eichborn, 1999).

10 Walter Doerfler, *Viren: Krankheitserreger und Trojanisches Pferd* (Berlin, Heidelberg, and New York: Springer, 1996).

11 A. Lürmann, "Eine Icterus-epidemie," *Berliner klinische Wochenschrift* 22 (January 12, 1885), pp. 20ff.

12 C.H. Hagedorn and C.M. Rice, "The Hepatitis C Viruses," Current Topics in Microbiology and Immunology 242 (Berlin and London: Springer, 2000): 1–376.

13 Stefan Zeuzem, "Die unter-schätzte Epidemie," *Forschung Frankfurt* 4 (2000): 39–45.

14 Stefan Zeuzen, W.K. Roth, and G. Herrmann, "Virushepatitis C.Z.," *Gastroenterol* 33 (1995): pp. 117–32.

15 Michael Koch, *Aids: Vom Molekül zur Pandemie* (Heidelberg: Spektrum der Wissenschaft, 1987)

16 Winnacker, op.cit.

17 Interview with Reinhard Kurth, "Viren sind Wiederholungstäter," *Spiegel* 52 (2000): 184–88.

18 Claudia Eberhard-Metzger and Renate Ries, *Verkannt und heimtück-isch: Die ungebrochene Macht der Seuchen* (Basel: Birkhäuser, 1995).

19 Katja Becker-Brandenburg and Heiner Schirmer, "Malaria: Mit neuen Methoden gegen eine alte Geißel der Menschheit," *Ruperto Carola: Forschungsmagazin der Universität Heidelberg* 2 (1999): 30–36.

20 Eberhard-Metzger et al., op.cit., p. 166.

21 P. Olliaro, J. Cattani, and D. Wirth, "Malaria: The Submerged Disease," *Journal of the American Medical Association*, no. 3 (1996): 230–33.

22 Werner Lang, ed., "Malaria," in *Tropenmedizin in Klinik und Praxis* (Stuttgart and New York: Thieme, 1993), pp. 7–36.

23 Lang, "Afrikanische Trypanosomiasis," in ibid., pp. 54–61.

24 Christine Clayton, "Achillessehne eines Mörders," *Ruperto Carola: Forschungsmagazin der Universität Heidelberg* 3 (2000): 18–24.

25 Ibid.

26 Press release by Paul Ehrlich Institut, March 23, 2001.

Henry A. Giroux

1 I wish to thank Carol Becker for encouraging me to write this article; Roger Simon and Harvey Kaye for their support and advice; and Peter McLaren for his editorial help. I would also like to thank Michael Hoechsmann for letting me read an early draft of a paper he is writing on Benetton pedagogy. I would also like to thank James Bradburne for the extraordinary effort and time he took in improving the quality of this piece. It is much better because of him.

2 Laurie Asseo, "Statistics on Black Crime Victims Released," *The Boston Globe* (December 9, 1994), p. 3.

3 The media bashing of youth is taken up in great detail in Mike Males, "Bashing Youth: Media Myths About Teenagers," *Extra* (March/April 1994), pp. 8–14.

4 David Bailey and Stuart Hall, "The Vertigo of Displacement," *Ten.8* 2, no. 3 (1992): 15.

5 Andrew Payne and Tom Taylor, "Introduction: The Violence of the Public," *Public*, no. 6 (1992): 10.

6 Unfortunately, Benetton was unable to give us permission to reproduce this advertisement.

7 Sharon Waxman, "Benetton Laid Bare," *Miami Herald* (February 8, 1993), p. C1.

8 Quoted in Benetton's spring/summer 1992 advertising campaign copy, p. 5.

9 Michael Stevens, "Change the World, Buy a Sweater," *Chicago Tribune* (December 11, 1992), p. 33.

10 Benetton's spring/summer 1992 advertising campaign copy, p. 4.

11 Noreen O'Leary, "Benetton's True Colors," *Adweek* (August 24, 1992), p. 28.

12 Benetton not only published, with Ginko Press, a book entitled *United Colors of Benetton*, which "vividly displays the Benetton corporate philosophy," it also published a book in 1994 entitled *What's the Relationship Between AIDS and Selling a Sweater*, which chronicles various responses to the controversial Benetton ads. Both books appropriate the controversy over Benetton's ads to spread the company's name and generate profits. It seems that nothing is capable of existing outside Benetton's high-powered commercialism and drive for profits. Spike Lee is one of the highest-profile celebrities to endorse Benetton's campaign. See, the interview with Spike Lee, which was sponsored as an advertisement in "United Colors of Benetton," *Rolling Stone*, no. 643 (November 12, 1992): 1–5.

13 Ingrid Sischy, "Advertising Taboos: Talking to Luciano Benetton and Oliviero Toscani," *Interview* (April 1992): 69.

14 Quoted in Carol Squires, "Violence at Benetton," *Artforum*, p. 18.

15 Benetton's spring/summer 1992 advertising campaign copy, p. 2.

16 Andrew Warnick, *Promotional Culture*, p. 181.

17 Cited in Stuart Ewen, *All Consuming Images* (New York: Basic Books, 1988), p. 247.

18 Benetton's fall/winter 1992 advertising campaign literature, p. 2.

19 Sischy, op.cit., p. 69.

20 Luciano Benetton, quoted in ibid., p. 69.

21 Toscani, op.cit., p. 69.

22 Ewen, op.cit.

23 Abigail Solomon-Godeau, *Photography at the Dock* (Minneapolis: University of Minnesota Press, 1991), p. 145.

24 Roland Barthes, "Shock-Photos," in *The Eiffel Tower* (New York: Hill and Wang, 1979), p. 72.

25 Roland Barthes, *Mythologies* (New York: Noonday, 1972), p. 143.

26 Douglas Crimp, "Portraits of People with AIDS," in Lawrence Grossberg et al., eds., *Cultural Studies* (New York: Routledge, 1992), p. 118.

27 Dick Hebdige, "After the Masses," in Stuart Hall and Martin Jacques, p. 83.

28 Ewen, op.cit., p. 264.

29 Tony Bennett, "Texts in History: The Determinations of Readings and Their Texts," in Derek Atridge et al., eds., *Poststructuralism and the Question of History* (Cambridge: Cambridge University Press, 1987), p. 72.

30 On the dialectics of consumerism, see Mike Featherstone, *Consumer Culture and Postmodernism* (Newbury Park: Sage Publications, 1991); Mica Nava, *Changing Cultures: Feminism, Youth and Consumerism* (Newbury Park: Sage Publications, 1992).

31 Dick Hebdige, "After the Masses," in Stuart Hall and Martin Jacques, p. 89.

32 I have taken this idea from the transcript of the television show *The Public Mind* with Bill Moyers (New York: WNET Public Affairs Television, 1989), p. 14.

List of Exhibited Works

Amsterdam

Albrecht Dürer (1471–1528)
Christ on the Cross with Three Angels
ca. 1516
Woodcut
Inv. RP-P-OB-1372
Amsterdam, Rijksprentenkabinet

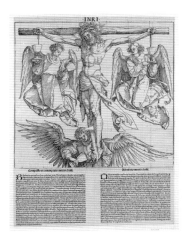

Hendrick Goltzius (1558–1617)
Miracula Christi
Engraving
Inv. RP-P-1885-9312
Amsterdam, Rijksprentenkabinet

Dirk Volkertsz. Coornhert
(1522–1590) after Maarten van
Heemskerck (1498–1574)
*Faith Washing Hearts in Christ's
Blood*
ca. 1550
Engraving
Inv. RP-P-BI-6538-b
Amsterdam, Rijksprentenkabinet

Annecy

Gilbert & George (b. 1943
and b. 1942)
Drops of Blood
Mixed media, 1997
Annecy, The Salomon Gallery

Bamberg

Theodore de Bry
Life of the American Indians
Engraving from "America"
Frankfurt am Main, 1593/99
Sign. Georgr.f.51/1
Bamberg, Staatsbibliothek

Basel

Bloodletting calendar
Calendar of 1499 with bloodletting
man
1498
Basel, L. Ysenhut
Inv. AU V 13 Nr. 13
Basel, Universitätsbibliothek

Berlin

*Five Wounds with Child of Suffering
in Sacred Heart*
Southern Germany, 1472
Woodcut
Berlin, Staatliche Museen zu
Berlin—Preussischer Kulturbesitz,
Kupferstichkabinett

Poster elucidating the 1935 race
laws (the so-called *Nürnberger
Blutschutzgesetze*)
Inv. 1989/2578
Berlin, Deutsches Historisches
Museum

Magical papyrus
Egypt, 4th century
Barol 5026 MG II 160, 177
Berlin, Ägyptisches Museum und
Papyrussammlung, Staatliche
Museen zu Berlin—Preussischer
Kulturbesitz

Günter Brus (b. 1938)
Selbstbemalung
1964
Photos
Berlin, Nationalgalerie

Malaria expedition to New Guinea:
Robert Koch with the governor of
German New Guinea
1900
Photo
Berlin, Archiv für Bild und Kunst

Besançon

Fernand Cormon (1845–1924)
Jealousy in the Harem
1874
Oil on canvas
Inv. D.875.2.1
Besançon, Musée des Beaux-Arts et
d'Archéologie

Bologna

Gina Pane (1939–1990)
IO MESCOLO TUTTO
1971
Performance, color photos
Inv. 95160
Bologna, Galleria d'Arte Moderna

Brussels

Hieronymus Wierix (1553–1619)
The Christ Child Spouting Blood
(*Fons Pietatis*), ca. 1613
Engraving
Brussels, Bibliothèque Royale de
Belgique

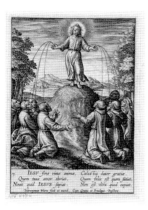

Hieronymus Wierix (1553–1619)
*Christ on the Cross, Refuge against
Miseries*
ca. 1613
Engraving
Brussels, Bibliothèque Royale de
Belgique

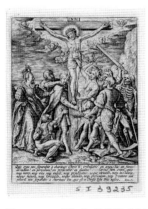

Hieronymus Wierix (1553–1619)
Christ in the Winepress
ca. 1613
Engraving
Brussels, Bibliothèque Royale de
Belgique

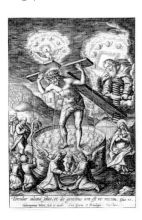

Cambridge, Massachusetts

Embossed disk depicting warriors
Disk F
Maya, Late Classic/Early Post-Classic
Period (9th century AD)
Mexico, Yucatan, Chichén Itzá
Gold
Inv. 10-71-20/C10068
Cambridge, Mass., Peabody Museum
of Archaeology and Ethnography,
Harvard University

Embossed disk depicting human
sacrifice
Disk H
Maya, Late Classic/Early Post-Classic
Period (9th century AD)
Mexico, Yucatan, Chichén Itzá
Gold
Inv. 10-71-20/C10047
Cambridge, Mass., Peabody Museum
of Archaeology and Ethnography,
Harvard University

Obsidian dagger
Maya (Aurora Phase) 1st–4th century
Guatemala, Kaminaljuyu
Inv. 62-23-20/21047
Cambridge, Mass., Peabody Museum
of Archaeology and Ethnography,
Harvard University

Chicago

Ecce Homo
Granada, 18th century
Wood, painted, gilt
Inv. 16.81
Chicago, Martin D'Arcy Museum

Cologne

*The Man of Sorrows as Fountainhead
of Blood and Dispenser of Hosts*
Germany (Lower Rhine), ca. 1480
Oil on panel
Inv. 1990/57
Cologne, Diözesanmuseum

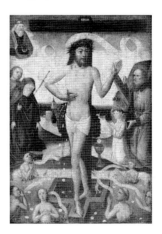

Bloodletting man
Second half of 15th century
Paper, parchment
Ms. W 308, c. 1v
Cologne, Historisches Archiv

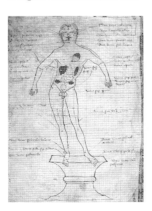

Figurine of a Maya prisoner
Late Classic Period, AD 600–800
Island of Jaina, Campeche, Mexico
Clay
Inv. SLXLIII
Cologne, Rautenstrauch-Joest-Museum

Copenhagen

Bloodletting man
Origin unknown, ca. 1400
Written text and painted illustration
on parchment
Ny Kgl 84 b 2
Copenhagen, Kgl Bibliotek

Denver

Juan Correa (ca. 1646–1716)
Allegory of the Eucharist
ca. 1690
Oil on canvas
Denver, Mayer Collection

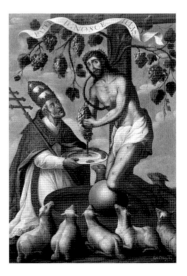

José de Páez (ca. 1720–1790)
The Adoration of the Sacred Heart of Jesus with Saints Ignatius Loyola and Aloysius Gonzaga
Late 18th century
Oil on copper
Denver, Mayer Collection

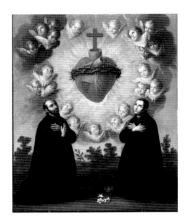

Düsseldorf

Joseph Beuys
Horn, 1961
Bronze
Ingrid and Willi Kemp Collection
Düsseldorf, Kunstmuseum

Edinburgh

Jacopo Negretti, called Palma il Giovane (1544–1628)
Christ in a Chalice, ca. 1620
Pen and brown ink
Inv. D3099
Edinburgh, National Galleries of Scotland

Florence

Aulus Cornelius Celsus, *De medicina*
Italy, late 9th–early 10th century
Parchment codex
Pl. LXXIII cod. 1
Florence, Biblioteca Medicea Laurenziana

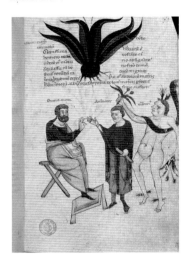

Euripides
Tragoediae
Venice, apud Aldum, 1503
Nenc. Aldine 1.1.11
Florence, Biblioteca Nazionale Centrale

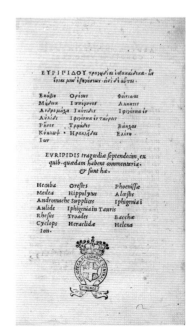

Aelius Aristides
Orationes
Florence, F. Giunti, 1517
Palat. D. 8.3.11
Florence, Biblioteca Nazionale Centrale

Seneca
Tragoediae
Venice, Aldo, 1517
Palat. D.7.6.25
Florence, Biblioteca Nazionale Centrale

Artemidorus
De somnium interpretatione
Venice, in aedibus Aldi et Andreae Asulani soceri, 1518
Nenc. Aldine 1.2.14
Florence, Biblioteca Nazionale Centrale

Valerius Flaccus
Argonautica
Venice, in eadibus Aldi et Andrea Asulani soceri, 1523
Palat. D.7.6.29
Florence, Biblioteca Nazionale Centrale

Heliodorus
Historiae Aethiopicae libri decem …
Basel, Joan. Hervagii, 1534
Palat. 15.4.15.43
Florence, Biblioteca Nazionale Centrale

Medici antiqui omnes, qui latinis literis …
Venice, apud Aldii filios, 1547
Palat. D. 1.28.
Florence, Biblioteca Nazionale Centrale

Horapollon
De sacris notis et sepulturis libri duo …
Paris, apud Jacobum Keruer, 1551
Magl. 19.6.283
Florence, Biblioteca Nazionale Centrale

Julius Obsequens
De' prodigi
Lyons, per Giovanni di Tournes, 1554
Nencini 1.4.3.36
Florence, Biblioteca Nazionale Centrale

Plutarch
Opuscula varia
Paris, H. Stephanus, 1572
Magl. 15.6.443
Florence, Biblioteca Nazionale Centrale

Porphyrius
De Abstinentia
Venice, apud J. Gryphium, 1547
Magl. 11.6.161
Florence, Biblioteca Nazionale Centrale

Tacitus
Annalium libri quatuor
Paris, apud Rob. Colombellum, 1581
Nenc. Aldine 2.6.30
Florence, Biblioteca Nazionale Centrale

Antonio Ricciardi
Commentaria Symbolica in duos tomos distribuita
Venice, apud Fr. De Francischis, 1591
Magl. 1.1.184, vol. II
Florence, Biblioteca Nazionale Centrale

Pierio Valeriano
Hieroglyphica, seu de sacris Aegyptiorum…
Lyons, apud P. Frellon, 1626
Magl. 1.1.271
Florence, Biblioteca Nazionale Centrale

Frankfurt am Main

Kevin Clarke (b. 1953)
Portrait of Nam June Paik
Frankfurt am Main, DG-Bank Collection

The General Pump
1848/49
Lithograph
Inv. N.C.8437
Frankfurt am Main, Historisches Museum

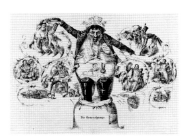

Crucifixion
Probably Germany or Austria, 17th century
Ceramic
Inv. 2589
Frankfurt am Main, Liebieghaus—Museum alter Plastik

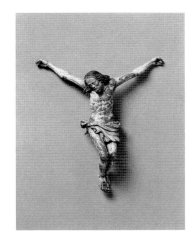

Raphaël Sadeler the Younger (1584–1632)
A Young Boy Ritually Murdered by Jews in 1283
Engraving, ca. 1600
Inv. JM88-1
Frankfurt am Main, Jüdisches Museum

Christ's Side Wound
Prayer book
Germany, 1608
Inv. LM 191
Frankfurt am Main, mak.frankfurt

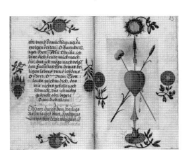

Chalice
Southern Germany, ca. 1480
Silver, gilt
Inv. MuSt 93
Frankfurt am Main, mak.frankfurt

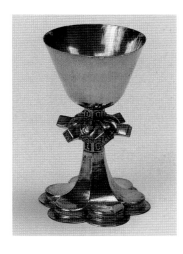

Processional Cross
Germany, 15th century
Copper, gilt and engraved
Inv. 6725
Frankfurt am Main, mak.frankfurt

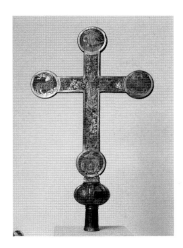

Jean I or Nardon Penicaud
The Passion of Christ,
Limoges, ca. 1520–40
Enamel on copper
Inv. WMH 2
Frankfurt am Main, mak.frankfurt

Oliviero Toscani
AIDS patient David Kirby on his deathbed, surrounded by his family
Billboard
Frankfurt am Main, Museum für Moderne Kunst

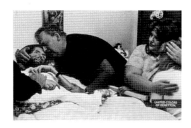

Lucas Cranach the Elder (1472–1553)
Allegory of Law and Grace
ca. 1529
Pen and ink
Frankfurt am Main, Städelsches Kunstinstitut

Master of the Wendelin Altarpiece
Trinity
1503
Oil on panel
Inv. SG 362
Frankfurt am Main, Städelsches Kunstinstitut

Master of the Friedrich Altarpiece
The Agony in the Garden
1477
Oil and tempera on panel
Inv. 1695
Frankfurt am Main, Städelsches Kunstinstitut

Arthur Comte de Gobineau
"Inequality of the Human Races"
Paris, 1853
Frankfurt am Main, Stadt und Universitätsbibliothek

Virgil (Publius Vergilius Maro)
Opera
Venice, 1491–92
Incunabulum
Inc. qu. 622
Frankfurt am Main, Stadt und
Universitätsbibliothek

Aristotle
Opera
Venice, 1495–98
Incunabulum
Inc. qu. 1097
Frankfurt am Main, Stadt und
Universitätsbibliothek

Aristotle
Parva naturalia
Cologne, 1498
Incunabulum
Inc. qu. 560
Frankfurt am Main, Stadt und
Universitätsbibliothek

Ovid (Publius Ovidius Naso)
Metamorphoses
Venice, 1493
Incunabulum
Inc. qu. 983
Frankfurt am Main, Stadt und
Universitätsbibliothek

Seneca
Tragoediae
Venice, 1498
Incunabulum
Inc. qu. 611
Frankfurt am Main, Stadt und
Universitätsbibliothek

Isidore of Seville
Etymologiae
Augsburg, 1472
Incunabulum
2° inc. c.a. 129, or 2° L impr.
Membr. 70
Frankfurt am Main, Stadt und
Universitätsbibliothek

Göttingen

Dioscorides
De material medica
Venice, 1518
Inv. 8° Bot. I, 370
Göttingen, Niedersächsische Staats-
und Universitätsbibliothek

Pliny the Elder
Historia naturalis
Rome, 1470
Inv. 2 Anct.Lat. IV, 720 inc.
Göttingen, Niedersächsische Staats-
und Universitätsbibliothek

Guatemala City

Ceremonial vessel with three
zoomorphic figures
Late Classic Period, AD 600–800
Probably from the lower Maya
countries
Clay
Cat. N. 0391
Guatemala City, Museo Popol-Vuh

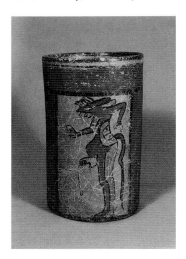

Haarlem

Gian Lorenzo Bernini (1598–1680)
(attributed)
The Blood of Christ
ca. 1669
Drawing
D10
Haarlem, Teylers Museum

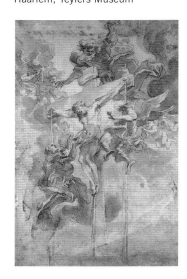

Heidelberg

Bloodletting men, from John of
Ketham's *Fasciculuis medicae*,
Germany, second half of 15th century
Paint on parchment
Cod. Palat. Germ. 644
Heidelberg, Universitätsbibliothek

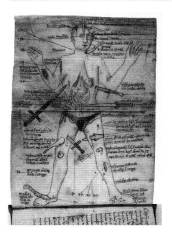

Houston

Petrus Nicolai Moraulus
(ca. 1499–1576)
Mass of Saint Gregory, ca. 1530
Oil on panel
Inv. 1963.1
Houston, Sarah Campbell Blaffer
Foundation

Innsbruck

Marina Abramovic (b. 1946)
The Lips of Thomas, 1975
Performance, 2001 re-installation
Innsbruck, Galerie Krinzinger

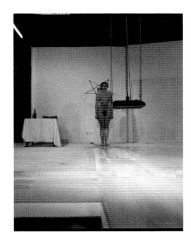

Karlsruhe

Soranus
De Pulsibus
Northern Italy, 9th century
Parchment codex
Cod. Reichenau CXX
Karlsruhe, Badische
Landesbibliothek

De quatuor elementis corporum
Reichenau, first half of the 9th century
Parchment codex
Cod. Reichenau CLXXII
Karlsruhe, Badische Landesbibliothek

Christ in the Winepress
Nuremberg, ca. 1435–50
Woodcut
Sammelhandschrift Hs. St. Georgen
61
Karlsruhe, Badische Landesbibliothek

Albrecht Dürer (1471–1528)
Man of Sorrows
1509
Engraving
Inv. I 779
Karlsruhe, Staatliche Kunsthalle

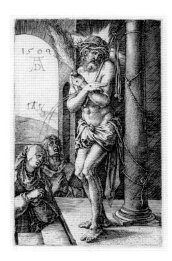

*Crucified Christ with Female Figure
Bathing in His Blood*
Strasbourg, early 16th century
Illuminated manuscript
Inv. Ms. St. Peter, pap. 4, fol. 30v
Karlsruhe, Badische Landesbibliothek

Lawrence

Max Oppenheimer (1885–1954)
Der Blutende (*The Bleeding Man*)
1910
Oil on canvas
Inv. 75.42
Lawrence, University of Kansas,
Helen Foresman Spencer Museum of
Art

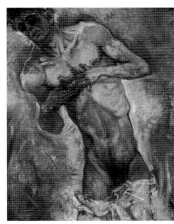
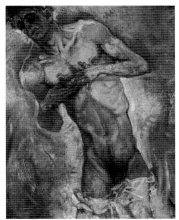

Leipzig

Lovis Corinth (1858–1925)
Salomé II
1900
Oil on canvas
Inv. 1531
Leipzig, Museum der bildenden
Künste

Leyden

Herman Jansz. Muller (1540–1617)
(after Maarten van Heemskerck
[1498–1574])
The Seven Bleedings of Christ, 1565
 The Circumcision
 The Agony in the Garden
 The Flagellation
 The Crowning with Thorns
 Christ Bearing the Cross
 Christ Nailed to the Cross
 Longinus Piercing Christ's Side
with a Lance
Engravings
Leyden, Prentenkabinet,
University of Leyden

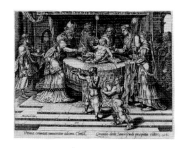
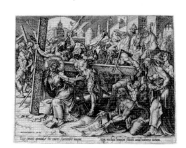

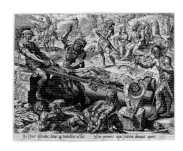

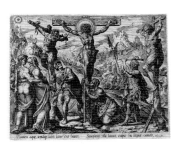

London

Bleeding bowl
Lambeth or Southwark
1640–1720
Tin-glazed earthenware
Inv. A626459
London, The Science Museum

Graduated bleeding bowl
18th or 19th century
Pewter
Inv. A43204
London, The Science Museum

Medical equipment for transfusion
Designed by Savigny (after plans by
James Blundell)
Inv. A43853
London, The Science Museum

Pocket surgical instrument set
in silver-mounted shagreen case
Incomplete, England, 1701–1830
Inv. A241492
London, The Science Museum

Case of six lancets
Various French manufacturers,
19th century
Steel and tortoiseshell, in silver case
Inv. A61831
London, The Science Museum

Set of cupping instruments,
in leather covered case
19th century
Inv. A200461
London, The Science Museum

Wire leech cage, painted black
Probably England, 1851–1900
Inv. A626813
London, The Science Museum

Clear glass leech jar, with internal
glass protuberances
Probably France, 1851–1900
Inv. A73610
London, The Science Museum

Mechanical leech
Brass leech in leather-covered case
with accessories
Produced by J. G. Birck, Sr., Karrick
Chirurgische Instrumente
Berlin, 1851–1910
Inv. A627092
London, The Science Museum

Earthenware leech jar
England, 19th century
Inv. A5943
London, The Science Museum

Enema syringe, piston action
Switzerland, 18th or 19th century
Pewter
Inv. A38783
London, The Science Museum

Scarificator with twelve lancets
Made by W. and H. Hutchinson,
Sheffield, 19th century
Inv. A626513 Pt4
London, The Science Museum

Cruise's sphygmometer
Made by Collin, France, 1861–1935
Metal and vulcanite, in case,
Inv. 1983-881/846
London, The Royal College of
Surgeons of England via The Science
Museum

Dudgeon's pocket sphygmograph
Made by Ganter, London, and Salt
and Son, Birmingham, 1881
Metal, in leather case
Inv. 1983-881/847
London, The Royal College of
Surgeons of England via The Science
Museum

Brunton's sphygmomanometer in
leather case
Made by Bailey and Son, London,
1920–50
Inv. 1983-561/47
London, The Science Museum

Various UK certificates for blood
donations and two small reports on
how and where the blood was used,
1920s and 1930s
Inv. 1996-278/69 and 70
London, The Science Museum
(Jenkins Collection)

UK color poster by Abram Games
OBE, R.D.I, used by the Emergency
Blood Transfusion Service to recruit
blood donors, ca. 1943
Inv. 1996-83
London, The Science Museum

Poster issued by the UK Ministry of
Health on behalf of the National
Blood Transfusion Service, ca. 1950
Inv. 1996-278/1
London, The Science Museum
(Jenkins Collection)

Poster issued for the Dublin branch
of the Blood Transfusion Service,
ca. 1950
Inv. 1996-278/66
London, The Science Museum
(Jenkins Collection)

Two posters from the United States
Red Cross, ca. 1950s
Inv. 1996-278/67 and 68
London, The Science Museum
(Jenkins Collection)

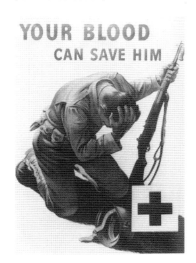

Prudentia and Pietas
Apocalypse manuscript, ca. 1420
WMS 49
London, The Wellcome Institute,
Western Manuscripts Collection

Pseudo-Galen
Anatomia
England, mid-15th century
WMS 290
London, The Wellcome Institute,
Western Manuscripts Collection

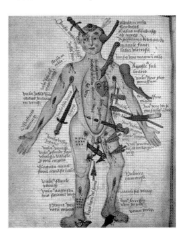

Arzneibuch
(Book of Medical Remedies)
Germany, 1524
WMS 93
London, The Wellcome Institute,
Western Manuscripts Collection

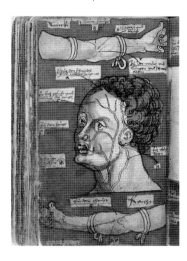

Hans von Gersdorff
Anatomical figure, *Feldtbuch der
Wundartzney* (Manual on the
Treatment of Wounds)
Strasbourg, 1530
EPB 2761/B, fol. 16v
London, The Wellcome Institute,
Early Printed Books Collection

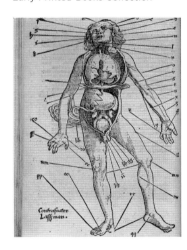

Marcello Malpighi
*De pulmonibus observationes
anatomicae*
Bologna, 1661
Illustration of frog lung, showing
capillaries
EPB MSL/D/MAL
London, The Wellcome Institute,
Early Printed Books Collection

Blundell's Gravitator in use, *Lancet*,
London, 1826–28, pp. 321–24
London, The Wellcome Institute,
Modern Medicine Collection

"Mendel's Rat Banner"
The Eugenics Society, ca. 1930
London, The Wellcome Institute,
Contemporary Medical Archives
Collection

Bloodletting Almanac, from
Grammatical Treatises
England, ca. 948
Parchment codex
Cod. Harley 3271
London, British Library

Apuleius Platonicus
Liber de medicaminibus herbarum
Germany, late 11th century–early
12th century
Parchment codex
Cod. Harley 4986
London, British Library

Zodiac man, from a medical treatise
France (?) 12th century
Painted parchment
Cod. Sloane 282
London, British Library

Magical Practices, from *Medical
Treatises*
England (?) 12th century
Parchment codex
Cod. Sloane 475
London, British Library

Christ in a Chalice Held by Angels
Register of the Scuola del Corpo di
Cristo
Venice, illuminated manuscript,
15th century
Add. Ms. 17047, fol. IV
London, British Library

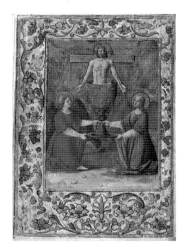

Desecrated Host of Dijon
Book of Hours of René of Anjou, King
of Sicily
Burgundy, 15th century
Egerton Ms. 1070
London, British Library

Ibn Kamal al-Din Afzal Muhammad
Akmal
Muscular and Arterial System
Manuscript
Persia, 17th century, Europe (?)
binding of plain brown leather,
18th century
Pen-drawn decoration at the begin-
ning of the text
Colophon dated Sunday, 14th
Sha'ban 1(0)83/5 December 1672
IO Islamic 1379, fol. 11b–12a
London, British Library

Lucca

Apuleius Platonicus
Herbarius
Northern Italy, late 9th century
Parchment codex
Cod. 296
Lucca, Biblioteca Governativa

Leonardo Dati
I temperamenti nella Sfera
Lucca, late 15th century
Miniature on paper
Ms. 1343
Lucca, Biblioteca Governativa

Metz

Gustave Moreau (1826–1898)
Oedype Voyageur
1864
Oil on canvas
Inv. 222
Metz, Musée des Beaux-Arts

Moscow

Throne of Tsar Alexander I
Russia, ca. 1800
Wood, gilt
GIM OD. 47744/1502
Moscow, State Historical Museum

Unknown artist
*Tsaritsa Catherine I (1684–1727),
Wife of Peter I*
ca. 1726
Oil on canvas
GIM IZO. 16385-Stch/I-I-2064
Moscow, State Historical Museum

Unknown artist (after a portrait by
F. S. Rokotov, 1750s)
Tsar Peter III (1728–1762)
1762
Oil on canvas
GIM IZO. 54687/I-I-4183
Moscow, State Historical Museum

Copy by an unknown artist (after the
original by G. Kügelgen)
Tsar Alexander I (1777–1825)
Early 19th century
Oil on canvas
GIM IZO. 13563-stch/I-I-3751
Moscow, State Historical Museum

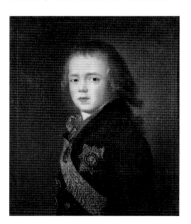

Copy by an unknown artist (after the
original by Ivan Nikitin)
Tsar Peter I, The Great (1672–1725)
Second part of 18th century
Oil on canvas
GIM IZO. 23291/I-I-264
Moscow, State Historical Museum

François Anne David (after a drawing
by Charles Monet)
*The Murder of Tsar Ivan Antonovich
on July 4, 1764*
Illustration taken from the *Histoire
de Russie, representé par figures [...]
gravées par F. A. David d'après les
dessins de Monet*
Paris, 1813
Colored engraving
GIM IZO. 55709-ya. 13 p. 4 nr. 459
Moscow, State Historical Museum

Alexandro Blanco (after Tomas Lopes
Engividanos ([1773–1814])
The "Humiliation of Tsar Peter III"
Illustration taken from the *Historia
Universal*, Lisbon
Late 18th century
Engraving
GIM IZO. 55709 ya/3 p4 nr. 387
Moscow, State Historical Museum

Copy by an unknown artist (after the
original by J. P. Voile)
*Grand Duke Constantine Pavlovich
(1779–1831)*
Late 18th century
Oil on canvas
GIM IZO. 16886-stch/I-I-1206
Moscow, State Historical Museum

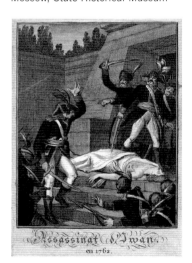

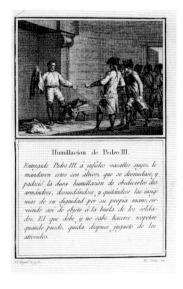

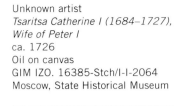

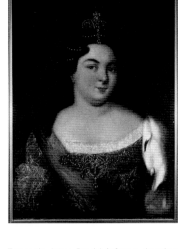

V. A. Tropinin (1776–1857)
Copy of a lithograph dating from the
1820s
*Princess Ioanna Antonovna of Lovich
(1795–1831), Morganatic Wife of
Grand Duke Constantine Pavlovich*
Oil on canvas
GIM IZO. 67393/I-I-1148
Moscow, State Historical Museum

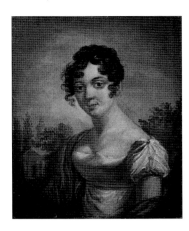

Unknown artist (after the original by
Orest A. Kiprensky, 1816)
*Future Tsar Nicholas I (1796–1855)
as Grand Duke in the Uniform of an
Officer of the Guard*
1820s
Oil on canvas
GIM IZO. 83000/72/I-I-4977
Moscow, State Historical Museum

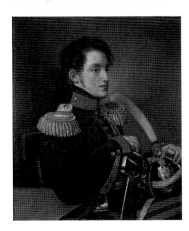

Alexander. A. Kharlamov
Tsar Alexander II (1818–1881)
1874
Oil on canvas
GIM IZO. 91961/I-I-4977
Moscow, State Historical Museum

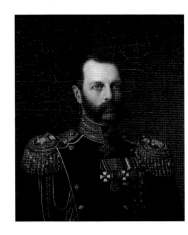

Atelier Levitsky & Sons
Princess Ekaterina Yurievskaya
(1849–1922), morganatic wife
of Tsar Alexander II
1870
Photo on card
GIM IZO. 95171/I-VI-35531
Moscow, State Historical Museum

F. V. Morozov (after a drawing by an
unknown artist, late 19th century)
"A criminal attempt on the Sacred
Person of the Lord Emperor
Alexander Nikolaevich. Explosion of
the second shell on March 1, 1881"
Late 19th century
Lithograph
GIM IZO. 45857. I-III khr 8379
Moscow, State Historical Museum

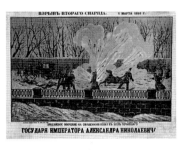

A. Daugel
*The Church of the Resurrection of
Christ—"Spas na krovi" (Redemption
by Blood), Built on the Site of the
Assassination of March 1, 1881*
First quarter of 19th century
Xylograph
GIM IZO. 82964. I-III-47737
Moscow, State Historical Museum

S. L. Levitzky
Tsar Alexander III (1845–1894)
1880s
Photo mounted on cardboard (silver
gelatin print)
GIM IZO. 68257/I-VI-33883
Moscow, State Historical Museum

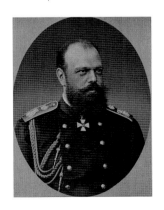

Atelier de Jongli frères
*Tsar Alexander III (1845–1894),
Empress Maria Feodorovna
(1847–1928), Tsarevich Nicholas
(the future Emperor Nicholas II) with
members of the Romanov family*
Paris, early 1890s
Photo mounted on cardboard (silver
gelatin print)
GIM IZO. 68257/I-VI-37891
Moscow, State Historical Museum

I. Ye. Repin (1844–1930)
Tsar Nicholas II (1868–1918)
1896, oil on canvas
GIM IZO 68257 I-5963
Moscow, State Historical Museum

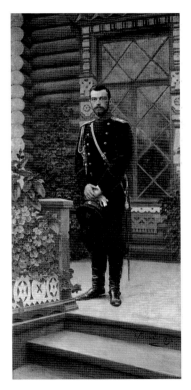

Unknown artist (after a late
19th century lithograph)
Contemporary icon of Tsar Nicholas II
the Martyr
2000
Printed paper pasted on board, varnish
GIM NV 6385/1 DRZh 1654
Moscow, State Historical Museum

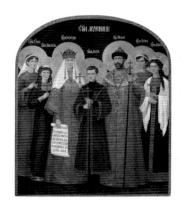

Contemporary icon of the "Noble
Martyrs" (Emperor Nicholas II, his
wife, Empress Alexandra Feodorovna,
and their children; after an unknown
artist)
2000
Printed paper pasted on board, varnish
GIM NV 6385/2 DRZh 1655
Moscow, State Historical Museum

Atelier Boisson & Eggler, Saint
Petersburg
The Crown Prince, the Tsarevich
Alexis (1904–1918)
1906
Photo mounted on cardboard (silver
gelatin print)
GIM IZO. 68257/I-VI-35283
Moscow, State Historical Museum

Court photographer K. Gan
The Grand Duke, the Tsarevich Alexis
(1904–1918), on a tricycle
Photo mounted on cardboard (silver
gelatin print)
GIM IZO. 95171/I-VI-31216
Moscow, State Historical Museum

Moyland

Joseph Beuys
Siberian Symphony
1963
Three drawings in one frame
Hare's blood applied to brown
packing paper
Inv. 00701
Moyland, Schloss Moyland
Foundation, Van der Grinten
Collection—Joseph Beuys Archiv des
Landes Nordrhein Westfalen

Joseph Beuys
Untitled
1959
Blood, pencil on paper glued to
cardboard
Inv. 01472
Moyland, Schloss Moyland
Foundation, Van der Grinten
Collection—Joseph Beuys Archiv des
Landes Nordrhein Westfalen

Joseph Beuys
Druid Measuring Apparatus
1961
Oil-based paint, watercolor, blood,
and organic juices on drawing paper
Inv. 00785
Moyland, Schloss Moyland
Foundation, Van der Grinten
Collection—Joseph Beuys Archiv des
Landes Nordrhein Westfalen

Munich

Thomas Theodor Heine (1867–1948)
"In Darkest Germany"
Crimmitschau, Simplicissimus, 1904
Caricature
Munich, Stadtmuseum

Thomas Theodor Heine (1867–1948)
"In Darkest Germany"
*After the Demonstration,
Simplicissimus*, 1910
Caricature
Munich, Stadtmuseum

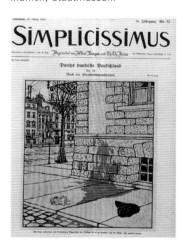

Georg Glockendon the Elder (active 1484–1514)
The Seven Bleedings of Christ
Late 15th century
Woodcut
Inv. 150384
Munich, Staatliche Graphische Sammlung

Five Wounds with Child of Suffering in Sacred Heart
Upper Rhine, ca. 1450–65
Woodcut
Inv. 118290
Munich, Staatliche Graphische Sammlung

Marbodo
Liber lapidum, Fragmenta medicinalia
Germany, late 11th century to early 12th century
Parchment codex
Cod. lat. 23479
Munich, Bayerische Staatsbibliothek

Pseudo-Galenus
Fragment, *De pulsibus*
Germany, late 8th century–early 9th century
Parchment fragment
Cod. lat. 29648.
Munich, Bayerische Staatsbibliothek

Lucan
Pharsalia
Milan, 1491
2 Inc.c.a.2585
Munich, Bayerische Staatsbibliothek

Homer
Opera
Florence, 1488/89
2 Inc.c.a.2046
Munich, Bayerische Staatsbibliothek

New York

Kevin Clarke (b. 1953)
Portrait of Professor Wilhelm Fresenius
Archive color print under acrylic
New York, artist's collection

Kevin Clarke (b. 1953)
Portrait of James D. Watson
1998–99
Archive color print under acrylic
New York, artist's collection

Andres Serrano (b. 1950)
Semen and Blood II
Cibachrome, 1990
New York, Paula Cooper Gallery

Andres Serrano (b. 1950)
The Morgue (Knifed to Death I)
Cibachrome, 1990
New York, Paula Cooper Gallery

Andres Serrano (b. 1950)
The Morgue (Knifed to Death II), 1992
Cibachrome, 1990
New York, Paula Cooper Gallery

Paris

Joseph Ange Tissier (1814–1976)
Algerian Woman and Slave Girl
ca. 1860
Oil on canvas
Paris, Musée Nationale des Arts d'Afrique et d'Océanie

Gustave Moreau (1826–1898)
L'Apparition
ca. 1875
Oil on canvas
Inv. 222
Paris, Musée Gustave Moreau

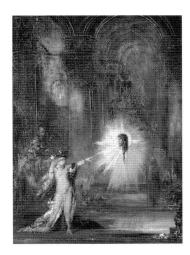

Apuleius Platonicus
Herbarius
Dioscorides
Liber medicinae ex herbis feminis
Chartres (?), late 9th to early 10th century
Parchment codex
Ms. lat. 6862
Paris, Bibliothèque Nationale

Man of the zodiac signs
France (?), ca. 1380–1422
Painted parchment
Ms. Lat. 11229
Paris, Bibliothèque Nationale

Cosmographical diagram
France, 12th century
Parchment codex
Ms. lat. 12999
Paris, Bibliothèque Municipale

Saint Catherine Drinking from the Side Wound of Christ
From Raymond of Capua, *Life of Saint Catherine*
Upper Rhine or Alsace, 15th century
Ms. All. 34, fol. 43v
Paris, Bibliothèque Nationale

J.-A. Roussel
Lexique sur la transfusion
Paris, 1888
Paris, Bibliothèque Nationale

Princeton

Portrait of a Maya captive
Late Classic Period, AD 600–800
Clay figurine
Inv. L 1974.10
Princeton, Princeton University Art Museum

Prinzendorf, Austria

Hermann Nitsch (b. 1938)
A New Action
Series of thirty photos
Prinzendorf, Schloss Prinzendorf

Hermann Nitsch (b. 1938)
Orgien Mysterien Theater (Orgies Mysteries Theater), recalling a ritual sacrifice
1998
Videos
Prinzendorf, Schloss Prinzendorf

Hermann Nitsch (b. 1938)
6-day play from the Orgien Mysterien Theater (Orgies Mysteries Theater)
Videos
Prinzendorf, Schloss Prinzendorf

Hermann Nitsch (b. 1938)
Vitrine with chasuble and medical
apparatus
1978
Mixed media
Prinzendorf, Schloss Prinzendorf

Hermann Nitsch (b. 1938)
Laboratory of Smell and Taste
Shelves, table (wood, glass), various
vessels, and essences
Prinzendorf, Schloss Prinzendorf

Hermann Nitsch (b. 1938)
Image from Poured Fluids
Jute, blood, paint
Prinzendorf, Schloss Prinzendorf

Hermann Nitsch (b. 1938)
Stretcher
Wood, screen, blood
Prinzendorf, Schloss Prinzendorf

Reims

Charles Landelle (1821–1908)
Jewess from Tangiers
ca. 1860
Oil on canvas
Inv. 874.10.2
Reims, Musée des Beaux-Arts

Rohrau

Juan Carreno de Miranda
(1614–1685)
*Queen Maria Anna (1635–1696),
Daughter of Emperor Ferdinand III and
the Infanta Maria Anna, Portrayed
as the Widow of King Philip IV, and
Regent for her Son Charles II*
ca. 1670
Oil on canvas
WF 339
Rohrau, Graf Harrach'sche
Gemäldegalerie

Juan Carreno de Miranda
(1614–1685)
*King Charles II of Spain
(1661–1700) Wearing the Insignia
of the Order of the Golden Fleece*
ca. 1677
Oil on canvas
WF 340
Rohrau, Graf Harrach'sche
Gemäldegalerie

Rome

François Spierre (after Gian Lorenzo
Bernini)
The Blood of Christ
ca. 1699
Oil on canvas
Inv. MR 45666
Rome, Museo di Roma

St. Gall

Epistola de phlebotomia
St. Gall, first half of 9th century
Parchment codex
Cod. 217
St. Gall, Stiftsbibliothek

*Qualis tempus est utilis ad sanguinem
minuendum*
Switzerland (?), first half of
9th century
Parchment codex
Cod. 44
St. Gall, Stiftsbibliothek

Vindicianus
*Epistola ad Pentadium de quatuor
humoribus in corpore humano
constitutis*
St. Gall, first half of 9th century
Parchment codex
Cod. 762
St. Gall, Stiftsbibliothek

Pliny the Younger
De medicina
St. Gall, late 9th century
Parchment codex
Cod. 752
St. Gall, Stiftsbibliothek

Stuttgart

Geopolitical and anthropological
wall charts with an emphasis on the
evangelical mission
Calw, 1883
Stuttgart, Universitätsbibliothek

Treviso

Oliviero Toscani
Bloodstained clothes of a Croatian
student killed by enemy fire
Billboard
Treviso, Benetton Group SA

Ulm

Arma Christi and *Five Wounds and
The Agony in the Garden with Saint
Augustine, the Virgin Mary, and the
Arma Christi*
Two panels from the Buxheim
Altarpiece
Ulm School, ca. 1510
Inv. 1922.5109
Ulm, Ulmer Museum

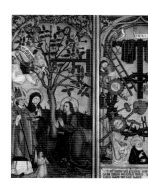

Utrecht

Pieter Aertsen (1507/8–1575)
Mass of Saint Gregory
Drawing
Inv. RMCC tc 00005
Utrecht, Museum Catharijneconvent

Vienna

Hermann Nitsch (b. 1938)
Stretcher (Cross)
1984
Screen, wood, organic substances
Vienna, Hummel Collection

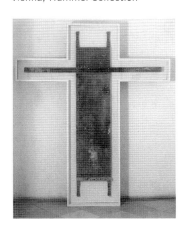

Hermann Nitsch (b. 1938)
Wax Image
1960
Wax on wood
Vienna, Hummel Collection

Gilbert & George (b. 1943 and
b. 1942)
Blood and Tears
1997
Mixed media
Inv. 3935
Vienna, Klosterneuburg, Essl
Collection

Chalice of Emperor Frederick III
Silver, gilt, 1438
Kunstkammer, Inv. G.S.B 1
Vienna, Kunsthistorisches Museum

*Duke Francis Stephen of Lorraine
(1708–1765) and Archduchess
Maria Theresia (1717–1780) as a
Bridal Couple*
Gemäldegalerie 8803
Vienna, Kunsthistorisches Museum

Benjamin von Block (1631–1690)
*Emperor Leopold I (1640–1705),
Son of Ferdinand III and the Infanta
Maria Anna, Portrayed as a
Fieldmarshal in Armor*
Oil on canvas, 1672
Gemäldegalerie 6745
Vienna, Kunsthistorisches Museum

Bartolomé Gonzales (1564–1627)
*The Elder Children of King Philip III
and Archduchess Margaret, the
Infante Philip
and Infanta Anna*
Oil on canvas, 1612
Gemäldegalerie 3199
Vienna, Kunsthistorisches Museum

Lorenzo Lippi (1606–1665)
*Empress Maria Leopoldina
(1632–1649), Daughter of Archduke
Leopold V of Tyrol and Claudia de'
Medici, Wife of Emperor Ferdinand III*
Oil on canvas, 1649
Gemäldegalerie 8119
Vienna, Kunsthistorisches Museum

Giovanni Maria Morandi
(1622–1717)
*Archduchess Claudia Felicitas
(1653–1676), Daughter of Archduke
Ferdinand Charles of Tyrol and Anne
de' Medici, as Diana*
Oil on canvas, 1666
Gemäldegalerie 3096
Vienna, Kunsthistorisches Museum

Georg Pachmann (1600–1681)
Emperor Ferdinand II (1578–1637), Son of Archduke Charles and Maria of Bavaria
Oil on canvas, ca. 1635
Gemäldegalerie 311
Vienna, Kunsthistorisches Museum

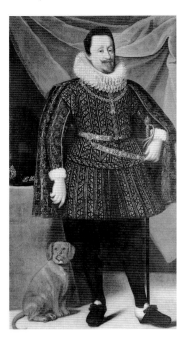

Hans Schöpfer (b. 1610)
Archduchess Maria, Married at the Age of Thirteen
Oil on canvas, 1564
Gemäldegalerie 8179
Vienna, Kunsthistorisches Museum

Justus Sustermans (1597–1681)
Princess Eleonore de Gonzaga (1598–1655), Daughter of Duke Vincenzo I of Mantua and Eleonora de' Medici, Portrayed as the Bride of Emperor Ferdinand II
Oil on canvas, 1621
Gemäldegalerie 7146
Vienna, Kunsthistorisches Museum

Diego Rodriguez Velázquez (1599–1660) and workshop
Queen Maria Anna (1635–1696), Daughter of Ferdinand III and the Infanta Maria Anna, Married in 1649 to Her Uncle Philip IV
Oil on canvas, 1652
Gemäldegalerie 6308
Vienna, Kunsthistorisches Museum

Hermann Nitsch (b. 1938)
Untitled
1976
Blood and paint on cotton
Vienna, Galerie Krinzinger

Washington, DC

Man of Sorrows (Cristo della Passione)
Bronze, gilt, from tabernacle door (now without backing)
Roman, second half of 15th century
Inv. 1957.14.581
Washington, DC, National Gallery of Art, Kress Collection

Williamstown, Massachusetts

Matthias Zündt (d. 1572)
The Ship of Christian Faith, 1570
Etching
Acc. no. 1982.112s
Williamstown, Mass., Sterling and Francine Clark Art Institute

Wolfenbüttel

Bloodletting man
Paper
Ms. 18.2 Aug. 4°
Wolfenbuttel, Herzog August Bibliothek

Zetel

School wall chart showing the five principal human races
Dresden
Late 19th century
Inv. 816
Zetel, Nordwestdeutsches Schulmuseum Bohlenbergerfeld

Private collections

Günter Brus (b. 1938)
Selbstverstümmelung
(Self-Mutilation), 1965
Vienna, Perinetkeller
Private collection

Günter Brus (b. 1938)
The Architecture of Total Madness, 1967/68
Private collection

Günter Brus (b. 1938)
Art and Revolution, June 7, 1968
Private collection

Günter Brus (b. 1938)
Endurance Test
1971
Video, twelve drawings, and twelve photos
Galerie Heike Curtze

Olaf Gulbransson (1873–1958)
The Blind Tsar
From "Aus meiner Schublade" (From My Drawer)
ca. 1905
Lithograph
Private collection

Luis de Morales (ca. 1520–1586)
Ecce Homo
Oil on panel
Private collection

William Harvey
De Motu Cordis
1628
Private collection, London

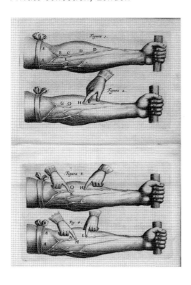

Gert H. Wollheim (1894–1974)
Der Verwundete (*The Wounded Man*)
1919
Oil on panel
Private collection

Acknowledgments

Elke Ahlers, Schulmuseum, Zetel
Dr. Claudia Balk, Deutsches Theatermuseum, Munich
Dr. Jürgen Blenk, Cologne
Andreas Blühm, Van Gogh Museum, Amsterdam
Wladimir M. Boiko, photographer, Moscow
Miel de Botton, London
Marina Bradburne, Frankfurt am Main
Peter and Caroline Cannon-Brookes, Oxford
Odile Coulon, Fondation Villette Entreprises, Paris
Taco Dibbits, Christies, London
Ingrid Erhardt, Frankfurt am Main
Rachel Esner, Amsterdam
Tom Freudenheim, Director, Gilbert Collection, London
Sonja Friedl, Kunsthistorisches Museum, Vienna
Geza von Habsburg, New York
Godelieve van Heteren, Amsterdam
Tamara G. Igumnowa, Vice Director, State Historical Museum, Moscow
Jan C. Jacobsen, Frankfurt am Main
Marina Koustnetsova, Moscow
Mikhail N. Kravzov, photographer, Moscow
Marc Landeau, Paris
Geneviève Lacambre, Senior Curator, Musée Gustave Moreau, Paris
Marc Leland, Washington, DC
Giovanni Leoncini, Florence
Friedrich von Metzler, Frankfurt am Main
Mary Miller, Yale University
Vassili A. Motchugovski, photographer, Moscow
Franziska Nori, mak.frankfurt, Frankfurt am Main
Karsten Otte, Göttingen
Paolo Pampaloni, Florence
Natalia A. Perevezentzeva, Curator, State Historical Museum, Moscow
Pamela Porter, British Library, London
Catherine Roth, Institut Français, Frankfurt am Main
Alexander I. Schkurko, Director, State Historical Museum, Moscow
Rolf Schlettwein, General Consul, Mexico
Ursula Seitz-Gray, Frankfurt am Main
Irina A. Semakova, Curator, State Historical Museum, Moscow
Rob Smeets, Milan
Stefan Soltek, mak.frankfurt, Frankfurt am Main
Norbert Steinhauser, Friedrichshafen, Lake Constance
Carmen Strobl, Mexico City
Olga B. Strugova, Curator, State Historical Museum, Moscow
Gary Vikan, The Walters Art Gallery, Baltimore
Marie-Claire Waille, Bibliothèque Municipale, Besançon
Helen Wakely, Assistant Archivist, The Wellcome Institute, London
John Walsh, Los Angeles
Dr. Ulrich Weidner, Münchner Stadtmuseum, Munich
Julian Zugazagoitia, New York

Website: www.bloodexhibition.de
Joost Bootsma, Amsterdam
Jeanine de Bruin, Amsterdam
Mike Murtaugh, Amsterdam

Special thanks are due to the Grand Duchesses Maria and Leonida of Russia for their generous permission to reproduce photographs from the Romanov family Archives.

"The Pump: Harvey and the circulation of the blood," "Blood: The pure, clear, lovely, and amiable juice," and "Self-made Man: The shift from blood to genetics" © Jonathan Miller, used with permission

"The Culture of Violence and the Politics of Colorful Sweaters: Benetton's 'World without Borders'" © Henry A. Giroux, used with permission

Exhibition concept: James M. Bradburne

Exhibition coordination: Maria de Peverelli

Curators: James Clifton, Valentina Conticelli, Stanislaw Dumin, Mino Gabriele, Georg Kugler, Giuseppe Orefici, Joachim Pietzsch, Miri Rubin, Annette Weber, Peter Weiermair

Registrar: Margrit Bauer (mak.frankfurt), Karin Grüning (Schirn Kunsthalle)

Administration: Klaus Burgold, Inka Droegemüller (Schirn Kunsthalle), Margit Emrich, Martina Schmidt (mak.frankfurt)

Exhibition design: Peter de Kimpe

Graphic design: Anja Harms, Ines v. Ketelhodt (ANAKONDA Ateliers)

Graphic production: Expoplan

Website: Mike Murtaugh (jamnewmedia)

Press coordination: Dorothea Apovnik (Schirn Kunsthalle), Sue Bond, Britta Fischer, Eva Linhart (mak.frankfurt)

Publicity campaign: Andreas Redlich (Publicis)

Installation supervision: Jürgen Dietrich (mak.frankfurt), Ronnie Kammer (Schirn Kunsthalle)

Transport: Andrea Kersten, Uwe Seidel (Schenker Deutschland AG)